THE IMMERSIVE WORLDS HANDBOOK

THE IMMERSIVE WORLDS HANDBOOK

DESIGNING THEME PARKS
AND CONSUMER SPACES

SCOTT A. LUKAS

Focal Press
Taylor & Francis Group

NEW YORK AND LONDON

First published 2013
by Focal Press
70 Blanchard Road, Suite 402, Burlington, MA 01803

Simultaneously published in the UK
by Focal Press
2 Park Square, Milton Park, Abingdon, Oxon OX14 4RN

Focal Press is an imprint of the Taylor & Francis Group, an informa business

Notices

Knowledge and best practice in this field are constantly changing. As new research and experience broaden our understanding, changes in research methods, professional practices, or medical treatment may become necessary.

Practitioners and researchers must always rely on their own experience and knowledge in evaluating and using any information, methods, compounds, or experiments described herein. In using such information or methods they should be mindful of their own safety and the safety of others, including parties for whom they have a professional responsibility.

Product or corporate names may be trademarks or registered trademarks, and are used only for identification and explanation without intent to infringe.

Library of Congress Cataloging in Publication Data

Lukas, Scott A., 1968-

 The immersive worlds handbook: designing theme parks and consumer spaces/Scott Lukas.—First [edition].
 pages cm

 1. Amusement parks—Design. 2. Themed environments—Design. 3. Senses and sensation in architecture. 4. Architecture—Physchological aspects. I. Title.
 GV1851.L85 2012
 791.06'8—dc23

 2012019867

ISBN: 978-0-240-82093-4 (pbk)

ISBN: 978-0-240-82098-9 (ebk)

Typeset in DIN Regular

Typeset by MPS Limited, Chennai, India

CONTENTS

For Krista, who always reminds me, "the greatest of these is the suspension of disbelief."

DEDICATION

One of the most exciting aspects of this text was working with the many fine professionals who shared their expertise with me. I appreciate the assistance of Joel Bergman, Kelly Gonzalez, Dave Gottwald, Gordon Grice, Henry Jenkins, Gordon Jones, Margaret J. King, Anna Klingmann, Mike Leeson, Carmel Lewis, Mindi Lipschultz, Thomas Muderlak, Bob Rogers, David Rogers, Nancy Rogo Trainer, Larry Tuch, and Mark Wallis, and the time that each took to provide the exhilarating interviews that appear in this book. I also extend much gratitude to the many professionals who assisted in providing many of the photos in this book or otherwise assisted with information—Chris Balcombe (Solent News & Photo Agency), Julie Brinkerhoff-Jacobs (Lifescapes International, Inc.), Jonah Cohen (The Venetian Resort-Hotel-Casino), Kristen Collins (BRC Imagination Arts), Luc Curvers (Heineken Experience), Thad Donovan (Smith Donovan Marketing and Communications), Michel den Dulk (Europa-Park), Valentina Gennadis (Propeller Island City Lodge), Jennifer Harper (Florida Hospital Celebration Health), Matt Heller (The Jerde Partnership), Helen Hüttl (BMW Welt), Sophie Madej (Annenberg School for Communication & Journalism, University of Southern California), Bruno Marti (25hours Hotel Company), Alice Mathu (IAAPA), Tim Motz (Toledo Museum of Art), Debbie Munch (Caesars Entertainment Corporation), Andreas Oberprieler (BMW Welt), Yogini Patel (Library Hotel), Mick Pedroli (Dennis Severs House), Brad Schulz (Bergman Walls & Associates), Dominik Seitz (Europa-Park), Lyan Sierra-Caro (Royal Caribbean International), Jeremy Tenenbaum (Venturi, Scott Brown & Associates), and Gary Thompson (Caesars Entertainment Corporation). I also acknowledge the many participants from the *Staging the Past: Themed Environments in Transcultural Perspective* conference (University Of Freiburg, 2009), especially Gordon Jones and Mark Wallis (who appeared in this book) and Cornelius Holtorf for his work on popular archaeology and pastness.

I owe special gratitude to Larry Tuch (Narrative Concepts) who acted as a skilled and thoughtful technical editor for the project. I am also grateful to my editors at Focal—Carlin Reagan and Laura Lewin—who made the whole process of writing this book easy and enjoyable. Most especially, I owe thanks to my wife, Krista Lukas, who has always believed in me as a writer.

This book is designed for anyone who wants to know more about immersive worlds and all that they entail and who wants to study some ways to make these worlds more meaningful for the guests who visit them. The topical areas in this book cover a lot of ground—theme parks, restaurants, casinos, and many other spaces are the subject matter—and the approaches discussed are drawn from the worlds of architecture, design, cultural studies, marketing, and cultural anthropology. There are many case studies. Some are taken from current, real-world cases in immersive worlds, others are historical examples, and some are conceptual ones that are intended to be thought about in a deep sense. The case studies in this book should not be read as an exhaustive list or even a best-of list. Rather, they are ones that help illustrate a set of design principles. Many other excellent case studies had to be left out due to space limitations and to corporate restrictions on sharing design information with the public.

The first chapter introduces the important issues that make up the world of themed and immersive spaces. You will gain insights on how understanding these spaces can lead to more successful forms of design, greater excitement for the customer, and greater revenue for the operator of the space. The second chapter focuses on ways in which you can make your themed and immersive spaces more interesting, effective, and profitable. The focus includes discussions on theming and design storytelling. The third chapter addresses the specific makeup of themed and immersive spaces. There will be a specific emphasis on creating atmosphere and mood within a space. The fourth chapter considers the issues of authenticity, believability, and realism and emphasizes ways in which themed, immersive, and consumer venues can be effectively developed. The fifth chapter focuses on the important component of guests within the themed

and immersive space as well as the issue of experience and how it relates to spatial design. Next is a "research break" that is dedicated to the use of research in design spaces. The goal of this textual interlude is to provide you with insights on how to use research to develop and maintain more effective themed and consumer spaces. The sixth chapter focuses on the relationship of forms of spatial design to branding and experience, including the use of the senses. The emphasis of the chapter is to orient you to ways in which forms of design can have a greater and more lasting impact. The seventh chapter considers the ways in which technology and material culture are a part of consumer space design as well as the issues of interactivity and flow or the ways in which guests move about a space, how they interpret it, and how they impact its overall approach. The eighth and final chapter addresses the ways in which tradition and change impact the design of consumer spaces. You will consider ways in which tradition can be developed through forms of spatial decision making and you will analyze what can be done to make your spaces meaningful, even through social change.

In addition to the case studies and ideas considered in each of the eight chapters and the research break, you will note a number of other useful features in this book. Each chapter features interviews with designers who have been willing to share their perspectives on the many issues that we will be considering. I have also included numerous photos to help illustrate the look of the many places and design issues that you will be reading about. You will also note a number of key features within each chapter. "Wouldn't You Know It!" presents a brief aside about a design issue while "Trending" offers a short look at a current trend that may impact your design work. In addition, you'll find a chart/table or two in each chapter. These help visually represent an idea from the text and you might find yourself marking a few of them with a sticky note

or two and coming back to them from time to time. There are also two features that give you an applied look at an issue. These are called "Applications" and "Provocations" and each is designed to be worked on, at your leisure, and will hopefully be the source of more consideration beyond the pages of this book. Included at the end of the book is a list of key terms. These are definitions for the bolded terms that you will find throughout the chapters. There is also an extensive reading list that will get you on the right track of looking at some additional sources on these topics. As well, there is a companion website that offers more information, useful links, extended and additional expert interviews, printable handouts for many of the exercises in the book, and more in-person discussions of these issues. Think of the companion website as a hub where you and others can come to discuss and debate these subjects. I would like to hear from you, so please come and share your ideas.

As you use the book, keep in mind that the design issues within your space—whether it be an interpretive environment, a hotel room, or a theme park attraction—will vary with those discussed in the book. The thousands upon thousands of variables—where your attraction is located, the nature of your clientele, budgetary issues, access to research and marketing resources, and whether you prefer blue walls to brown ones—will all impact how you utilize the advice offered in the book. Enjoy the book and let me know what you think. You can always contact me at scottlukas@yahoo. com or scottalukas@gmail.com

1. What is an immersive world?

2. What are some principles of space?

3. What is placemaking and why is it important?

4. What are the components of immersive world design?

THE NATURE OF THEMED AND IMMERSIVE SPACES

Immersive Worlds

An **immersive world** is a place in which anyone can get wrapped up. Whatever your background in life, whatever your political or religious views, and whatever you enjoy doing in your spare time, an immersive world will take you in such that you won't want to leave. This book is about the variety of immersive worlds that have existed and the ones that can be designed, and it details how design can be applied to the many spaces that are typically a part of an immersive world—theme parks, restaurants, cruise ships, hotels, interpretive environments, cultural museums, casinos, mixed-use spaces, shopping malls, resorts, lifestyle stores, and other spaces.

Etymology of Immersive World

immersion

Mid-15th century, from Lower Latin and Latin, meaning, "plunging or dipping into." Later, in the 1640s, meaning "absorption in some interest or situation."

world

Circa 1200, meaning "the known world" and "the physical world in the broadest sense, the universe." In Gothic meaning, the "seed of man," and in Old Norse meaning, "the middle enclosure" or "where humans dwell."[1]

[1] Online Etymology Dictionary, http://www.etymonline.com

When we combine the ideas of immersion ("absorption in some interest or situation") with world ("the known world…in the broadest sense") we get a place known as an "immersive world." You might be wondering, "Isn't every world, in some sense, an immersive world?" Yes, it's true that wherever we go—whether on a vacation to a tropical island, on a mundane trip to the grocery store, or on a commute on the freeway to our place of work—we are being immersed in the people, situations, smells, sights, and other senses of that world. The immersive world has a more specific meaning though. When we talk about the immersive world we mean a place where people *want to be*. This is a place, whether a restaurant, theme park, or café, where people enjoy what they are doing. They become immersed in two senses. First, there is something about the place—its evocative quality—that creates a set of complex feelings in the person there and this results in the delight and willingness to stay in that place. Second, the person, him or herself, gets wrapped up in being in that place and, in his or her mind, creates associations and feelings that result in more pleasure. As you'll soon see, immersion in a world is a two-way street. But more on that later.

What Is a World?

We have talked briefly about an immersive world—the subject of this book—but in order to understand how to create immersion in a space we first need to go back to the beginning. What, exactly, is a world?

Defining a World

As the earlier definitions suggest, a world is literally everything that is known to us, in the broadest possible sense. The planet Earth could be called a world (an astronomical definition), the Mayan culture could be referred to as a world (a cultural definition), the Blizzard Entertainment **MMORPG** World of Warcraft is considered a world (a technological definition), some people refer to things like "the media world" (a social definition), and many would call theme parks and other places of immersive entertainment magical worlds (a design definition). A world can be understood in many senses, but for the purposes of this book we will be considering worlds that are a part of some entertainment, consumer, or branding experience. Let's look at a

definition of "world" that can be more easily applied to immersive spaces.

A World

A world...is a place inhabited by beings. It is complete, diverse, consistent; it has a background or history, and a culture. It is ever-changing or evolving and is characterized by relationships and forms of interconnection.

Figure 1-2

The definition of a world that we are using in this book has some advantages. First, it indicates that a world is always made up of beings. "Beings" is used because it allows us to include everybody and everything in a world. If we are inside a theme park attraction, for example, we can include the people or actors who are playing parts in that attraction, the guests who are paying to see it and be a part of it, and the sometimes fictional begins (like creatures, animals, space entities, etc.) who also play a part in the world. Second, by saying that the world is "complete, diverse, and consistent" we acknowledge that the world, like any world, isn't one dimensional, bland, or uninteresting and that it is complex and consistent in its complexity throughout its spaces. Third, by including a "background or history, and a culture" we see that a

world isn't shallow. It's made up of so many things that we must acknowledge as designers. Consider how the popular James Cameron film *Avatar* would have been had Cameron not spent so much time conceptualizing the cultures of the Na'vi and the humans within the *Avatar* world. Last, by acknowledging that a world is always changing or evolving and is characterized by relationships and connections, we see that a world is never static—it is something that is always on the move.

Worlds—Big and Small

Figure 1-3

Figure 1-4

Using this definition of a world we can begin to talk about how to create an immersive world. First, let's look briefly at the issue of scale. Our earlier look at

the different astronomical, cultural, technological, and other definitions of worlds showed us that worlds can be understood in so many different senses. The same can be said of the scale of a world. A world can be an entire planet (perhaps one that will form the fictional background of a theme park that you are creating) and it can be a very small place on that planet (like a small ecosystem on one of the planet's continents). These two senses of a world are key. The first "big" world is a **macro world** or one that has a large scale. The second "small" one is a **micro world** or one that has a smaller scale. Big and small are both variable. Scale is related to the actual proportions and dimensions of the spaces that you will be creating in your own venues. Whether you design a macro or micro world, you will need to keep in mind the attention to details, the sense of believability and realism, and the need to keep people excited about the world they are visiting. As well, it is likely that the space that you are designing might have multiple worlds—big and small—within it. In 2011, while visiting the Field Museum in Chicago, Illinois, I was intrigued to walk through exhibits that focused on the makeup of soil (the micro) world and on the life of whales in the ocean (the macro). What this reminded me is that all worlds—whether big or scale—can intrigue and interest us.

Creating an Immersive World

Whether we are creating a big or small world, or some combination of both, we are interested in creating an immersive world. Combining our definitions of world and immersion we get an immersive world or a place in which guests can become fully absorbed or engaged. *Anyone* is an important point of emphasis here. While in some cases we might design a world that is intended for a more specific group or audience—such as a religious theme park or museum that is geared at "all people

who are religious" or "all people of a certain religious denomination"—nine times out of ten we want to create a place that can be enjoyed by anyone regardless of their background. Later I will tell you a short story about the historic amusement parks of Coney Island. One of the most uplifting things about Coney Island amusement parks was that they were places where, in the words of Giuseppe Cautella, "democracy meets…and has its first interview skin to skin," meaning that people—rich and middle class, men and women, black, white, and other ethnic groups—could all enjoy the attractions that had been created for them.[2] Some of the rides there, like the Human Roulette Wheel, in fact literally threw people together. Talk about immersion!

In today's world, we are lucky that because of multiculturalism and more general good will among people that guests don't have to be literally thrown together in the same space to enjoy it. It's more on you, the designer, to create intriguing immersive spaces that will be ones that guests will visit again, again, and again. As you create an immersive world, you will find that the places you have designed—because of the things that we will be talking about later—are ones that people come first to experience, second to revere, and third to love and to incorporate as part of their life traditions. An immersive world, as we'll see, simply (and perhaps **existentially**), *is*.

Application—Iconic Spaces

Sometimes a certain place is iconic to us. It could be something about where it is, or what sorts of features it has—perhaps the certain visual look of a mountain range of snow-covered peaks—or perhaps it has to do with your memories and the events that happened in that place. Whatever the reasons, we attach our memories and feelings to certain places while others

[2] Quoted in the documentary *Coney Island* (PBS, *The American Experience*), directed by Ric Burns, 1991.

remain entirely forgettable. As designers we can think more closely about the certain feelings and memories that we associate with an iconic space. Take a moment here, in this application, to do just this. On a piece of paper, make a note of a place that is iconic for you. Next, write a list of associations that you have with that place. This can be free form. Just be sure to jot down key words that represent your fondness for that place. After you have completed the list, try to organize your word associations into categories—spatial, event, sensory, or your own versions. The key is to group the associations into subsets. Then observe which of these subsets relate to the others. If you like, a design partner can work on one and the two of you can share your lists. As you finish considering the list, focus on how you could translate some of the same fond associations that you had with your iconic space into an iconic space that you can create in a design world.

Cave Art

The immersive world that you considered above is one that had a personal effect on you. It was, we could say, **evocative**, meaning that it produced something vivid, memorable, and profound in you. For any of us, when we have very vivid memories of being in a place we have them because something about the place stays with us and because we were once, in whatever way, immersed in that world. After the fact we could describe it, in fine detail, to any person who asks us. It's a part of us.

One of the earliest and more important immersive worlds can be found throughout Europe and other parts of the world. Step back in time about 30,000 years before now and you would have found cave art in some of the places that you would have lived. On the walls you would have seen images of bison, deer, and horses, as well as images of human hands and other representations. You would have likely felt something immense, something bigger than yourself when you looked at the images

Figure 1-5

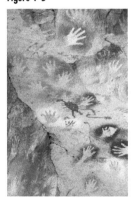

on the walls. The images on the walls and the caves themselves would have had an effect on you. The key to cave art, like the themed consumer spaces of our world today, is that *both* the thematic artistic representations *and* the fact that humans interpreted the images, used them in some way, and could relate to them, and likely others through them, are what made cave art significant for people.

Wouldn't You Know It!—Cave Art

Well, it turns out that cave art gives us both our first insight and our first bit of confusion. What's the confusion? We don't exactly know why cave art was made. We hear a lot of theories about it. Some archaeologists have theorized that the art represented a form of magic that related to successful hunting, but others have said that the evidence points to representation of animal species that were less frequently hunted. Some believe that cave art was a reflection of deep mythological beliefs that people had in their minds. Others have concluded that cave paintings must have been the work of shamans who entered trance states, while some have said that they reflect early calendars that helped humans understand ecology and nature. One theorist has argued that cave art may be the doings of oversexed young males and one goes as far as to say that the drawings are the simple scribbles of early humans—their equivalent of us doodling on a napkin. So, wouldn't you know it, all these theories add up to a lack of consensus on why cave art existed. What we do know is that it was very important to the people who made it and, perhaps if we combine some of the theories, we might conclude that people produced cave art for a variety of reasons. The same conclusion might be made of guests who visit the theme parks, restaurants, and cruise ships that you create. Each comes for a potentially different reason, but each person is there to be part of something bigger than him or herself.

Designing a World

Like the cave artists of the past, today's immersive world designers have a palette of choices in front of them. You will have to decide what structures to build, which colors to use, which forms of technology to plug in, and which design stories to tell. Every project necessitates new thinking and produces new challenges, but there are a number of key principles that can be applied to gear your projects more to the successful routes of immersive worlds. One of the first principles that we need to look at is the issue of what to include and what to leave out in your world.

The first thing we can do is to compare a real world with a designed immersive one. Table 1-1 lists, rather exhaustively, the many elements that make up a real world. For example, people live in a physical world and this includes the environment, natural features, etc. We can also reflect on how people have a society and this includes social organization, economics, and so forth. Even this chart does not do justice to the complexity that exists in any real world. So, we have this real world as a background and then you, the designer, face the task of translating *some* of these same elements into the attractions that make up your immersive world. Where do you start?

Table 1-1 Components of a World

Area	Subcomponents
Place	Planet, Continent, Nation, City, Town, House
Beings	Species, Races, Organisms, Sexes
Environment	Natural Features, Geography, Weather
Structures	Housing, Work, Leisure
Language & Communication	Signs, Verbal Language, Pictorial, Written
Transportation & Movement	Getting from Point A to B
Population (Vital Statistics)	Age, Demographic Patterns
Health	Disease, Illness, Medicine
Diet	Food, Culinary Traditions
Relationships	Internal (Family, Work), External (Politics, Conflict, War)
Material Culture	Technology, Tools, Everyday Design
Belief & Worldview	Knowledge, Views, Attitudes, Opinions
Evolution & History	Development, Innovation, Diffusion
Culture	Traditions, Folklore, Key Aspects
Behaviors	Basic Behaviors, Actions, Personal Hygiene
Values	Core Values, Roles, Value Conflicts
Social Order	Law, Conformity, Deviance, Rules
Expressive Culture	Art, Leisure, Stories, Rites of Passage, Festivals, Leisure

Simplification, Translation, and Adaptation

Argentine writer Jorge Luis Borges once told the tale of a culture that wanted to create a map of the world that was incredibly detailed.[3] This 1:1 map was literally the same size as the world that it represented. Borges' tale gives us a profound sense of how difficult it is to represent the world in any way. Whether we decide to paint it, to write a poem about it, to map it, or to create a theme park in it, we must first realize that we can never create an *exact representation* of the world.

Simplification is the process by which a designer takes elements from the real world (or from a fictive world that has been designed) and adapts them into various forms of design. Simplification does not, in any way, imply that the designs you will create are simple. It suggests that you must make choices about which things to leave out since it is not practical to re-create the entirety of the world that you are attempting to relate in buildings, attractions, and other features within your venue. You might have a specific idea like creating an undersea world populated by numerous sentient species each with its own form of culture. You cannot create the entirety of what you have dreamed up so you have to choose a few key areas of this world—perhaps you pick one of the species' town halls, another species' place of worship, and so forth. You simplify the idea that you have created in order to make it meaningful for the guest and manageable for the designers and workers involved in the project.

Translation and adaptation refer to the ways in which designers take one or more ideas—whether based in the real world or designed as part of a new world—and bring those to life in a designed world. To use the previous example of the undersea world, you can think about taking the spaces of the town hall and place of worship and bringing those to life in a theme park attraction. You decide that the best way to translate the ideas of your world is to create a simulator ride that will show some key aspects of how the various species relate to one another.

Method of Loci

The method of loci was one of the earliest and most interesting connections of physical space and the mind. In Roman culture a speaker would use landmarks in the natural world to help memorize a speech. Perhaps it was a river that allowed the person to recall a certain part of the speech and a hill another part of a speech. This method helped establish a clear connection between physical and architectural features and the mind. In today's world, we see similar connections between images, space, and mental processes. Consider the icons on the desktop of your computer. The look of the trashcan, the image of a file folder that holds your important papers—these and many other representations help us with our daily tasks and they also illustrate our continuing relationship with space.

Figure 1-6

Basis of the Designed World

As we think about how we can translate ideas from an imagined world into an immersive space, there are four main elements that we can focus on. These will allow us to better understand the space that we are trying to create. The *big idea* refers to what you are trying to have the guests get out of your designed space, the

[3] "On Exactitude in Science" or *"Del rigor en la ciencia"*

story is how you will present the narrative of the place, depending on what you are trying to accomplish, the *experience* is how the guest will be involved with the ideas within the space, and the *design* involves the ways in which you will create the experiences for the guest (architecture, material culture, technology, lighting, etc.).[4] These elements should be thought of as forces that work together to create a compelling immersive place. Let's look at one example of how this could work from a design perspective.

Big Idea: The creation of a food museum that will give guests a vivid sense of the value that food plays in their lives.

Figure 1-7

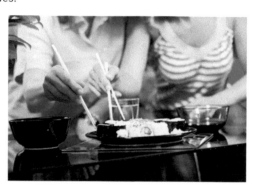

Story: The story will discuss the history of food and culture, the connection of food and diet, and food in pop culture.

Figure 1-8

[4] Thank you to Larry Tuch for his great suggestion on the Big Idea.

Experience: The guests will look at the importance of food in a gripping story about how food affects their lives.

Figure 1-9

Design: The museum will feature modern architecture, cutting-edge technology, and hands-on exhibits.

Figure 1-10

We'll call this place "The World of Food." It's fictional, but not unimaginable, given food concepts like COPIA (Napa Valley). We begin with the big idea, which is the idea of a food museum that will show people the value that food plays in their lives. Next, we aim to tell a story—in this case, the history of food, its role in human cultures, and issues like diet, nutrition, and the environment. The experience will be a multisensory interaction with food that will get guests wrapped up in the importance of food. The design will include modern architecture, new forms of interactive technology, and hands-on exhibits. For the sake of keeping things general and applicable to your projects, the concepts have been simplified. What's key is that we consider the ways that these important elements can be used together to create the immersive spaces that guests will flock to.

Figure 1-11

Story and the Power of Place
Interview, Larry Tuch
Writer, Creative Consultant, Narrative Concepts

Larry Tuch is a writer and creative consultant working in the areas of traditional, interactive, and themed entertainment. He has written for prime time network television series and worked as a freelance writer and interactive designer for Paramount Pictures and Walt Disney Imagineering.

Can you speak a bit about building a project from the ground up? What steps do you take when you first conceptualize a design project?

My primary focus is creating the story. That's my role on the team. That could involve writing a script for an immersive environment, the narrative for a museum exhibit, or the backstory for a resort property or a planned community. Most of my recent work has focused on placemaking projects, so let's use an example from that area. In the case of a resort property that I helped design in China, I started by tapping the history and culture of the area to shape two stories that would appeal to the visitor's imagination and evoke the romance of a colorful history. Then I wrote narratives that were essentially "backstories"—they recounted adventures of a bygone era that gave rise to the villages that form the resort. Since I was working in sync with the designers who were doing the master planning, I made sure that my stories mentioned iconic structures they could replicate—features that would bring the stories to life and create a sense of atmosphere. I also looked at the recreational features they wanted to provide and created thematic links between those features and the narratives.

You mentioned backstories for projects like resorts and planned communities. What about stories that deal with the visitor experience itself?

That kind of story is fundamental. It can frame the visitor experience or structure its continuity. That's how it most often works in theme park attractions and museum exhibits. But you mentioned resorts and planned communities, so let's look at those. In addition to backstories for these kinds of projects, I often write "experiential narratives." An experiential narrative is, essentially, a walk-through of the property—a preview of what it will be like once it's built. As a narrative, it includes the kind of sensory details that makes clients feel like they are on site, seeing the property through the eyes of future visitors, and experiencing what it will be like to be there.

Working with Jeff Mayer and Partners, I had to write this kind of narrative for a development in Shaanxi Province. It included resort and residential, cultural, and retail-entertainment districts. The approach involved highlighting key elements and making them vivid by appealing to the senses. The narrative followed the arc of the sun over the course of the day starting at the property's entrance plaza and ending after dark at a performance in its music center. The sensory details start with what the mountains look like as the sunrise breaks over the ridgeline while the shaded areas of the landscape are still cool and moist from the night before. So the place is just on the edge of waking up and when it does, we see people showing up on the streets and public spaces—kids heading off to school, older folks playing Mahjong under the awnings of tea houses. Then there is the sound of cascading water from the fountains and waterfalls in the parks and a variety of other sensory experiences as we continue to explore the property. When night falls, we get another sensory mix: the glow of lanterns in the public gardens, laughter spilling out of the clubs and restaurants, and the hubbub of theatergoers converging on the music center.

It sounds, then, that a lot of this work is about figuring out which story to tell and how to tell it.

Right. In most of the projects I've worked on, story is indispensable. It's the source of most of the design ideas and thematic elements. Sometimes you inherit a story or, at least, some story elements. That's the case with museum exhibits or historical sites. You're working with your client to create a story that interprets some aspect of the human experience or the natural world. So you're using your storytelling skills to frame the significant and factual aspects of the subject and make them vivid and memorable. On the other hand, when you have a blank slate, I think the best thing to do is start with the kind of experience your client wants to offer their guests—the activities of a family fun zone or a wild or spooky dark ride for example—and then craft a story that supports that experience.

What about the use of a theme?

Theme is very important. Even in projects where story isn't a fundamental aspect of the experience, theme is usually indispensable. It's the shorthand for defining the project—as a key part of the concept during creative development and as a branding element once the venue is open. Here's an example of a project where a story wasn't required but a theme was very important. I was working with Jeff Mayer again on thematic design for the public areas of a commercial and residential tower in Tianjin, China. The project, one of many new developments in Tianjin, needed a strong identity—something attractive to prospective tenants and shoppers. I always start by examining the significance of the setting. Tianjin has a history as an important port and it's positioned to be even more important in the future. Ports are about prosperity and commerce; they're places where nations and cultures exchange goods and ideas. This is the timeless story of any major port—it's a crossroads of sorts. So "Crossroads of Prosperity" became the theme. It evoked the economic dynamism of Tianjin and positioned the development as a center of that dynamism—something

that would appeal to the aspirations of future tenants. I sketched out a physical metaphor for the crossroads: an intersection of water courses that fed a multistory water sculpture in the atrium. Then we partnered with Nextep Design to reimagine it as an installation animated by contoured water curtains and lighting effects.

When you conceptualize a new space, are there ways to assess what design features will be successful?

At the concept stage, the issue is which design features will do the best job of creating the most engaging guest experience. If you look at your design features as the language you use to talk to your guests, the question is "Am I saying what I want to say and saying it in a compelling way?" That's the test. Remember that your design "language" should have the power to enchant, amuse, fascinate, or inspire. It should evoke particular emotions and weave the kind of spell that transports your guests to another place.

What can you say about your own background and how it helped you in your design and consulting projects? What type of education will be helpful to readers who wish to take a similar career path?

As far as formal education goes, I focused on art, literature, and film. That combines the expressive power of language and visuals. Adding the humanities to that, I had a store of material and reference points I could use to create stories and context for projects. Beyond college, I zigzagged from writing for television to educational films to interactive and themed entertainment. That kind of eclectic background allowed me to take the techniques and tricks I learned in one medium and apply them to other media. It also gave me the chance to learn from my clients and my fellow team members. For a writer or designer—for any creative professional, really—it's the totality of your life experiences that shape how you think. Your childhood impressions; your love of a certain type of painting; your knowledge of architecture; your understanding

of how stories are built, of how scenarios are played out on a stage, on a movie screen, in a book; and your relationships with others—these can all be drawn upon. In the long run, it's your workaday professional experience and a lifelong curiosity about people and the world around you that make the big difference. They feed your imagination and sharpen your instincts.

Application—Worldbuilding

We have now spent some time thinking about the process of creating a world. Now let's take a moment and focus on creating your own world.

Part I: Begin to create your own immersive world. In order to do this you will need a few sheets of paper. First, work on the main idea of the world—what is it? Will this be another planet, a part of a planet, an undersea world, a historic place, a futuristic one? You can decide the main basis of the world. Just make sure that it is unique. If you wish, you may name this place. Focus on adding details to the world. If you would like, use Table 1-1 to write down key aspects of the world, such as ecology, climate, cultures, important rituals, etc. When you have completed this you should be sure that you have a pretty good sense of the world, enough that you could describe it to someone else and that person would have a mental picture of what the world is.

Part II: Take out another sheet of paper and begin to write down which of these aspects of the world you will simplify, translate, and adapt for guests. Write down how you will translate one feature that you devised in Part I into a feature that you will design for guests in a venue of your choosing.

Aspects of Space

In order to better understand how effective design principles can be applied to the worlds that we create, let's first look at some ideas that relate to what space is, how it is used, and the different spaces that exist in the world.

Defining Space

Among the many different definitions of space—which range from describing a three-dimensional area, expanse, or region—one of the most interesting and applicable ones refers to blank and empty areas. If we are watching a science fiction film we might have that same sense—of space, literally and figuratively out there. Just like an adventurer in a film, as designers we can approach space as a blank or empty area. It's a piece of clay that we have to mold into whatever story or idea we wish to tell. Throughout this book we will be looking at a range of spaces and discussing the best practices that we can apply. Just as there are many definitions of what space is, there are many different senses of how it is used.

Types and Uses of Space

Understanding the specific uses of space can assist us in designing more provocative and more meaningful venues for guests. One of the most common ways that space is organized is in a *personal* sense. Personal space includes our homes, our cars, and even the desktop of our laptop computer and the screens on our cell phones and tablets. Personal space has become increasingly mobile—meaning that we take what's personal with us. This type of space can present challenges to designers since people may get wrapped up in what is familiar to them and they may be unable to step out of their own space, but designers can look to this form of space by considering ways to connect with guests in more intimate ways. Somewhat related to this form is *intimate space*. Intimate space is the space of secrets, deep thoughts, and ideas shared between lovers or persons who are very close. Designers wouldn't generally create venues for this form of space but one possible use is to design spaces that people can "take with them" when they leave. For example, you might create an attraction that is so compelling that it becomes the subject of a later

conversation between two people, even when they are far removed from the place that they visited. Though it would be hard to assess, you could say that the quality of your designed place is related to how willing people are to accept it as a part of their most intimate thoughts and consciousness when they are away from the space that you have created.

Other types of spaces are less personal but no less meaningful. *Work* space is the place where people spend a good amount of time. This could be a cubicle in an office, a laptop screen and coffee table, or the cab of a big rig truck. Work space can be expansive as the phrase "taking your work home with you" would indicate. While a trainer at AstroWorld, I became familiar with how we could reference work space to make our theme park more enjoyable for guests. In our training sessions we would talk about the qualities of work that people sometimes express—drudgery, boredom, stress, alienation—and we would try to create leisure spaces that were the opposite of these feelings. If people felt boredom at work, let's give them excitement in the theme park and if people felt constant stress, let's show them a carefree time. There is also *sacred* space, which is an arena that people occupy when they feel devout, when they are going to a place of worship, or when they are considering existential values. Some designers have considered the use of theming and other immersive approaches in their work with sacred spaces. Somewhat challenging from a design standpoint is *political* space or the space that involves our sense of justice, our ideas about how the world works (or should work), and our senses of social, economic, and other policies. Political space is a challenging one to engage in a design world.

Social space is multifaceted. It's a space that we all occupy whether we are speaking with colleagues at work, talking with our family at the dinner table, or interacting with others at a sporting event. Social space, like fantasy space below, is an important form of human space. So much of who we are is because of the ways in which we are brought up in the company of others and because we develop our sense of self in relation to others around us. Think of how you feel when you are truly alone and you get a sense of the importance of social space. Designers can use social space in ways that are truly transformative. George Tilyou, the mastermind behind Steeplechase Park at Coney Island, understood the power to transform guests by mixing them up with other guests.

Fantasy space is a unique space to humans. This world is sometimes immaterial at first—the ideas behind a poem, the thoughts that lead to a scribble on a napkin, a tune in someone's head that becomes a few strums on a guitar. Fantasy space often begins as an idea and then becomes something material. Think of the fantasy space created by author J. K. Rowling. It eventually became a multibillion dollar franchise that has included books, merchandise, and a theme park. Fantasy space is the result of the unique cognitive abilities of humans and we saw one example of it earlier in the discussion of cave art. Because humans spend a lot of time in fantasy space—such as in daydreaming—designers can take advantage of this rich space. It is one of the most significant spaces that we will consider. Related to fantasy space is *consumer* space. This is a broad type of space that could include the shopping mall, theme parks, home improvement stores, the consumer products that we bring into the home, and many other examples. Consumer space is the type of space that most readers of this book will be designing.

The Diversity of Space

As the types and uses of space reflect, we should be aware that space may be thought of in incredibly diverse ways. Likewise, the ways in which designers can create their own spaces are equally numerous. As we consider the diversity of space, let's look at one example of a series of amusement parks in which no idea, concept,

or attraction was off limits. Then, let's look at the types of spaces for which you are likely designing.

Coney Island

Coney Island was many things—a playground for all people, an amazing beachside resort, a collection of multiple amusement parks, and a testing ground for some of the most innovative rides and architecture that we have ever seen. Yet, surprisingly, many people have never thought of Coney Island as being such an influence on contemporary immersive consumer spaces. Consider that Captain Paul Boyton's Sea Lion Park (1895-1903), with its aquatic and land animal shows, acrobatic performances, and thrilling water rides predicted later theme parks like Busch Gardens and SeaWorld or that George Tilyou's Steeplechase Park (1897-1964), with an enclosed berm, thrilling rides, and numerous dark rides and technologies that simulated other times and places, proved before Walt Disney and Angus Wynee Jr. (Six Flags Over Texas) that a theme park could be an entire space with varied rides, attractions, and shows that all members of the family could enjoy. Also, think about Frederic Thompson and Elmer "Skip" Dundy's Luna Park (1903-1944) with its one-of-a-kind eclectic architecture, amazing 250,000 lights, and shows and spectacles that would have rivaled any theme park that is around today like A Trip to the Moon, Twenty Thousand Leagues Under the Sea, The War of the Worlds, infant incubator demonstrations, and themed ethnic buildings. And, consider that William H. Reynolds' Dreamland (1904-1911), which tried to do everything bigger and better than Luna Park, predated future theme park stunt shows and Las Vegas casino light features when it offered amazing spectacles like re-creations of the Boer War and live firefighting shows and even had a tower with a light that shone 50 miles out to sea. Coney Island's remarkable legacy is that it gave all of us inspiration to do what we do today. The history of Coney Island teaches us that with consumer spaces, literally anything is possible.

Figure 1-12 Luna Park (Coney Island)

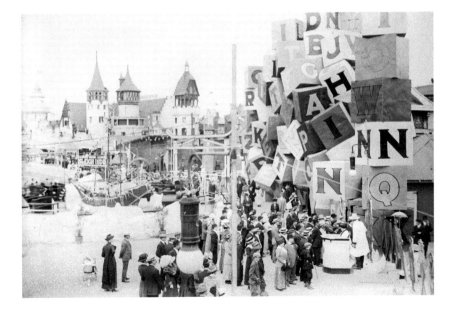

Venues

As you work on developing your own iconic spaces, you will have to consider how to work within a specific venue. Each type of space presents its unique advantages and disadvantages and the remainder of the book will spend time on these so as to give you more opportunities to think about design. Keep in mind that principles for creating engaging attractions within one space can be utilized in other spaces as well.

Amusement Park: Amusement parks, like those from the historic era at Coney Island, are enclosed spaces that are composed of rides, games, spectacles, and shows and other attractions that are designed to maximize the enjoyment of guests. Amusement parks are different from theme parks in that they generally lack themelands. In addition to the parks of Coney Island past, some examples of this form include Blackpool Pleasure Beach (Blackpool, England) and

Cedar Point (Sandusky, Ohio). Today's amusement parks have a very historic feel to them and sometimes seem less commercial than some theme parks. Amusement parks are popular design spaces for attractions that may focus on pure adrenaline (like rides) and that require less of a story component to them.

Theme Park: Theme parks can be historically attributed to the advancements at Disneyland, Six Flags Over Texas, and Knott's Berry Farm. Theme parks are enclosed spaces that include rides, games, and shows like amusement parks, but the key difference is that they have one or more central themes (and sometimes themelands) that orient the guest to the space. Theme parks are popular design spaces because they allow designers to develop complex stories that can span more than one attraction or ride. This allows the designer to tell more involved stories and to engage the guest in more of the world than is possible in other venues.

Figure 1-13

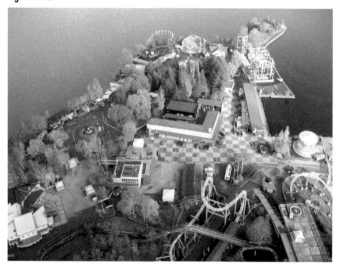

Figure 1-14

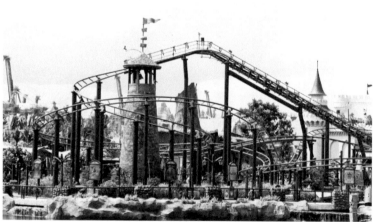

Restauant:

Figure 1-15

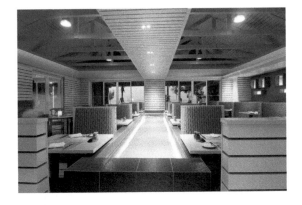

A restaurant is any venue that focuses on the food or drink needs of customers. There is an incredible diversity in terms of the types of restaurants. Fast food can be contrasted with sit-down restaurants as can adjectives like "fancy," "casual," "BYOB," and others. Bars are a subcategory that marks an important contemporary space of design, as are nightclubs. Theme restaurants are those that use a key theme (like country

and western) to help deliver food and drink in a unique way to guests. Because food and drink are often the key focus of a restaurant, the challenge for a designer is to create a space that complements the food. In some cases, the designers will be asked to minimize explicit story components of design so as to not "interfere" with the delivery of food. This is a subjective area, as we shall see.

Casino: Casinos are spaces that focus on the development of various forms of gaming (or gambling) in conjunction with other services ranging from hotels, restaurants, theme park attractions, shows, and others. Some casinos are themed according to a specific or general theme. The casinos on the Las Vegas Strip, since the 1990s, have illustrated the power that theming has. Since the 2010s, however, theming has given way to more modernist and grand architecture like that at CityCenter. Some forms of casino design are limited by regulations, such as those related to gaming operations, and in other cases a theme may be deemed inappropriate for the given venue.

Figure 1-16

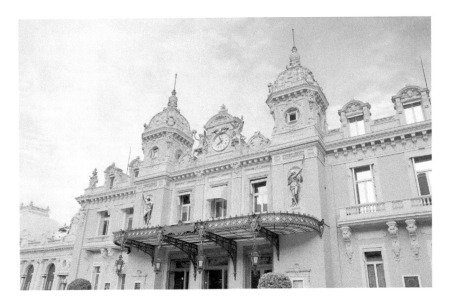

Resorts/Hospitality Environment:

Figure 1-17

These are spaces that focus on meeting the needs of guests who spend their time away from home sleeping and relaxing. Resorts and hospitality environments are sometimes themed and are sometimes part of another venue, perhaps ancillary or complimentary to it, like a casino or theme park. In such cases hotels may be designed to fit the theme that might be expressed in the casino or theme park.

Home and Planned Community:

Figure 1-18

Apartments, condominiums, homes, and planned communities are additional venues that are sometimes themed. All spaces of personal living are developed in accord with design principles but in some cases these principles are related more to functionality than experience. Planned living communities have become a recent trend in this venue. Celebration, Florida and Seaside, Florida are two examples.

Shopping Mall:

Figure 1-19

Shopping malls are spaces that include a large, often enclosed, space that includes numerous stores, larger anchor stores, restaurants, and other services. Brands and franchises are commonly found in shopping malls. Malls like the Mall of America (Bloomington, Minnesota) have become major tourist attractions. Some malls follow a specific design principle that connects all of the stores and other services together. This is the case at Crystals (CityCenter, Las Vegas).

Lifestyle Store:

Figure 1-20

A lifestyle store focuses on the delivery of a very specific and targeted product or service. Lifestyle means that the focus of the store is always on the lifeworld of the guest. REI, Whole Foods, and similar stores deliver products and services in a way that matches with the specific demographics and interests of their customers. Lifestyle stores, as themed retail, often use theming or distinctive design principles to create a sense of relaxation or purpose with customers.

Cruise Ship: Cruise ships are large, or sometimes small, ships that transport guests from one part of the world to another. In the 2000s a trend has been towards the development of massive luxury liners like those of Royal Caribbean and other lines. These new mega-ships deliver all of the spaces that one would find in a large theme park—restaurants (many themed), bars, activity spaces (pools, arcades), shows, and many other features. Cruise ships often involve theming or the use of architecture and design in unique ways.

Brand Space:

Figure 1-22

Somewhat related to a lifestyle store is a brand space. This refers to venues that develop a particular brand in a very explicit way. M&M's World or Heineken World are two examples of brand spaces that focus on the exclusive brand within the venue.

Figure 1-21

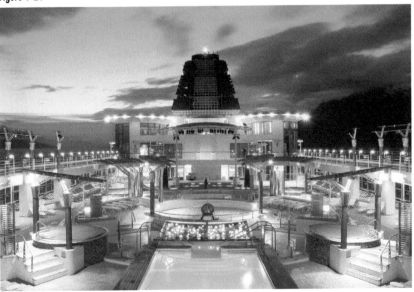

Interpretive Environment:

Figure 1-23

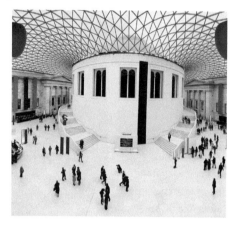

Figure 1-24

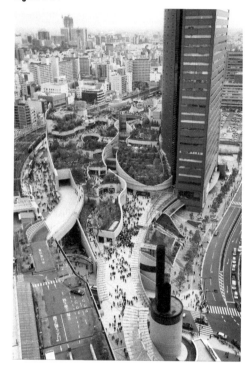

Interpretive environments include museums, aquariums, nature centers, zoos, and related spaces. These are places that display the history, culture (including material culture), science, and other aspects of the world around us; they often focus on a specific sphere of life—such as natural history, technology, or astronomy. Since the 1990s interpretive environments have begun to emulate some of the techniques of theme parks, combining education with entertainment. Many involve intricate design, architecture, and theming as part of their overall appeal. A subset is the cultural museum. This is a place that focuses on the culture or history of a specific people, such as the Polynesian Cultural Center (Oahu, Hawaii). In these cases there may be an emphasis placed on delivering lived history or interpretive performance as a part of the venue.

Mixed-Use Space: A mixed-use space is any space that combines one or more of the above forms. The idea behind a mixed-use space is that people can enjoy more than one product or service in the space. In some cases, an overarching theme or design principle is attached to the mixed-use space. Since the 2000s mixed-use spaces have become increasingly popular places of design.

Virtual Space:

Figure 1-25

Virtual worlds include the spaces of the Internet, of MMORPGs or massive video game worlds, or other places where humans interact with others in a virtual sense. While virtual spaces are are not a focus of this book, they should be seen as important sources of inspiration for design. Also, in some cases you might design an attraction that uses a virtual space (on site) or that refers to another version of your space (as a virtual space) that guests can use when they leave the physical space.

Application—Spatial Brainstorm

Take a moment to work on this short exercise. Choose one of the venues discussed above—theme park, lifestyle store, etc.—and begin a brainstorm on a design idea that has *never* been tried in that space. Write down the main design concept—a theme or overarching idea—and then discuss how this theme or concept would be worked out in

1. A design sense: What will the space or spaces look like?

2. A spatial sense: What sorts of attractions and components will be used in the space?

3. An operational sense: What things will guests do in the space?

After you have finished your brainstorm, share it with a design partner. Make some comments on the design ideas including

1. Has this idea been tried before? If so, where and when?

2. Is the idea possible? What hurdles would be faced in trying to execute this design?

3. What sorts of things would be needed to pull the idea off?

4. Does the nature of the venue—it being a theme park, bar, etc.—limit the feasibility of the project?

Components within Space

Throughout the book we will consider the many ways in which successful design can be applied to venues like those considered above. Within each venue you will encounter multiple components or the smaller parts of the venue that have to be designed and incorporated within the venue (Table 1-2). These will, no doubt, vary in function, use, and design within your space.

Common Uses of Space

The different components of space in part indicate the functional uses of space. It is important to review the overall ways in which guests interact with space. One common use of space is *consumption*. Whether the emphasis is on purchasing a good or service in a place, all designed spaces rely on this use. One thing to think about is how your design can mediate the forms of consumption in the space. There is a big difference between someone being hawked to buy a photo after they get off of a ride and being able to carefully, even quietly look at products in a private store space. The designer needs to consider the nature of space and how it will relate to this use. Similarly, you will have to think about the important ways in which *social interaction* plays a role in space. People, as we know from Coney Island, often love to do things in the company of others. Think of the moment of being scared with others during a fast-paced segment on a dark ride or consider the excitement of a group of people all winning on the same throw in a game of craps in the casino. The experience is heightened because of the social component of it.

Space also involves *personal use*. We spoke earlier of the idea of personal space and how we all like to have our own space. Each of us is unique in our use of space but we are similar in that sometimes we need to escape the crowds. One of the powerful abilities of the Las Vegas Strip is to be able to cultivate the most extreme emotions—such as a person moving from a raucous,

Table 1-2 Components within Space

Restrooms are necessary for public convenience. Sometimes they are purely functional, other times they are themed.	There are places where people *eat and drink*. The décor of the places and sometimes the food follows a design theme.	Many venues will have built-in forms of *spectacle*. These could be any number of attractions or design features.	Any venue will have ample sources of live *entertainment*, such as shows or attractions that take the boredom away.
There are *pathways* and places of *movement* in which people go from one space to the next.	*Technology* is a vital part of all venues. Whether a slot machine or theme park ride, technology forms the basis of much of the experience of guests.	Each venue has forms of public *information*, such as signage and other cues that lead guests from one place to the next.	A space will likely have *public areas* that allow people to mingle, look at others, and simply sit.
Walls and dividers are necessary features as they help break space into parts.	There are *private spaces*, whether these are a hotel room or a space inside a casino where a person can relax and do nothing.	*Customer service* and *interaction* with guests forms a primary part of the experience side of the space.	Spaces will have *products* and *services* that are related to the principles of the space at hand.

dueling piano bar act to a solitary dip in the hot tub at a hotel. Designers thus need be aware of the fact that people will, no matter your space, at some point need to be alone or feel a sense of intimacy and privacy. Another key aspect of how space is used is through forms of *discovery*. People often visit a theme park or take a stroll in a casino because they want to find something—perhaps a sense of excitement, perhaps a new side of who they are. Towards the end of the chapter, the section on design influences will consider some additional aspects of discovery. It is important to think about how to lay out a space in order to give guests a sense that they have the ability of finding something new or interesting, whatever their interests are.

Principles of Space

We can see that space gets used in a variety of ways. For the designer the key is to apply principles of space that will result in guests more thoroughly enjoying your space. In later chapters we will be looking at more specific ways to successfully work on your spaces, but here are two important areas that we should consider from the onset.

Holism

First, we need to understand **holism**. Holism is an approach to looking at things that takes the big picture into account and looks at how things are connected to

make up a whole. In designing any space it is important to take the big picture into account in two ways. First, as you go about designing the nature of your immersive world—including the **backstory** and other aspects of it—you should think about how all the pieces fit together to make up the whole of the world. Table 1-1 illustrated the many ways that parts fit together to make up the whole of the world. Second, as you interpret this world for the comfort of the guest, you should consider how one part of a space (like a restaurant) connects with another part of a space (like a store or even a restroom). By taking into account holism or the big picture, you will be able to create more convincing and authentic designed spaces.

Culture

The idea of culture is a key idea in anthropology (with its own branch within the field, cultural anthropology). Culture is so important to who every person is and, thus,

it should also be a key idea in the field of immersive world design. **Culture** represents the sum total of a people—the things that make them who they are. Culture is something that you can use to make your world more real, more immersive, and more interactive. The downside of thinking about culture is that it is, by its nature, subjective. That means that it is something that is felt by people but if you ask those people to detail aspects about their culture they may be unable to do so. When you grow up in a culture, learn its language, its customs, its folkways, and its nuances you could say that you are more perfectly immersed in that world than you would be in other worlds. It's the challenge of the designer, then, to think about how to create similar levels of culture within your immersive world.

Chart 1-1 indicates some of the features of culture and these can be useful to review for your design projects. These are not necessarily direct design applications but

Chart 1-1 Features of Culture

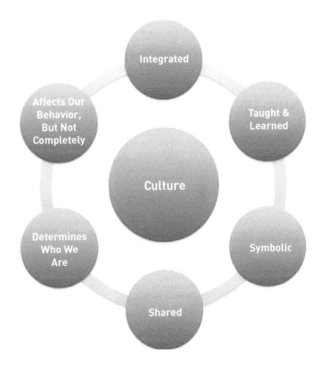

more guiding principles to think about as you create an immersive world. For example, culture operates through symbols so it may make sense that your designed world has a distinctive set of symbols that the people or beings in that world relate to. Then, as a designer, you can develop architectural, design, and material forms in your world that reflect that particular side of culture related to symbols. In future chapters, we will discuss more of the ways in which we can apply culture. For now, consider some of the culture exercises below. Try one or more of these out and think about how you can use them to create more immersive and realistic spaces.

Application—Culture Exercises

Take a moment to try some of these exercises. They are designed to get you to think about the subjective realm of culture and how it describes the world you have created. You may find that using one or more of these exercises may assist you in creating a more convincing story and spatial design. If you like, use them in reference to the world that you began to create in the Application—Worldbuilding segment earlier in the chapter.

1. Stream of Consciousness: Write a one-minute paper. This should be a stream of consciousness reflection of a person (or being) from your designed world. This means that you are writing down the ideas that are in the person's (or being's) head.

2. Travel Guide: Write and/or graphically represent a travel guide to your world. Like a typical guidebook, consider the customs, etiquette tips, cuisine, and activity suggestions that are found in a travel guide.

3. Life History: Write an account that represents an accurate life history of one of the characters from your world. Include the upbringing of that character, major life events, trials and tribulations, and the like.

4. The Space Box: Write a list of 10 things (items of culture, historical events, famous people/beings, etc.) that could be hypothetically put on a satellite and which could communicate the essence of your world to other beings on other worlds.

5. Mood Board: Using graphical elements and color coding, create a mood board that expresses the key feelings, attitudes, and values of the beings in your world. Please see the Research Break for examples of mood boards.

6. Ethnography: Were an anthropologist to visit your world, what would he or she see? Write an account of your world as if it were being visited by an anthropologist. Detail the customs, rites of passage, rituals, and everyday behaviors of the beings in your world.

7. Artifact: Using multiple media, create one or more artifacts that reflect the essence of the cultures present within your world. After creating the artifact, write a written description of it that might parallel what an archaeologist would understand about the artifact if he or she came across it.

Placemaking
Interview, David Rogers, AIA
Partner, Design Director, The Jerde Partnership
Figure 1-26

David is a senior partner and co-design director at The Jerde Partnership, an architecture design and urban planning firm in Venice, CA, where he has worked for the last two decades on advancing the firm's philosophy of creating memorable and compelling public experiences within entertainment retail, mixed-use, urban theater, and integrated resort projects that result in huge economic and social value to developers and cities. Most recently, David developed designs for the Kuntsevo mixed-use complex, a sports city district concept for Jeddah, KSA, and several major CBD mixed-use developments in China. David prides himself in creating projects to revitalize districts of cities and create new public realms. His landmark and award-winning two million square foot Zlote Tarasy has helped restore and reinvent Warsaw's urban identity. David was also design principal on Fremont Street Experience in Las Vegas and Beursplein in Rotterdam—both credited for significantly rejuvenating blighted areas of their respective cities.

Can you talk a little bit about the work that you do?

As a visionary architecture and urban planning firm, our work involves designing memorable places that people love to visit and go back to time and again. Over one billion people visit Jerde Places every year. Because of our creative and out-of-the-box approach, we are often commissioned to create solutions for places involving some of the most complex urban challenges. Located around the globe, Jerde Places are iconic, "go to" destinations that pulse with life through a carefully orchestrated procession of public spaces, shops, parks, restaurants, entertainment, housing, work space, and nature.

One of the things that the Jerde Partnership is known for is placemaking. Can you describe what is meant by placemaking?

Unfortunately, the term "placemaking" has become relatively overused and applied to any version of retail or mixed-use development by any number of firms. Jerde is the firm that pioneered the philosophy of using architecture and planning as a means to introduce compelling spatial sequences and a sense of discovery for visitors. We term this Jerde Placemaking. Simply put, this is the art of making places where people love to go. Jerde Places attract millions of people every day and make them want to come back. The reason Jerde Places are so popular is they are designed as experiential environments. It is the experience and the memories people have for a particular place that is transcendent and magical. This often results in a timeless destination quality.

Some years ago, I read an interview with Jon Jerde who was describing the firm's approach to the design at Horton Plaza: "We don't design 'things,' don't focus our energies on advancing forms for forms' sake. What we do is design places and environments people really love...You just have to be smart about thinking about how people will experience the place."[5] Can you speak a bit about this design philosophy and how it comes into play in your projects?

This relates to the above description of our philosophy and placemaking approach as the art of making places people love to go. Unlike most international architects that are in the business of "object making," The Jerde Partnership's approach to creating attractive places that remain in the public's memory has to do with the unique spaces between the buildings since this is where social interaction and communal gathering will occur. In order to create these spaces, we focus on the need and desire of people wanting an experience and social interaction within a compelling environment. Historically the exchange of goods took place in a marketplace, along the downtown "main street," in a bazaar with street vendors, or in a farmer's market. These places

[5] "Jon Jerde: Architecture and Design Interview," *Art and Living*, Spring/Summer 2008, p. 72.

became the hub for social exchange; they were a part of everyday activity and created over time in response to the characteristics of the city and people that lived there—such as the attraction of a place like St. Mark's Square in Venice. The proprietors, vendors, or tenants that survived were well positioned to be seen and situated in that part of the city people wanted to go to. These organic and holistic environments—a coexistence of nature and buildings—are the true inspirations for our design works of today. At the end of the day, the architecture and buildings are complementary to the innovative spatial sequences and as a collective whole, deliver a landmark and desirable place for people.

The types of projects that you and The Jerde Partnership design have been called iconic. Can you enlighten us a bit about what makes your projects so iconic and likeable?

To us, the word iconic has different meanings within different cultures and regions. More often, it usually applies to the idea of creating a landmark building or tower. For us, we much prefer magical or special or memorable in terms of the types of responses our projects elicit from visitors. We are in the business of understanding the psychology of enjoyment and creating a place that delivers on that expectation. This tends to result in a project that feels as if it has been there for decades and allows the public to take a figurative ownership in the project—that in turn creates the special feeling they experience in a Jerde Place. It is all about the people that will use and visit the space.

Places like Antelope Canyon, Niagara Falls, Grand Canyon, Machu Picchu, the Spanish Steps, Taj Mahal, all may be "iconic" in some form, but they also represent significant forms of inspiration for our projects. Not in a way of literal aesthetic, but in a way related to various emotional responses visitors have to these places, and the type of quality experience they evoke through multiple generations and demographics. Our approach to placemaking and architectural design involves taking

the magical aspects of nature and attraction of historic landmarks and translating them into a contemporary sense of discovery and place. Layered on top of this, Jerde Places are often inspired by an area's physical and historic characteristics, which further enhance the public's emotional connection to the place. Our solutions include early considerations and ideas of a spatial quality that is inspired by the local context and aspirations of the local citizens to create an authentic and vibrant project that becomes the most popular destination in the region. The spaces within the project are approached to be interwoven with the surrounding pedestrian circulation and are highlighted with contextual textures and colors along with a landscape that attracts people of all ages. Likewise the building shapes are formed to reinforce the spaces within and to establish an exterior identity and landmark within the city. This approach is both practical and artistic. The result is the emotional and psychological connection people have to the new place.

Can you talk about the importance of thinking about how a place will be experienced and how it needs to create a story?

In terms of our process and philosophy, we approach every project with the idea of creating a "storied place." This is the most important aspect of the solution. The first consideration is to ask: What does the project want to be? And how can this project benefit both the surrounding context and the individual users themselves? The answer is related to the success of our interest in designing for people and our ability to solve issues through what we call the "The Big Idea"—a design solution that creates an experience and place that is so compelling it will attract people in large numbers, provide pleasant memories so customers return with their family and friends, and cause huge economic success.

You have been involved in a lot of mixed-use projects, including Canal City Hakata. Can you talk about this project, your unique approaches to it, and perhaps detail to our readers why mixed-use sites have become somewhat popular?

Canal City was the firm's first international mixed-use project. Since then, we have designed and completed many mixed-use developments around the world. While this is not quite a common project type here in the United States (yet), it is one that dates back for centuries in Europe and Asia where land is much more sparse and an integrated form of building and sustained livability is desired. Fortunately, these environments require a foundational public attraction, which is often the last remaining vestige of a communal gathering place—the retail component. Our firm's experience in the complexities and nuances of retail and entertainment are sought out by sophisticated developers who understand the value of creating a visceral and dynamic public experience within the first thirty feet of a project. This is where people will gather and drive the success of any mixed-use development.

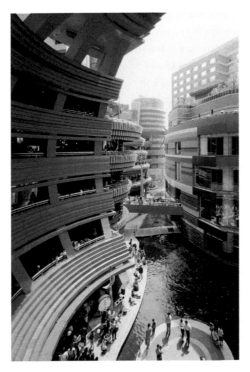

Figure 1-27 Canal City Hakata, Fukuoka, Japan.

In the case of Canal City, this was a triumphant opportunity to incorporate our immersive and experiential design approach into a fully integrated district inspired by nature. Nature is Canal City Hakata's metaphor, echoed in the use of water as the organizing element; the gentle arc of the canal; and the stratified layering of the buildings lining the canal which reference the creation of a canyon as a river slowly cuts a path through rocks. The project's five districts are inspired by the universal elements of sun, moon, stars, sea, and earth. With a vibrant mix of uses, including retail, entertainment, theater, office, and hotels, Canal City Hakata has restored new life to its area and reversed decline in the city's historic shopping district. It has also become the city's cultural and community center.

Trending—Blurring

More and more, you may have the sense that you have "seen this before." Perhaps you are in a Starbucks and you are reminded of something you saw in a theme park. Or, perhaps aboard your Celebrity cruise ship you have the sense that the design features there look like a casino that you saw in CityCenter Las Vegas. There is a blurring of space at hand. Design principles of casinos find their way into theme parks and the décor of cafes find their way into theme parks. A second sense in which blurring is taking place is through the nature of the use of spaces. More and more, we find mixed-use and multi-use spaces. Walk into any Walmart and you will find restaurants and services that add to what Walmart delivers to its guests.

Placemaking

Geographer Yi-Fu Tuan once noted that "when space feels thoroughly familiar to us, it has become place."[6] To transform space into place, design needs to focus on

[6] Yi-Fu Tuan, *Space and Place: The Perspective of Experience* (Minneapolis, University of Minnesota Press, 2001), p. 73.

concepts and techniques that will, first and foremost, value the ideals of the people—the guests—who come to the place. There is brilliant design and there is brilliant story writing but virtuosity in design and story writing will not necessarily result in the happiness of the guest. To think about creating a place that is memorable to guests, it is important to think of them as being in the driver's seat. In an earlier application, we learned that an iconic space was one that struck evocative chords in us. In order to produce the same places for guests, we should consider the value of experience, the vivid dream, and the suspension of disbelief. These principles of placemaking can be applied to all of the case studies discussed in this book.

Experience

Ever since the attractions that thrilled people at the amusement parks of Coney Island, theme parks and other immersive designed spaces operate with a key principle in mind: guests, and their experiences in the space, are the key foundation. Every component of an immersive world should be designed with experience in mind. Very few people will leave a space that you have designed and remark, "What a great choice of color on that wall." They will, however, leave a space and say, "I had a great time today," or "That was fun!" The key to creating an immersive space is to think about how the space will relate to the direct experience of the guest. As we move deeper into the book, you will be asked to think about the ways in which experience, much like space, is incredibly diverse. There are no cookie-cutter solutions to the experiential design of a space. Here are some ideas for thinking about the experience of a design space.

Keys to Thinking about Experience:

1. *Difference*: We must remember that everyone is different and that each person will have a different understanding of an immersive space. Design should take into account the differences that people bring with them to a space.

2. *Common Themes*: In spite of this difference, we can think of designing experiences that all people might have in common. For example, a theme like love or adventure could be viewed as common enough that anyone could relate to it, regardless of that person's background.

3. *Depth*: The depth of the experience created in your space is a key. If you have ever played a one-dimensional video game you were probably left with the feeling that something was missing. You got bored because the same routines repeated again and again with only subtle variation. To make a space compelling, you should focus on the depth and complexity of the story being told to the guest.

4. *Purpose*: For spaces to be compelling to people, they should have a purpose. Some designed spaces focus heavy on activity, such as interaction with screens and technology, and the designer should ask: Is there a reason behind the experience? If the experience is not rooted in some purpose—whether that be making more money for the company or teaching an important moral lesson—the guest will likely find it to be shallow.

5. *Open-Ended*: Experiences are sometimes best when we (the guest) help complete them. Think of the feeling when you are reading a great mystery or thriller and you seem to have the thing figured out, even before the author. Of course, you haven't really figured out the mystery before the author, but you have the sense that you did. We'll talk more about this soon, but the key here is to not close off all of the routes of your experience such that the guest has the feeling that she has nothing left to do in it.

The Vivid Dream

When creatively used, theme park stories can create what John Gardner (in *The Art of Fiction*) called "vivid and continuous dreams." Or, as Aristotle wrote of

drama, a form that is "complete in itself" and that creates catharsis (it resonates) in an audience. The greatest theme park rides, the most memorable themed restaurants, and the most captivating museums have one thing in common—they all create dreams that people can inhabit. People feel as if they can move through dreams that designers create for them. Like experience, dreams can give people a sense of being empowered. They feel, if for only a moment, that the world of traffic jams, of office cubicles, and of less-than-ideal social relationships are put on hold. As they live inside the dream they feel different about everything. They have the sense that things are right and that they can put the undesirable aspects of life on the back burner. The high stakes of spatial design are not just the profit margins of the company but also the fact that people depend on what you design and the experiences that you involve in it for their very basic needs to be met.

Suspension of Disbelief

The suspension of disbelief, associated with Samuel Taylor Coleridge, is the idea that a person—whether engaged in a novel, a theme park ride, or playing a video game—willingly goes along with the story being told. Even in situations in which disbelief might get the better of the person and result in them pulling out of the drama being told, they stay with it. In some films a character might never age or in an action sequence there is a gunfight in which the protagonists never seem to run out of bullets. Most audiences will accept these decisions of the author, or in other cases bad special effects or even plot holes, because they are caught up in the drama being told them. In this sense we must respect the fact that audiences are generally kind and will overlook things that would cause them to lose interest in the story, but in other cases they will not. Later in the book we'll discuss some of the reasons as to why people lose interest in a space.

Application—Would You Accept It If?

Now that we have discussed the suspension of disbelief, take a moment to reflect on it in your own work. Think of an example of a story in which you were unable to suspend your disbelief. Write down the story and what it was about (this could be a novel, a movie, a theme park attraction, a video game, etc.). Next, discuss the elements in the story that didn't work for you. Write down at least three reasons why you couldn't suspend your disbelief. Next, write your own version of the story in the sense of how you would do it right if you could correct the mistakes that were made in this less-than-perfect story. If you like, share your work with a design partner and then discuss your experiences with the suspension of disbelief.

Trending—Commitment

One of the most significant recent trends to have impact on design is the idea of commitment. Being committed to someone, something, or some idea means that you value the object of your commitment. More and more contemporary venues focus on commitment as a part of their product or services. It is hard to leave a Whole Foods store, for example, without seeing information that details the plight of less fortunate people across the world, environmental issues (like the global water crisis), and other topics (such as information about health). What's key in this use of information is that it connects with customers. Many of the people who shop at Whole Foods care about some of these issues and by raising them in the store, Whole Foods has shown that in addition to being consumers people can also be committed citizens. Commitment appears in many forms and in many spaces. We will likely see more of this trend in future years.

Design Influences

As we close our discussion of placemaking, we can reflect on some of the influential themes that have

affected many of the places that we will be considering. For each one, you can consider some of the key words that are associated with the major theme as well as some general design ideas for the theme.

The Adventure: The adventure is something that many of us seek in life. For some people, adventure might be found in an illicit or even illegal activity, but most people would like to experience a sense of adventure in a socially acceptable way. Theme parks and other immersive spaces can draw on the spirit of adventure in all of us by giving us thrilling rides, exciting displays, and attractions and promoting the general idea that adventure is something natural for us to experience.

Key words: risky, unexpected, experience, danger, peril, venture

Design ideas: fast-paced, mystery, movement, journey

The Hidden World: Coupled with the idea of adventure is the hidden world. This hidden world is a place to be found. It can be a real place, an imagined one, or a state of mind. Think about the time that you went on a theme park dark ride. The ride took you through the dark and into a place of mystery. This feeling of finding a hidden world can be applied in just about any design project.

Key words: concealed, dark, secluded, out of view, private, mystery, new

Design ideas: darkness then light, contrast, movement through varied spaces, a sense of drama

The Exotic: The exotic could be the new place, people, or species that someone discovers when they enter the hidden world. The great discoveries in science fiction and fantasy novels occur when one group discovers another. There is a sense of magic that comes with the discovery, then learning takes hold. The exotic is a powerful influence because it shows guests a sense

of a new, fantasy world that looks *nothing* like their world.

Key words: alien, strange, unknown, uncanny, striking, odd, new, romantic

Design ideas: exotic and unexpected architecture, things out of proportion or out of the norm, wild and uncanny uses of color, shapes, and textures.

The Transformation: When someone moves from one state to another the person is said to undergo a transformation. It doesn't matter what the transformation is but that it actually takes place. When a guest enters a themed casino like the Venetian for the first time, he might feel a sense of being transformed. Once the guest feels the effects of the ambiance of the casino, he might feel different inside. A sense of change is felt.

Key words: alteration, change, metamorphosis, renewal

Design ideas: movement and mood that combine with one another, doorways and thresholds, pathways, extreme changes in sensory states

The Luxurious: A number of venues that used to rely on an explicit theme have now moved away from the theme. Take CityCenter in Las Vegas as one example. There a sense of luxury is the norm. Clean lines, extravagant surfaces, and the appeal of affluence create a much different sense of casino escape. Luxury will continue to be a powerful force in the design of all spaces.

Key words: affluence, bliss, comfort, delight, enjoyment, extravagance, gratification, opulence, rarity, uniqueness

Design ideas: clarity of vision, decadence of design, sense of purity of design, monumental architecture

The Search: The search is a design influence that has impacted many themed and consumer spaces. In some

theme park rides, the guest is asked to go on a journey and, in the end, the journey wasn't just the search for a new land but the search for a message. In other cases, such as in museums, there is a search for meaning. For example, the Museum of Tolerance in Los Angeles asks participants to focus on the reason why inhumanity has been common in our world.

Key words: seeking, examination, investigation, looking inward, finding

Design ideas: spaces for self-reflection, mirrors, passageways

The Spectacle: Spectacle involves the creation of drama—whether through incredible architecture, elaborate design, or compelling performance. It is a form that we see in so many venues, ranging from the fountains at the Bellagio in Las Vegas to the laser light shows at a nightclub in Ibiza. David Rockwell and Bruce Mau have an interesting look at this topic in their book *Spectacle*, which is listed in Further Reading at the end of the book.

Key words: drama, curiosity, marvel, performance, sight, view, wonder

Design ideas: architecture and forms of design that attract immediate attention, design forms that invite people to gather, to watch, and to participate

Wouldn't You Know It!—The Great Idea

Wouldn't you know it! You have a great idea, one that no one else has ever thought of. This particular idea involves a new creative themeland based around the cultural history of serial killers. The attractions would include rides, shows, and interactive displays that detail the serial killer in the United States. Obviously, this concept, though somewhat creative but equally tasteless, would not likely make it beyond the drawing board of a design team. Ideas are everywhere but

only certain ones are hits. Later, we'll talk about the ideas that really stick. We call these **memes**. So, we quickly learn that all of our ideas are limited by how convincing our pitch is, the nature of our resources (including design, execution, and operation), the ability to convince others that our idea will be saleable, and the long-term commitment of others to our idea. There is a fine balance to be struck between an outrageous idea that seems completely unpalatable and one that is too palatable because it is safe, even milquetoast.

The World and the Designer

As Larry Tuch expressed in his interview earlier, much of what we will be considering falls on the will of the designer. All great ideas begin and end with an author. This is the person who brings creativity, vision, life experience, and a willingness to deal with extreme challenges to the table. The result is sometimes exceptional design, sometimes standard design, and sometimes complete failure. Whatever the result will be, it's on the designer to deal with the uncertainties and to move forward with a vision. As you think about the many issues that we will be considering, focus on the possibilities, the rewards, and the successes and you will likely be more fulfilled in your own work. As well, it's likely that a future guest will thank you for it.

Have a look at Chart 1-2. The idea behind it is to consider a design project from the stage of conception through the stage of execution and operation. As we close this chapter, use this chart to think about the challenges (and possibilities) of a spatial design project.

About the Author

Now that you have gotten through the first chapter, you might be wondering, who is this guy? Well, let me say

Chart 1-2 From the Ground Up

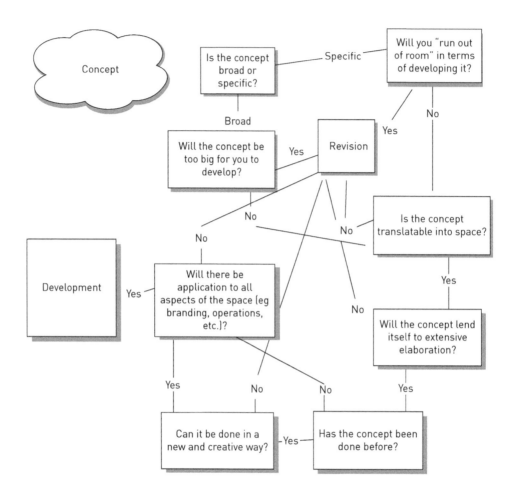

a little bit who am I and this might help put the ideas that you'll be getting in this book into better context. I'm a cultural anthropologist by training and I wrote my dissertation about my experiences being an employee trainer at Six Flags AstroWorld—a theme park in Houston, Texas that has sadly closed since I worked there. As a kid, I was always taken with theme parks and roller coasters but my experiences at AstroWorld first sparked my interest in theming and trying to understand the "how'd they do that" aspect of theme parks and other consumer venues. I've since written

some academic books on theme parks and theming and through the course of speaking at national and international conferences on these subjects, I have begun to study the design aspects of these spaces. I continue to work as a consultant in the theme park and theming entertainment industries and as I visit new theme parks and themed spaces around the world, I try to keep a "beginner's mind," as a Zen practitioner would say, when I enter any such place. I hope that you might take the same open-minded approach to the issues in this text and those in your own life as a designer.

1. Take a moment to think about one very memorable place that you have visited. Perhaps this is a place that you return to frequently. What is evocative about this place? What are the things about it that you really like? Could any of the elements of this place be translated into a themed or consumer space that you would design? How?

2. What are the biggest challenges that you face as a designer? What are the things that give you the most pleasure as a designer?

3. If you could design any space — regardless of budgetary, operational, or other limitations — what would that space be?

4. Even though you are a designer, in some cases you are a guest when you visit a themed or consumer space. Briefly think about how your approach to spatial design is impacted by the times in which you are a guest in a consumer space.

1. How do language and meaning relate to the design of immersive spaces?

2. How can design projects be created from the ground up?

3. What is the value of storytelling as it relates to creating immersive design spaces?

4. What are some of the key elements of design storytelling?

DESIGNING EFFECTIVE, IMMERSIVE, AND CREATIVE SPACES

Figure 2-2

Provocation—The Blank Space

The image represented on this page is of a white room. In a practical sense, there is nothing in the room. You have been given a blank space before you and you have to decide: How will you fill it up? Take a moment or two to look at this image, or think of any blank space in the world—whatever image you can conjure of a space without design, without color, without any apparent meaning. Fixate on that space for a moment. Now, as the surrealists did with "**automatic writing**," write down a one-minute reflection of what you would do with this space. Afterwards, discuss why you chose to fill the space up as you did.

Meaning

While design is sometimes thought to happen at the level of form and function, it is also important to look at the meaning behind design. In this chapter we will explore a number of ways in which immersive spaces can be created. We begin with meaning because it is the foundation of all things in the human world—architecture, social interaction, belief, and most other things. Because of our unique abilities, we can, as designers, design anything that is imaginable and guests, because of the same abilities, have the opportunity to take it all in and give meaning to it. But, in the case of the blank space, where do we begin?

Giving It Sense

What will it all mean? When we begin any creative project, we should think about the meaning of it. In some cases, like if we are doodling on a scrap of paper, we might not give the thing we are drawing much thought, but in the case of design, so much attention needs to be paid to the issue of:

What Does It Mean?

One of the most important things that we can think about in terms of design is the meaning of what we are creating. In some cases, the meaning of one of your creations will have already been partially determined for you. For example, if you are designing a casino that is themed according to a city in Italy, some of the ideas of what Italy is, how it looks, and what it is like when people experience it will already have some basis in reality. Or, if you are designing a theme park attraction that is based on characters from a graphic novel, some of the meaning will have been established for you. Even in these cases, attention must be given to editing the meaning for the space and the attraction. If you are fashioning a space out of the sky and without a preexisting background, you are in a position to think deeply about what the space means. In all forms of thinking about the meaning of your space, you might consider:

1. *Goal*: What are you trying to accomplish? Are you trying to establish a positive interaction between guests and a particular brand? Are you hoping to teach people an important message about cultural tolerance? Are you looking to establish a sense of joy and mystery by immersing people in a fantasy world? The goal (the big idea) of your project is the most important aspect of the design project. Knowing what you want to do with the space—from the get-go—will result in a much more meaningful design story.

2. *Openness*: How open will guests be to the proposed meaning of your space? If you are pushing the edge a bit—perhaps playing with controversial issues—you might want to think about this. Are you willing and able to hire focus groups to discuss the meaning of your space? What if people are less receptive to the meaning? Will you alter the idea behind the space?

3. *Change*: In terms of the idea behind your project, will this idea still be relevant in 5, 10, or 20 years? Can the meaning be adapted or changed over time?

Does the primary meaning behind the work seem to be rooted in one period of time or one place?

4. *Space and Material*: Are there any ways in which the meaning of your space will be impacted by the space and material that you will be using? If so, will you have to alter the meaning or the story behind your project?

As we think a little more about meaning, let's work on this short application.

Application—Idea World and Material World

Take a moment to produce a short list for a fictional project. This can be any sort of project—a theme park, casino, cruise ship, etc. After you have indicated the type of project, choose an overarching meaning that you wish to convey. This hypothetical meaning could be related to:

1. A branded project that you are interested in developing (like a theme park attraction based on a famous toy or product)

2. A form of popular culture that you could retell in space (such as a famous video game that could be turned into a themed restaurant)

3. An emotion (like joy, excitement, etc.)

Begin to write out the associations or ideas that you would like to have the guest understand (this is the "idea world"). Next, write a list of how you would attempt to translate those ideas in space, design, and architecture (this is the "material world"). After you are finished, discuss the challenges of connecting the idea world with the material world.

Perception

When we think about the meaning of the spaces that we are creating, we must focus on both the meaning that we intend as the maker of the space and the meaning that will be received and created by the guests who visit a space. The *koan* or Zen paradox "What is the sound

of one hand (clapping)?" is something that I always remember when I am thinking about meaning. As a teacher, when I go into a classroom I have one or more ideas that I am trying to get across to my students. Every time that I step into the classroom I remember that each student receives and works with meaning in a different way. Thus, I am constantly thinking about how perception impacts the meanings that I provide to students. Design is no different. In fact, you can think about it as a form of teaching in space. Just because you design clear sightlines in your themeland and just because you create signage and information technology to guide people along does not mean that they won't get lost. Their perception—not yours—is one of the guiding forces that you should consider in design projects. The Zen paradox keeps us honest and reminds us that just when we think that we've figured something out about our design, there will always exist another way of thinking about it.

Beauty, Preference, and Great Design

One of the things that perception reminds us about the world is that it is inherently subjective. Take the concept of beauty as an example. Beauty is something that we are all familiar with, yet none of us would likely agree on what it is in an exact sense. When we are confronted with something that we call beautiful, we are stricken with an intense pouring out of our emotions. We feel connected to the object of beauty; it seems to complete us. The combination of our senses with the ideas in our mind helps define, for all of us, what beauty means. If we decide to talk about beauty with another person, we soon realize that we can't agree. What if I express to you that Frank Gehry's Guggenheim Museum design (Bilbao, Spain) is extremely beautiful? You tell me that it's too cold, too abstract, or too minimal to be beautiful. Our disagreement about whether Gehry's architectural object is beautiful or not illustrates the challenge of getting any design

Figure 2-3

project going. How will you go about the difficult task of creating something that anyone, regardless of personal standards of beauty or anything else, can appreciate? Great design will move beyond personal preferences and will create places that all guests will enjoy. To do so, great design must:

1. Know, up front, what it wants to accomplish. Stressing the big idea will result in a clearer sense of purpose.

2. Focus on evoking emotions, memories, feelings, and sentiments that all people can enjoy regardless of their specific backgrounds.

3. Attempt to go for universals that cut across cultural, personal, and political boundaries. These are core stories, design approaches, or other forms that can be appreciated by all.

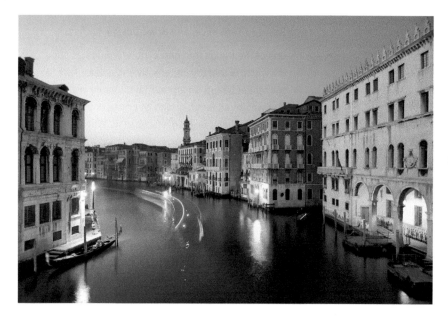

Figure 2-4 For some people this scene from Venice, Italy might be regarded as an absolute form of beauty. For others, it could have different associations.

Naming

It may be no surprise to us that one of the meanings attributed to the word "name" is reputation. A name can signify many things—the reputation of a brand or company, the sense of what is supposed to take place at the place so named, a sense of emotion of the place that is named. In many cultures people give their children names that reflect family history or a virtue or value that they would like to have their children emulate. In naming a product or a place, you might think about the significance of the name—especially as it could have a lasting good effect. The naming of any large or smaller component of a design project can be based on a variety of factors:

1. *Product or Brand Associations*: In some cases, you have to name your space due to the fact that it is fully themed or perhaps partially associated with a brand or product. We will focus on this topic in Chapter 6.

2. *Preexisting Contexts*: You may have to name your space or spatial component in conjunction with a previous context established by the space. For example, if you have a country-western themed place, you would not likely want to name a new space within it with a tropical association.

3. *Cultural or Psychological Associations*: Many brands have names that attempt to connect people to another idea. This is called **metaphor** and involves making a connection between an idea in one world with an idea in another world. You might use metaphor to name a space that can help create associations with the guests. For example, a bar named "Sonata" may resonate with guests because it makes a connection with the world of music. Further, the name and the ideas of music may be associated with concepts like elegance, luxury, softness, beauty, refined form, etc.

Adapting Languages

So far we have talked about language in a somewhat general sense—using the idea of "How do we say this?" or "What's the meaning of this?" Let's now look at some more specific uses of language. In this case we will be talking about how we can adapt the languages of various fields and use them to create design projects. We all come from different backgrounds but we can learn the power of using the language of various fields to create stunning and interesting spatial designs.

Table 2-1 presents a summary of some of the ways that language may be adapted from other fields to the field of design. Two concepts have been chosen from each field. In his interview in Chapter 1, Larry Tuch discussed the value of designers having varied professional backgrounds. In this sense, we will emphasize the value of being able to speak more than one design language.

The language of film has been one of the most powerful ones. Film has influenced design in powerful ways.[1]

Figure 2-5 One of the most classic forms of *mise-en-scène* in film—Robert Wiene's expressionist film *The Cabinet of Dr. Caligari* (1920). Watching the film, the viewer is likely taken with the consistency of the scenery and how it helps create a total effect in terms of the viewer's perception of the story.

Table 2-1 Adapting Design Languages

Language	Concept 1	Design Application	Concept 2	Design Application
Film	*Mise-en-scène*	Total Design	Edit	Spatial Transition
Video Games	Simulation	Re-created Experience	Action & Goals	Design Cues
2- and 3-D Art	Collage	Combined Elements	Medium	Appropriate Spatial Design
Culinary Arts	Flavor Combinations	Composition	*Amuse-bouche*	Dominance
Performance Art	Happenings	Spatial Excitement	"Everyone is an artist."	Guest Involvement
Dance	Choreography	Rhythm	Connection	Part–Part Relationships
Theater	Set Design	Unity	Staging & Blocking	Design Emphasis
Music	Improvisation	Improvisation	Harmony	Elements "Talk" to One Another
Fiction & Poetry	Setting	Ambiance	Foreshadowing	Anticipation

[1] For more on this see Stephen Barber, *Projected Cities: Cinema and Urban Space* (London, Reaktion, 2004), Nezar Alsayyad, *Cinematic Urbanism: A History of the Modern from Reel to Real* (London, Routledge, 2006), and the exhibition catalog *Film Architecture: From Metropolis to Blade Runner* (New York, Prestel, 1999).

We can apply the ideas of *mise-en-scène*. This refers to the overall visual theme told through a film (see the image of *The Cabinet of Dr. Caligari* in this chapter). In a design sense, the overall appeal that a space has to people is akin to this idea from film. It could also be seen as the distinctive appeal that a designed space gives off. Also, the idea of the edit, in which a filmmaker creates tension, rhythm, and interest by cutting from one scene to the next, can be applied to the ways in which you design a spatial transition from one space to the next. Let's look at the power of the edit in the next short application.

Application—The Edit

For this application, you should first view the classic Odessa Steps sequence from *The Battleship Potemkin* (Sergei Eisenstein, 1925). Eisenstein's film is one of the most important films in the establishment of principles for editing and montage. You can find the film on the Internet free of charge (see www.archive.org and then search by the film's title). The Odessa Steps sequence is found at the 47-minute mark in the film. After you watch the sequence, write a short free association piece. In the first part describe the feelings that you had as you

Figure 2-6 A part of the famous Odessa Steps sequence from *The Battleship Potempkin* (1925).

watched the Odessa Steps. In the second part, discuss how you could create those same feelings (such as rhythm, tension, consistency, etc.) that you had from the film in a design space of your choosing.[2]

Like film, the approaches of video games have transformed how we think about design. The idea of **simulation**, in which a person takes on the role of a different person or being through an **avatar** and in which elements of cause and effect are at play, can be applied to forms of design in which a space is used to re-create an experience that a guest normally couldn't have. Similarly, the ways in which action and goals are designed in games can be extended to your spatial projects—think of each patina on a wall, each sign, each wall as a visual cue that gives the guest a sense of purpose and action in your world. 2- and 3-D art has already likely made a great impact on your design. Many designers come from the world of art and the techniques are thus already a part of your design repertoire. Two important applications include collage, or the ways in which you can combine elements together to create effects in guests, and medium, or how you think about which form to use to create an appropriate spatial world.

Culinary arts is perhaps thought of less as a design influence. This is too bad since some very influential forms of art have emerged from this world. Consider the efforts of chef Ferran Adrià (elBulli, Spain). We can take the concepts of flavor combinations and *amuse-bouche* (a small, single serving of food) and think about composition (the combination of elements) and dominance (the impact or focus of design elements) in spatial design. Performance art, dance, theater, and music also have many elements that we can apply to the world of design. In the first area, we can combine the idea of the **happening** (a 1960s art expression in which a situation is created in public) with performance artist Joesph Beuys' idea that "everyone is an artist" to realize spatial excitement and guest involvement in a spatial design project. In dance, where there has been significant contribution with architecture, we can use choreography and connection (among dancers and audience) to look at the rhythm of spatial design aspects and how one part of a space fits in with or relates to another part of the space. In terms of theater we have the significant ideas of set design combined with staging and blocking. Within music, we can analyze improvisation and harmony as influences for design. Think of using your own forms of improvisation to brainstorm innovative spaces and harmony as a way of looking at how elements within a space "talk" to one another. As we translate these into spatial design terms, we might think about the ideas of unity and design emphasis. Finally, in terms of our last "outside" language, we should use the concepts of setting and foreshadowing in fiction and poetry to think about how we can create ambiance and anticipation in our spaces.

Let's consider a few of these examples in terms of how they have been applied in theme parks and other popular settings. Using film, we can look at the wildly

Figure 2-7

[2] Incidentally, there is a book that explores the relationship of Sergei Eisenstein and Walt Disney. See Jay Leyda, *Eisenstein on Disney* (Calcutta, Seagull, 1986).

popular Disney dark ride Pirates of the Caribbean. This ride takes an approach that resembles concepts from film. The *mise-en-scène* or total design of the ride is what has, in great part, made this attraction so successful. Guests are completely immersed in a world of fantasy. As they travel from one area of the ride to the next, they have a sense of a total experience that is unfolding. Audio-Animatronics are used to establish characters like Jack Sparrow; technology, stage design, and other elements create setting; and as the guests move from one scene to the next, the sense of editing occurs as spatial transitions are used.

Using video games, we may consider the idea of simulation. The ride Toy Story Midway Mania at Disney's Hollywood Studios is an attraction that, in many ways, models the ideas of video games. As guests board the ride, they wear 3-D glasses and begin moving through a simulated world that re-creates an environment similar to a classic midway games area. The ride involves guests using toy cannons to interact with various virtual targets among a number of mini-games. Goals are involved as guests compete against others (and themselves) to see how high a score they can get. What is unique about this particular ride is how closely it utilizes the principles of video games to create an immersive experience that stresses interaction.

The world of theater gives us a number of interesting parallels with design. The Amazing Adventures of Spider-Man at Universal's Islands of Adventure is a ride that owes much to the ideas of theater. In terms of set design, the ride takes full advantage of technology, including a ride vehicle that simulates guests moving up a forty-story building. Like sets in a theatrical work, the ride creates a sense of unity that fully immerses guests in the experience of the ride. Staging and blocking occur as the guest moves from one scene in the ride to the next one.

Learning design languages is akin to learning multiple foreign languages. We've only touched the surface of design approaches here, so keep in mind the value of each of these languages and try, as much as possible, to combine languages from different fields. In the end these multiple languages will make your space more provocative to the guest. So, the next time you are eating at a creative restaurant, think of it as design fieldwork that will come in handy later.

Designing for Culture
Interview, Margaret J. King
Director, The Center for Cultural Studies & Analysis

Figure 2-8

Margaret J. King (Ph.D.) is Director of the Center for Cultural Studies & Analysis, a think tank that studies the brain, behavior, and decision making in cultural context to provide customized research for the theme-park industry, nonprofits, design firms, ad agencies, and other research groups. She has the first graduate degree in Popular Culture and the doctorate in American Studies from the East-West Center. She has authored hundreds of studies, articles, and chapters, including projects for Disney Imagineering, Six Flags, NASA, Thomas Jefferson University, Harvard, The Geographical Society of Philadelphia, and the Themed Entertainment Association.

In your work you have spoken of a number of principles that can be applied to forms of theme park and consumer space design. I wonder if you could speak about a few of these and how they can be used as general advice for all designers looking to create compelling theme parks and immersive places?

Human beings have been creating and using themed environments for millennia. Over 32,000 years ago, the cave painters at Lascaux used effects from illustration animated by flickering firelight, focused attention, natural acoustics, music, manipulation of space, and narration to create a virtual reality environment. That was a bordered system—the creators shaped everything within its boundaries to a purposed effect. The technology changes and the stories evolve, but the way people interpret sensory input does not. Culture is the software of the mind and designers need to understand—at a conscious level—how culture affects not only how we interpret what we see, hear, feel, and smell, but how that influence focuses our attention so we may not even "see" the design because our minds are focused elsewhere.

Your work highlights why designers should look at the specifics of culture and the context of people and their cultures when they go about designing theme parks and themed places. Could you comment on why you think culture and context are vital in the design of these spaces?

Since people are going to be the users and real focus of these places, they need to reflect human values. Values are simply broad tendencies of the group to prefer one state of affairs over another. In the United States, for instance, personal mobility equals freedom. Lose your mobility and you lose your freedom. That simple algorithm explains both acute anxiety in seniors who fear they will lose their driver's license and the Tea Party movement whose members fear losing their social mobility. Americans think of this as a human universal, but it is not. In many cultures, moving away from the group is a loss proposition and should be avoided at all costs.

There is an intuitive cascade of questions the mind asks when it enters a new place. It never varies. Before they can do anything else, designers have to answer the Cascade. The first question a designer needs to answer is "What is this place?" The answer has to be clear and instantaneous, which means that the first element of design must be the Mindsetter. The Mindsetter is the capsule, the thumbnail portrait, the abstract—the first thing people see that gives them an impression of what they can expect the place to be. Without it, you have uncertainty, and uncertainty leads to avoidance. Time and again I've seen people walk into museum lobbies—stunning architectural statements—look at the admission price, and see nothing that gives them any idea of what experience they are being asked to buy into. They turn and walk out. Without an effective and instantaneous Mindsetter, the rest of the designer's work is wasted because it will never be seen.

Your work goes beyond the "how much" and the "when" of consumer behavior and has, more importantly, emphasized why consumers do what they do. Could you comment a bit on this level of research and, secondly, offer some tips to designers who might use this line of consumer "why" when they go about designing theme parks and immersive spaces?

Traditional market research asks people to say directly what things they like or don't like, why they buy what they buy, and what they would like to see designed so they can buy it. The problem with this approach is that people don't really know why they are attracted to certain products. The unconscious mind makes the choice and then the conscious brain rationalizes it. The rationalization may have nothing to do with the actual unconscious drivers of choice. However, the beauty of studying what people do rather than what they say is that patterns of behavior reflect unconscious beliefs. Behavior is how culture is expressed. If you study what people do, rather than what they say about what they have done or will do, you get a very different picture of

human motivation—one that can be used to accurately predict what the majority of any group of people will do in a given set of circumstances.

In so many ways, designers have to think about how they will tell their "design stories." Do they create a certain type of building, use specific mood lighting, develop forms of technology, and other variations? What advice do you have for designers as they think about how they will tell a story in their theme park or immersive space?

People have been telling stories with space even before the advent of architecture. Theme parks are environmental artworks in specialized settings; so are churches and temples, parking lots, gazebos, palaces and castles, classrooms, hospitals, and airports. The technology evolves, but the values of design continue in their original purpose: to create context. Context is the first Mindsetter, evoking ways of thinking that serve or fail to serve the purposes inside. There are many living examples of poor, subprime, and failed design, because we simply adapt ourselves to live within bad design. The best design matches the human factors to purposes.

In your opinion, what sorts of things separate the most memorable, creative, immersive, and life-changing theme parks or similar spaces from the least memorable and simply boring places?

An awareness of human factors. What has always surprised me is how many subprime places there are in our daily lives—starting with our own homes. Design is conservative because construction, which has been standardized over centuries, is conservative. Anything not on the list counts as custom design. In public spaces, there is less excuse, because these spaces are supposed to be the result of real thought and planning. However, that planning is usually founded on older ideas of highways, malls, stores, libraries, hotels, hospitals, airports, etc. By starting out with the people rather than the buildings, highways, town squares, or neighborhoods, we can do much better because that starting point is totally human-centered, which is the approach of neuroarchitecture. This is the field that studies the "normative power of the actual."

Could you comment on how your own work has focused on the power of storytelling and perhaps provide insights on how designers may use storytelling in their spaces?

The term storytelling may be overused. What is important is the creation of spaces that evoke various values, concepts, stylizations, and other ways of thinking, both intellectual and aesthetic. When someone visits the home of President Franklin Pierce's family, Albert Einstein's Princeton home, or Edison's lab, he or she is part of a *mise-en-scène* that fires up synapses useful to empathy and cultural understanding. It's about inspiration, imagination, evocation, and the provocation (or calling up) of other times and places. It's about the mood, theme, style, and modalities of being human and living in a particular time and the ambience of that time. Stories are, in the end, capsules of something more than story. They express the "prime directives" of culture—the values that motivate our actions, thinking, and decision making.

Inspiration

We now have the sense that language and meaning opens up both a world of possibility and a world of problems. We can do anything with language but we have to keep in mind that the choices that we make about our projects will be assessed by the guests who enter our spaces. What if they don't get what we're trying to say? What if they misunderstand our meanings? These are important questions, so let's take them apart by looking at the issue of the vision behind a design project. This is the place where it all begins, often from the ground up.

Vision

Now that we have reviewed the role that language plays in creating the meaning behind an immersive world space, we should look more closely at how design projects get started. There will be much variation in your own projects, but in many cases you will be asked to build a project from the ground up. This is quite the challenge, but we can discuss some general approaches that will make this task more meaningful.

One Person's Idea

In Chapter 1 we looked at a few of the individuals who had ideas for inspiring architecture and design at Coney Island. George Tilyou introduced many elements at Steeplechase Park that would inspire amusement and theme parks to follow. He created an iconic "funny face" that became the first amusement park logo. He understood the importance of enclosing a park within a berm and he saw the need to use rides to get people up off their feet and enjoy the park. Similarly, Walt Disney used his insights as an animator to create and inspire a series of successful theme parks. Disney understood the value of focusing on the needs of the guest and he is especially remembered for his efforts to bring a new standard of quality to outdoor amusements. Tilyou and Disney remind us of the power that vision plays in any design project. One person's idea can have an immediate and often lasting impact on a design project.

Massive Creativity

Creativity is one of the most fundamental aspects of developing a vision for a space. If we review the contributions of contemporary theme park visionaries, we see that they used massive doses of creativity to get their spaces going. There are many different understandings of creativity, but one of the best definitions is the idea of "to make, bring forth, produce." This reminds us that *we* have to create something that guests will love. It can't be cookie cutter, predetermined,

or copied from another venue. It has to be original, in so many ways. Mihaly Csikszentmihalyi's important book *Flow: The Psychology of Optimal Experience* looked at issues associated with creativity and found that individuals who had "flow" or a mental state of total involvement in an idea, activity, or project seem to exist in a state of "groove." If you have ever played music, or have been wrapped up in it while listening to it, you might have a sense of how being in a groove works. Csikszentmihalyi similarly points to how a person involved in flow is *immersed* in the world in which she is a part. This means that as we think about new design projects we have to "live the life" of the design. We have to put ourselves as far into the world of design as we can. This is massive creativity. If you would like some additional examples of exercises that may promote creativity, go to the Research Break, which is found after Chapter 5 in the text. The charette may be especially useful for thinking about design inspiration and creativity.

Getting Started

To get started, one has to begin at the obvious but challenging phase of asking: What do I want to do? Are you creating a new design for a lifestyle store, perhaps for a highly identifiable brand? Are you creating a new theme park ride that will develop a specific story of adventure? Are you making a new concept section for a cultural museum that will fill an important informational gap in your museum? This is the phase of *concept first* and it involves one of the key decisions in designing a space. You have to determine what your project is and what you want it to do. If we return to the provocation that began this chapter—the blank space—we arrive at a point in which we now have to decide what to do.

Real versus Fictive

One of the first things that we must consider in any design project is the source behind our design. When The Wizarding World of Harry Potter was created at

Universal Orlando, the fictional world of J. K. Rowling's *Harry Potter* was brought to life in a three-dimensional world. Though the world of Harry Potter is not real, it is very real to the millions and millions of fans who love the books. The Wizarding World of Harry Potter is an example of how even in designing a fictional spatial world the designer must pay close attention to translating design elements in a consistent sense. Using Chart 2-1 we can see that this type of design fits into what is referred to as Level 3 of the basis of a world (see also Table 2-2). This is a fictional world that is created in a great degree of depth. In a different light, the theme park World Joyland (Changzhou, China) falls into Level 6. It's based on a fictional world of video games (in fact, it has appropriated, without permission from Blizzard Entertainment, Inc., ideas from the popular video game *StarCraft* and MMORPG World of Warcraft) but only in a surface manner.

In terms of spaces that are inspired by real places—like New York, Paris, or Venice—there is a similar line of emphasis that ranges from depth to surface. The Venetian Macao-Resort-Hotel creates a great deal of authenticity by recreating many of the architectural, performance, and art features found in Venice, Italy. It does so with incredible attention to detail, including recreations of the Doge's Palace, St. Mark's Square,

Chart 2-1 Basis of a World

Basis of a World

Real	Blended	Fictive	
Level 1	Level 2	Level 3	Depth
Level 4	Level 5	Level 6	Surface

Figure 2-9 Venetian Macao-Resort-Hotel — an example of the level of authenticity that can be achieved in spatial design.

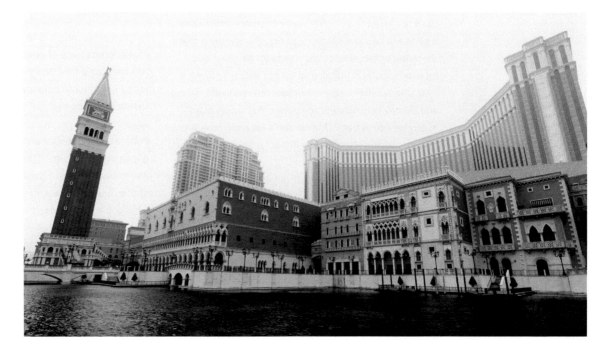

Table 2-2 Types of Worlds

Type of World	Level (Chart 2-1)	Basis	Examples	Common Uses
Real (Depth)	Level 1	Based on the real world, attempts to create in detail	The Venetian (Las Vegas)	Historical museums, casinos, some theme parks
Real (Surface)	Level 4	Based on the real world, focuses on less detail and more surface	Europa-Park (Rust, Germany)	Theme parks, themed restaurants
Fictive (Depth)	Level 3	Based on a fictive world, attempts to create in detail	The Wizarding World of Harry Potter	Theme parks, themed restaurants, lifestyle stores
Fictive (Surface)	Level 6	Based on a fictive world, focuses on less detail and more surface	World Joyland (Changzhou, China)	Theme parks, some lifestyle stores
Blended (Depth)	Level 2	A blend of real and fictive world, attempts to create in detail	Celebrity Solstice	Cruise ships, some casinos, branded shops, and restaurants
Blended (Surface)	Level 5	A blend of real and fictive world, focuses on less detail and more surface	(Some) Tiki bars	Some shopping malls, lifestyle stores

Figure 2-10 The world of Tiki bars has excited many people. In some cases the detail of the Tiki bar is less important than the ambiance and spirit that it creates with people.

Campanile Tower, Bridge of Sighs, and San Luca Canal. Other places are based on some real place, culture, or time but they use a less realistic approach to the theming. An example here is the excellent Europa-Park in Rust, Germany. The park uses multiple themelands to deliver an interesting experience to guests.

The third type of space is called a blended space. It is one that combines elements of both the real and the fictive world. Cruise ships, branded venues, and some lifestyle stores rely on this approach to tell a design story in a way that blurs the line between the real and the fictive.

A note about the words "depth" and "surface." You should not read too much into these terms, especially in the sense that depth means good and surface means bad. There are plenty of reasons why a designer might

decide to deemphasize details in a given project. For example, in the case of some Tiki bars there is less focus on the precision of the cultural representations and more on the pleasure that people derive from the Tiki theme and its overall meanings.

Margaret King reminds us that we need to focus on the small details—the fine-tuning—in order for people to find our spaces to be real and provocative. If you would like to think more about this topic now, you may jump ahead to Chapter 4 and look at the ideas related to authenticity.

Provocation—Anxiety of Influence

In 1973 Harold Bloom wrote a book about poetry called *The Anxiety of Influence*. Bloom's interesting study looked at the ways in which poets of the present were able (or often not!) to write poems of their own given

that other poets had come before them. The "anxiety of influence," it would seem, is a result of a new poet having to write *given* the frame of reference established by a previous poet. Does the poet completely forget the past and write a new poem or does he or she attempt to write a poem that somehow references the other poems of the past? The conundrum of the anxiety of influence is that we can never seem to fully create something new without paying respect to the past. With this challenge in mind, let's move beyond poetry to the world of three-dimensional spatial design. Take a minute to reflect on a design project that you have worked on (or one that you are planning to work on). What are some ways in which previous projects impact the new one that you are working on? Have you felt this anxiety of influence? How can you deal with it?

Reality, at All Levels

In Chapter 1 we talked about the ideas of culture and holism and we considered why using them in design worlds is key. We can continue this discussion here and focus on the importance of developing the world—whether fictive or real—in ways that will convince guests of the "reality" of your world. The **reality principle** of design refers to the idea that designers create spaces—whether based in a real or fictive world—that guests will come to see as real to them. They will come to appreciate the space so much that they will forget, akin to being in a state of "flow," that they are in a designed space. They will feel at home, at ease, and, at times, one with the world that you have created for them. Holism and attention to culture can assist with designing worlds that reflect a sense of reality. Chart 2-2 presents a few other keys.

Associations

As we move into the power of stories and space, let's focus just a bit on one of the items related above. The associations that are created in a space are key to that space's success. This cannot be stressed enough. We'll

Chart 2-2 Keys to Reality

The place satisfies people at every level—basic needs (food), psychology (entertainment and interest), and social levels (people watching, interacting with others).

The place feels that it has always existed. It is timeless and does not seem to have been overtly constructed.

The place feels unique to people. It doesn't feel cardboard or put together quickly. It has real character and value to it.

The place integrates the brand, various products, or other aspects of meaning that are important to the company producing the experiences within the space.

The place creates associations with people that are related to the continued success of the place.

discover a bit more about this in Chapter 6 as we tackle the brand, but right now we can think of any number of good (and bad) associations that we have with certain brands. The same is true for space. If people have a good time in your place, they will remember it. We know that memory is based on association (recall the method of loci in Chapter 1) and if people enjoy what they are doing their associations may range from excitement, entertainment, happiness, and fulfillment to boredom, disgust, discontentment, etc. One of the most powerful ways to create immediate and effective associations in your space is through the techniques of stories.

Stories

Stories provide some of the most important foundations for any immersive world. They give us the magic behind the places that we make. Anthropologists have said that storytelling is a near human universal that most cultures share. Cognitive psychologists and evolutionary thinkers argue that stories are a hardwired part of our brains. These forms likely gave us an evolutionary advantage and allowed us to stick together once we started organizing ourselves into social groups. They also likely gave us a sense of purpose. Any great story takes you on a journey and it's hard not to get caught up

in the action yourself—you become a part of the story and thus your life is given new purpose and meaning. Also, the great story, as we shall see, can give any space—even a mundane one—a sense of meaning.

Values of Storytelling

In addition to our brains being hardwired to tell stories, we look to the fact that stories serve real and significant purposes for people in all cultures. Understanding some of these reasons can assist us in developing more involved and meaningful stories in design spaces. As we just learned, stories help *bring people together*. They give us a sense of shared purpose. You can imagine what it must have been like ages ago to be huddled up with your family around a campfire. Predators of every sort were around you but stories gave you something that you could share with others, amidst the uncertainty of early life. Especially in tough times, even in our world today, stories *help preserve the foundations* of a society. In Mali and other African nations, praise singers or griots tell the age-old stories of their cultures. Many of the ideas wrapped up in these stories *reflect the core values* of the culture. In this sense there are two other closely related values of storytelling. Stories help us *understand the history* of a group of people and they also allow us to *learn* about those people. My wife teaches elementary school and she has discovered that one of the best ways to teach in her classroom is to use methods of storytelling. In her classes, students are required to learn famous folktales or fables from different world cultures. The students have to learn the tales, adapt them for their own minds, and then tell them to other classes. The process of storytelling has taught the students important lessons about other cultures and has given them cognitive, social, and creative/artistic skills that can only be acquired through stories.

Stories also allow us to *more fully perceive the world*. Stories, especially when told persuasively, can fill in the details that are otherwise lost in other ways of thinking about the world. Robert Coles' wonderful book *The Call of Stories* helps us understand why this is significant. Without hearing another person's story, you might lack empathy or understanding of that person's unique situation. By hearing a story you become better acquainted with the circumstances of the persons involved, you *develop empathy*, and you can *put yourself in their shoes*. Stories thus also allow us to heal. They can serve as forms of *therapy*. I was reminded of this important function when I visited the Museum of the Holocaust in Los Angeles. The museum features real stories of the Holocaust told by survivors. These important retellings of the horrors of the past help all people come to terms with the most difficult of times. Beyond these serious and culturally significant values of storytelling, we come to a last one—this is the value of *entertainment*. Stories bring the world alive and they allow all of us to feel better within it.

The Modes of Stories

As Table 2-3 illustrates, we can look to the many types of stories that exist in the world and find inspiration in millions of places. Stories range from fables to complex epics and they also range from sources of entertainment and comedy to forms of cultural mandates and lessons. As you look over the forms considered in the chart, you might think about how some of these specific ones could be translated into space. When we begin to analyze the many different stories, their modes of telling, and their content, we begin to see some important things that we can apply to our design stories. From culture to culture, we learn that people often enjoy stories that:

1. Teach us an *important lesson*, like being frugal with our money.

2. Involve *heroes* who overcome obstacles and are victorious in the end. The hero is often the underdog (be sure to see the discussion of monomyth in Chapter 6 for more on this idea).

Table 2-3 Types of Stories

Type	Description	Example	Function
Parable	A short story that involves human characters and includes the use of analogy	Parables of Christianity (Bible)	Teaches a lesson, value, or key principle
Fable	A moral story, often using animals or beings in place of humans	Aesop's Fables, Hans Christian Andersen	Focuses on a moral issue
Fairy Tale	A story involving creatures or beings	Märchen, Brothers Grimm	Entertains and occasionally teaches a lesson
Folk Tale	A story in which ordinary people deal with adversity	The Magic Orange Tree (Haitian culture)	Teaches a lesson
Legend	A story that appears to have historical or locational merit	King Arthur and the Knights of the Round Table	Teaches important values of a culture
Myth	A traditional story often involving gods and heroes	Greek Mythology	Creates models for behavior
Story	Any recounting of fictional or real-life events	Many examples	Creates excitement in the world
Epic	A lengthy narrative poem	*Beowulf, The Odyssey*	Illustrates the important tales of a culture
Urban Legend	A story that is retold from person to person that has no basis in fact	The vanishing hitchhiker	Helps connect people with one another
History	An account of things as they happened	*An Ecclesiastical History of the English People* (Venerable Bede)	Provides a historical account of a place or people
Trickster Story	A story with an animal or other being that breaks the rules of the culture	Native American tales (Coyote)	Teaches a lesson, often about overcoming obstacles or of being an outsider
Personal Story	A story that is told by an ordinary person	Memoir	Teaches others about the lives of real people
Traditional Tale	A story that is passed down from one generation to the next	Griots and praise singers (African cultures)	Preserves the history and values of a people through time
Design Story	A 3-D story	Your design projects	Creates a provocative space

3. Focus on *beliefs or values* that could help us or our society.

4. *Distract us* from our own lives and let us *live out our fantasies*.

5. People can *relate to*. There is something to the story that makes it compelling to us.

6. Enable us to *experience things* that we could not first hand.

Application—Your Favorite Stories

Take a moment to reflect on one of your favorite stories. It doesn't matter what the story is or what medium it is told in. Just think about the reasons why you like the story. Write down the title of the story. Next, write down five reasons why you like the story so much. What are some of the things that resonate with you in the story? Finally, write down a list of ways that you could translate some of the specific things within the story (or, more generally, the things that could be effective in another story as well) to a design space of your choosing. Discuss some of the challenges of retelling this story, especially if there is a change in medium involved.

The Story Behind the Story

Once, I was working as a consultant for a media company and was asked to assist in the company's efforts to develop new stories for their different product lines. In the process of working with employees from different departments of the company, I was impressed to see that so many people were wrapped up in the process of creating new stories. It was wonderful to see people get so excited about the possibilities that could be created with new stories. During the process, I recall telling a few people about the value of making sure that the foundation of the story being created was stable. What I meant by this was:

1. There were *enough details* (characters, events, places, etc.) and *variation* in the story that people could get immersed in the world.

2. There was *a sense that the story wasn't made up* but that the things in it actually did, or could, happen.

3. There were *connections* between each and every thing, place, person, or being in the story that made sense.

Sometimes, this aspect of story stability is referred to with the term backstory. This is a method of relating more information about characters, aspects of a world, or both that gives the person a better sense of what the characters or world are like. The backstory helps explain things like why the world is the way it is before the guest got there and offers some explanation of what the guest's role, if any, is. Even though we are telling stories within space, we cannot forget about the important role that backstory plays in the development of the effective space.

Trending—Antiheroes

Stories are often attractive to us because of the ways in which heroes play a role. If we are reading *The Odyssey*, we can't help but get wrapped up in it in part because of the exploits of Odysseus. In recent years, a new trend has taken hold—the antihero has become more popular. We see this figure in literature, in comic books (*Sin City*, *The Punisher*), in video games (*Infamous*), and in feature films (*The Dark Knight, Sin City*). Does this trend mean that you will have to write in more antiheroes into your designs? Not necessarily. Instead, you might think about what this trend says at a deeper level. Perhaps traditional heroes have become tired. Maybe people are more cynical about typical good versus evil stories. Or maybe people want to see a bit more realism in terms of the characters that they connect with. Whatever the case may be, we can use the antihero trend to think about more complex storylines within our spaces. The video game *Infamous*, for example, presents the player with a choice of moral options—one can act in good ways or rather evil ways. This trend also connects with the issue of the choices given to guests in a space (see Trending—Open Worlds later).

Building Your Story

As Larry Tuch expressed in his interview in Chapter 1, a story is a key aspect of the immersive world. It's what gives the space *context* and meaning and it gives the guest a reason to be in that space. If the "story" you plan to tell is simply selling a product because it's good, that will not be enough to convince the guest to stay in that space. Now, if you figure out a way to tell a story that incidentally relates to the desirability of the guest buying that product, then you've got something. Let's look at some specifics of what I call a **design story**.

Design Stories

All compelling spaces begin with a story. The story is the source of the material that guests will enjoy as you create immersive worlds through architecture, interior design, and forms of material culture. Let's look at some specifics of design stories.

What Is a Design Story?

A design story is told in three-dimensional space, using architecture, design, and forms of material culture. It may also include actors, performance, and forms of technology. Just like the traditional stories described above, the design story creates a world in which people can relate, interact, enjoy, and explore. The design story represents a melding of the techniques of design, interior design, architecture, and applications of technology and material culture with the techniques of storytelling and associated areas like performance, acting, and interaction. Chart 2-3 presents three possible scenarios in which design and storytelling interact. In scenario 1, the story is the initial element that is used to drive the design and architecture of the space. A designer might be asked to develop a project for an area. He or she begins with knowledge of the area, the interests of the clients, and then develops a story that could be viable for the space. Architects

and landscape designers then produce an appropriate spatial design based on the guidelines of the story.

Chart 2-3 Story & Design

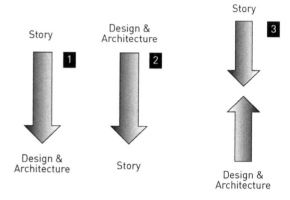

In scenario 2, the architecture and design drive the story. A client might approach the designer and ask for a project that will be built around an iconic architectural structure or feature. The client wants this feature to be the foundation of the project and then the designer must come in and develop a story that will wrap the project up in values, emotions, or qualities that will excite guests who visit the place. In this way, the story is an important "after effect" that is used to amplify or add to the quality of the architecture. In the last scenario, design and storytelling have an equal effect on one another. A story is written for a place and this leads to inspiration within architecture and design; design further inspires the story and it is changed to accommodate the design. In this case, reciprocity of design and storytelling takes place. We can get a further sense of the challenges of integrating design and storytelling by looking more closely at some similarities and differences of traditional storytelling and design storytelling.

Telling Stories in Design Spaces

An important idea to consider is how telling a story in a three-dimensional architectural space is different

from telling a story in text or in oral forms. Table 2-4 expresses some of the differences and similarities between these two types of storytelling.

There are two ways to look at this table. One is to think of literal ways that we can translate the effective elements of traditional storytelling into the effective elements of design storytelling. For example, we can think about the plot of a novel, including its character development and pacing, and then apply that to a cultural museum in which guests will move through a series of spaces and feel a sense of plot or narrative. The National Museum of the American Indian (Washington D.C.), the United States Holocaust Memorial Museum (Washington D.C.), and the Museum of Tolerance (Los Angeles) all use this technique. As people move through the exhibits, a story is told. In the case of the United States Holocaust Memorial Museum, the story is especially vivid because of the way that pacing (plot/narrative) develops through the exhibits. The effect on the visitor is powerful. A second way to think about the chart is to consider less literal interpretations. We can think of characters, for example, in a more general sense. In some spaces, buildings can even act as characters or can be combined with animals, beings, or human characters. It is my feeling that the second (less literal) form of understanding is best, but both views can directly benefit the development of the design space.

History of Design Spaces

What are some of the specific trends that have impacted the telling of stories within design spaces? This survey

Table 2-4 Traditional versus Design Story

	Traditional Story	Design Story
Plot or Narrative	Developed through pacing, action, and events that take place through characters.	Developed through the journey that takes places through different design spaces and elements.
Perspective	Created through voice and literary techniques.	Created in visual cues, major features, design forms and all elements of a space.
Theme	Offered through the actions of characters, the nature of events, and sometimes the narrator.	Manifested through forms of design—in some cases explicit themes, in others, more subtle features.
Characters	Expressed through the action in various scenes and in events.	Offered in the form of architecture, technology, characters, actors, events, and guests themselves.
Setting	Produced through evocative language and actions that give a sense of the place.	Produced through forms of spatial design and attention to all features that make up a space.
Reader	A story is often read alone. Ideas about the story are shared in conversations and in book clubs.	Individuals interact with design spaces. In so many cases, the interaction is in the company of others.

reflects some of the historical trends that we see with storytelling in the major venues that we are considering. Please note that the list includes explicit stories as well as implicit ones. Some of these can be taken as general forms of inspiration that can be thought of in your future projects in these design spaces.

Figure 2-11 A scene from one of the fantasy spaces at Luna Park — a recreation of the canals of Venice.

Amusement parks have had an interesting relationship with the design story. The parks of Coney Island past—Sea Lion Park, Steeplechase Park, Luna Park, and Dreamland—helped usher in a number of important trends in storytelling. First, they highlighted the value of *an attraction as a specific type of story*. This was the case with rides like A Trip to the Moon and the many forms of simulations that would lead to stunt shows and disaster-based rides like those at Universal Studios Hollywood. This is important because it shows that the public will accept a variety of different stories within one larger space, but the disadvantage is that there is less continuity between the various attractions within that space and this leaves the designer missing out on the opportunity to tell a bigger story to the guests. Another value of the legacies of these parks was the idea that *spectacles* (including animal shows, circus acts, and disaster rides), themselves, could be a story. People could be awed just by the idea of someone doing something dangerous or an animal acting in a strange or amazing way. Of course, this is a limited story since the depth at which a guest can appreciate it is less than what would come in theme parks. A final influence that is still felt today, namely in parks like Kennywood, Cedar Point, Knoebels Amusement Resort, and Blackpool Pleasure Beach, is the story of the amusement *ride*. A ride, itself, tells a sort of story, however limited. Roller coaster enthusiasts have proven this point as they look at the specifics of roller coasters in incredible detail and examine the personalities and qualities of the rides, their function, and their designers. In many cases, though, a ride needs more than itself to tell an involved story (for more on this, please see Chapter 7). To deal with this many rides have been given sufficient backstory to add to the technology (for example, Space Mountain and Rock n' Roller Coaster).

As we move to theme parks, we see some of the strongest elaborations of storytelling in space. The theme park

proved to many people that *an entire space could be a story*. The greatest theme parks have the ability to captivate people once and they enter the park and even after they leave the front gate. What theme parks provide is a sense that space would be incomplete without a story to go along with it and in this way we owe much to the theme park as *the* form that established the precedent of telling stories through architecture, material culture, design, and technology. Further, theme parks help develop one of the most important of all design storytelling forms—theming. We'll address theming in Chapter 3.

Restaurants, bars, cafes, and other related spaces are a unique case of design storytelling. More than in theme parks, which typically have some form of story as a foundation of the place, restaurants vary widely in their integration of design and story. One story that has been told, often without explicit design touches, is the idea that *good food is good*. This is a natural story that focuses on the main function of a restaurant—the food. But this appeal often isn't enough. As more and more competition occurred in the restaurant industry, owners of establishments competed with new forms of dining, including fast food, and some looked to the appeal of forms of storytelling that could be applied in a restaurant. Mike Leeson, the owner and visionary of the Industrial Revolution Eatery and Grille (interviewed later in the chapter), took the steps to create an eclectic theme that helps create a sense of place in a venue that serves food and provides an experience. While visiting the restaurant, I had the opportunity to see, firsthand, how such a story might be told.

Field Journal

Today I came to check out the Industrial Revolution Eatery and Grille to get a better sense of this unique new restaurant. Initially, I was surprised to hear about a place that is themed in lines with the Industrial Revolution. It didn't seem like a theme that I would find in a restaurant. The first notes of the place greet me with a sense of the theme—the iconic photo of workers eating their lunch on a skyscraper girder is brought to new life in a statue by Sergio Fernari. The door knobs, some shaped like wrenches, give a further sense of this theme. Before my meal is brought out, I have the chance to read quotes on the wall and look at many photos. The quotes speak of the values of the Industrial Revolution—American ingenuity, hard work, perseverance, creativity, and the power of technology and industry. On the tables are menu cards that feature a photo of a local hero or celebrity and it appears that menu items have been themed along the lines of the person featured on the card. On televisions throughout the restaurant, I see feature films of the time, as well as an occasional video loop of a steel mill in operation. A train shoots out of the wall and moves along tracks that have been affixed just below the ceiling. I end up chatting with one of the managers who offers to give me a short tour of the place after my meal. He tells me that one of the most important things about the restaurant is how it draws on the story of the Industrial Revolution. "It's about the values and the people that made this time great." He then tells me that one of the women featured on a photo on the wall at some point came into the restaurant. She was tickled to see a younger version of herself in the photo and when she began to tell a bit of her story to those in the restaurant, some turned to tears.

Casinos have had an interesting relationship with stories. Due to the developments of themed casinos on the Las Vegas Strip in the 1990s, many people became familiar with one of the key forms of design storytelling—theming. Casinos like Paris, Mandalay Bay, New York-New York, the Venetian, the Bellagio, and many others showed us that the *replication of a place, or the replication of the feelings of a place, is a good story*. People could visit New York-New York and

have the sense of some of the things they would see in New York. Academics and journalists often scoffed at this idea, but they missed the point about what story is—it is always a retelling and this means that the New York-New York is a different story, as is Times Square in the "real" New York City. Casinos also tell the story of *excitement* through gaming experiences, sexual appeal, and varied forms of entertainment and they tell the story of *opportunity and hope* as people have the chance to win it big in forms of gaming. Like restaurants (and food), casinos have to balance the story of gaming as it relates to the design elements of the place.

Shopping malls and lifestyle stores have focused on storytelling in unique and often appealing ways. Traditionally, shopping malls have told the story of *more and variety is better*. This is found in the fact that malls often have hundreds of stores that each tells its own story of lifestyle, products, and services. There is often less effort to tie together all of the individual stores within a mall because of differences between franchises and corporations that operate the individual stores. In mega stores—like Bass Pro Shops Outdoor World and Cabela's—there is a better ability to connect products and departments together using one theme. This is due to the fact that there is less difference between the products being sold in these stores. This makes it easier to create an overarching story of the outdoors, sportsmanship, and nature in these outdoor mega stores. One of the most significant of the newer stories of these spaces is the *idea of the brand*. The brand has become a staple in design spaces and now more than ever, stories resonate through brands. Nike was one of the first companies to figure out that *form was not enough*. It wasn't enough to advertise a good running shoe—you had to tell a story with that shoe. Phil Knight and others at Nike began to tell the story of sports filled with ideals about competition, success, defeat, perseverance, and many other subthemes. Other stores,

like REI and Whole Foods, have developed associations with the brand that help tell *favorable stories*. These are stories about saving the planet, helping others in drought-stricken nations, and exercising and eating healthier foods.

Cruise ships, at their heart, tell the story of *transportation*. But this is more than the story of transportation. It is the story of a *journey* and all that it entails. When you step aboard a cruise ship, the excitement builds as you think about the ports of call that you will see, the activities on the ship, the many people that you will encounter. More recently, cruise ships have picked up on the idea of *elegance and luxury* to give guests a sense that any desire or wish is possible while aboard the ship.

Museums and cultural museums have traditionally relied on a story. The ideas of *the unfolding nature of history* and the *diversity and uniqueness of culture* have been stories that have been retold in museums in incredibly creative and educational ways. Museums have also shown us that by combining design and storytelling, guests can be *educated* and will better appreciate things and people in the world. More and more, museums are telling the story of the *difficult and painful aspects of history*, perhaps because it would be seen as less tasteful to do so in a theme park (consider the torrid history of Disney's America as one example of this).

What we can see in this general overview of how design storytelling has developed in space is that there is much variety to how stories are told. As we consider more of these spaces in depth, we should keep this in mind and try to be open to the possibilities of moving outside some of the current molds established in these spaces.

Experience

In the first chapter we spoke a bit about the value that experience plays in any designed space and one of the

things that we will address in later chapters is to what extent the experience of a space relates to the design of the space. Most designers would agree that the two are connected at the hip. There is no way to separate them and when this happens, the nature of the story being told in the space begins to break down. One question to think about in this regard is: How much control are you willing to give your guests? You might remember the popular Choose Your Own Adventure series of books in the late 1970s. Children enjoyed the books because they gave the reader a greater sense of control than is found in a typical novel. The trend impacted video games as well as new forms of electronic text called hypertexts. The less linear path given to the reader/user provided new opportunities to think about the experiences of readers/users in these worlds. The same issue can be considered in design. Designs might reflect the idea of the "open work." This is a term used by Umberto Eco to indicate a text that is more "readerly" (the choices sit with the reader) as opposed to a "writerly" text (the choices sit with the author). We will come back to this issue and the topic of interactivity in Chapter 7.

Trending—Open Worlds

One of the most interesting trends that has evolved out of the world of video games is the open world. An open world game—like *Infamous, Saints Row,* or *Grand Theft Auto*—gives the player a world that seems limitless. In video games of the past, like *Pac-Man,* a player was confined to a very limited space. There wasn't much to it. Now, due to the increased processing power of video game machines, players can interact with a much larger landscape. The open world, like the open work, is a space in which the player is given more respect and more sense of control within the world. Instead of predetermining the action, the player is asked to explore. In this sense we might all look at the power of open worlds. While it would be impossible to design a

truly open world in a casino or theme park—for a variety of reasons, including safety, cost, attention to the flow of a story, etc.—it is a good philosophy that might inspire designers to think about openness as a feature of design. You could decide to leave more of the decisions about where to go and what to do up to the guest.

Theming the Industrial Revolution
Interview, Mike Leeson
Owner and President of Synergy Steel Structures
(Lansing, Illinois) and Industrial Revolution Eatery
and Grille (Valparaiso, Indiana)

Figure 2-12

Mike Leeson founded Steel Sales & Services in 1995 and was a majority owner of Steel Structures of Ohio in Akron, Ohio. He is the current owner and President of Synergy Steel Structures. He earned the "young entrepreneur of the year" award from the Chicago Southland in 2001 and has received awards for structural steel design. In 2010 he opened the Industrial Revolution Eatery and Grille.

Can you talk a little bit about your life, your background, and your work?

I was born in South Holland, Illinois and raised by great parents who always promoted hard work, common sense, and fulfilling commitments. Being some kind of

a serial entrepreneur, my father gave me an opportunity at the age of 20 to start a new company in an area that he saw some opportunity. I took the opportunity and ran with it. This led to three divisions of steel companies servicing different markets in three different states.

You are the creator of one of the more interesting themed restaurants that I have ever seen. It is called the Industrial Revolution Eatery and Grille, located in Valparaiso, Indiana. I understand that you created this themed restaurant in part due to your background in the steel industry. Can you give us a sense of how this all happened?

I saw the markets changing for the worse as the economy was declining and none of the right things were being done to correct it. I ended up selling one of my companies to try this crazy restaurant idea that I had. The timing felt right to do so. I didn't see anyone else attempting what I had visualized, so I realized

that I was the one who needed to do this—to create a restaurant establishment where people could connect on an emotional level and where we could "Salute America's Greatness." It would also be a restaurant where people would be entertained, they would be inspired, and would walk away with having a great handcrafted meal.

When you first thought of the idea of creating an Industrial Revolution themed restaurant, how did you go about your plan? There doesn't seem to be an existing model for this type of restaurant, so I wondered how you went from concept to an actual restaurant.

I had an enormous amount of ideas listed out on paper. Most of these original ideas were not used as there was just too much. The concept became clearer as we thought about the design and construction process. Overall, it was important to develop a strong story for the restaurant.

Figure 2-13

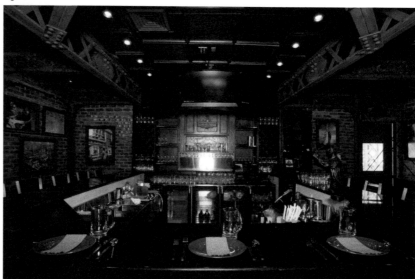

Did your experiences with any other places—restaurants, theme parks, museums, etc.—influence your approach to the design of the Industrial Revolution Eatery and Grille?

I have always loved and respected Walt Disney for what he did with theme parks. My inspiration is best described as a cross between Walt Disney and my own internal fire to stand up for our industries.

Why was the Industrial Revolution the theme that you chose for the restaurant?

I wanted to celebrate our industrial heritage and promote its value to us as a nation. This is important given that today we see so much of our industry being exported to other nations. We became the world's superpower by inventing, building, and making things—things that are now exported elsewhere.

The design of the restaurant is what you call "Upscale Industrial." Can you talk about what this design entails? What decisions did you make in terms of the photographs on the walls, the art and statues, the material that plays on television screens, the door handles, the specific décor?

Everything in the restaurant is custom and hand built. I wanted to have a balance of steel, wood, and brick for the majority of the building materials. There is no drywall or any other budget materials used. The steelwork is meant to be exposed to show its structural beauty as an interesting design element—as opposed to the traditional approach of hiding it. Much time was spent on both choosing inspirational quotes to be hand painted on the walls as well as the selection and placement of the photographs. The statues that are on display have a lot of history and were crafted by artisan Sergio Furnari of New York City. The sculpture of the eleven ironworkers (Lunchtime on a Skyscraper - A Tribute to America's Heroes) sat at the observation deck at Ground Zero before traveling across the nation on tour. The other statues were made to have the look of a building that became "frozen in time," right before completion with the workers frozen in place. There are a lot of little extras (wood carvings, fabricated door handles, etc.) that are intended to be noticed only after several visits. There is simply too much to notice after one or two visits. The televisions showcase educational material and highlight industry, important people, and manufacturing to keep the guest entertained and interested during the visit.

Figure 2-14

I understand that a big part of the construction process involved using authentic materials (including reclaimed steel) and building processes. Why was this important to you?

It was important for the flagship location to be as authentic as possible because of what we symbolize and our idea of "Saluting America's Greatness." We used reclaimed flooring, 100-year-old clinker brick throughout the interior and exterior, all-American-made steel fabricated to the way we used to do it at the turn of the century and then chemically rusted it to show its richness. There is 200-year-old granite cobble for the outdoor patio, American-made copper tin panels, and distressed complicated woodwork.

When I visited the Industrial Revolution Eatery and Grille, I noted that the steel girders and roofing seemed very real. What was the source of this steel?

The source of this steel was designed and fabricated by Synergy Steel Structures out of Lansing, Illinois, which is a company that I own. We fabricate for the commercial and industrial markets as well as architecturally exposed steelwork that is designed in house. It is used as an architectural statement, as opposed to structural only purposes.

How does the menu relate to the theme of the Industrial Revolution?

We specialize in hearty handcrafted comfort foods with a new twist. Some of our favorites are Mom's Double Shift Pot Roast (my mother's secret recipe), Legendary Meatloaf, and brick-oven pizzas. Some of these items are named after people or occupations like our Tradesman, which is a huge sandwich with 5 different meats, cheese, peppers, other veggies, and our homemade giardiniera pepper sauce.

I understand that you do a weekly special that focuses on a local celebrity or public figure. Why was that important to you?

In an effort to "Salute America's Greatness," every week we tell the story of a known or unknown great American with the emphasis on their accomplishments or contribution to America. We want to inspire our guests to go out and do the same thing.

When you walk into the Industrial Revolution Eatery and Grille there seems to be a story that is being told. There's a rich history in terms of what the Industrial Revolution was and the restaurant seems to be telling a part of it. Can you comment a bit on what customers can get out of this story or telling of the Industrial Revolution?

When they enter the restaurant, people are brought back in time and embark on a journey away from their daily grind. They think about the people in their lives that get up every day and help build America and they think about their parents, their grandparents, and their relatives with whom they share in these stories. I believe they begin to appreciate the risks and sacrifices that many people have made to provide for their family and they understand how people—during the Industrial Revolution and in other times—have risked a lot to help build our nation. I think people walk away with a different level of patriotism or pride as compared to when they walked in.

Application—Storytelling in Popular Places

Go to a place of popular culture (or recollect on a place that you have visited in the past), such as Starbucks, Target, a casino, Whole Foods, Trader Joes, etc. Work on this application by writing a short response for each item. This application may be repeated for multiple places. Think of it as a design story assessment tool.

- Place of observation:

- Material elements (discuss the architecture, décor, signs, or other material elements):

- Who is the audience?

- Does the background of the audience affect how the story is told/received?

- Is there a backstory?

- What is the pacing like?

- How are people led through the story?

- How does the audience experience the story?

- What roles do the audience play in the story (active, passive, please discuss...)?

- Who or what are the characters?

- What are some of the themes?

- What is the perspective? How is the story told?

- Are people asked to suspend their disbelief? If so, how?

- Is the audience asked to do anything? Is it being persuaded?

- What cultural themes can be identified in the story(ies) being told?

- What happens when the audience leaves? Does the story go home with them?

- Discuss your overall observations of this form of popular storytelling:

Wouldn't You Know It!—Reality Check

My wife and I are both writers. She writes poetry and fiction, while I write nonfiction. A conversation that we usually have (often around the time when we are stressing about our writing) is whether one has to sacrifice one's artistic integrity for the sake of commercial or marketing forces. If you're a novelist, can you stick to your guns and write what you want to write, how you want to write it, or do you have to conform to the market? If vampire novels are the norm, does that mean you have to write about vampires too? Well, wouldn't you know it, whether you are telling a story for an audience in a text or whether you are telling a design story in space you have to consider the audience *and* the market. There is no way around it. As we move through more of the book, we'll focus on some ways that this dynamic can be managed.

IDEAS FOR CONSIDERATION

1. In your mind as a designer, what is the most challenging thing about conveying your intended meaning of a design project to:

 a. Members of your design team

 b. Individuals from other departments (such as marketing)

 c. The public

2. Whether telling a story in text or a story in three-dimensional design, the author/designer must focus on creating immersion and believability in the story. What are some of the ways that you can work on creating more immersion and believability in your design projects? Feel free to refer to a project that you have already considered in the course of this chapter.

3. Stories that are told in space can captivate us. They can make us believe that we are somewhere else. In your mind, what are the three most important things to think about in terms of creating effective design stories?

4. In your mind, which types of spaces—theme parks, interpretive centers, cruise ships, etc.—present the greatest challenges in terms of telling design stories?

1. What is atmosphere and mood and how can they be used to create effective spaces?

2. What is theming and how does it relate to creating immersive spaces?

3. What are some good practices of form and design?

4. What are some ways of thinking about bringing the space to life?

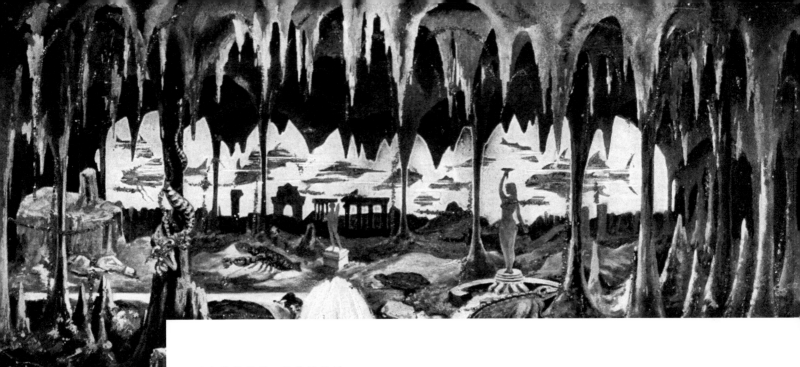

ATMOSPHERE, MOOD, AND EFFECTIVE SPACES

Figure 3-2

Atmosphere

You could be anywhere in the world—Mumbai, Los Angeles, New York, Mexico City, Paris, or Moscow. You are stuck in traffic, in a hurry and getting more and more impatient. You look at a driver in a car next to you. The person looks just like you—frustrated and agitated. The cars begin to move but only at a snail's pace. Exhaust fumes pour over the roadway. You think about how you won't make your appointment. At this moment, this place seems like the last place you want to be.

Space is amazing. Whether it's the space inside our car in a traffic jam or a cabana outside a luxury beach resort, space never fails to affect us. When we talk about the experience of being in a traffic jam, we likely focus on the sorts of associations that we have while we are in it: frustrated, exhausted, annoyed, impatient, and other variations. We can also think about atmosphere or the qualities of a particular space. Atmosphere has the meaning of a "surrounding influence, mental or moral environment." In a sense, it's *everything* that we encounter when we enter a space. Whether it's a grocery store, a theme park, or our home, the space that we inhabit, use, and come to love (and hate) is connected to atmosphere.

Some of my fondest memories are tied to places that have had an impact on me—a street in London, a themed casino in Las Vegas, a theme park in Houston, Texas, my home in Nevada. These places speak to me in different ways, but what each has in common is the sense of its "totalness"—its ability to impact me in sometimes immediate ways, sometimes more lasting ways. We begin this chapter with atmosphere because it reminds us of the total sense of design in a consumer and themed space. Similarly, mood speaks to the awesome responsibility of the designer to create a space that guests will come to love. If atmosphere is the overall effect of a space on us, mood is the result of that effect.

Application—Experience and Mood

Work on this short written application. Take a minute to think about the best and worst experiences that you have had in themed and/or consumer spaces. Divide your piece of paper into two columns. Label one "Bad" and one "Good." Think of one or more places that you can associate with each of the types of spaces. Write down the associations that you have with the places in each column. For example, perhaps in the good column you write down, "I got lost in the world that was there," and in the bad column you write, "The workers there were rude and uncaring." Take a few minutes to write down the associations. Next, go through the two columns and see if you can come up with any general trends that might be worth exploring later. For example, if customer service came up in the different cases on your sheet, you can circle that as one of the main trends worth exploring. After you finish looking at the trends, write a second short piece in which you discuss the keys to effective mood in a themed or consumer space. What sorts of things do you need to be on the lookout for in your own design spaces?

Mood

This last application helps us think about the role that mood plays in any themed or immersive space. **Mood**, or the associations that people have when they enter a space, is a key to designing an effective space. As you considered in the application, any guest who enters a theme park, restaurant, or museum will develop associations with places that they have visited in the past and they will make new ones in the spaces that you design. Looking closely at how mood can influence design will give you a head start at being able to better connect with guests in your spaces. Have a look at Table 3-1. This presents a list of some moods, associated design ideas, and possible positive and negative results of these.

Table 3-1 Moods

Mood	Design Idea	Positive Result	Negative Result
Welcomed	Elements that will create a sense of the guest being accepted in the space, including a variety of elements that will speak to all guests.	Creates an environment in which each guest—regardless of background or interest—is accepted.	Results in a more general focus or meaning behind the space, thus not allowing you to make appeals to specific guests.
Alone	Interior spaces create womb-like places or lighting is used to make the guest feel solitary.	Allows the guest to feel relaxed and perhaps calm, outside of the action of the space.	Results in a sense of loneliness—the guest thinks about things not related to the space—or in the guest leaving the space.
Amused	Use of stimulating colors and textures; the use of rides or technology that cause the eye to wander and wonder.	Makes a space that is thoroughly thrilling to the guest. The guest feels alive and empowered.	Results in guests eventually getting tired, perhaps because of the crowds, loudness, or other reasons.
Annoyed	An element that causes a reaction in a guest, like a form of technology that singles the guest out.	Forces the guest to become part of the action within the space.	Results in guests getting upset about being put on the spot.
Calm	Design will include color, architectural, and interior design features that soothe guests.	Presents a space that can be enjoyed because the guest is made to feel at ease in the place.	Results in guests getting bored or in need of something more exhilarating in the space.
Confused	Eclectic or crazy architectural features, use of color in whimsical ways, and design features that challenge common sense could be appropriate.	Results in the guest being startled and unaware of things, thrown off balance.	Results in people feeling uneasy because of the crazy nature of the space.
Contemplative	Smooth textures, less angular features, and pleasing colors may be useful.	Allows the guest to focus inside him or herself.	Results in guests not interacting with others in the space.
Curious	Design uses focus on spaces to be explored or things to be understood. Caves, doorways, portals, and the like.	Creates a "How'd they do that?" mentality.	Results in guests lingering for too long in a space.

(Continued)

Table 3-1 (Continued)

Mood	Design Idea	Positive Result	Negative Result
Adventurous	Design elements that allow for a search or journey to take place. Corridors that lead to new spaces.	Presents the guest as someone important who can find what he or she needs or is looking for.	Results in guest focusing only on the quest in the space.
Excited	Broad, open spaces and spaces that allow people to mingle and interact could create excitement.	Gives the guest a sense that they can, and should, have fun in the space.	Results in guests sometimes feeling a need for peace, quiet, and calm.
Impressed	Design aspects are bigger than life—they appear expensive, thought out, and not rushed.	Offers the guest a sense of the extraordinary as in something that the guest couldn't see at home.	Results in the guest feeling smaller than life—in the sense that the guest couldn't have achieved what was done in the space.
Refreshed	Elements could include vistas, landscape architecture, color, and water elements that focus on the sense of renewal.	Makes each guest feel transformed. Guests feel that they can relax and enjoy their time in your space.	Results in some guests feeling a need to be constantly refreshed. This may not be possible in the space.
Romantic	Design elements create multiple senses of charm. They allow lovers to linger and to feel special. Elegance and refinement rule the day.	Creates a sense of atmosphere that will allow guests who are fond of one another to connect and better appreciate their relationships *because* and *through* your space.	Results in some unattached guests feeling a sense of loneliness.
Surprised	The use of design could include elements that would startle guests—technology or interactive forms that jump out at people or design forms that are unexpected.	Creates a sense of wonder and asks each guest to act like a kid, if for a moment, and to take in the magic of the space.	Results in some guests expecting surprise around every corner.
Otherworldly	Dramatic entry spaces, use of design elements to say, "You are here, now!"	Offers the guest a sense of being somewhere *completely different* from where the person was before.	Results in guests feeling pressured to do and see everything.

What we can see by these many moods—and there are so many more that we could talk about—is that each one can have a potentially positive or negative impact in a design space. As is the case with other design aspects, we can only speak to some possible ways that moods can be used in a space. The specifics of their use is up to you. Another important thing to think about is what can be called the *crosstalk* between moods. This means that you could design a feature with a specific association in mind—like excitement—but then have a second feature that is connected to the idea of peacefulness. How do these moods speak to one another? Does one dominate the conversation? Do they somehow each have an ability to make a mark on the guest? You might think of mood

crosstalk in terms of the *overall mood* of the space, that is, if you want one. If there is an overall mood, such as in a Zen garden, then introducing a contrasting mood, like excitement, will result in an inconsistent integration of design and mood into the space.

Figure 3-3 The Love Room (The Library, New York). Here the moods and associations of love are connected to the hotel's unique themed room.

Application—Your Moods

Now that we have talked about mood and design associations, let's take a moment to reflect on the power of using moods in a space. You may choose one or more of these exercises.

1. Create an additional list of moods and, using the format of Table 3-1 (Mood, Design Idea, Positive Result, etc.), write your own list of these moods, their design elements, and the positive and negative results. Before you begin your list of moods, establish a hypothetical *big idea*, and detail the *story* as well as the *experience* that is planned for the space (these concepts were discussed in Chapter 1). Use these to create the specific mood associations for this exercise. Afterwards, write a short reflection on how you could incorporate three or more of these moods in your own design projects.

2. Look at the list of moods above and add design features that may have been left off. For example,

Figure 3-4 At Europa-Park, Hotel Colosseo creates a sense of excitement by using a space that is visually open, wide, and full of people.

for "Surprised" list some design ideas that I didn't consider. After you have done this, write a short piece discussing how you could use some of these moods and design elements in your own spaces.

3. Write a short reflection on *mood crosstalk* and *overall mood*. You may choose one or both of the concepts. Discuss the challenges of competing moods in a space and discuss the benefits and disadvantages of a space that has an overall mood versus one that has many moods. When you have completed one or more of these applications, feel free to share your results with a fellow designer.

Approaches to Telling

Whether we create an open world (in which there are more available choices to the guest in that world) or a more closed one (in which there are substantially less choices available to the guest), it is important that we consider the big picture that will inform how we tell guests about our world and the spaces within it. We've already learned about atmosphere (or the overall impact of a place on us) and mood (or the effect that the place has on us). It's also important to think about why people come to consumer and themed spaces. After all, there is something that is pretty compelling about these places, otherwise people wouldn't want to visit them. At the end of Chapter 1 we covered a few of the overall design influences that have affected these spaces. People like the sense of an adventure, people seek out things that are hidden or exotic, people sometimes want luxury, and they often want to be transformed. Taken as a whole, we can say that these design influences show us that people want to be in spaces that are:

- Spectacular, creative, and amusing
- Places of fantasy
- Different, unique, and like nothing else they have seen
- Involved in telling a story in which the guest can get immersed

Let's look at some of the specific ways of telling design stories.

Theming

One of the most popular and powerful of all forms of immersive world design is **theming**. Theming involves the use of an overarching theme or key concept (like Western) to organize a space. In theming a central idea or theme is used to create associations between the space and the guest. Theming has been one of the most successful concepts to have impacted spatial consumer design. It can also be seen as a form of storytelling that takes place in a three-dimensional world. Whatever the theme is, the designer acts as a storyteller and creates settings, characters, actions, and other elements that will make the space a compelling story for the guests to take part in.

Theming is highly distinctive because it uses recognizable symbols.

Theming relies on guests' previous associations with certain themes.

Theming uses "shorthand" or abbreviation to communicate with guests.

What Is Theming?

We will be looking at how theming is used in four main ways. Whether you go to a theme park, an interpretive environment, or a restaurant, you will likely see theming

as one of the main approaches to designing the space. Theming is especially popular because it uses symbols that most people know, it uses previous associations that we have had with themes, and it is a shorthand that allows a designer to accomplish a lot with a little.

Chart 3-1 lists four overall types of theming. Within each of these types there are a number of subcategories. A common form of theming is that based on *place and culture*. In this form, a place of the present or the past is brought to life as a themed representation. The many casinos on the Las Vegas Strip illustrate this form of

theming. Paris, places in Italy, and tropical islands are some of the given themes. We should keep in mind that theming can take a range of approaches and in the case of the casinos on the Las Vegas Strip, some focus on more literal and place-based interpretations of the spaces they take as their inspiration and others use more general approaches to create associations of place and mood. In theming of another sort—that based on a *brand*—there is more attention to the desirable associations to link between a brand, people who use the brand, and certain qualities. We can look at a lifestyle store like Niketown and see the power of brand-based theming. At Niketown, visitors are offered thousands of Nike products in a store that reflects the many values of Nike—competition, excitement, individuality, and perseverance are a few of the values found at the store.

A third approach to theming involves *interest and lifestyle*. Over the years, music and sports have been popular forms of interest and lifestyle theming. Bars and restaurants often use both forms of spatial design to create a specific mood. In interest or lifestyle theming an appeal is made to a certain type of guest.

The last approach is theming that uses *mood and association*. This is one in which the connections between the theming and the ideas are tied to moods or abstract associations. One example is the Propeller Island City Lodge (Berlin, Germany). In the two examples here (two of over twenty different guest rooms), guests are presented with an untraditional use of themes. One room uses design materials like concrete and uncanny angles to suggest a bunker type space. The other situates the traditional features

Chart 3-1 Types of Theming

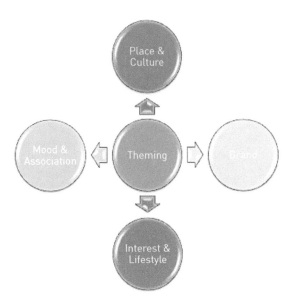

of a hotel room—notably the bed—beneath the floor and places others (chairs, etc.) on the ceiling. Here an association with the subterranean or the underground is created.

One important note on the types of theming is that there can be overlap between these four types. Outdoor sports and lifestyle stores like Cabela's, Bass Pro Shops Outdoor World, and REI often combine aspects of brand, place and culture, and interest and lifestyle forms of theming. This is because of the fact that some

aspects of a brand may be directly connected to certain lifestyles or that, over time, people begin to develop new associations with a brand or a place and, thus, overlap occurs.

Common Themes

We see that theming falls into four major categories. Let's look at some examples of some of the common specific themes within each of these categories (Tables 3-2 to 3-5).

Figure 3-5 "Upside Down" and "Wrapped" from Propeller Island City Lodge.

Figure 3-6

Table 3-2 Place & Culture Theming

Theme	Example	Type	Location	Notes
Paris	Paris Las Vegas Hotel	Casino	Las Vegas	
Italy	Bellagio, Venetian	Casino	Las Vegas	
Rome (Ancient)	Caesars Palace	Casino	Las Vegas	
Ireland	Fitzgeralds	Casino	Las Vegas, Reno	
Ireland	Fado	Pub	Various	
Wild West	New Frontier	Casino	Las Vegas	Closed
Egypt	Luxor	Casino	Las Vegas	
Egypt	Wafi City	Mixed-Use Space	Dubai, UAE	
New York	New York – Hotel Casino	Casino	Las Vegas	
Americana	Dollywood	Theme Park	Pigeon Forge, TN	
San Francisco	Barbary Coast	Casino	Las Vegas	Closed
New Orleans	The Orleans	Casino	Las Vegas	
England (Arthurian)	Excalibur	Casino	Las Vegas	
Tropical Island	Tropicana, Mandalay Bay, Mirage	Casino	Las Vegas	
Asia	Imperial Palace	Casino	Las Vegas	
Asia	P.F. Chang's	Restaurant	Various	
China	House of Mao II	Restaurant	Singapore	
Russia (Imperial)	Red Square	Restaurant, Bar	Las Vegas	
Mediterranean	Riviera, Monte Carlo	Casino	Las Vegas	
The Netherlands	Huis Ten Bosch	Theme Park	Nagasaki, Japan	
Arabia, Middle East	IBN Battuta Mall	Shopping Mall	Dubai, UAE	Also includes China, India, and other themed areas
Arabia, Middle East	Aladdin, The Sahara	Casino	Las Vegas	Closed
Space	Mars 2112	Restaurant	New York	Closed

Figure 3-7 The use of the Levi's brand at the distinctive 25hours Hotel by Levi's (Frankfurt, Germany).

Table 3-3 Brand Theming

Theme (Brand)	Example	Type	Location	Notes
Nike	Niketown	Lifestyle Store	Various	
M&M's	M&M's World	Store	Various	
BMW	BMW World	Multi-Use Branded Space	Munich, Germany	
Heineken	Heineken Experience	Branded Experiential Space	Amsterdam	
Apple	The Apple Store	Lifestyle Store	Various	
American Girl	American Girl Place	Store	Various	
Hershey's	Hershey Park	Theme Park	Hershey, PA	
Hershey's	Hershey's	Store	New York	
Urban Outfitters	Urban Outfitters	Lifestyle Store	Various	Retro, irony, kitsch focus
Anthropologie	Anthropologie	Lifestyle Store	Various	Owned by Urban Outfitters
Coca-Cola	World of Coca-Cola Experience, Coca-Cola Store	Store, Museum	Las Vegas, Atlanta	
LEGO	LEGOLAND	Theme Park	Various	
Levi's	25hours Hotel by Levi's	Hospitality Environment	Frankfurt, Germany	
Starbucks	Starbucks	Café	Various	Celebrates the "third place"
Ferrari	Ferrari World	Theme Park	Abu Dhabi, UAE	
Kellogg's	Kellogg's Cereal City USA	Branded Experiential Space	Battle Creek, MI	Closed
Volkswagen	Autostadt	Museum, Branded Experiential Space	Wolfsburg, Germany	

Table 3-4 Interest & Lifestyle Theming

Theme	Example	Type	Location	Notes
Electronics	Fry's Electronics	Store	Various	The themes of Fry's stores vary with location
Sports	ESPN Zone	Restaurant	Various	
Outdoor/Sports	REI, Cabela's, Bass Pro Shops Outdoor World	Lifestyle Store	Various	
NBA (Basketball)	NBA Store	Lifestyle Store	New York	Closed
NASCAR	NASCAR Sports Grille	Restaurant	Various	
Pro Wrestling	WWE New York, Nitro Grill	Restaurant	New York	Closed
Ninjas	Ninja	Restaurant	New York	
Health	Whole Foods	Lifestyle Store	Various	
Books & Reading	The Library Hotel	Hospitality Environment	New York	
Education/Schools	McMenamins	Hospitality Environment	Portland, OR	
Education/Schools	Class 302	Restaurant	Rowland Heights, CA	Taiwanese school theme
Music	Toby Keith's, Country Star, House of Blues	Restaurant	Various	
Music	Hard Rock	Restaurant, Casino	Various	
Music	Experience Music Project Museum	Museum	Seattle, WA	
Movies	Planet Hollywood, MGM Grand	Casino	Las Vegas	
Movies/Americana	Bubba Gump	Restaurant	Various	
Stock Market	ING Direct Cafe	Cafe	Various	
Religion	Holy Land Experience	Theme Park	Orlando, FL	
Religion	Christon Café	Restaurant	Japan - Various	
Sexuality	Hooters	Restaurant	Various	
Sexuality	To Kouklaki	Restaurant	Greece	

Figure 3-8 The hospital themed restaurant—a common mood and association theme that is found in many Asian cultures.

Table 3-5 Mood & Association Theming

Theme	Example	Type	Location	Notes
Era – The "Cave Days"	Restaurant Pravěk	Restaurant	Prague	
Era – 1920s	Tommy Gun's Garage	Restaurant, Dinner Performance	Chicago	
Era – 1950s	Johnny Rockets	Restaurant	Various	
Medieval Period	Medieval Times	Restaurant, Dinner Performance	Various	
Era – Industrial Revolution	Industrial Revolution Eatery & Grille	Restaurant	Valparaiso, IN	
Hospitals	Heart Attack Grill	Restaurant	Chandler, AZ	
Hospitals	The Clinic	Restaurant	Singapore	
Prisons	Alcatraz E.R.	Restaurant	Tokyo	Closed, combined prison and hospital themes
Prisons	Bollesje	Restaurant	Rüdesheim, Germany	
The Circus	Circus Circus	Casino	Las Vegas	
Pirates	Treasure Island	Casino	Las Vegas	Now TI, pirate theme lessened
Monsters	Frankenstein 1818	Restaurant, Bar	Edinburgh, Scotland	
Monsters/Gothic Associations	Jekyll & Hyde Club	Restaurant	New York	
Vampires	Vampire Café	Restaurant	Tokyo	
Vampires	Count Dracula Club	Restaurant	Romania	
Dinosaurs	Jurassic Restaurant	Restaurant	City of Industry, CA	
Cats	Cat Paradise	Restaurant	Taiwan	Cat themed, diners may play with cats
Darkness	Opaque	Restaurant	Various	
Death	Eternity	Restaurant	Truskavets, Ukraine	
The Unsavory (Defecation, Vomiting, etc.)	Modern Toilet Restaurant	Restaurant	Taiwan	Toilet themed eatery
The Unsavory	Bon Bon Land	Theme Park	Copenhagen	
Adolf Hitler	Hitler's Cross	Restaurant	Mumbai, India	Closed
Rudeness	Ed Debevic's	Restaurant	Chicago	
Guns and Violence	Buns and Guns	Restaurant	Beirut, Lebanon	Closed

Trending—Biography

A form of theming that falls somewhere between the Place & Culture and Interest & Lifestyle forms of theming could be called *biographical theming*. In this approach, a famous person from history, media, or popular culture is given new life in three-dimensional space. The most famous of this example is how Walt Disney took key moments from his life—his upbringing in Marceline, Missouri, his experiences in popular outdoor amusements, his work on attractions at world's fairs, and his experience in animation and filmmaking—and transformed those into iconic attractions and architecture at Disneyland. Much later, Dolly Parton took this approach at her theme park Dollywood, as did singer Bobbejaan Schoepen at Bobbejaanland. Many other celebrities have themed restaurants around their unique life histories. In addition to this trend of famous people and their lives being used as forms of theming, we have seen interpretive environments focus on the idea of everyday people and their contributions to history and culture.

As you review these themes, think about which ones might work best for a given space. It is interesting to note some trends behind many of these themes. For example, in Place & Culture theming the places chosen for the themes are those that have associations like luxury, romance, sophistication, culture, and exotic. Theme parks and casinos tend to be the popular choices. In Brand theming we find that very established brands have opened up lifestyle stores or product centers, some of which feature demonstrations and hands-on activities. In Interest & Lifestyle theming we note that that a trend is to choose themes that are reflected in society at a general level. For example, music and sports are very important foundations of many cultures. Lastly, in Mood & Association theming we discover the most risky and outlandish of all themes. Almost exclusively all of the venues in this category are restaurants. This suggests that restaurants may be the place to try an edgy or unconventional theme. In all four of these main cases, one of the key reasons for a designer choosing a theme versus another one is the associations that are created with that theme.

Associations of Themes

One of the reasons that designers employ forms of theming is that using a recognizable theme may trigger an association in the guest. Just as we discussed with the concept of mood earlier, in this case we can see that a certain theme is useful because it creates an association with the guest. As the guest moves through the space, purchases services and products, and interacts with others in it, he or she is impacted by the overall theme that is portrayed. The associations that guests have when they are in a designed space are key. We can compare it to the mental state that takes place when someone reads an engaging novel. The reader begins to fill in details that have been left out by the author because of the vivid associations that have been made.

In Chart 3-2, we can take a look at one example of how associations are created with a specific theme. I have chosen Western (the Wild West), but any theme could be picked. What I've done is suggest the overall associations that we might have with the theme at the top of the chart. These ideas, ideals, and attitudes are

what we think of because of movies, video games, trips, novels, attitudes about history, visits to museums and theme parks, and just about any other way that we have grown to know this theme of the Wild West. Both the guest and the designer "filter" these associations. The guest and the designer have a similar toolkit in terms of both having attitudes about the theme, but the designer uses additional skills—mental models, knowledge about design, understandings of marketing and trends, and budget and design models—to bring the theme to a three-dimensional level. The guest then interacts with this Wild West Design Project. In the end, there are repetitions that occur as the designer thinks about the design, assesses guest satisfaction with it, and then revises the design project.

It is important to think about all of the ways that a theme can be interpreted. Chart 3-2 gives us one example of a theme and some of the associations. Of course, the picture is even more complex than what is painted here. You can use this simple model in future design projects. It might help you think about the key associations that you wish to convey in your space. Chart 3-3 includes additional associations for other themes within the Place & Culture type.

Chart 3-2 How and Association Is Created

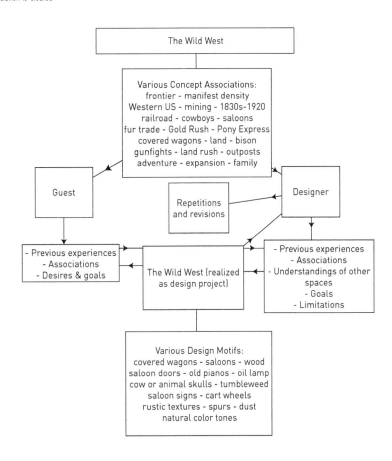

Chart 3-3 Common Theme Associations

Tropical (Island)
Concept Associations: island, tropics, paradise, relaxation
Design Associations: palm trees, lushness, beaches, wood

Western, Wild West
Concept Associations: cowboys, gunfights, adventure
Design Associations: saloons, rustic textures, tumbleweed

Italian
Concept Associations: Renaissance, comfort, sophistication
Design Associations: canals, lakes, gondolas

Parisian
Concept Associations: romance, culture, sophistication
Design Associations: elegant features, art objects, cloth

English
Concept Associations: history, knights, royalty
Design Associations: brick, chimneys, quaint hamlets

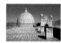

Egyptian
Concept Associations: science, tradition, monumental design and architecture
Design Associations: pyramids, hieroglyphs, lush cotton

Middle Eastern
Concept Associations: markets, windcatchers, domes
Design Associations: minarets, earth tones, geometric patterns

New Orleans
Concept Associations: history, Mardi Gras, jazz
Design Associations: eclectic architectural styles, varied colors, balconies

Irish
Concept Associations: countryside, tranquility, magic
Design Associations: whitewashed décor, stone, lush grass

Americana
Concept Associations: adventure, patriotism, tradition
Design Associations: main street, patriotic symbols, color (red, white, and blue)

Asian
Concept Associations: tranquility, balance, refinement
Design Associations: gardens, pagodas, lush spaces

Mexican
Concept Associations: confluence of cultures, artistic, family and tradition
Design Associations: colors, antique doors, wood beams

Theming and Stereotypes

One of the most interesting aspects of theming has been the varied, and sometimes critical, reaction to it. Social critics have expressed deep concerns about theming, especially as they see it as a form of stereotyping, an inauthentic representation of places and people, and a type of symbolism that seems superficial. We will address many of the concerns about authenticity in the next chapter, but in terms of the other issues as to whether the designs found in themed spaces are stereotypes and superficial versions, we should remember that theming is, like any other form of symbol in the world, both a simplification and a representation of places, people, and things. Looking at an Italian-themed casino and attempting to equate it with a real place in Italy would be a mistake. Theming could be called a "stereotype" of place, culture, and people, but more accurately we might say that theming is a conscious, thoughtful, and effect-producing representation. As they go about designing the theme of a particular venue, designers need to focus on ways to create effective ambiance and character through theming.

Certain popular publications—ranging from newspapers to magazines—give everyday people tips on how to theme their own homes. In fact, interior design and décor is a field that reflects the growing popularity of theming. Often, in such publications, homeowners are told to focus *only* on using the most stereotyped versions of a theme. To make an Egyptian bathroom, for example, the homeowner is told to install silk and Egyptian cotton, paintings of hieroglyphs, and statues of guardian cats and King Tut. Because most homeowners are not professional designers and do not have access to prop shops, technology, and other professional tools, these choices could actually make sense for the context. In the world of themed and immersive design, theming must go beyond the surface stereotypes and instead focus on a use of key symbols, materials, and other forms of material culture that will create a balance between the familiarity of the theme that will strike instant chords with the guest and the unique elements that will cause the guest to linger in the space and reflect upon the thematic design. In Chapters 6 and 8, we will consider other aspects of theming and symbols that may shed additional light on this important and complicated topic.

Aspects of Theming

As we close our discussion of theming, we can focus on a few additional elements that can directly benefit the themed space. These are elements that are commonly used, especially in theme parks, themed restaurants, lifestyle stores, and some shopping malls.

Multiple Themes: Many themed spaces, especially theme parks, have more than one theme within their space. Theme parks have popularized a model in which a guest moves from one themeland (like Wild West) into a second one (like the Future or Space). In this way the guest is given a variety of places that can be visited. This is an effective approach and one that will continue in the theme park industry for years to come. One thing to consider recalls our discussion of *mood crosstalk*— what happens when one theme comes in contact with another? It could be an uncanny contrast in which one theme contradicts the other, or it could be an interesting dialogue much like the coming together of two worlds in the graphic novel and film *Cowboys & Aliens*. Whatever the case, attention needs to be given to transition spaces between the two different themes. Also, the designer should consider whether the individual themes within a space effectively convey any overarching themes (such as adventure) that may be part of the space.

Themelands: Themelands are commonly found in theme parks. They are an innovative form of general design that began with theme parks like Disneyland, Knotts Berry Farm, and Six Flags Over Texas. A themeland is a space that consists of many buildings, attractions, and other features that conveys one primary theme. Theme parks have many themelands and use them to give guests the sense that they can see the world within one theme park. Themelands can be effective spaces where specific products can be marketed.

Microtheming: Microtheming is a form of theming in which attention to very small detail is given. Visiting the New York–New York casino you might find smoking manhole covers in their city themed area or visiting the Venetian casino you will notice incredibly fine-detailed patinas on walls. These sorts of features show us that microtheming can be used to let the guest know that she is in a place that looks quite authentic. Attention to the details, as Mies van der Rohe reminded us, results in a space that looks more believable than not. We'll consider a bit more about microtheming in Chapter 4.

To Theme or Not to Theme

Thomas Cole's wonderfully provocative "The Architect's Dream" gives us a glimpse of the possibilities that are opened up with every design project. Do you choose a classical look? Something Egyptian? Which one of these? Theming has been a popular approach to design spaces because of its potential. That being said, some corporations have been reluctant to use theming on their properties.

Figure 3-9 Thomas Cole (American, born England, 1801–1848), The Architect's Dream, 1840, oil on canvas, 53 × 84 1/16 in., Toledo Museum of Art (Toledo, Ohio), Purchased with funds from the Florence Scott Libbey Bequest in Memory of her Father, Maurice A. Scott, 1949.162.

The Las Vegas Theme Debate

What could be more exciting than a theme? Paris, Italy, Pirates, Egypt, Tropical Paradise....and all of the other variations have made the Las Vegas Strip an icon on the planet. Beginning in the 2000s, some casinos began a process of **retheming** and/or **detheming**. This is the process by which, in the first case, a casino gets a theme different from its last version (the Aladdin to the Planet Hollywood) or, in the second, the process by which a casino removes its theme and becomes relatively unthemed (Luxor). This trend has also begun to impact the building of new casinos—many of which now are unthemed. On Las Vegas online discussion boards, fans of themed casinos have cried afoul of this trend—"Bring back the Vegas we love," some of them shout. I discussed this tendency once with a number of

marketing representatives from one of the major Strip casinos. They felt that re- and detheming was necessary. It was a sign of the times. Some of the old themed casinos looked old, appeared to be childish, or lacked sophistication, so the solution was to go a new direction. All of this made sense to me when we were having this conversation, but all the time I wondered: How will the story change? In these new versions, will there be no story at all?

We can see in the Las Vegas Theme Debate that theming is a debated subject of design. Theming can be an effective way to tell a vivid story within a space. At the same time, it may be hard for the operational people behind the space to keep that theme fresh as the times change. What if, for example, you go with a pirate theme and then, because of real events in the world in which the associations with pirates change (think Somali pirates not Captain Jack Sparrow here), that theme suddenly seems less appropriate. You might decide to change that theme, but that will cost money. Whatever you decide, think about the values of theming and consider whether it will work for your space.

Application—Theming

Now that you have read these ideas about the values of theming, take a moment to reflect on this important approach. Write a short reflection in which you consider your views of theming. Consider:

1. How have you used theming in design projects?

2. What are the benefits and disadvantages of theming?

3. In terms of telling a story, how effective is theming? Can you think of design approaches that don't use theming that still tell a convincing design story?

4. Knowing what you know about theming now, how will you use theming in future design projects?

5. Do you think that we will see more or less theming in design projects? Why?

Elements of Design

Theming is only one of many possible approaches to effective spatial design. Let's consider some of the elements that can be applied to any space—regardless of whether it is themed or not. First, we need to focus on how the overall design of a space is created. The Hierarchy of Needs is one way of looking at this important area of design.

Hierarchy of Design Needs

In 1943 psychologist Abraham Maslow released an influential paper that detailed the human "Hierarchy of Needs." The hierarchy describes the most basic human needs (at the bottom of the pyramid in Chart 3-4), as well as the most complex ones at the top. In his mind, the basic (bottom) needs had to be met before the top ones could. Designers have also looked at the Hierarchy of Needs in terms of design projects. One version is given here with Chart 3-5.[1] In their version, designers can benefit by first looking at how function must be met, followed by an analysis of the reliability and usability of the design, then the proficiency of it and, finally, the creativity of it and how people use it in innovative ways. I have provided one additional version of the hierarchy that is adapted to the world of themed and consumer spatial design (Chart 3-6).

[1] William Lidwell, Kritina Holden, and Jill Butler, *Universal Principles of Design* (Beverly, MA: Rockport, 2010), pp. 106-07.

What a Place Can Be, it Must Be.

Chart 3-4 The HIerarchy of Needs

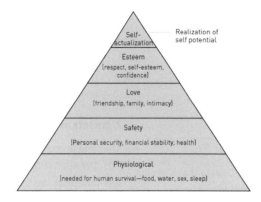

Realization of self potential

- Self-actualization
- Esteem (respect, self-esteem, confidence)
- Love (friendship, family, intimacy)
- Safety (Personal security, financial stability, health)
- Physiological (needed for human survival—food, water, sex, sleep)

Chart 3-5 The Hierarchy of Needs (Adapted for Design)

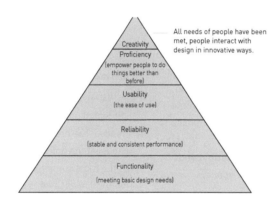

All needs of people have been met, people interact with design in innovative ways.

- Creativity
- Proficiency (empower people to do things better than before)
- Usability (the ease of use)
- Reliability (stable and consistent performance)
- Functionality (meeting basic design needs)

Chart 3-6 The Hierarchy of Needs (Adapted for Themed and Consumer Space Design).

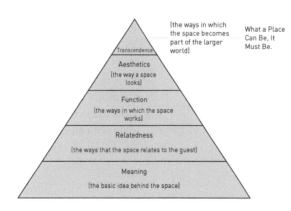

(the ways in which the space becomes part of the larger world)

What a Place Can Be, It Must Be.

- Transcendence
- Aesthetics (the way a space looks)
- Function (the ways in which the space works)
- Relatedness (the ways that the space relates to the guest)
- Meaning (the basic idea behind the space)

What you will notice in my version is that meaning is the bottom or most basic level of needs. This may seem counterintuitive since elements like function, cost, or practicality would seem to take precedence. Meaning is at the bottom since I believe that the idea behind the space is where all good spatial design projects must begin. You could have an incredibly functional space that has decent interior design, wonderful lighting, appropriate technology, and forms of guest interaction but it could have either no meaning behind it (making it a stale space) or it could have a lousy meaning behind it (making it unappealing to guests). So, I argue that you must *begin with meaning and move up*. Similarly, I place relatedness next on the pyramid because so much of what is successful in design spaces is based on how well the guest can relate to it. Third on the hierarchy is function. Function is obviously of key importance to a space, but function only works if sound meaning and relatedness is behind it. Then we move to the fourth level or aesthetics. Finally, there is transcendence. This draws on Maslow's fifth level of self-actualization in Chart 3-4. Maslow described this stage with the phrase, "What a man can be, he must be," and if we apply this to a space we might come up with, "What a place can be, it must be." When your space reaches the stage of transcendence it means that it has been fully integrated into the culture. People adore it, they accept it without thinking, and they make it a part of their most intimate and personal traditions (see Chart 8-1 in Chapter 8).

A note about the charts. Some psychologists have argued that the needs described by Maslow aren't necessarily fulfilled on a hierarchy. They are all significant and all have to be met. This could also be said of the two design charts. In some cases aesthetics might be more important than function. Clearly, all are significant aspects of a design space and as long as you think about all of them, the guest will be happier for it.

Color

Color is the most relative medium in art

—Josef Albers

Figure 3-10

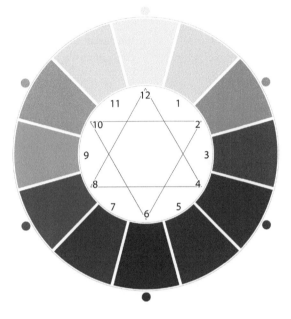

First, the bad news—*there are no universals in terms of the meaning of color*. We might like to think that white is a constant symbol of innocence in purity, but in some cultures it is associated with death and mourning. What this means is that a color choice can never come down to a universal like "white = purity." Instead, we need to think about the use of color in its *context*. When you design for a space, if you think of the context of its use, who will use it, and the type of story that you are trying to tell, then you will have a more effective use of color.

Color is valuable in terms of:

1. *Conveying a Distinctive Mood*: People might associate one color with a certain attitude or idea like winning, excitement, or solitude. We might call this the emotional use of color.

2. *Creating a Physical or Psychological Effect*: Certain colors can be used to make people sleepy, make them come alive, or put them at ease.

3. *Associating Space with a Brand*: Think of your favorite rental car company. What it has in common with every other rental car company is a distinctive color that we associate *only* with that one brand.

4. *Creating Visual Excitement*: Color can be used to move the eye from one space to another. It can create a feeling of distinctiveness as you enter a space. It can give us a sense that things are happening even when they are not.

5. *Achieving Balance and Variation*: Color schemes, if employed effectively, can create a sense of balance in a space. Color variations can be used to offer guests a similar sense of spatial variation in a venue.

6. *Adapting Reality*: Especially in a themed space, the use of color can highlight an effect of borrowing from reality. If you are creating a space that imagines a historic world of 18th century England, you would want to use color schemes that mimic those of the time. This way, the guest is led to feel that they are in the place and time in which you intend them to be.

As you use color in a design space, in addition to keeping in mind the context of the project, you might also think about how colors work together. Looking at Figure 3-10, we might focus on the need to sometimes use *analogous colors*. These are the ones next to each other on the color wheel (like 2 and 3 or 6 and 7). There are also *complementary colors* (those that are opposite one another on the color wheel, like 2 and 8), *triadic colors* (those at the tips of the triangles, equally spaced from one another, such as 2, 6, 10), *quadratic colors* (those that appear if we drew a rectangle on the color wheel, such as 2, 4, 7, 10), and *neutral colors* (or any

that do not appear on the color wheel—beige, black, gray, white). In addition to how the colors relate to one another, we can think of the properties of color, such as hues (warm and cool), saturation (the amount of gray), intensity (the brightness or dullness), temperature (red makes a space feel warm, blue cool), and other elements. We can increase or decrease the hue of a color to achieve an effect (like making a space seem more serious) or we can increase or decrease the saturation of a color to achieve another effect (like making a space seem inviting and exciting). The good news about the use of color is that color can add much drama, excitement, and emotion to a space. No matter your use of color, keep in mind the value of approaching the design space in an authentic, exhilarating, and compelling way.

Figure 3-11

Figure 3-12

Figure 3-13

In Figure 3-11, we see that the world gives us a rich array of colors to use. In Figure 3-12, color has been used to convey a mood at the Russisch Brot room at the Goldman 25hours Hotel (Frankfurt, Germany). In Figure 3-13, color is used to create an overall dramatic effect at the Therapy Room at Propeller Island City Lodge (Berlin, Germany). Hotel guests may use supplied lights to change the room to one of six possible colors.

Doctrine of Signatures

How much can we emphasize the value of what nature gives us? Not enough! Many cultures use plants in medicinal and ritualistic ways. Anthropologists have taught us that the use of such plants follow what's called the Doctrine of Signatures. It means that people believe that the color of a plant corresponds to the use of the plant. For example, if we find a plant that oozes a reddish-colored substance then the substance, because it is red, can be used to treat problems with the circulatory system (red blood corresponds to the red substance from the plant). The Doctrine of Signatures teaches us that people have always found the colors of nature to be stimulating, if not life saving. Designers can look at the inspirations of nature for ideas for their own projects. Go out to your favorite canyon, forest, or lake and grab a sketchbook and some colored pencils. What inspires you? Sketch that. What colors work together in nature? Sketch that. How could you use some similar color combinations in a design project? Begin to sketch that. The sky's the limit!

Shape

Like color, shape can lend so much to a space. In Old English, shape came from the word *gesceap*, meaning "creation, form, destiny." It's interesting to think about the destiny part of this meaning. Think of your favorite product—perhaps it's your laptop computer, your cell phone, or your vegetable peeler—and focus a bit on what it is about the object that excites you. Maybe it's the color, or the way that it works so effortlessly, or maybe it has something to do with the shape. That laptop that

is sleek or the contours of the vegetable peeler—both speak to a sense of destiny that results in us loving them as we do.

Chart 3-7

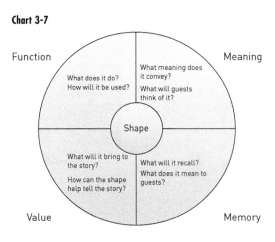

We can look at shape in four important ways. These are summarized in Chart 3-7. Function gets us thinking about how the shape will be used in space. If you have a wall you might think about how it will be used—to direct guests to a new place, to help control them in a queue area, etc. The meaning of the shape is a key aspect. If a person encounters a circular sculpture feature in the middle of your design space, it will tell a different story than an angular sculpture. The meaning also relates to how guests will understand the shape within the context of a space or world. Memory is an important feature of shape. We can think back to the distinctive shape of a soda bottle when we were kids and then we can recreate that shape, or a variation of it, in a 1950s-themed diner, thus making an immediate connection with the guest—all because of memory. Lastly, we have the value of the shape. What can the shape bring to the story? Will a series of circular and maze-like wall features add to the story you are telling?

Figure 3-14

Figure 3-15 Like color, nature provides us with a variety of rich textures that can be used in any design project.

Gary Hustwit's intriguing documentary *Objectified* (2009) offers a look at how design works at the level of objects. Why do certain objects speak to us? What is it about them that captivates us so much that we hold on to them (and their new versions) for life? One of the important things that we can learn from this film is that shape—whether an object like a computer or a feature like a wall—can have an important and lasting effect on the guest. The best brands use shape in innovative ways as part of their product design and their corporate marketing. The same sort of innovation should be applied to the use of shape in design spaces.

Texture

Texture is the feel and appearance of a surface. When we see a distinctive texture or we touch it, there is an immediate effect. The surface of a historic brick wall in York, England resonates with us because something in that surface tells the story of the ages. It's all there, bottled up in the textures of bricks. What texture can do for a space is immeasurable.

You can use it to:

1. *Make an Immediate Impact*: There is so much that goes into texture that it can be used to fulfill the **Pareto principle** or the idea, adapted from economics, that 20% of the design of a space can be used to make 80% of the impact on guests. Texture is thus very economical.

2. *Help Tell the Story*: When combined with color and shape, texture can give guests a more precise sense of the ideas that you are trying to convey. Walking through a space made up to be like a dungeon, one wouldn't be telling a good story if the designer used smooth spaces that lacked crevices, impressions, patinas, or imperfections.

3. *Help Define a Space*: Both visual and tactile texture can be used to make a space stand out. When a guest encounters forms of texture, he will be better able to understand what you are trying to create in terms of the story of the space.

4. *Create Mood and Emotions*: Shape and color help us to create mood, and so too does texture. Walking into a bar with an elegant wood finish tells you something immediate about the place. This use of texture might relax you and make you more inclined to linger there and enjoy a cocktail.

5. *Recreate Place and Attach Memory*: We might recall the texture of a rock when we were kids, or perhaps the patina on a castle that we visited on our honeymoon....whatever the texture, there is a memory that goes along with it. Places can be created on the memories that certain textures can provide.

Texture has had an overwhelming impact on the ways that we see the world. Today, even Web designers use texture to create a sense of space in the two-dimensional world of the Internet. In thinking about inventive ways to use texture, keep in mind, as is the case with color and shape, that good texture should add to a space, not detract from it or unnecessarily distract guests. It has to be used in organic senses.

Size, Mass, Scale, and Proportion

Another important set of elements that we should address is size, mass, scale, and proportion. Size refers to the physical extent or magnitude of an object, mass to the unified body of matter or the sum of parts that make up an object or space. Both size and mass have a valuable role to play in a design space. They can be used to create contrast or to emphasize certain features of a space. They can also be effective in conveying a sense of awe or majesty—such as in the use of an extremely large castle that could give guests a sense of place. In some cases, you could use size and mass to highlight one aspect of the story or the theme that you may wish to have a greater emphasis in the space.

Figure 3-16

Scale relates to the size relationships between objects and proportion to the ratio that defines the size relationships. A giant-sized chair could be used to convey a sense of the magical or the fantastic in a space, while proportion could be used to create visual illusion, such as the forced perspectives of buildings that appear to be larger than they actually are.

Lines

Lines begin and end. They take us somewhere, they point our eyes in a direction, they help tell a story by orienting us in space. We might begin to think about lines by looking at lines of music. Music creates a space in a sense different than we often think about when we are designing three-dimensional space that incorporates lines. In music, we can combine one line with another in order to create forms of rhythm, counterpoint, and harmony. In three-dimensional space, a line can have a similar function. Whether a line on the side of a wall, a line of sight that directs people along a pathway, or a form of lined art in a space, the effect of using lines is transformative. Review the following four figures.

Figure 3-17

Figure 3-18

Figure 3-19

Figure 3-20

In Figure 3-17 we see lines being used to create a dramatic and powerful architectural effect. The lines move up into the sky and lend the structure a sense of power. Figure 3-18 shows us a different use of lines. Here, the curving lines move up towards the top of the gherkin, giving a much more feminine yet transcendent sense of movement. Figure 3-19 offers a similar use of lines, with curves again creating a more serene feeling. Figure 3-20 uses lines to establish a sense of rhythm, as well as provide for a pathway. However used in a space,

lines can have an effect that ranges from the dramatic to the understated.

Provocation—Concept Space

We have discussed some of the major elements of design—color, shape, texture, size, mass, scale and proportion, and lines. Take a moment to think about this provocation. You have been assigned the task of designing a new themed restaurant. The concept is called "Art Space" and it is a restaurant/café that is themed according to the great works of 20th century avant-garde art—surrealism, Dada, and performance and conceptual art. Your overall design must convey this theme through the various elements of design and should also extend into the operations of the café, including the menu. Your task is to use the major elements of design and come up with a visual layout that will be fitting for this space. Work for a few moments and sketch a quick plan that helps illustrate your approach to this project. After you have finished, compare your design with the design of a partner. What are some of the differences in your designs?

Principles of Form

In addition to these many useful elements of design, we can consider some specific principles that have been useful in many design fields. We can apply these in many senses, including to the overall design of a large space (a theme park) or the approach to a smaller space (a café). In using these principles, keep in mind that the overall context of the space should dictate how these principles are applied. There are no hard and fast rules to spatial design, other than the principles that get used should relate back to the overall atmosphere, mood, and story of the space. They are listed in no particular order of importance. Think of them in terms of the sum value of their combined use in a space.

Form versus Function

We sometimes get caught up in debates about whether form or function should take the important role in a space, whether one should follow the other, and other variations. Form and function should sometimes be looked at independently. This is especially important if one is designing a theme park ride concept that relies on the availability of a technology system, but in the end, both elements have to be considered as an integrated part of a venue. There are some interesting examples of situations in which function seems to drag down a space and make it dull. In restrooms we sometimes start with the assumption that restrooms should only fulfill function—people use them to go about their business. But, look at how a little bit of design or form can go a long way. At the Goldman 25hours Hotel in Frankfurt, Germany, functional urinals have been designed to fit in with the hotel's hip and sometimes rock-and-roll theme.

Figure 3-21 The public restroom at the innovative Goldman 25hours Hotel (Frankfurt, Germany), thus proving that a functional space does not have to be functional or, even, boring.

Unity

The whole, the idea of oneness is what we mean when we think of the unity of our design space. The individual parts no longer matter on their own. As in the case of holism of an immersive world, the principle of unity means that guests will understand the totality of what you have created, not the parts. Unity can be achieved on a visual level. Consider the image of the building on this page (Figure 3-22). You could, at any moment, focus on one of the windows, the color of the building, its mass and shape, but as you look at it for the first time, you look at the whole thing. It is unified because similar principles of design have been applied to all of the elements within the space. Unity can be achieved through forms of repetition (discussed later), proximity (the sense that our eye gets when some objects seem more connected to others because they are closer to some objects than others), continuation (the use of one element across or throughout a space), and closure (or the ability of the human brain to fill in gaps that have been left out).

Consistency

The second aspect of unity (the first was visual unity) is conceptual unity. This can be closely related to the idea of consistency within a space. We can think about consistency by relating the example of the tablet device. After the iPad came out, other designers produced versions of tablet devices for other companies. What was interesting was that some of the features—visual layout, functionality, user controls—were maintained in these different, non-Apple versions. This suggests that users and potential buyers of new tablets became familiar with the design of the earlier models—the iPads. The same concept can be thought of in design spaces. For guests to truly appreciate the space, they will likely need to be able to experience the space in a consistent way. As we'll see later, sometimes inconsistency results from operational problems within the space, but even more profound are the problems of design that result from inconsistency. The conceptual unity of a space depends on the ability to combine consistent design with forms of storytelling that are complete, varied but unified.

Figure 3-22

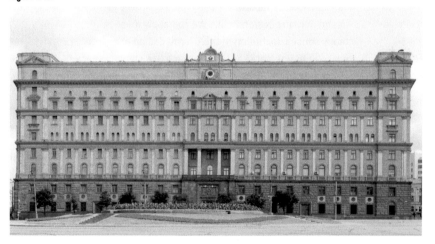

Harmony and Balance

Harmony and balance are core principles from the world of art and design. Harmony combines previously mentioned elements like color, shape, and texture. Similar colors go with similar colors, like shapes with like shapes, and related textures with related textures. In this way the space benefits from the manner that humans look at spaces and how they process them in their minds. Our brains often want to find unity or harmony in a space, such as the example of people seeing faces, animals, or other images in random cloud formations (known as pareidolia).

Figure 3-23

Figure 3-24

Consider the bridges pictured on this page (Figure 3-23). From a design standpoint, the two are nearly identical

and, equally important, their placement in space allows the eye to detect harmony in their overall visual look. Balance refers to how elements are distributed in a space. A big component to understanding balance is thinking again about human perception and how our eyes and brains make sense of a space. When we enter any space, we might think about what our eyes are drawn to, how the layout of objects within the space impacts our understanding of it, and how we make sense of the space given the balance applied to it. If you look at the interior image on this page (Figure 3-24), you will note that the achievement of balance in the space is due to the use of symmetry or the presence of corresponding elements on both sides of a point, line, or plane. The symmetry achieved by the design of the columns and the windows creates a soothing effect in us as we view and enter the space. Balance can also be achieved through asymmetry, including the weighting of one or more elements on one side of a point, line, or plane heavier than those on the opposite side. When used effectively, harmony and balance can create any range of emotional states and can be used to tell more complete forms of design storytelling.

Contrast and Tension

Contrast and tension operate in ways opposite to principles addressed in harmony and balance. Instead of using like things (colors, shapes, and textures) with other like things, we use one thing with a contrasting

Figure 3-25

element. In the case of the sofa pictured (Figure 3-25), there is unity or consistency of form in terms of the shape and continuity of the object, but there is contrast created by the uses of two colors, especially since the mind would not be accustomed to a dual-colored couch. The image below (Figure 3-26) uses contrasting angles, textures, and construction materials to create a visual space that immediately captures the eye of the onlooker. This more **postmodern** approach utilizes the contrast of multiple styles and is reminiscent of some of the dramatic architectural contrasts that were common in Coney Island amusement parks of the past. Contrast is a great technique to use because it can make a very big impact on the guest.

Figure 3-26

Emphasis, Dominance, and Focal Point

Figure 3-27

Along with balance, spaces benefit from the use of emphasis or dominance. Both terms refer to the focus given to elements within a space. Often, one or more elements are emphasized through combinations of perspective, color, texture, or placement within the space. In the example of the duck boats on this page (Figure 3-27), the blue duck functions through a position of dominance due to color. The eye is drawn to the blue duck as it becomes the focal point of the space. Not having forms of emphasis in a space may result in a boring space, so it's good to mix things up and work with dominant and subordinate elements. An interesting way to achieve dominance in some spatial designs is to use a main feature that can be seen from most areas of the venue. In a theme park, a "weenie," such as a mountain, a tower ride, or other visually dominant forms can appeal to guests (this idea is derived from its common use in Disney theme parks). It can also be a practical

way to orient guests to movement within that space. We'll talk more about this in Chapter 6 when we discuss symbols and memes.

Repetition, Variety, and Rhythm

Repetition involves using an element more than one time. Often, the element (color, texture) or object is very similar to the next one, thus creating a situation in which patterns of repetition develop. Repetition can occur along a plane, across a line, outward from a central point, in regular or irregular manners. One of the benefits of repetition is that it gives unity and consistency to your space. It can also allow you to emphasize certain visual or material points as well as connect those to elements of the story that you are telling in a space. Just like a call and response vocal song in which the same response is sung over and over again, in this aspect of design, a feature is used over and over again. Though elements often repeat in design, care must be given to maintaining variety within a space. The idea of theme and variation is one way of combining repetition with variety. Finally, we can think about how repetition and variety help carry a form of rhythm in space. Rhythm occurs when people look at a space and its features, take it in, and have an overall impression. Just like in music, people can begin to feel a "jam" or sense of movement to a space. This happens as they take everything about the space in and as it begins to act on their eyes and minds.

Figure 3-28

Energy

Energy in design is the idea that something is built up into a space such that it has the power to impact people as they move through the space. It could be something about the color of the walls, some form of technology that is there, or some structural feature that conveys a sense that something is happening in the place. Particularly in nightclubs and modern bars, there is emphasis placed on creating energy through design. The idea is that the energy of the place will transfer to the guests who are using the space. Design becomes contagious as it is used to assure that people will get into the mood that is most desirable for the space.

Figure 3-29

Edit

We discussed the importance of editing in Chapter 2. There, a point was made about how as in the case of film, a space can benefit from the use of editing. In space, an edit is the "cutting" and "splicing" that you do to create a design story that will be the most exciting and immersive to the guest. It may begin with the "stock footage," such as the types of attractions, spaces, performances, technology, or other design elements that you would like to use in conjunction with the story (recall our model, Table 1-1). Using this stock footage, the designer takes the best possible elements of these and then arranges them in a way that, like a film, will result in a compelling drama from beginning to end. So, if you are working on a cruise ship design, you would consider what happens when the guest first enters the ship, when he or she goes to the buffet, to the pool, to a show, and you would focus on whether these various edits will make for a compelling drama in the space. An edit can act as a natural transition between one space and the next and when combined in the entirety of the space that the guest visits, the effects can be dramatic.

Figure 3-30

Distinctiveness

All of these previous effects may be combined to create a distinctive space. This is a space that stands out, among all others. We sometimes talk about the Von Restorff Effect or Isolation Effect which says, quite simply and profoundly, that the thing that stands out will be remembered above all other things. What this means for a design space is that the designer must employ forms, techniques, perspectives, and modes of design storytelling that convey a sense of space that guests will be able to spot from anywhere. They'll be more likely to remember it, and visit it more often, if it's a cut above the rest.

Trending—Relevance

One of the more interesting trends that has impacted design is that of relevance. In a sense, we could say that all forms of design should be relevant, since function, use, and aesthetics all make an object or space relevant to the user, but it's much more than this. Relevance means that the design executed in the space is meaningful not because it seems so to the designers or operators of a space but because the guest who visits the space finds it to be so. We have all been to places where we thought in our heads, "I don't really care," but imagine a place that you have visited where you did care. An effective space says, "You should care about me because_____." The designer, depending

on the project, fills in this blank, but it could be: "I can show you how to improve your life," "I can teach you about a growing ecological disaster," "I can show you a new side of yourself," and thousands of other variations. The relevance of a space is directly related to the "big idea" that we considered in Chapter 1. The point is that a design space has to be relevant for reasons well beyond "Because it's here." The contemporary guest is too educated, and sometimes too cynical, to accept anything less than this.

Effective Spaces

Effective spaces combine a number of the elements that we have discussed. First, they create compelling atmosphere and appropriate moods for the guest to experience. Second, they often use a theme or another form of design story that can excite and involve guests in the space. Next, they apply principles of forms, and elements of design that will make the space ever more enriching. Finally, they combine effective operational systems, including performers and actors, to help make the space come alive.

In order to execute an effective space, we will need to think about all elements of the space, including those beyond the level of physical design. In your own projects, you may be required to think about these nonmaterial aspects of design more, or less, and depending on your work, you may

be required to check in and assess how these are going during the lifespan of your space. Let's consider a few of these and focus on how we can use them to better a space. We will be returning to many of these in future chapters, but it's important to get a head start on them now.

Operations

Operations form a core of any designed space. In a sense, you can think of operations as what happens when the design space has been completed and the world is filled with the people who will act out roles, sell products to guests, operate rides or attractions, and fulfill any number of thousands of guest needs. Operations include the people who fill these positions and the systems that have been designed to run the venue. Systems include human resources, training, accounting, management, planning, guest relations, marketing, technology and engineering, sanitation, and numerous others. In future chapters, we will consider additional ways that operations and systems can be used to benefit your design project.

Performing and Interpreting Spaces
Interview, Mark Wallis
Managing and Artistic Director, Past Pleasures Ltd

Mark Wallis has been involved in professional costumed interpretation since 1977 when he received his first paid commission for coproducing a historical event celebrating the oldest bridge over the River Thames—he can thus claim to be among the first to have used costumed interpretation professionally in the United Kingdom. He was instrumental in setting up Britain's first living history event at Kentwell Hall while still a student, where he experienced the different, complementary disciplines of reenactor, actor, and interpreter. Mark holds a BA in costume design and an MA in theatre history—the latter gained

in America where he lived and worked for nine years, bringing history to life on a massive scale with the Living History Centre's Elizabethan and Dickensian festivals, and—on a more purist level—with the Colonial Williamsburg Foundation (for which he remains a consultant). While at Williamsburg he founded Past Pleasures Ltd, and on moving back to Britain in 1987 set about employing costumed interpreters in historic sites. Amongst his—and Past Pleasures Ltd's—relevant accomplishments, Mark was responsible for setting up the daily award-winning live interpretation at Llancaiach Fawr Manor (Wales) and that at the Palace Stables Heritage Centre (Ireland).

Could you discuss how you became interested in performance and historical reconstruction?

While I was in California, I worked at a Renaissance fair and saw how things could be done on a large scale for visitors. There wasn't such a fair like it in England at the time and the only ways that one could experience the time period was on stage and through film. I became familiar with the many other dreadful medieval banquets and jousting tournaments that had very little to do with what they purported to be recreating. With the Renaissance fair in California, I saw that you could bring history to life, make it educational and, all the while, make it fun.

One of your main mottos is taken from Gilbert & Sullivan: "To Trick into Learning with a Laugh." Can you explain what this means and how it can be related to people who perform—whether in historical reenactments or in theme parks?

I use this not in the sense of a belly laugh but in the idea of a light in the eye—a sense that the guest will be absorbed with the performance of the interpreter. As opposed to getting something from a boring lecture, the visitor will be calmed and won over by the performance.

Then they can get the facts and learn something from the experience. A light in the eye is the inspiration that the visitor gets from the performance.

When you talk of inspiration, what do you mean in terms of the guest's experience with the performance? Will they take something from it?

Hopefully they will go back home having learned more from the performance. They might then desire to read up on the people, events, and periods they learned about in the performance.

Can you comment on what designers should know in terms of the power of human performance to transform the experiences of their guests?

Yes, this is a complicated matter. When we look at a building, we can resonate with the power of that building's authenticity and the authenticity of all of the objects in that space. We can look at buildings and the objects within them as sets that need access—people—to make them come alive. Some critics of historical performance would rather just interact, by themselves, with the place. They would rather go around with a guidebook and their imagination to understand it. But most people would like to learn something in a space by seeing it come alive and this is why animating these "stages" can be so rewarding. You look at what Disney did with their theme parks. They created all of these features that gave each place a sense of atmosphere. These made the public want to come in and get a sense of what they are all about. There was something inviting about these places—a sense of mystery. I worked on a project at Dover Castle. In a controversial move, a stage designer was hired to help with the renovation of the interior space. Stage light was used to help bring life to the room—including the king's throne. Obviously, in the 12th century this wouldn't have been the light used, but today it has a necessary effect on the visitor. You can use design in dramatic and theatrical ways and still

be historically accurate. We've heard members of the public comment that the space looked so much different from the modern world that they live in and that it looks nothing like a Hollywood set.

One thing that I would say about working with designers is that when they ask me what should be in a space, I often advise them on not putting so much in the space that it distracts from the job of the interpreter (performer). Sometimes designers do not think about how the space—including technology, lights, video screens, etc.—can make concentration of the interpreter more difficult. So there needs to be a balance between the design and the performance.

You have written about the values that recruitment, training, assessment, and costuming play in any form of live historical interpretation. Can you speak about why these are so important, especially as they relate to the ability of a place to effectively and convincingly use live performance to connect with the experiences of guests?

These four are totally key to the success or the failure of the performance. In terms of recruitment, you need to know that working in historical costume is physically tiring and mentally exhausting. Since we don't use scripts, we have to improvise and correctly play the part. Interpreters need a good brain and they should be charming so that visitors want to spend time with them. Training is a key because you have to have interpreters who are both engaging and who get the facts right in terms of history. **Assessment** plays a role because we are constantly gauging whether or not the guest is learning something from the performance and whether the interpreter is engaging the guest. In terms of costuming, I often say that the clothing is a springboard for interpretation.

How does authenticity play a role in the costuming?

We try to make the costumes as authentic as possible. The cloth that we use today is different from the cloth

used years ago, so there will be obvious differences in the construction. We endeavor to get the correct fabrics for our reproduction clothes, but in some cases the right materials are no longer manufactured, so we get as close as possible. We take a clever and pragmatic approach to it by machine sewing the parts of the costume that won't be visible and hand sewing the ones that will be visible. We try to maintain period shapes, colors, and textures, all the while making the costumes as durable as possible.

How do you think about situations in which interpreters interact with the guests in a space?

Every guest receives a greeting and at that point the interpreter will instantly see whether the person wants more engagement or not in the performance. We shouldn't put the public on the spot but rather be gentle and sweet in the interpretation that we provide.

A lot of this seems to come down to personality and charisma.

It does. You need personality to be able to perform and to relate to the public. I would say that "your eyes are the best thing." As an interpreter you can use them to watch and to think through empathy. Every guest is bombarded with hundreds of things when they enter a space—everything from ice cream to the gift shop—so the interpreter has to use empathy to relate to the guest.

What advice would you give designers in terms of developing spaces that will be conducive for the use of live interpreters?

I look at the examples of Plimoth Plantation, Old Sturbridge Village, and Colonial Williamsburg in the United States and would say that these places are perfect sets. Everything within these spaces is thought out and is historically accurate. By having everything designed in this holistic way, the interpreter can then do his or her job. It helps the interpreter get into the frame of mind of the person being portrayed and it helps the

visitor learn more because there are fewer distractions due to the accurate design.

You have been involved in thousands of performances in your life. Could you comment on the inspirational value that performance (including improvisation techniques) may provide for designers? How can they use performance, even if they aren't interpreters by trade, as a way of making creative and exciting theme parks and similar spaces?

I often talk about the "E-words"—empathy, excitement, energy, education, and entertainment. All designers and all interpreters can think about bringing these kinds of qualities to the spaces and performances that they create.

Performance and Characters

Mark Wallis makes a number of important points about the value of accurate, emotional, and committed performances by actors and workers in terms of the overall atmosphere of your design space. Characters, however used in a themed or immersive space, come in many shapes, sizes, and possible uses.

Figure 3-32

In a design project, characters may include:

1. *The Space Itself*: The nature of the space that you design can become its own character. People interact with the space and it begins to speak to them. In this way, it becomes its own character in the story that you are telling.

2. *Story Characters*: Whether a film, a theme park ride, or an interactive display, the presentation of the design can be greatly enhanced with a character—perhaps a fierce creature like a Yeti who helps tell a story of mystery or danger on a ride or a loveable singing bird that makes people laugh in a performance space.

3. *Human Performers*: As Mark Wallis commented, human performers can play make or break roles in the themed and immersive space. They bring life to what might otherwise be static spaces.

4. *The Guest*: In so many ways, the design of a themed or immersive space can take advantage of the guest becoming a character in the design story. The potential is endless because the guest has been given the opportunity to star in his or her story.

In later chapters we will focus on the interaction that takes place between the architectural/material environment and the actors or other characters that might be a part of your design space. When combined with other aspects of operations, the design space can truly come to life.

Lived Theming

There's a neat story about a boy who was cast to play a prominent part in a famous theme park attraction. He was to convey a character from a novel and, it turned out, he took the part to heart. The character in the novel was somewhat rambunctious, so the actor decided to act this out among guests. He actually ended up getting in fights with some of the guests who came to the attraction to enjoy their time. Little did they know that they'd be living out part of the theme. **Lived theming** is a name we give to a situation in themed spaces that develops when a guest, worker, or actor begins to take

on the theme in a closely personal degree. When I trained workers at Six Flags AstroWorld, I sometimes saw this develop among them. They would "spiel" at the Western-themed ride the Wagon Wheel, and they would end up talking in a drawl or a manner of speech that resembled the Wild West theme. Some people who visit theme parks get so wrapped up in the space that they begin to feel that they are a part of the imagined place. Lived theming has some powerful potential because it suggests that a space becomes transcendent and that people—workers and guests alike—feel an intimate connection with it.

Design Deeper!

As we move into the next chapter, we'll begin to look at even more specifics of how to tell effective design stories. Making your space as authentic and as believable as possible will result in guests better appreciating your designs. Regardless of the challenges that you face, remember that in the end you have to come up with ways to design deeper!

IDEAS FOR CONSIDERATION

1. What are some of the most important moods that you feel should be conveyed in any design space?

2. If you were asked to develop a themed space, where would you begin? How would you think about designing that space from the ground up? How would you design the space to keep the theme fresh, even as the times change?

3. What are some innovative ways that you could use color, shape, texture, scale, and lines in your design spaces? In the past, what hurdles have you encountered in terms of their use?

4. How do the operational aspects of your design space impact how you think about the design of the space? Have you ever had to change your design based on operational needs or issues that arose during the design process?

1. What is authenticity and how does it relate to creating effective immersive spaces?

2. What are some ways to develop authenticity in a space?

3. What role does the human factor play in designing an effective space?

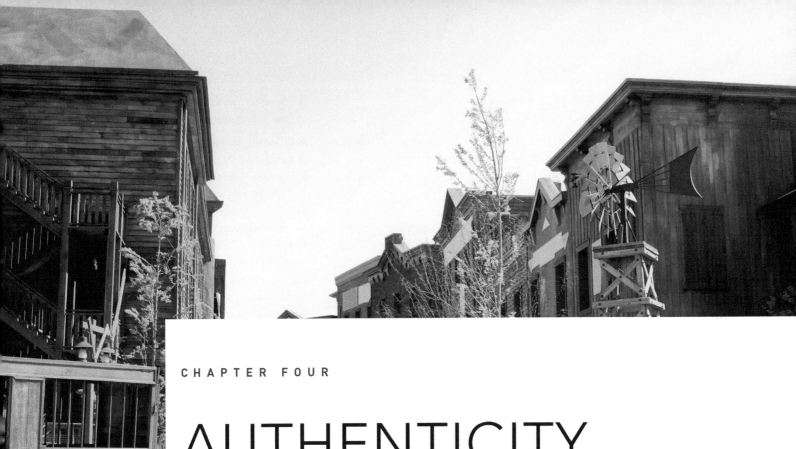

AUTHENTICITY, BELIEVABILITY, REALISM

Figure 4-2

Taking Space Beyond the Space
Why People Believe

The eye seems to know all. The eye is used to look out into the world. Images, ideas, events, situations, and moods are processed by the brain. A person uses this information to interpret, understand, and reflect on the world around him or herself. Decisions are made, new places are sought. The process repeats over and over again.

We begin with the eye because it is, along with the other sensory parts of the body, a tool of perception. When guests enter a themed or immersive space, they use all of their senses to interact with that place. In Chapter 6 we will talk directly about the important roles that the senses play in effective design, but let's think a little bit about perception in general. We could design a space that all of our fellow designers consider to be brilliant, one that even wins prestigious awards, but if the guest doesn't perceive the space to be exciting, exhilarating, and first-rate, it might as well not have been designed and built. A key, likely *the* key, to any authentic space is *whether the guest will accept it as believable*—that is, will the guest suspend his or her disbelief and accept the design choices that have been made by the designer?

In Chapter 1, four important elements were discussed in the context of creating an immersive space. These included the *big idea* or what you want to accomplish in the space, the *story* or the specific way that you will detail the big idea, the *experience* or the way that the guest will interact with the space and experience the story, and the *design* or the specific ways that the space is created through architecture, design, and material culture. I added *purpose* to the list to get us to think about whether guests feel that a space has a reason for them to be there. We can review many of these elements and apply them to the ways in which guests understand the immersive spaces that they visit. An important aspect of the guests' perceptions of a space is their level of belief. Belief, much like in the use of the term in religion and politics, involves a deep connection with a thing, as in "I know it is true" or "I know it is important" or even "I know it is a part of me." Table 4-1 presents some reasons that guests develop belief in a space and some reasons why they do not.

Table 4-1 Reasons Why People Believe and Why They Don't

	Belief	Nonbelief
Story	The story is detailed, involved, and gives guests the sense of a complete journey.	The story lacks details and guests feel a sense of emptiness.
Design	The space is designed with every detail in mind; it seems real and complete.	The space seems to be missing elements, as in the sense, "I get the idea...sorta."
Purpose	The guest feels that he or she has a real purpose there—perhaps being part of the story.	The guest feels that his or her purpose is to be a consumer, a cog in the wheel.
Experience	The guest feels that the experience is exciting and varied; there is something to do around every corner.	The guest feels that the experience is rather one-dimensional and limited in nature.
Ideas	The guest, for whatever reason, can relate to the concepts that are expressed in the space.	The guest is unable to connect with the ideas conveyed within the space.

If you review these reasons, you will note that belief is dependent on the *extent to which* you do something. How *far* do you go in providing an immersive world to a guest? A great story is only so if every element is developed in a convincing way—backstory, plot, characters, and setting. Design is very similar in that it must be executed in a way that stresses every possible detail, nuance, nook, and cranny. Purpose also plays a role as the guest must feel that he or she is part of something—a journey in every sense of the word. Thus, the experience must take the guest in many directions with many variations and the ideas behind the space must be ones that the guest can understand. If all of these elements are developed—if they go far enough—there is a greater chance that the guest will believe what they are seeing. The sole purpose of an immersive design space is to fulfill the needs, wishes, and desires of the guest. The guest's ability to accept and believe what you have designed is entirely based on your fulfillment of this purpose.

Application—Guest Enjoyment

Have a look back over Table 4-1 and think about two or more of the main elements—story, design, purpose, experience, or ideas. Write a short reflection on some issues that you have faced in these areas. This should focus on your views of a design project *after* it has been built. How were you successful in terms of guests enjoying the space? How were you unsuccessful? What sorts of things could you do, hypothetically, to make the space more believable to the guest?

Evocation

Belief, as it is understood in religious and political contexts, always involves experience. There is a famous Chinese proverb that says: "Tell me and I'll forget; show me and I may remember; involve me and I'll understand." This is an amazing proverb because it nicely sums up the design choices that can be made in any space. You could design a space that just tells the guest something—like "Here's why World War II started"—and you could show a guest something in that space—like "Here's a display of old artifacts"—but the most effective way to create belief in a space is to *involve* a guest in that space. Whether this be accomplished by an epic ride, a moving film, or an amazing scenic space, the result will be the same—the immersion of the guest in that space.

In order to make a space in the immersive world most compelling, it should evoke. Instead of telling someone what to do or how to feel, let that person discover, for him or herself, what the space is like. Evocation aims for the ultimate and most real forms of action within a space.

When we speak of the involvement of someone in a world, we need to address the idea of evocation. **Evocation** is a way of telling a story that evokes or makes vivid the world related in that story. Every smell, every sight, every sound, every touch sensation is made real to the listener or reader of the story because of the unique abilities of the storyteller. If you have ever heard a master storyteller, you probably can bring to mind a picture of what that story is. This is because the storyteller practiced evocation—he or she used elements of storytelling that first got you interested in it, second hooked you to a purpose or value of the story, and lastly changed you in some way as a result of it.

The tradition of Chautauqua performance illustrates the value that evocation can play in design storytelling. In Chautauqua skilled storytellers portray famous historical figures—Thomas Jefferson, Sir Francis Bacon, Martin Luther King Jr. People enjoy the experience of hearing a "famous person" speak, even though

they know that the person performing is not the real historical celebrity. Why do they suspend their disbelief and believe the performance? It is because of the skills of the storyteller. The best Chautauquans combine realistic period costume, authentic speech and oratory styles, vast and accurate knowledge of the person, and other historical aspects to convey, or evoke, the essence of that person. There are moments within Chautauqua performances in which the audience actually seems to forget that they are not listening to the real person in the flesh.

The lesson of Chautauqua is that design storytelling is a multifaceted thing. There are no easy design solutions. Evocation is, ultimately, about perception and feeling. If a storyteller has truly evoked the qualities of the story, the listener will be more able to fully engage with the story and the world that it evokes. But what happens when attempts at evocation and authenticity fail to live up to their potential?

An Unbelievable Space 1

In 2008, a "theme park" opened near Bournemouth, England. It was called Lapland New Forest. According to its website, it promised a magical tunnel of lights, real reindeer, Hollywood special effects, an ice rink, a Christmas market, log cabins, and a slogan of "It's You that Makes It Beautiful." Up to 40,000 tickets were sold to guests before it opened, but in a short time after the park opened to the public, it became a major story on national news. When guests arrived at the park, they discovered there was not a magical tunnel of lights, or there was one but it turned out to be a six-foot white string of Christmas lights strung on some trees. The "real" animals included some husky dogs (in a fenced-off kennel) that many guests described as angry and looking starved and a reindeer with a broken antler. The Hollywood special effects included a cabin with Santa in it and a plug-in stuffed bear as a main feature of the

space (Figure 4-3). The ice rink didn't work and the Christmas market was a structure with a plastic roof and some bins with "pound store" items. When some guests got stuck in a muddy bog that was supposed to be a nativity scene (Figure 4-4), on-looking "elves" failed to help out and it was reported that many were seen smoking while in costume.

Figure 4-3

Figure 4-4

Two scenes from the now defunct Lapland New Forest.

In the end thousands of people who had either visited the park or who had lost their ticket money after the park shut down were left with terrible memories. Two brothers responsible for the space were convicted of misleading the public and sentenced to thirteen months in jail. This theme park was an unbelievable space—not in the positive sense of "wow, I can't believe they did that"—but in the negative sense of "not only do I not believe the wonderland that they have created for me but I wish I had never been there!" In television interviews, families recall how horrible the experience was, how their hard-earned money had been wasted, and how they wish the whole event had never happened. Attempt at authentically recreating a Lapland Christmas village...failed!

An Unbelievable Space 2

Figure 4-5

There is a second unbelievable space that we may look at. Some years ago, upon being hired for my first job at a theme park, I had a conversation with a veteran operations manager. The topic was the lack of money that was often available to produce authentic and believable attractions. The manager expressed some frustration that the budget didn't allow for more exciting and effective attractions. Everything from the signage near rides to the facades that were used in the themelands, he said, could be improved with just a little more money. He then went on to detail what he felt was a low point in the park's struggles with budget and authenticity. Years back, he watched a revue that the park had designed to celebrate the Halloween season. This musical revue involved dancers, props, and music, and while some of these elements weren't bad, the audience (and the manager) fixated on what stuck out. A pumpkinhead dancer—donning a cheap, prop shop pumpkin head and orange costume—entered the stage on cue. It turned out that the person playing the part couldn't see out of the pumpkin mask, and as the pumpkinhead began to dance around, he ran into other dancers and eventually took out a number of rather flimsy cardboard stage props. As the manager related, the pumpkinhead dancer struck a chord in the audience but for all of the wrong reasons. No one left the show talking about the choreography, the costumes, or the songs. All they could think of was the hilariously bad pumpkinhead dancer clumsily lopping around on the stage knocking things over. Attempt at using an authentic performance to connect with an audience...failed!

An Evocative Space

Let's go from the negative to the more positive. Like many aspects of design covered in this book, the issues of authentic and believable spaces are connected to thousands and thousands of variables. We all probably have images of evocative spaces in our minds right now. What is it about these spaces that compel us so much that we want to go back to them, again and again? Table 4-2 suggests some ways in which a space can be designed to be more evocative for guests.

Table 4-2 *Why a Place Evokes*

Factor	Why It Evokes	Spatial Example	Consumer Space Example
The Senses	Guests feel the vivid pull of the senses.	The smell of fresh baguettes in a Parisian market.	The sound of a carnival midway.
History	Guests feel the depth of the place before them.	The sense of history felt at a Civil War graveyard.	The feeling that one has traveled back in time at Colonial Williamsburg.
Belief	Guests have a sense that the place connects with their beliefs.	A visit to a church, synagogue, temple, or place of worship.	A stroll down a "main street" in a theme park.
Awe	Guests feel something bigger than themselves.	The feeling that occurs when one sees the Grand Canyon for the first time.	The feeling that happens when one explores the spaces of a massive cruise ship.
Emotions	Guests are able to relate to multiple emotions in the space.	A stroll through a historic part of a European city.	The emotions that are part of a night out at a great nightclub.
Curiosity and Wonder	Guests can explore, ponder, find, and change themselves in a place.	The experiences of a hike in Yosemite.	The feelings that one has when starting an exciting museum exhibit.
Diversity of Space	Guests have the sense that there is much to the space.	The exploration of a Gothic cathedral.	The movement through an exciting theme park dark ride.
Reality	Guests enjoy the space because it feels real to them.	A hike along a picturesque nature trail.	The experiences inside an authentic-looking themed casino.

We'll explore a number of these examples in Chapter 5—especially the idea of awe and the use of emotions in a space. The ways in which you can create evocative spaces will vary with the specifics of the project—the client, the nature of the space, the products or services being offered, the demographics of guests—but one thing is key in any space. To evoke the kinds of feelings and sensibilities that guests will have if they decide to spend time in your space, the space must be real, believable and, most of all, authentic.

Authenticity

Evocation and authenticity are related, hand in hand. Authenticity, we might say, is one of those things that reflects an "I know it when I see it" attitude. We can look at some of the ideas that we often associate with

authenticity. The word cloud (Figure 4-6) includes words like real, true, genuine, original, and many others. Most people will agree that these words often characterize something as authentic, but there's a lot of disagreement about how these qualities come into play in our everyday world.

Figure 4-6

Authenticity is all about bringing life to a space in such a way that the guest will see it as real, believable, and worthy of their time and attention. For a space to be authentic, it must involve a number of key qualities (Chart 4-1).

Chart 4-1 The Authentic Space

Authentic space

It is multi-sensory and multi-experiential.

It contains nuanced, detailed, and involved design elements.

It is a space where story is the key and through which design elements emerge.

It is a space that people enjoy, sometimes contrary to your design intentions.

It is a place that is fully connected to a world, whether based on a real or created space.

It does not feel artificial, fake, or unreal.

If a space is multisensory and multiexperiential it accomplishes two important things. It connects with all of the senses and will approximate, more, what a real space (or in the case of a re-creation of a fictional world, the imagined space) is like (see Table 4-2). In the real world culture is multisensory. Second, it will get people involved in more than one thing and this, too, replicates how culture works in the world. The space will also reflect nuanced, detailed, and elaborate designs and this will strike the guest as being more authentic because it will suggest to them that the designer put all of his or her efforts into the space. As we have stressed, the space needs a story—a good one. The story unfolds and this quality will resonate with guests who expect that your space, like the space of a Civil War battlefield, will have a rich history behind it (what we have discussed as the backstory of a space). The space will also focus on its uniqueness and the multiple ways that it can express a sense of authenticity through the design. It should never use an excuse—like, "I have to sell a product"—to orient the guest in the space and it shouldn't feel at all artificial. Otherwise, the guest will feel cheated. The place should also feel connected to another world—whether real or fictional—and this connection will give the guest a sense of the totality of the design. Of course, the most important aspect of authenticity is whether the persons experiencing the space—the guests—feel that it is authentic. If they don't, even if you spent every dollar and brain cell developing the space, they will walk away unimpressed.

Some of the most interesting and involved discussions of authenticity have occurred among communities of historical reenactors. Gordon Jones relates one example among Civil War reenactors.

Performing Authenticity
Interview, Gordon Jones
Senior Military Historian and Curator, the Atlanta History Center

Figure 4-7

Gordon L. Jones is the Senior Military Historian and Curator at the Atlanta History Center in Atlanta,

Georgia, where he has worked for the past twenty years. He was the writer and curator of the 9,200 square-foot signature exhibition Turning Point: The American Civil War. Gordon holds a Ph.D. from Emory University, specializing in the Civil War in popular culture and the processes of remembering, commemorating, and recreating the past. Gordon also holds a BA in history from Furman University and an MA in applied history and museum studies from the University of South Carolina.

Can you speak a bit about your background?

I began participating in Civil War reenactments in 1981 when I was in college. My approach to public history—indeed my decision to go into that field as a profession—was profoundly shaped by my experience in the reenacting hobby. It forces you to look at the past from the bottom up, from the standpoint of the ordinary person, not the elite leadership. It teaches you to look at material culture from the standpoint of use and function, not connoisseurship.

Your work deals with the interesting culture of Civil War reenactment. You have described this culture as being concerned with "making a past visible." Can you comment on why this is a key for Civil War reenactment?

Visual stimulation is the main trigger for achieving the fleeting illusion of time travel, that ephemeral sense of "being there." Reenactors try to achieve that illusion through the physical transformation of a landscape, populating it with costumed performers and all the appropriate props—horses, cannons, tents, music, campfires, gunsmoke—all part of an interactive, multisensory, and ever-changing fantasy environment. Of course, the extent to which that illusion is considered successful depends on the extent to which it meets the

mutually held and preconceived notions of what the past actually looked like, which is deeply (and often unconsciously) based in movies, paintings, battlefield landscapes, and other visual tropes, including and especially previous reenactments.

In describing reenactment participants, you speak about how they enjoy the fact that reenactment involves all of the senses and that participants often seek a sense of the sublime. Can you discuss your observations on this?

The real ambition of reenacting is to go beyond the external visual illusion to create an internal feeling of real experience, of simulated time travel. Participants do that first by trying to hear, touch, smell, and taste their self-created illusion. Hence, physical embodiment of the past goes well beyond costuming to include visceral experiences such as smelling the exploding gunpowder, eating salt pork and hardtack, or hearing your buddy speak with the correct fake Irish brogue. The end result of this process, if done properly, is a cathartic emotional rush—the sublime two- or three-second déjà vu sensation of actually "being there"—which is the highest personal goal of most Civil War reenactors.

Figure 4-8

In your work you have mentioned that part of Civil War reenactment culture involves a politics of deciding what gets done and how it gets done. In terms of differences in opinions about how to re-create the past, what have you observed? How do differences get resolved?

Despite the fraternal bonds of its members—or perhaps because of them—a reenacting unit can be a seething cauldron of controversies, petty jealousies, and political intrigue. Nearly all serious disputes involve questions of authenticity (what did the past really look like?), authority (who decides?), and autonomy ("It's my experience; I can do what I want!"). Theoretically, such disputes are resolved peacefully by discussion, consensus, and voting. In reality, they are often resolved through argument, conflict, and schism, with factions breaking off to form new units, which in time, breed both additional schisms and reunifications (what I call the "lava lamp" effect). Most dissatisfied reenactors would rather leave their unit than leave the hobby; in the end, units are expendable, but the experience of reenacting is not.

It appears that within forms of Civil War reenactment, there is a range of theming that is expressed by participants. Can you discuss the levels of theming and authenticity that you have noted?

At stake in these levels of theming is the definition of reenacting itself: a hobby for fun (achieving enough visual authenticity to make the performance believable to the audience) versus a tool for experiential learning and mystical quests (achieving a deeper internal intellectual and spiritual understanding which has nothing to do with an audience). Units that fall into the first category are known derisively as "campers" or "farbs," while those that fall into the second are also known derisively as "campaigners" or "hardcores." Everyone else—by far the vast majority—falls somewhere in between.

Each side understands itself by describing how it is not like the other; the specific differences, and the degrees of difference, become defining identities for each unit, and indeed, for each participant.

Figure 4-9

In terms of the people reading this book and who are designers by trade, what do you think that they could learn from the approaches to theming that you have studied in Civil War reenactment circles?

The more-or-less universal human fascination with that sublime feeling of a "rush" is the key ingredient in any

historically themed environment. The main difference between the visitors to a theme park and reenactors is that reenactors take their fascination further by finding ways to internalize the experience. During the past 50 years, the rise of social history, cable TV, the Internet, and the reenacting hobby has created a sophisticated and cynical audience. It is much harder to convince visitors of a historical truth claim today than it was in the 1960s, but at the same time they are more eager than ever to have that "rush," or at least what passes for a "real" experience. I think a themed environment that makes some creative use of reenactor-styled internalized experience—or really anything that goes beyond the visual sense alone—has a better chance of stimulating visitors' emotional triggers, hence building their intellectual fascination and promoting learning.

Do you think that there are any direct (or indirect) applications of the approaches taken in Civil War reenactment groups that could be applied to: a. Design principles in theme parks, cultural museums, and other spaces (architecture, décor, etc.)? b. Performance practices in theme parks, cultural museums, and other spaces (costuming, acting, etc.)?

Given their experience, reenactors generally understand very well the practical limitations of themed environments. Such experience can yield a wealth of practical knowledge on everything from building techniques to parking cars. It can also yield impressive historical knowledge on clothing, gear, language, or military doctrine, though often that knowledge has less to do with reality than it does oral folklore among participants. No matter: to be effective at stimulating a "rush," historically themed environments need not be "true" in any historical sense; they need only be "real" in the eye of most beholders. As seen in reenacting though, what is "real" is always contested, since each of us imagines and approaches the past slightly differently.

It is easier to teach an actor how to do history than it is to teach a historian how to act. There is nothing less convincing than a 300-pound reenactor with a brand-new uniform and fake southern accent talking about the hardships he has experienced in the Confederate Army—even if everything he says is historically accurate (and it usually isn't). Ultimately, it's the convincing delivery of the historical information, not the verity of it, that makes live interpretation effective as a teaching tool. As a historian, I cringe when I hear (or see) reenactors grossly misinterpreting the historical record. But I also know that spectators are quick to spot inconsistencies (even if not inaccuracies) such that many will later seek additional information on their own. Hence, the immediate purpose of performance is to make people feel and think, not necessarily to keep them accurately informed.

The experiences that Gordon Jones relates are very significant. Most of us, and many of the guests who visit immersive spaces, will not develop an excitement for immersion that leads to the depth felt by Civil War reenactors. We can look at their cases and see tremendous insights for our own spaces. As Jones expressed, within reenactment camps, we may talk about three general levels—hardcores, mainstream, and farbs or campers (See Table 4-3). With each group we can evaluate authenticity by looking at clothing, behavior, mental state, the connection to the outside world, use of objects, the nature of storytelling, and immersion. While this case study uses the example of Civil War reenactment, any type of storytelling can be substituted. You can use the three levels of authenticity discussed within each group as a sense of inspiration for your own spaces—the key is thinking about what authenticity means for your individual space and how far you wish to go in terms of realism and believability.

Table 4-3 The A-Factor

	Campaigners/Hardcores	Mainstream	Farbs, Campers
Degree of Authenticity	Complete	Middle of the road	Just good enough
Immersion	Total	Middle of the road	Lacking
Clothing	Sewing of inside seams (period garments).	Clothing that resembles period but may deviate in the construction.	Clothing may be highly inaccurate, including nonperiod items.
Behavior	Behaviors mimic, as closely as possible, the behaviors of the time period, such as sleeping in mud during battles.	Behaviors mimic the time period, but may resort to nonperiod behaviors when not "on stage."	Behaviors may include those that do not directly relate to the time period.
Mental State	Tries to feel how it was to live in that time—exactly as it was then.	May focus on getting into a mental state of the time, especially when in costume.	Often does not directly relate to the time. The mind may be focused on other matters.
Connection to Outside World	In some instances of "total immersion events," the outside public is banned from participation.	Audience may watch the reenactments.	In some cases there may be little distinction between audience members and "farbs."
Use of Objects	Objects that are used must be related strictly to the period.	Attempt to use objects that reflect the period to the best of their ability.	Often use objects not associated with period (cigarettes).
Nature of Storytelling	The story *IS* the Civil War.	The Civil War is reflected in key events.	The Civil War is loosely connected to activities.

In any situation of designed space—whether a theme park, interpretive environment, or themed casino—people will not fall into neat categories. In fact, we can think of authenticity and how it applies to your design spaces in terms of not a group of categories but a continuum. In Chart 4-2, we see in the first situation the idea that what is authentic or inauthentic falls into fairly distinct categories, while in the second situation we see a continuum or line ranging from the authentic to the inauthentic.

Chart 4-2 Authentic and Inauthentic

1

Authentic Inauthentic

2

Authentic Inauthentic

The value of looking at authenticity in this way is to be able to see the many different ways that a space might appear to be authentic. To reiterate what was said earlier about perception, the only thing that matters is whether the guest will see your space as authentic. We also need to keep in mind that authentic does not necessarily mean filling in every detail and designing every possible element in a space. What if, for example, you are working on a project to design a captivating tropical themed bar? What would be the elements needed to convey the mood, to evoke the passions on tropical island places, in order for guests to buy drinks and enjoy the space? So, authentic in this case in not necessarily the *most* elements but the *most relevant* elements that reflect the mood you are trying to create in the place.

Figure 4-10

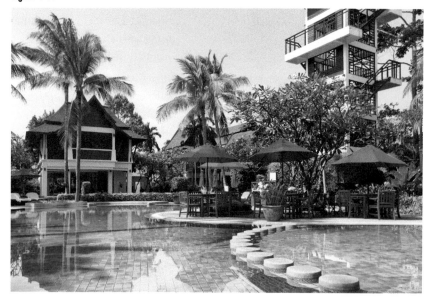

Provocation—Authenticity

We've been talking about authenticity for some time now. We've used the framework of Civil War reenactment as an example because some of the biggest debates that occur within themed spaces take place in the reenactment circles. Now is your chance to extend the discussion to your own worlds and spaces. Work on responding to these three questions

1. In today's world authenticity is or is not an important issue. Respond either "is" or "is not" to this statement and then defend your position.

2. Consider a space that you have been working on or one that might be in the works. To what extent does authenticity relate to that space? Discuss some of the elements that relate to the issue of authenticity.

3. In your mind, what are 3-5 key things to keep in mind when you are considering authenticity and a design space?

Into the Depth

The discussion of belief, evocation, and authenticity gets us thinking about some of the ways that we can apply effective design in a space. We now move into a consideration of some of the many ways that more believable and authentic spaces can be achieved.

Authentic Design

One of the most important keys to designing an authentic space is to let the design match the big idea, purpose, story, and experience that you are intending. Some ideas for creating a design space that is authentic, believable, or realistic to the guest include:

1. Every element of the designed space should relate back to the big idea of the space and the story that you are trying to tell. Do not include unnecessary elements, even if they are aesthetically appealing or "neat," because they may detract from the big idea and the story.

2. To create an authentic design space, each element should relate in a consistent manner to the other elements. Think of ways of establishing a sense of believability by looking at the insights of culture and

the real world—how does a door relate to a window and to a roof?

3. Think of how each design element will be experienced by the guest. As the space unfolds over time and space, consider what a guest's mood or experience will be like in each area or element of the space.

4. Focus on form and function together and think about how each relates to the big idea of the space, the story being told, and the nature of the experiences there.

Stage and Set Design

Figure 4-11

In the world of theater, one of the most important aspects of bringing a play to life is staging. Staging refers to the ways that a director uses actors, construction materials or the stage set, blocking or where actors appear on stage, lighting, and forms of technology to create an immersive drama. Theater gives us an excellent opportunity to think about authenticity in consumer spaces because theater involves a three-dimensional world that includes actors

(akin to the service personnel and actors in a consumer space), a story (similar to the story that you have to develop for the space that will immerse guests), and a constructed space (much like the three-dimensional world that you are creating). Theater is a bit more apt a comparison than film. While film has edits that can help inform how you move from one "scene" to the next in your space, theater is sparser because it cannot use multiple set locations like film. Indeed, theater follows what Strunk & White offered about writing in *The Elements of Style*: "Vigorous writing is concise. A sentence should contain no unnecessary words, a paragraph no unnecessary sentences, for the same reason that a drawing should have no unnecessary lines and a machine no unnecessary parts. This requires not that the writer make all his sentences short, or that he avoid all detail and treat his subjects only in outline, but that every word tell."[1] Set design involves making choices about which elements to include and which to leave out and effective forms of such design are ones that evoke the spirit of the playwright regardless of what is left off the stage.

In addition to teaching us that the most necessary design elements should appear in our spaces, theater takes us back to the issues of the big idea and the story from Chapter 1. If we are clear about what the big idea is or the main purpose of the space, then guests will be able to appreciate the design that we have created for them and better relate to the experiences that take place in that space. Similarly, if the story that we are telling in space has been fully developed—thought out, analyzed, play-tested (see Joel Bergman's interview in Chapter 8), revised—then the design elements in the space will pop—they will come to life just as the stage set of a compelling play seems to take on the life of the place described in the play.

[1] William Strunk and E. B. White, *The Elements of Style*, third edition (New York, Macmillan, 1979), p. 23.

An Example of Design in Action—What's in a Roof?

A key to authentic design is drawing on techniques and elements that reflect the essence of the place that you are trying to create. In Chapter 1, Table 1-1 offered a look at some of the many elements that could be drawn on in a space. If you are designing a space that reflects a fictional world, you will want to pull on elements and techniques that illustrate the moods, values, feelings, attitudes, and culture of that world. In the case of a space based on a real place—like a historical place—you will want to similarly establish the physical features, sights and sounds, and activities that will convey what you want to show to the guest. There are too many design permutations to address in this book, but we can look at one example and get a sense of the value of authentic design.

variable. Look at Figure 4-12 on this page. What you might note here is that there is incredible diversity in the ways in which different people and cultures have tackled the covering up of their homes. In Australia, a roof might be made of plant and stone, in England of slate, in Hungary of terracotta tiles, in Namibia of wattle and daub, and in Switzerland slanted and of thick stone or wood. These differences are the result of *ecological necessity*, such as the Swiss roof that has to be slanted to push snow off of it; *tradition*, such as people wanting to fit into a community of homes that reflects a similarity of aesthetic style; and *personal choice*, such as one neighbor wanting a roof made of concrete for its durability, and another wanting a metal one for its aesthetic look. What's interesting about these differences in real-life roof design is that they are not necessarily consistent with one another.

Figure 4-12

The roof is a feature that is nearly universal. Ever since humans took up residence in cities and in rural areas, the roof provided necessary features that include safety, a sense of personal and family space, and an enclosure that marks off the home from another house. While the feature is universal, the specific form is incredibly

Figure 4-13

In your design space, if you were about to create a roof for a building, this issue of consistency would also come up. For example, if you are designing a Swiss restaurant that purports to take guests back to a romantic era of snow-covered Swiss chalets, you might opt for a traditional slanted wooden Swiss roof. Perhaps that look would be the closest, in your mind, to the authentic Swiss chalet because roofs often look that way. But other considerations may include *practical* ones, such as the slope and dimensions

of the roof and whether this will force you to alter the functional or operational aspects inside the space; *budgetary* ones, including how much money can be spent on the roof and whether an expensive roof will require you to skimp on other design features; and *aesthetic* ones, including how appealing the roof will be to guests.

Authentic versus Imitation

The roof is an example of a rather large-scale detail that relates to authenticity, but small details are equally significant. Linen, a fabric made from flax, is one of the oldest known and most challenging fabrics to make. Before it is woven, excellent quality flax must be harvested (which is grown in select regions of the world) and there is an extremely lengthy process through which the fibers are processed. Afterwards, the fibers are carefully spun into various textiles. In some cases they are dyed or modified in various ways. The finished product is one that speaks of its heritage. It has a sense of history because of all of the work that went into its production. We can contrast a handcrafted textile (Figure 4-14) with a mass produced one, like the one pictured in Figure 4-15. It tells a much different story—it was made on an assembly line using technology and its final appearance, unlike the linen, is cheap and quite ordinary.

Figure 4-14

Figure 4-15

When we look at the case of fabric we see two extremes. On the one side is an object that can be called "authentic" because of how it came to be; the other is less authentic because of its mass-produced nature. One clear piece of advice for design on the micro level is to use objects and elements that speak of the type of richness, history, and hand production that is evident in linen. An important point that remains is the issue of *perceived* versus *actual quality*. It would be possible to produce synthetic linen and just as in the case of artificial diamonds, it could be difficult for a person not knowledgeable in textiles to know a synthetic fabric from an authentic or traditional one. For the designer, there is an opportunity to use reproduction, simulation, and imitation to very successful ends. Archaeologist Cornelius Holtorf has written about the idea of "pastness" or how a place may be perceived to be old even when it is not. Holtorf says that material cues (like patina, cracks, wall texture, and missing bits of a structure), the desires of the audience (like people wanting to feel that they are somewhere old or historic), and a key narrative or story (like one that explains how something came to be or how it got there) are all a part of producing pastness.[2]

[2] Cornelius Holtorf, "The Presence of Pastness: Themed Environments and Beyond," in Judith Schlehe et al. eds., *Staging the Past: Themed Environments in Transcultural Perspectives* (New Brunswick, Transaction, 2011), pp. 23-40.

Pastness is a great way to think about the choices that you have in terms of producing a space. There is nothing wrong with simulating the uniqueness of something or the age of a place so long as the end product fits in with the story that you are offering to the guest. Imitation *can* result in authenticity.

Figure 4-16 Grandma's, a specialized hotel room at Propeller Island City Lodge (Berlin). An example of a recent sense of the past—and all of the associations—being brought to life in a hotel room. Even though the room uses modern materials, it conveys a sense of the past. **Figure 4-17** Wall texture is one way to achieve an authentic look and appeal in a space.

Application—Imitation and Pastness

Take a minute or two to write a short reflection on your own experiences with either imitation or pastness. Focus on a design project that you have worked on and discuss issues that you faced in terms of that design. How did imitation or pastness play a role in it? What hurdles did you have to deal with? What overall thoughts do you have on the challenge of making something authentic given that the guest's perception always plays a role in the success of a space?

Fakery

Fakery, as opposed to imitation, can never result in a sense of authenticity. **Fakery** refers to a process by which an aesthetic or design means is used as a shortcut to a spatial end. Perhaps a designer is charged with creating an authentic knights and jousting dinner and tournament show. Because of budget limitations, the designer throws together a few elements—a castle and a drawbridge—but the overall product fails to impress anyone. This instance of fakery is the *problem of low detail*. It results in a design that lacks details and depth because the designer focused on too few elements in the space. Another example could be called the *problem of overdetermination*. This refers to a situation in which too much, not too little, is put into a design space. Perhaps you are working on an Irish-themed pub. You decide to fill it, wall to ceiling, with all of the symbols, ideas, and associations that people have with Irish culture—there are Gaelic touches, modern Irish ones, and fabled creatures like leprechauns. The guest finds it to be too garish because there is too much happening in the space.

Figure 4-18

Another issue is the *problem of faux details*. This is illustrated in Figure 4-18, an image of a Mexican restaurant that shows a scene that could be repeated throughout the world. A red pepper still life and a

painting of a saxophone are slapped on the walls. There is nothing evocative about the images. Guests do not see them and have associations with the Mexican food that is served in the restaurant. Instead, they likely ask, "Why did they bother to throw up these paintings?" The *problem of the cheap copy* involves a situation in which the successful and often authentic design of one space is lifted and copied for a new space. In some parts of the world, theme parks have been opened that look eerily similar to Disney theme parks. In some cases major architectural features and even rides and attractions are reproduced in a cheap and unfulfilling way. The *problem of bad detail* involves a situation in which the detail does not match the thing, event, or mood being portrayed. In Figure 4-19, we see this syndrome in the case of a historical reenactment in which the performer got "out of costume." A final issue is the *problem of no story*. This happens when the designer believes that he has created a space that tells a story when, in fact, it does not. In some cases, design is overgeneralized and because of its lack of specifics, the effects of design are muted. If one were to create an Old West theme park ride that is geared at giving the visitor a sense of the Old West, yet if one used the most immediate and simplistic associations that they could think of in terms of the Old West, the result could be a space that feels like there is no story behind it. Whatever the problem involved, fakery should be avoided at all costs.

Figure 4-19 In this instance of historical reconstruction from World War II, the actor's use of a nonperiod cell phone strikes of fakery.

Microtheming and Detailed Design

In great contrast with forms of fakery, microtheming is an effective way to immediately convey an authentic sense of place. If used effectively, it can have a lasting effect on the guest and his or her desire to linger in the space and visit it again and again. Microtheming is one of many ways that can be used to show more complexity, detail, and depth behind your space. You could call it the icing on the cake in terms of how it completes the design picture of a space. If we are designing a city-themed venue, for example, it might be the many details that would make the space more lifelike. These could include smoking manhole covers on the paved areas, patinas on the walls, streets that are aged (as if worn by time), and other features that convey the small (or micro) details of the theming.

Figure 4-20

Whether a theme or used is not, microtheming can be an effective way to express the nuance of a space. Consider these ideas in terms of microtheming and detailed design:

1. Develop focus on small-scale aspects of a space by considering what elements would be missing if they weren't there. Think of this beyond a functional sense. For example, while a street scene doesn't really need a manhole cover, having that feature in the pavement may give a greater sense of an authentic space.

2. Think of microtheming and detailed design by focusing on the guest's perspective. What would the guest like to see if that guest were designing the space? When you visit someone's house for the first time, the homeowners will often give you a tour of the main features—here's the kitchen, bedroom, den, etc. Inevitably, the conversation will turn to smaller objects within the space: "This is a vase that Joe and I picked up when we were in Cabo last year," and other variations. Lived personal space is alive because it bears the imprints of the people who make it their own. Consumer space should be no different, so think about incorporating small details and microthemes that people will identify as sources of the unique personality of your space.

3. Consider microtheming and detailed design as an opportunity to introduce mystery and magic into the space (more on this in Chapter 7). For example, if a guest notices an intricate design carved into a table, perhaps into an out-of-sight area, he or she will feel a sense of discovery, as in, "I found this." The person will reflect on that feature and it will become one of many parts of the overall ambiance and effect of the space on that person's consciousness.

4. Focus on using instances of microtheming and detailed design as ways of extending the story of the space beyond the obvious and foundational levels. If a guest discovers a small and nuanced design feature in a space, the person will likely be more able to relate to the story being told in that space. In writing there is a term called *hypotyposis*. It refers to a form of writing that is so detailed, picturesque, and vivid that it seems to re-create a picture of the thing being described in the reader's mind. The same idea should be applied to the idea of stories told in designed spaces—small details will make the vividness of the space pop out for the guest.

Perspective

Perspective relates back to our previous discussion of perception. Here we are talking about how we look at a space in terms of our point of view and what the relationship between ourselves and that space is. In designing effective spaces that give guests a sense of authenticity, the designer should think about ways of using perspective that help establish the mood of the place or somehow advance the qualities of the story being told. There are seven different types of perspective that we can consider.

Framing refers to the techniques that can be used to place emphasis on one part of a space—or one object in that space—while taking attention off of other elements. In theme park rides, framing is used to incredible results. When guests board a ride like the Twilight Zone Tower of Terror or the Haunted Mansion their experience is heightened greatly through the use of framing. As certain parts of the story develop, the ride vehicle moves onto another plane or different angle and the guest is forced to see a new scene. The impact of this use of framing is monumental because it allows the designer to quickly and efficiently control the pace of the story.

Figure 4-21 In this example of framing at an Abu Dhabi resort, architecture is used to frame the natural landscape. The effect is a heightening of the guest's perspectives of the water.

Illusion may include spatial puzzles, architecture that challenges traditional expectations of being oriented in space, and forms of technology that can create disorientation or an altered state of perspective in guests. The use of illusion in space can accomplish many things. It can create a sense of distinctiveness that asks the guest to suspend his or her sense of what is normal. It can offer a sense of something new that has never been experienced before and it can create an association between the space and the viewer that is memorable.

Figure 4-22 In Mirror Room at Propeller Island City Lodge (Berlin, Germany) the guest's perception is altered by the use of mirrors. A sense of endless depth is achieved as the person's image is projected into infinity.

Depth can be a remarkable way of creating a sense of authentic space. When someone peers down a long corridor or looks off a tall building, there is an instant sense of depth. The space unfolds before the viewer as she looks into the distance. The effect of depth in designed spaces can create associations with guests that are especially useful. These range from the idea of a journey, to the sense of the expression of the self, to the notion of a mystery to be found. By experimenting with depth, you can create a sense of drama and awe

in the space. The feelings that will resonate with such examples of depth can increase the sense of realism that guests feel while in your space.

Figure 4-23 In this example of a spiral staircase, the viewer experiences an immediate sense of movement as the eye is taken in a circular pattern and then downward towards the bottom of the stairs.

One method of altering the viewer's perspective in the space is the use of *contrast*. We talked about contrast in the last chapter and discussed how it could be used to create a dramatic effect. Especially if your goal is to take the viewer from one mood or association to a completely opposite one, contrast can have a positive effect in this regard. Contrast can be achieved through color, form, orientation in space, and many other examples. Associations might range from good to evil, old to new, tranquility to upheaval, serenity to excitement.

Figure 4-24 In this example of contrast, the viewer is given a contrast of the old and the new.

Forced perspective is a technique that has been employed in commercial as well as more everyday, functional spaces. The scale of buildings may be altered to give the viewer a sense of their greater size (for example, at the New York – New York Hotel & Casino) or the scale of buildings may be adjusted to make a street appear longer than it actually is (for example, in Main Street USA at Disney theme parks). Forced perspective is a great example of a technique that can create a sense of visual authenticity without having to build full-scale spaces.

Figure 4-25 A stairway in Odessa—the effect of the design is to extend the viewer's sense of the length of the stairway.

Figure 4-26 At the 25hours Hotel by Levi's (Frankfurt, Germany), the intensity of space is amplified by the perspective of collage, creating associations with the hotel and the Levi's brand.

Another form of perspective is called *spatial complexity*. In this instance the viewer is asked to process a number of different and often contrasting elements in a space at once. The technique of collage popularized in Dada art has influenced this form. As many different elements

are organized in space, the designer may choose to use techniques of variation (theme and variation) in terms of size and placement within the space. The effect of the use of spatial complexity is to give the guest a sense of multiple things happening at once—an excitement of the moment before the person.

Altered reality is a use of perspective that can completely change the orientation of the guest in a space. Lighting, technology (including optics and special glasses), and forms of sensory alteration can create an almost immediate sense of the authentic. The reason for this is that powerful sensory stimuli alter the guest's perception of the real world to a very great degree.

Figure 4-27 Magic Cinema (Europa-Park, Rust, Germany).

As we think about these seven examples of perspective, we should consider how they assist the designer in creating more authentic spaces. Table 4-4 reflects some of the ways in which these tools can benefit the authenticity of a space.

Table 4-4 Perspective and Authenticity

Use of Perspective	Benefit to Authenticity
Framing	By using framing in conjunction with the pacing of the story, a space may feel more authentic because it offers the guest a series of interesting spaces to look at and explore.
Illusion	Illusion can be a powerful tool that makes a space feel more authentic because it gives the guest a sense of being somewhere different and the possibility of experiencing (and perceiving) an entirely different space or world.
Depth	This approach to authenticity can take the guest beyond their immediate experience and can establish a sense of being in another place.
Contrast	Contrast can be effective because it shows that the space is varied and full of depth.
Forced Perspective	This approach assists in authenticity because it allows the designer to create a sense of being somewhere else when it is not practical to create every aspect that would appear in the real space (including building scale) within the designed space.
Spatial Complexity	Spatial complexity creates authenticity by suggesting to the guest that there are many things to see, experience, and take in within the space.
Altered Reality	This approach can impact authenticity because it gives the guest the idea that they are somewhere else because they are *perceiving* something else.

Application—Perspective

Reflect on these examples of forms of perspective and design and consider some of the ways that you have experimented with different forms of perspective in space. Which projects have been successful and why? In your mind, what are some of the key ways that perspective can be used to (1) increase the sense of the authenticity of the space and (2) increase the enjoyment of the guest?

Figure 4-28

Bringing Authenticity to Life
Interview, Kelly Gonzalez
Associate Vice-President, Newbuilding Architectural
Design, Royal Caribbean Cruises

Kelly Gonzalez is Associate Vice-President, Newbuilding Architectural Design at Royal Caribbean Cruises. She joined the company in 1998 and has played an integral role in the success of the design of the modern fleet, beginning with the Radiance-class ships. As the principal design lead, Gonzalez oversees all newbuilding and revitalization projects with numerous designers, architects, and consultants worldwide. Her focus includes the most innovative ships to date—the Solstice-class for Celebrity Cruises and the Oasis-class for Royal Caribbean International, as well as a series of ships for Azamara Club Cruises and TUI Cruises. Kelly's extensive experience has involved her with more than fifty cruise ship vessels

over the years. Prior to joining Royal Caribbean, Gonzalez enjoyed an accomplished career with a local Miami firm providing hospitality, corporate, residential, and cruise ship design. Gonzalez holds a Bachelor of Science degree from Florida International University.

Can you talk a little bit about your work? Specifically, what sorts of approaches do you use in designing exciting aspects of Royal Caribbean International cruise ships?

We always take a collaborative approach to the design process. This starts with when we are planning a project. First we discuss what the main objectives are and then we discuss strategies with a broad group of people like marketing, food and beverage, and others. We organize these design sessions as a consortium with creative-minded individuals from different backgrounds—including a large base of architects and designers—focusing on expansive strategies for the project. When we do design presentations the architects are all in the room at the same time and they get to see the others' presentations and they learn and build off of others through the whole process. We also use the charette approach to generate creativity and facilitate creative environments in general. In both cases, creative people feed off of others in a collaborative environment.

The Oasis class of ships—Oasis of the Seas, Allure of the Seas—includes the largest passenger ships in the world. Can you talk a little bit about what is revolutionary about this class of ships?

One of the most innovative things is the design of meaningful neighborhoods like Central Park, Royal Promenade, and Boardwalk. Each one of these

neighborhoods sustains its own energy level and offers unique experiences with dining, entertainment, retail, and other options. Central Park has more of a serene and upscale feel while Boardwalk is active, family oriented, and includes a carousel. The uniqueness of the neighborhoods is complemented by how they flow through the ship. In terms of Central Park, the architecture is also unique. There are glass canopies, which are aerodynamic skylights that punctuate the steel deck and swoop down into the neighborhood below—the Royal Promenade—and the light becomes an inverted imprint of a ceiling component onto the space. The carousel in Boardwalk, the Aquatheater (the largest theater at sea), and the Rising Tide Bar (a bar that moves up and down like an elevator) are also really unique features to see on a cruise ship.

In terms of the design of the space and the use of light in Central Park, how did this develop as an idea?

Again, it was a part of our unique design culture. We create spaces for these things to happen, in any number of ways. Any one of our architects or designers could come up with an idea and that might present a design challenge. The original idea of Central Park was quite different. We originally had the idea of greenery and rolling hills of grass and there was glass on the side of the hills that would bring the light down from above. We looked at the prototypes and mockups and conducted tests and retests by bringing in experts from all areas. One area we analyzed was the wear and tear of guests on the grass. In the end, we came up with an even better design because the final skylight became a key element in Central Park. This was a result of creative people working together and setting aside egos for the greater good of the design.

Figure 4-29

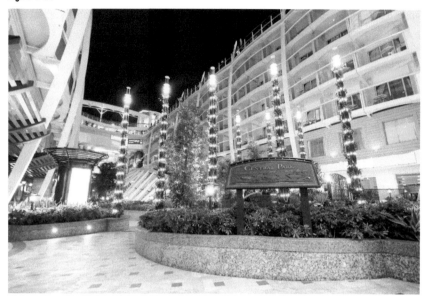

As far as designing for cruise ships versus other spaces (museums, theme parks, restaurants, etc.), how does cruise ship design pose its own challenges?

One major difference is the fact that we are offering an entire resort at sea. We have to maximize the utilization of every square meter on the ship in order to offer everything to the guest. Another difference is the approach we take to building materials and design. In the case of the carousel, we had to come up with innovative ways to design it. Unlike a carousel on land, we were dealing with the fact of a moving ship. As well, we had to make a lot of components out of noncombustible materials. We also look at how the flex and vibration of a moving ship impacts the design of hanging or ceiling elements, like chandeliers.

At some level, the idea of designing ships on this scale with so many features seems impossible, but your designers

pulled this off. At any point did people say, "This can't be done" or "It's too big to pull off"?

While we try to raise the bar and push the limits of design, we do compromise in terms of practicality. If issues of safety or fire codes come up, we have to look at the practical issues that might cause you to change your design a bit. In many cases, thinking through the practical aspects leads to even better forms of design.

I have experienced a Solstice class ship on Celebrity Cruises and one of the things that struck me—more so than in any other immersive environment that I have visited—is how every moment of the cruise was an experience. From the minute you got on, to your meals, to entertainment, and the stateroom itself— everything seemed to focus on the guest. Can you talk about how the guest plays into the decisions that you make about design on a ship and perhaps discuss a few examples?

All of this is intentional. We often create these big-thinking and high-flying environments that people talk about but we are also very good at looking at the details. With the case of chairs we hold "chair parades" and "chair shows" that involve us bringing in all of the possible chairs that we might use and we then test them. We look at comfort, durability (most chairs have to be used in multiple meals in our dining rooms), and aesthetics. Another example is how we organize the elevator features on a ship. The call buttons and how the signals let you know what floor an elevator is on is one example of design that helps move people smoothly and effortlessly, all the while making the design very transparent to the guest. A third example is the use of LED nightlights in stateroom bathrooms. This is an energy-saving measure that is also a small detail designed for the guest's comfort.

Figure 4-30

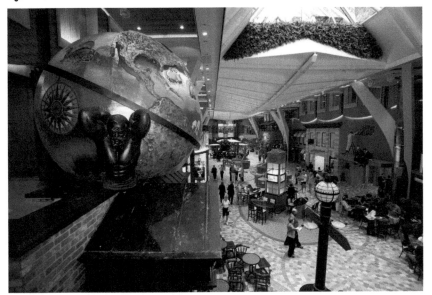

How do you think about making a space aboard a cruise ship authentic, realistic, and believable for guests?

We try to uphold a balance of authentic features wherever practical. In Central Park every plant is a piece of living nature. In terms of the ice rink we didn't even flirt with idea of artificial ice—it had to be real ice. When we do a pub, we try to make it as authentic as possible. In some cases, we have to think about the components and materials that we are using. While we might want to use real wood for an authentic look, we have to make sure that we use a noncombustible material like a laminate. It feels like real wood even though it isn't. There are also weight restrictions that we have to look at. If we want the look of stone, we often have to engineer stones and marbles in thin veneers. In short, there is priority on authenticity in areas that matter the most to guests (like plants and ice) and we find the right balance in other areas.

The Bigger Picture

We've now seen some specific design techniques that can be applied to the creation of authentic and believable spaces. Let's now look at some bigger issues to help solidify the quest for authenticity in our design.

Some Style Clusters

A **style cluster** refers to a trend within the design of consumer spaces that reflects a major theme or approach. Unlike a theme, which tends to have a more specific association with a place or imagined locale, a style cluster involves more general associations like history, fantasy, or the modern era. As such, the style cluster presents some challenges to authentic design, as well as some benefits.

Figure 4-31

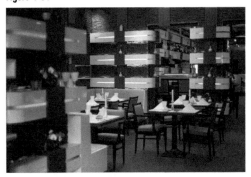

The *modern* cluster has been a very popular approach to style in space. It reflects a use of materials that associates well with notions of elegance, refinement, sophistication, intelligence, beauty, decadence, and wealth. A popular use of this cluster is found in the many spaces in CityCenter (Las Vegas).

Values in terms of authenticity: If done in the right—read high budget—way, the modern cluster can have great dividends in terms of feeling real. In a sense, the guest will feel that what she is experiencing could not be had anywhere else.

Challenges in terms of authenticity: If the modern cluster is used excessively, the sense of story may be lost. In such a case, the guest may feel less convinced about the choices made by the designers.

The *historical* cluster reflects a sense of history, typically the past. Whatever the period is, the space uses textures, construction, and other elements that try to transport the visitor back in time. Many bars and interpretive environments use this style.

Values in terms of authenticity: History captivates all of us and thus a historical style cluster can immediately and effectively create a sense of the real.

Challenges in terms of authenticity: If not executed properly, the space may seem shoddy or perhaps dated in nature.

Figure 4-32

What the *futuristic* style approach uses is the opposite idea—the idea of what is coming next, not what is behind us. The future seems exciting in part because it is unknown. Technology, media, and extremely interactive and busy design elements are combined in projects that seek to connect with the guest on the level of the senses.

Values in terms of authenticity: The future is often very exciting and thus it creates a sense of something real, albeit beyond our current time.

Challenges in terms of authenticity: Sometimes, futuristic spaces seem cold or lifeless because the design choices reflect less of a human touch. Authenticity may decrease in such a case.

Figure 4-33

The *personal* style cluster says to the guest—*you* are here. It focuses on the specific needs of the guest and makes him or her feel at home. You, as the guest, seem to be the primary focus of the space. Technology, media, images, and design elements (as simple as mirrors) can be used to put the guest into the middle of the space.

Values in terms of authenticity: Because people readily connect with what is theirs, the personal space can have major payoffs in terms of the authenticity meter.

Challenges in terms of authenticity: If spaces seem too personal, guests may lose the feeling that they are somewhere else, somewhere different.

Figure 4-34

Figure 4-35

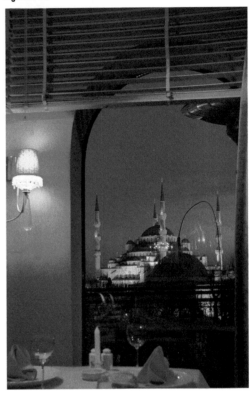

The *otherworldly* cluster takes people elsewhere—to somewhere exotic, somewhere off planet, somewhere distant and far removed from their everyday lives. The excitement of being in another world is created by exotic design elements. In some cases these could be those of another culture unfamiliar to the guest, in other cases it could be a world of an alien culture.

> *Values* in terms of authenticity: The guest can feel that he or she is being taken to another world and that feeling tends to be all encompassing.
>
> *Challenges* in terms of authenticity: If not executed with a clear and convincing story, the space may feel too generic.

Somewhat related to this cluster is the *fantasy* one. Here, the guest is taken to another place that may have roots in folklore, tales or fables, or even the worlds of fantasy novels. Design reflects the characteristics of the world described by the story.

> *Values* in terms of authenticity: Such spaces give people a sense of being in a fantasy space and, if executed effectively, design can convey a sense of the authentic.
>
> *Challenges* in terms of authenticity: If the design of the fantasy is too general—as in the many examples of undifferentiated fantasy space—the guest may feel that the space is too bland.

Figure 4-36

The *sports* style set focuses on the extremely popular world of sports. Whether football (Europa-Park's Arena of Football is pictured in Figure 4-37), American football, basketball, baseball, MMA or other forms, the sports cluster taps into the extremely visceral emotions and overall excitement of sports.

> *Values* in terms of authenticity: Because many guests experience sports in their own lives, they will have a powerful connection with such spaces that reflect a sports style.

> *Challenges* in terms of authenticity: Such spaces may become too everyday and thus do not reflect a fantasy or escape from the everyday. There is a threat of these spaces appearing too mundane, such as in the example of the common and entirely too generalized sports themed restaurant or bar.

Figure 4-37

Nature is another powerful style cluster. People experience nature in their own lives and sometimes designers choose to create an environment that replicates nature or one that is situated in and creates a relationship with nature.

> *Values* in terms of authenticity: Nature is incredibly evocative and orienting people in a nature space could result in half of the work being done.

> *Challenges* in terms of authenticity: The space could suffer from a lack of differentiation from nature and appear to be too much like the nature that guests experience outside of the designed space.

Figure 4-38

A last but significant cluster is the *childlike* one. This space appeals to children and their parents. The design elements use whimsy, fun, and forms that children can directly relate to.

> *Values* in terms of authenticity: Children and their parents will be especially drawn to such spaces.

> *Challenges* in terms of authenticity: People without children may find the spaces to be too childlike.

Figure 4-39

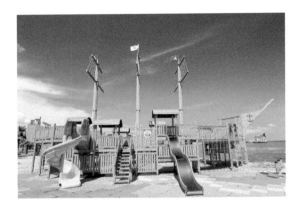

Integrating with Preexisting Space

Back in the early 1990s, controversy erupted when Disney announced plans to build a Civil War and American experience theme park on the grounds of some Civil War battlefields in Manassas, Virginia. The concerns expressed over the park—many unwarranted, in my opinion—often focused on the idea that the park would take away from the sacred grounds of many Civil War battlefields. What the controversy highlighted is the issue of how an immersive space can, or cannot, be integrated into an existing space. Integration can be a key to the guest's acceptance of a place. If a space is successfully placed within a previous, and especially a loved or popular, place, it will increase the attractiveness of that space to guests twofold or more. In the example of Disney's America, the issue of integration involved *history* and the idea of what a historical space is and how it can achieve sacred status.

In addition to history, a space can be developed in conjunction with *nature* itself. One especially successful integration of an immersive space and the preexisting landscape is Dollywood. This theme park is nestled in the woods near Great Smoky Mountains National Park. Its overall design includes many rides and attractions that effectively tie in with the natural landscape. As you walk through the park, the attractions there seem to be naturally placed and don't at all detract from the natural landscape that surrounds them. Many shows and attractions, such as craft and trade demonstrations in Craftsmen's Valley, similarly take the guest on a journey that is at once in nature and in a theme park.

Famous or loved places, like a historic town center, are also areas in which a new attraction or space might be built. In the United States and other parts of the world, historic towns have attempted to produce better placemaking by retheming their areas. Flagstaff, New Mexico revitalized much of its central business district by reconnecting it to the legacy of the railroad in Flagstaff.

Figure 4-40

Whether the place in which you are integrating your space is historic, nature-based, or a loved place, the key is to think about how the new space can add to the meaning, not take away from it. Using a place that has some history or fandom behind it can only add to the power of your new space.

Trending—Behind the Scenes

One of the most interesting trends that has impacted theme parks, casinos, restaurants, and interpretive environments is the idea of "behind the scenes."

Attractions like the Universal Studios Tour, Behind the Scenes Tours at the Georgia Aquarium, Donn Arden's Jubilee! at Bally's in Las Vegas, and many others offer guests the idea of seeing how things are from the inside. The guest might see how a ride works, or how a production or show is practiced, created, or executed. In an era of mass experiences, the behind-the-scenes tour gives guests an opportunity to see something different—something off limits—and to get a glimpse at how things are made. This is a significant trend and it can show the guest another side of your space. In cases in which the guest sees the inner workings of your space, the person may gain new respect for the complexities behind the operation. The downside is that it may break down the magic—it may detract from the main show. Typically, consumer attractions work from a front and backstage approach and the behind-the-scenes tour gives the guest a sense of backstage. Does this go too far? It depends, again, on the purpose of your space and the extent to which you want to explore experiments with staging.

Wouldn't You Know It!—What's Real?

A few years back I had the opportunity to take part in a conference on historical reconstruction and theme parks in Freiburg in Breisgau, Germany. The conference brought together individuals involved in historical reconstruction—from projects like Colonial Williamsburg, Civil War reenactment, and the Cologne Tribes (groups of men who re-create the cultures of Native Americans, Vikings, Romans, Huns, and Mongolians)—and others who focus on theme parks and more consumer-based attractions. The conference was quite stimulating in terms of the discussions of what constituted a theme park, what was meant by historical reconstruction, and other issues. What was most interesting was how it ended on a note of contention among the participants. When the topic turned to authenticity, I had a sense that things would get heated. Indeed, many of the people involved in

historical reconstruction felt that the people involved in theme parks were "getting it wrong." I recall that one participant put up a picture of two knights reenacting a battle in front of a Pizza Hut restaurant. This turned into a "You see, you see, that's not real!" argument. Wouldn't you know it, authenticity is a tricky thing!

Culture and the Believable

So far we have talked about numerous ways that spaces can be made more authentic and believable. Back in Chapter 1 we talked about the value that culture plays in developing an immersive space. Culture is a valuable tool because it is, in a sense, what is real to the people who are a part of it. We can think of culture as a tool to use in creating believable worlds and spaces. Consider Chart 4-3.

Spaces that are immersive involve the guest in them (something we'll get to shortly in Chapter 5). Effective venues involve key symbols, memes, and forms of allegory in order to convey both the essence of the place and a sense that the designer has done her homework—the person took the time to get it right. Authenticity and consistency are keys, as we have been discussing, and you can think about why guests will be more likely to stay in a space that has both going on. Both mana (see Chapter 7) and feeling can be used to make the guest feel a sense of something special within the space and integration and all of the small details, as we have learned, will complete the picture. Consider these multiple approaches in the design of your own space.

Application—Culture

Focus on the ten areas considered in Chart 4-3. Choose one or more of them and write a short piece that reflects your concern with the area. How could the given area be used to create more believability in your space? What things can you do to make the guest's experience more memorable? Write down as many of these as you like and share them with a fellow designer.

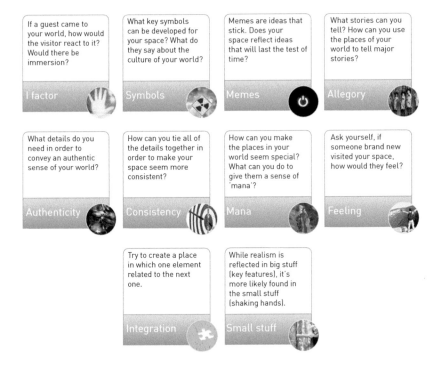

If a guest came to your world, how would the visitor react to it? Would there be immersion?	What key symbols can be developed for your space? What do they say about the culture of your world?	Memes are ideas that stick. Does your space reflect ideas that will last the test of time?	What stories can you tell? How can you use the places of your world to tell major stories?
I factor	Symbols	Memes	Allegory
What details do you need in order to convey an authentic sense of your world?	How can you tie all of the details together in order to make your space seem more consistent?	How can you make the places in your world seem special? What can you do to give them a sense of 'mana'?	Ask yourself, if someone brand new visited your space, how would they feel?
Authenticity	Consistency	Mana	Feeling
Try to create a place in which one element related to the next one.	While realism is reflected in big stuff (key features), it's more likely found in the small stuff (shaking hands).		
Integration	Small stuff		

Chart 4-3 Culture and the Believable

Figure 4-41

Trending—The Niche

The collection *Niche Tourism* details a number of interesting niche trends that could impact the future of designed spaces.[3] Guests are beginning to clamor for *special interest tourism* (geotourism, photographic, youth, dark, genealogy, gastronomic, and even transport tourism), *tradition and culture-based tourism* (tribal, cultural heritage, peripheral, and research forms of tourism), and *activity-based tourism* (small ship cruising, sport and wildlife tourism, volunteer and adventure tourism). According to the authors, on the horizon are the further forms of space, virtual, and ethical tourism. What this trend of niche tourism indicates is an ever-increasing willingness of guests to take part in environments and activities that are different, outside the norm, transformative and, in some cases, risky. What the designer of themed and immersive spaces might learn from this is a sense that a space could, because of its sometimes extreme or unique nature, lend itself to a clear sense of authenticity.

The Human Factor

In the last chapter, we introduced the important roles that performers, actors, and other service workers play

[3] Marina Novelli, ed., *Niche Tourism: Contemporary Issues, Trends and Cases* (Oxford, Taylor & Francis, 2005).

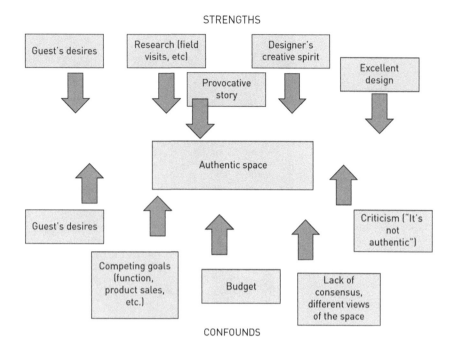

STRENGTHS

Guest's desires

Research (field visits, etc)

Designer's creative spirit

Provocative story

Excellent design

Authentic space

Guest's desires

Competing goals (function, product sales, etc.)

Budget

Lack of consensus, different views of the space

Criticism ("It's not authentic")

CONFOUNDS

Chart 4-4 Authentic Spaces

in the themed and immersive space. In Chart 4-4 we see that there are many factors beyond the physical design of a space that impact authenticity. Guests, as we have said, bring their own perceptions to the table. These can, and will, alter your own efforts to meet their needs. Competing goals, like how to deliver a fast and profitable operation, may impact some of your efforts at authentic design, as will issues of budget and a lack of consensus

among team members. As I related with an earlier aside, some people, including social critics, will decry that your space reeks of inauthenticity. You'll have to deal with that and the many other confounds that impact the design and operation of an authentic space.

On the bright side, you can apply many strengths to the achievement of a believable space. Consider ways of applying the guest's desire to be somewhere else or to be in an immaculate and well-designed space as you make design choices and work on using research and knowledge of other cultures and places to strengthen your excellent design choices. Also, we cannot underestimate the value of a strong story and how it can lend a great dose of authenticity to an immersive world. Last, but not least, think about your own sense of creativity and how it can be best leveraged to create worlds that you, and the guest, will be proud of.

IDEAS FOR CONSIDERATION

1. What is the most evocative space that you have ever visited? What qualities of that space made it evocative for you?

2. How have you thought about authenticity, believability, and realism in your previous design projects? In your mind, what are some of the keys to each of these?

3. What are some of the most successful ways that you have used principles of design to create authenticity in your spaces?

4. What do you think are the biggest challenges to creating authenticity in an immersive or consumer space?

1. What is immersion and why it is valued in spatial design?

2. Why is the guest the most important aspect of themed and consumer space design?

3. What are some characteristics of guests that can be useful understandings for design?

4. How does storytelling help create the immersive space?

THE GUEST, EXPERIENCE, AND IMMERSION

Immersion

What Is Immersion?

In the last chapter we discussed a number of ways that can be used to make a space more realistic, more authentic, and more believable to the guest. This is only part of the picture. We could, for example, find a space that is truly authentic according to our definitions. Perhaps it is a reconstructed 18th-century French town. Every detail has been scurtinized by the designers—the costumes, the architecture and facades, the material culture (including tools, household devices, cooking implements), even the performers and their attention to period speech, accents, and behavior. The only thing is that *you*, the guest, do not connect to the space. You are unable to feel immersed in it, even though you should. We will use this chapter to focus on immersion, experience, and the guest and talk about a scenario just like this one and how you can overcome it.

By looking at immersion we can address two key elements—the ways in which spaces can be made more exciting, experiential, and involved and how the guest can be drawn into those spaces. Immersion is one of the most significant features of the spaces that we have been considering, yet it is also one of the most difficult to achieve. Earlier, we talked about the idea of culture and the things that people feel when they are part of a culture versus those things that make them feel like outsiders. Culture relates to immersion because if a person is truly immersed in a world or in a space related to that world that person will *feel* a part of it.

The word immersion comes from Latin and means "plunge, dip" and later, "absorption in some interest or situation." Immersion means that someone is able to connect (often deeply) to a place—whether it is a temple, a museum, or a theme park. Immersion is all about the ways that the guest feels able to be part of that space.

Levels of Immersions

As we related in the example of the reconstructed French town, a space can be incredibly authentic, rich in detail, and full of experiences, and yet, for whatever reasons, a guest in that space does not feel, or does not want to feel, immersed in that space. Let's review Chart 5-1 and consider the different levels of immersion.

Immersion ranges from relatively low, which could be a situation in which a guest comes to the space but never gets wrapped up in it (which, in this case, is likely not an actual form of immersion), to high, which could be a circumstance in which a guest is so excited by a space that he decides to somehow make it a part of his everyday life. In Chapter 8 we will focus on this more exclusively and discuss situations in which a themed or consumer space is so significant to the guest that it becomes a tradition in the person's life. The levels of immersion that are felt by a guest will, no doubt, vary with a number of key variables relative to the space. These include the

Figure 5-2

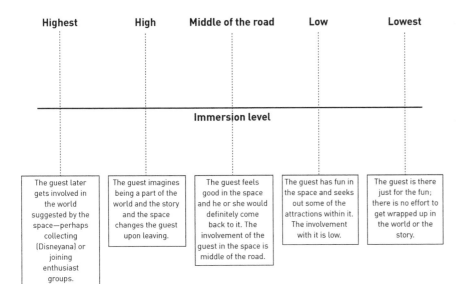

Highest	High	Middle of the road	Low	Lowest

Immersion level

The guest later gets involved in the world suggested by the space—perhaps collecting (Disneyana) or joining enthusiast groups.	The guest imagines being a part of the world and the story and the space changes the guest upon leaving.	The guest feels good in the space and he or she would definitely come back to it. The involvement of the guest in the space is middle of the road.	The guest has fun in the space and seeks out some of the attractions within it. The involvement with it is low.	The guest is there just for the fun; there is no effort to get wrapped up in the world or the story.

Chart 5-1 Levels of Immersion

type of space that is being designed, the functions of that space, and the background of the guest.

Immersion is one of the most valued aspects of a designed space because it is all about how the space can be used to wrap the guest up in it. If a guest is truly immersed in a space and the world that it promotes, he or she will feel powerful emotions, incredible senses of discovery, and even feelings of personal transformation. So, what are some specific emotions of immersion and how can knowing about these assist us in creating more exciting spaces for guests?

The Emotions of Immersion

In her book on the power of games, *Reality Is Broken*, Jane McGonigal writes of a certain quality that is shared by many popular video games. This is the quality of something feeling *epic*.[1] The stories, actions, the environments, and the projects or missions of video games all promote a sense of the player being wrapped up in something epic. McGonigal goes on to relate the

sense of the epic to the feeling of *awe*. When someone is in awe, according to psychologists, the person feels part of something bigger; he or she not only feels good but is more likely to do something good. It is no coincidence that McGonigal's project focuses on many of the most popular contemporary video games and MMORPGs like World of Warcraft. It turns out that these popular spaces of gaming are dynamic worlds that include places, people, other species, and various events. These games and virtual worlds also are places in which powerful stories are developed. The players and their avatars get wrapped up in the worlds and the stories that are being told.

Figure 5-3 Many spaces can inspire awe in us. Awe is one of the most powerful human emotions.

[1] Jane McGonigal, *Reality Is Broken: Why Games Make Us Better and How They Can Change the World* (New York, Penguin, 2011).

In addition to experiencing the emotional qualities of awe and the sense of the epic, the guest who is immersed in a space will feel a sense of *completeness*. What this means is that the person will first have the sense that the space created for him or her is its own world. It is complete in every detail and it tells a story in a seamless manner. Second, the guest feels a natural part of the space—there is no clear separation of the guest from the space—and, third, the person leaves the space somehow different, transformed. Completeness applies to both the space and the ways in which the designer has effectively merged the big idea, story, experience, and design and to the guest who truly feels a part of the space.

A third significant emotion of an effective immersive space is that it creates strong feelings of *imagination*. A person who visits a space like a theme park may find himself making connections between the rides, attractions, and events within the space and with ideas *outside* of the space. We'll talk later about this idea through the notion of the lifespace. It means that the designer has created a sense of magic and fantasy within the space such that it leads to guests feeling the many emotions of imagination. In a café, the use of design, the layout of the space, and the promotion of the brand identity can result in the visitor developing vivid and lasting associations that create an overall sense of imagination in that person's head. Combined, these and many other emotions are the results of the successful design of an immersive space.

Figure 5-4

Spaces That Connect

The true magic of a space is found in how it moves us. In you are in a particular café, the texture of the wood on the walls makes you think of a moment that you had in York, England and you jot down a quick note about the association. The smell of the coffee makes you think of an open-mic night that you experienced in a Houston, Texas performance space. The sound of the espresso machine working creates an association of a meeting that you had with a unique person in another café in Iowa City, Iowa. This list could go on with thousands of variations and examples, and for each of us, and for each of your potential guests, the associations of place will differ. The key is realizing that space can profoundly impact the guest and looking at ways of creating associations that will cut across *all* personal and social differences. So, why do some spaces connect with us and why do those spaces stick out in our minds? What marks off a space as truly transformational from truly ordinary?

How can the designer create an immersive space and all of the vivid emotional associations that guests will have in such a space given the fact that all guests are different?

First off, people feel a connection with a space because for whatever reasons, *it speaks to them*. Even though a series of architects, designers, and developers have created it for the guest, he feels that it is all about him. The space is so evocative that the guest feels that he was meant to be there. In a theme park, a family feels a sense of joy. As their time evolves in a visit to the park, they feel more and more connected as a family. At some point they forget that they are in a space that has been designed for their entertainment and they forget that they are one of thousands of families in the park. Each

visit to a ride, each trip to a show, and every stop in a gift shop give them the idea that they are the reason that the theme park exists.

Also, guests who enter a place that has special meaning to them feel that there is *something to discover* within that space. In religious contexts, a person who visits a synagogue may find that the place and all of the people in it create a sense of self-discovery—there is something that the person wants to change in her life and the space allows this to take place. In a consumer setting, a guest who takes his first trip aboard a cruise ship may get the sense that the space unfolds before his eyes. Upon boarding the ship, he is given a map and this establishes his goal to explore the space. He finds a unique bar that he might visit later that night. Then he takes a gander at the pool area with its remarkable features. His overall feeling is that there is much to see aboard the ship—likely more than he can see during the cruise—and this itself creates a strong sense of excitement about the discovery that awaits him.

A third dimension of spaces that connect is that they have *a sense of history*. A truly historical place, like the site of a former Roman occupation, conveys history because of the actual events that took place there. With some exceptions, most designers are required to create a new sense of history that will help establish the **placeness** of the space. The Atlantis Bahamas and Atlantis Dubai are massive resorts that are effective, in part, because of their created histories. The myth of Atlantis is a provocative and widespread one. Sol Kerzner and others used this myth as a way of giving guests a space that has history as they enter it. The lost city of Atlantis is re-created in a resort space that provides the opportunity to connect with and impact guests upon their first visit to the space.

We'll look at how some of these associations can be achieved in a space in the next few sections. Also, in Chapter 6 we will focus on the brand and how associations between space and guests can benefit from the powerful uses of the brand.

The Guest in Space

In addition to the general reasons why spaces connect with people, we can focus on some specific reasons. Each of these addresses a specific type of space and describes how guests typically approach, understand, or use that space. These profiles are based on research conducted in the spaces, but keep in mind that the specifics may vary with the type of space that you are involved with. For each space, there is a discussion of Typical Uses of the space (why people come to the space, what they like to do, etc.), Pre-associations (what guests bring with them as they enter the space), Post-associations (what guests take with them when they leave), and Internal Monologue (or what a guest might be thinking in that space). It is hoped that these elements of space will help you brainstorm some design ideas for your own venue.

Amusement Park:

Typical Uses: In this book, we have distinguished the amusement park from the theme park with the latter being a space that more fully uses stories, narratives, and specific themes to connect with guests. The amusement park, thus, is typically used by the guest to achieve high senses of thrill, excitement, exhilaration, and an escape from everyday life. Like many of the other types of spaces, there is mixed-use—meaning that guests enjoy rides, shows, shop for products, and eat good food.

Pre-associations: The desire to escape; looking forward to enjoying time with others (friends and family); wanting to get away from it all.

Internal Monologue: "What's the most amazing roller coaster here? I want to ride that one!"

Post-associations: The sense of a great time; wanting to come back again.

Theme Park:

Typical Uses: The theme park gives the sense of a fantasy world that tells a story; it's an all-encompassing place that looks nothing like what the guest has likely seen before; it has many things to do within it.

Pre-associations: A real sense of excitement to get there; a feeling of wanting to see it all; the hopes of having a great time with others important to the guest.

Internal Monologue: "How they recreated the Matterhorn here is absolutely amazing! I can't believe it!"

Post-associations: A desire to share the experiences with others; conversations about how "we'll be back"; the sense of optimism and hope that results from escaping the issues and problems of everyday life.

Restaurant:

Typical Uses: The restaurant, whether themed or not, is designed to deliver two or three primary products. The first is food, often of a distinctive sort, the second is service or the attention given to the guest by wait staff and servers, and the third is a sense of experience (something that is epitomized at "molecular gastronomy" restaurants like elBulli, Alinea, and the Fat Duck).

Pre-associations: Ideas about how one will splurge and have a gluttonous meal; the desire to try new things and to be exposed to new sensory experiences.

Internal Monologue: "Oh my God, this crab is divine!"

Post-associations: The feeling that one had an incredible meal/experience; the wish to tell friends and family about how amazing the food/service was; the desire to save up and go back to the place.

Casino:

Typical Uses: The casino typically focuses on gaming (usually not referred to as "gambling" inside of the industry) and augments it with shows, high-end dining, hotels, and other attractions.

Pre-associations: The sense of hope and destiny in winning something big; the idea of escaping everyday life for a few days; the hope to reconnect with a loved one while on vacation; the idea of doing things one never does ("What Happens in Vegas, Stays in Vegas").

Internal Monologue: "I won a load at 21 today! Let's eat!"

Post-associations: The sense of wanting to come back; worries about how much money was spent; the excitement of having gotten away from it all; the joy of having seen places unlike any others that one has seen.

Resorts/Hospitality Environment:

Typical Uses: A resort, hotel, or other hospitality environment is designed to give the guest a sense of luxury and relaxation and to provide for as many comforts as possible. Resorts strive to focus on meeting all of the needs of the guest in that space.

Pre-associations: The hope for real relaxation; the idea of getting away from it all; the desire to live at excess.

Internal Monologue: "This is the most amazing, plush bed that I have ever slept in."

Post-associations: The feeling of total rejuvenation; the dread of having to go back to work; the hope to come back and do it again.

Home and Planned Community:

Typical Uses: The home or planned community is designed to give guests (or more appropriately, residents) the feeling of "being at home." A home or community is designed with the intents of comfort, identity (of the resident), and the sense of community or good relationships among the residents.

Pre-associations: A wish to live somewhere very nice; the hope to meet new neighbors and to live next to others that one likes; the desire to find a place of one's own that will reflect their uniqueness and will "be theirs."

Internal Monologue: "I love living there. Everyone is so nice and they all keep their houses up real nice."

Post-associations: Not applicable unless the resident sells the home or leaves the community.

Shopping Mall:

Typical Uses: The shopping mall derives from the arcades of France and the bazaars of the Middle East. Its primary use is to deliver quality goods and services to guests. In some venues, there is a third element of giving guests exhilarating experiences (such as at the Mall of America).

Pre-associations: The sense of wanting to find something new, perhaps to complete who the person is; the desire to relax, unwind, and spend time window shopping.

Internal Monologue: "I finally found the Jimmy Choo shoes that I was looking for."

Post-associations: The willingness to come back and to shop there again; telling friends and family about was discovered there or a particular store that excited the person.

Figure 5-5

Lifestyle Store:

Typical Uses: A lifestyle store is a store on "identity steroids." This means that it really makes an effort to serve a niche market or a clientele interested in a certain distinctiveness of brand, service, and experience. This space is all about the guest and the products and services, and experiences there must focus on the guest, 100% of the time.

Pre-associations: The sense of finding something that will fit that person's sense of who he or she is; the feeling of exclusivity.

Internal Monologue: "This has always been *my* place!"

Post-associations: The feelings that the space spoke to who the person is; the want to come back, again and again.

Brand Space:

Typical Uses: The brand space is all about introducing (in some cases) the guest to the brand or (in other cases) about strengthening the connections between the guest and the brand. A brand space always has some sort of product that reflects the brand that is available for purchase, typically in multiple forms and formats. The space will also likely have experiential activities connected with the brand.

Pre-associations: The guest typically may have some ideas about the brand on display in the space due to previous associations with the brand.

Internal Monologue: "Wow, they have so many types of M&M's stuff here!"

Post-associations: A stronger sense of what the brand is; a clearer sense of the values that are connected with the brand.

Cruise Ship:

Typical Uses: The cruise ship experience is about two things—taking the guest from one point to a series of other points and offering the cruising lifestyle. While some guests in this space want to see the places that the ship travels to, there is a more "conceptual" form of travel in that the guest is sometimes on the ship *only* to stay on the ship. Some studies have said that over 30% of cruise ship guests never leave the ship for shore excursions and, instead of going ashore, these individuals spend the time on the ship experiencing all that it has to offer.

Pre-associations: The idea of seeing the world; a sense of exploring far-off and exotic places; the time of the person's life; a quest for true luxury; a hope for relaxation.

Internal Monologue: "I cannot believe that they spent so much time on getting every detail of the ship just right."

Post-associations: The sense of an amazing, once-in-a lifetime experience; the desire to go on another cruise; wanting to tell others about the great experience.

Interpretive Environment:

Typical Uses: The interpretive environment includes museums, cultural centers, and other such spaces. It is typically used to communicate important cultural, historical, or other information to guests. It often has a "message" or set of key educational (pedagogical) points to impart on guests.

Pre-associations: A desire to learn more about something; the quest for knowledge; previous interest or some expertise in some of the areas considered in the space.

Internal Monologue: "I never knew that a single tablespoon of soil contains billions of organisms."

Post-associations: The piquing of curiosity; quest for more knowledge and information; inspiration.

Mixed-Use Space:

Typical Uses: The name "mixed-use space" says it all in terms of function. This space is about combining multiple elements of previous venues. It has multiple uses and is sometimes connected by an overarching theme or set of associations that draws the guest in.

Pre-associations: A sense of wanting to do a lot—shop, see a movie, relax, and have a cup of coffee; the excitement of wanting to see it all; a sense of looking for the new, either in a new store that has opened or a new movie at the multiplex.

Internal Monologue: "After I see *Avatar*, I want to go to Crate and Barrel and get the new kitchen organizer that I was talking about."

Post-associations: A desire to come back; a sense of community or feeling that the space has the mood of a small town; the willingness to tell friends and family about all that is available to do there.

Virtual Space:

Typical Uses: The virtual space gives the guest (or player) the ability to experience another world—a virtual one that typically looks nothing like the real world. With the growth of MMORPGs and virtual communities like Second Life, there are more associations from everyday popping up (for example the use of currency, religion, education, diplomatic relations).

Pre-associations: The idea of escaping the real world; a sense of fantasy; a quest to meet new people or see new (virtual) places.

Internal Monologue: "Today I got twenty frags in Quake III. Next time, I'll get thirty!"

Post-associations: The sense of wanting to go back to the world to experience it more fully; the desire to get others (friends and family) involved in the world.

We can use these four areas to think about how a design within one of the venues can maximize the immersion of the guest. A pre-association combined with an understanding of why people are there to begin with (typical uses), an internal monologue, and the post-association can give us a fuller sense of what that space is in a *total* sense—from before the guest gets there to what happens when the guest is on site to what is taken home with the guest.

The Immersive World

Chart 5-2 The Immersive World

Immersive World
The world is "full," meaning that every nook and cranny of it is detailed (what it looks like, how it feels, etc.). It is as if you could feel yourself living there. It has depth and is expansive, all encompassing.

Non-Immersive World
The world is empty, meaning that only a few details of a few places are expressed. You cannot have a sense of the world (the big picture) because it lacks depth—it is all about surface.

As we saw in the section on the emotions of immersion, an immersive world in one that is all-encompassing. In short, it takes the guest in—in as complete a way as possible. Within our world, we can think about the many instances of immersive worlds that we have enjoyed.

Novels can often create a sense of mood and atmosphere that makes us feel that we are a part of the place being described. A well-written poem can convey more emotion and energy than a film. A film can take us into depths of other worlds and places that seemed unimaginable before we saw them. A video game gives us a sense of interacting with the elements of a world that has been created on a screen. All of these forms, and many, many others, provide us with a rich tapestry of possibility in terms of how immersion can make a difference in people's lives.

In terms of the goal of creating an immersive designed world—whether in a theme park, interpretive environment, cruise ship, or other environment—we can focus on the general ways in which immersion can play a role in the space. The next section will provide some specific elements for the achievement of immersion. If you look at Chart 5-2, you will notice a sense of how immersion works at the most general level. In situation 1, we can think about a world—pictured by a space of cultural reenactment—that is full. This means that every detail of the world has been thought out and that the guest is able to feel, sense, and experience all of the details. The space becomes a part of the person and he or she is somehow changed by it. In situation 2, we have the opposite or a place that lacks depth, feels empty, and results in guests having very little sense of connection to it. In Chapter 4, the example of Lapland New Forest, with its dismal attempts at recreating a Lapland Christmas village, shows us the extreme end of this lack of depth. Of course, spaces will not neatly fall into one of these two immersion camps. Earlier, we looked at the guest being immersed in a world and spoke of five levels of immersion. In reality, just as was the case with authenticity, the immersive nature of a space is a continuum—a line from nonimmersion to immersion and all that is in between. So how do the small details and specific elements of a space help make it immersive for the guest?

Elements of the Immersive Space

What are some of the elements of an immersive space that, regardless of their specific content or theme, can be used to make the place more inviting for a guest? The following represents a survey of some of the key features that are typically found in a themed or consumer space.

Entrance Areas: The entrance is a key aspect of any immersive space. Those who work in theme parks, restaurants, and cruise ships have been trained to emphasize the points at which the guest enters the space and later leaves it. A lackluster entrance immediately communicates to guests that the place they are about to enter is far from dynamic or immersive.

Figure 5-6

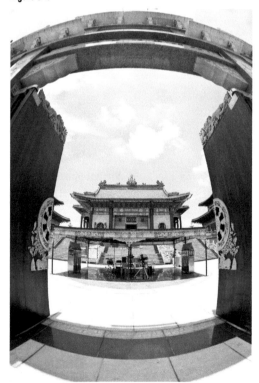

What it can mean: Mystery, welcoming, the beginning, a doorway to excitement or another world.

How it can be maximized: A combination of exciting visual elements (arresting colors, detailed textural patterns, eclectic architectural features) could be used.

How it can be tied to the spatial story: The key elements of the feature should give the guest a sense that he or she is truly entering another world. This is the threshold and this means that it should be more than a functional gate that marks the space off from the outside world—it should be fully magical with a sense that it signifies the world of the story that is about to be told to the guest.

Functional Areas: Restrooms could be considered the epitome of a functional area. In most cases, an immersive space would not directly use the restroom as part of the major narrative or story of the space. A space can, and often should, use the functional space as an ancillary to the story or theme being developed. By using functional spaces in this way, the story will remain consistent and strong throughout the entirety of the world.

What it can mean: A necessary break, a place of relief, comfort.

How it can be maximized: The functional space can be (a) themed entirely with the space, (b) designed with more abstract and less thematic elements, or (c) created without regard to the theme of the space. The use of a theme or key design approach depends on the desires of the client.

How it can be tied to the spatial story: Depending on the space at hand, the functional space can still lead to the sense of the other world being created for the guest. At Paris Las Vegas, for example, the restrooms indicate features that one might find in France. This use of design allows the space to convey a sense of its placeness in an area that normally seems out of bounds for the spatial story.

Lead Areas: Lead areas are ones within a space that reflect the core identity of the space. For example, within a theme park, lead areas might be roller coasters, dark rides, or major attractions that reflect major capital investment of the company, powerful brands, or types of resonant experiences. The lead area is akin to how paramount the cross is to Catholicism—it is the symbol that encapsulates the core of the space.

Figure 5-7

Figure 5-8

What it can mean: Arrival, the sense of majesty and grandeur, the signs of another world or exotic place.

How it can be maximized: The lead area should be considered in the overall context of the space. In a theme park, too many lead areas in the same themeland can present conflicting messages or overpowering sensory stimulation.

How it can be tied to the spatial story: The lead area can be looked at as a character in the story that you are trying to tell. If it is placed effectively within it space, it can help convey—along with the other elements—a sense of what the space means.

Merchandise Areas: Some guests have commented to me that the merchandise space is often overused in a space. As well, some complain that its placement in a space is sometimes too overt. The exit of a museum exhibit or a themed ride in a theme park may lead the guest to a gift shop. The question must be asked: Does that gift shop have a purpose in the immersive space *other* than merchandising?

Figure 5-9

What it can mean: Ideally—the continuation of the story being told in the space and a way to experience the ideas of the space later in the home. Less ideally—"Buy This!"

How it can be maximized: Care must be given to using all merchandise spaces in ways that will complement the theming or design nature of the space. Focusing on merchandise for the sake of merchandise may come off as a hammer over the head to the guest.

How it can be tied to the spatial story: An effective merchandise space conveys a sense of the story being told in the space and it does so in a way that seems authentic or natural to the space. The guest is offered a bit of the story to take home (see the idea of lifespace later in this chapter and in Chapter 8).

Service Areas: The service space is sometimes referred to as the "front line" in a themed or consumer space. This is the area where guests have direct and intimate contact with members of the service team. A service space is absolutely key to the creation of an immersive world because, as Mark Wallis helped communicate in Chapter 3, the service worker is the primary interactive means through which a guest experiences a place. Designers may wish to distinguish between those service workers who provide a more functional role in the space and those who are directly involved in the frontline delivery of the brand, product, or spatial character.

Figure 5-10 Inside Mille Miglia at Europa-Park (Rust, Germany).

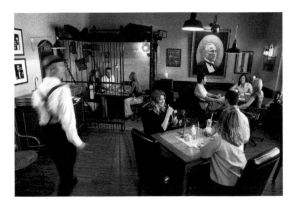

Figure 5-11

What it can mean: A sense of what the space is all about, the idea of the space coming alive through the service persons working there.

How it can be maximized: Service persons should be trained in ways that reflect the overall meanings of the space. For a space that relates the nature of a far-off land (World Showcase at EPCOT, for example), the individuals must effectively and convincingly portray their parts.

How it can be tied to the spatial story: For the story to be convincing, the service persons must, like the characters in a novel, establish the core moods, values, sensibilities, and concepts of the space. A balance of core service standards (the guest is always right, the value of being courteous and helpful, etc.) and specific service standards relative to the theme or design approach of the space should be struck.

Quiet and Secluded Areas: The quiet or secluded area is a challenging element for an immersive space. The trick is how it can be made a part of the overall space. Guests should be given places to relax and unwind but not at the expense of their inclusion in the narrative of the immersive space.

What it can mean: Relaxation, respite, freedom, reflection.

How it can be maximized: Care must be made to make sure that the space fits in with the overall theme or design approaches of the space. The design should also consider how much of a break from the flow of the space is desired.

How it can be tied to the spatial story: An effective quiet or secluded area complements the theme or design approach of the space. It might include elements or nuance within the design as if to say to the guest, "The story continues here, even when you are resting."

THE GUEST, EXPERIENCE, AND IMMERSION **147**

Public Areas: A public area is any space in which guests mingle with one another. In a themed casino, it might be a public space that is apt for staging performances; in a museum, it is a central hall where guests enter before reaching smaller and more secluded exhibition spaces; and on a cruise ship, it may be a public pool area.

Figure 5-12

What it can mean: Relaxation, respite, freedom, reflection, possibility, interaction, meeting, vastness.

How it can be maximized: Care must be made to make sure that the space fits in with the overall theme or design approaches of the space. The public area is a great space in which to present large-scale performances or in which to highlight a key design element, perhaps a lead element as discussed earlier.

How it can be tied to the spatial story: The public area should be themed and designed in accord with the overall mood of the space. It should take advantage of its openness and vastness to create feelings of escape, freedom, and possibility in the minds of guests.

Atmosphere: As we talked about in Chapter 3, the atmosphere of a space refers to the general "climate" that is promoted in a place. Just like the actual atmosphere that helps support life, an immersive atmosphere involves the total combination of all of the elements of the space and the resulting moods and feelings that it generates in guests. Atmosphere could be described as the ability of an immersive space to make all of the connections needed—with the guest's senses, his or her personality, desires, etc.—in order for the guest to be fully immersed in that space or world.

Figure 5-13

What it can mean: I am here, this is where I want to be, I am overcome with this place.

How it can be maximized: Atmosphere is key to a meaningful immersive space. Uses of sensory elements, technology, and forms of interactivity (see Chapter 7) can add many dimensions of atmosphere to a space.

How it can be tied to the spatial story: The various elements of a space, in combination, form the atmosphere of a space. In using forms of atmosphere, attention must be given to how the story or design should unfold in space. Atmosphere can be used to "punctuate" or highlight key sections of a space; this is akin to elements of setting in fiction.

Application—Your Walkthrough

What would you want to see if doing a walkthrough in an imagined space? Take an opportunity, here, to focus on the elements of an effective immersive space. We have reviewed some of the possible elements of an immersive space. Let's look at these and use them to work on three possible exercises.

Exercise 1 (Other Space): Take the above elements—entrance areas, lead areas, etc.—and create a short chart on your piece of paper. This will be for a space that you have chosen and should be one where you haven't been directly involved with the design. For each of the elements that you have included, create one row, then make two columns. Label one "Successes" and the other "Failures." Now, work on writing down some reasons why, for example, the entrance area of the space you picked works and other reasons why it does not. Repeat this for all of the elements that you have chosen.

Exercise 2 (Your Space—Current): Do the same for one of the spaces that you have designed. Use the same elements and produce the columns for successes and failures. You can think of using this exercise to review the effectiveness of the immersion within your space, perhaps with the idea of future alterations.

Exercise 3 (Your Space—Future): Now consider a space that you might design in the future. For the successes and failures columns you will want to write ideas of how you can make the space successful in

each area—entrance areas, atmosphere, etc.—and also some reasons why the space might result in immersive failures. Work on as many of these exercises as you wish and consider sharing your versions with the versions of other designers.

Trending—Reflexivity and Personal Space

Figure 5-14

When we talk about reflexivity we are talking about forms of reflection. We all reflect on our own experiences and we often think about how we relate to the bigger world. Religion and forms of belief, including politics, give people a sense of connecting their individual experiences to the bigger world. Likewise, consumer culture, including branding, provides the same sort of connection that people often experience with belief. Over time, space has become more personal. If once early humans shared a cave, we now often carve out spaces of our own. Perhaps it is the inside of our car, our den, or our favorite diner that we frequent and make our own. The trend of spaces becoming more personal has resulted in interesting opportunities for designers. New immersive spaces can take into account the idea of personal focus. Spaces might *focus on the uniqueness of the guest*, especially in the sense that the guest is made to feel as an individual who has her own special qualities, interests, and desires, as opposed to

one of thousands of others in the place. Venues could also ask the guest to *look inward* during the course of the stay in the place. In a museum, for example, an exhibit on recycling might, ever so gently, ask the visitor to reflect on his own consumption and recycling patterns. Similarly, a space could focus on the value of the guest *celebrating his or her identity*. A theme park could have a themeland that celebrates the contributions of all people of various backgrounds and there could be design elements within the space that project the image of the individual guest onto a bigger screen, thus emphasizing how the individual person contributes to the world. Lastly, a space can be developed to help *empower guests*, such as in the sense of saying, "Yes, *you* do make a difference." A lifestyle store could create a specific display that asks shoppers to donate some of their money and, in so doing, it promotes the values of the company and the contributions made by guests who enjoy the store. These are just a few possibilities of how the reflexivity and personal space trend can be imagined.

The Guest

The guest is where any themed or immersive space begins and ends, plain and simple. A theme park without guests is a static collection of rides, a cruise ship without passengers is a hollow vessel without purpose. Everything that designers do in a space has to do with the guest. Who the guest is, what the guest likes to do, what quirks the guest has, and many other issues all impact the design of a space. Let's talk more specifically about the guest in order to think about the why and the how of connecting the immersive space to the world of the guest.

Reflection—Scott A. Lukas

I have had a lot of experiences in the spaces that are considered in this book. As a cultural anthropologist, I am somewhat unique since I don't study traditional cultures. Once, during a research trip to the Las Vegas Strip, I found myself inside a cab talking to the driver

about why I was there. "Here for a conference?" "No," I said, "Here for work." He asked me what I did and I explained that I am an anthropologist and I study, among other things, themed spaces like the casinos along the Strip. He seemed confused, "Don't anthropologists study *real* places?" Over the years, I have taken insights like this and have applied them to better understanding what these many themed and consumer places are all about. My most unique experience was the time I spent as a trainer at Six Flags AstroWorld. This was really the first time when I became aware of the role that the guest plays in a space. Up to that point, I had only been a guest at Six Flags, Disney, and other theme parks, but when I got the job at AstroWorld, I was transformed. I began to think of the person who visited a theme park as a whole different creature.

Figure 5-15

One of my first jobs at the theme park was to learn all of the positions. This involved cross-training in departments like Parking, Operations, Human Resources, and Guest Services. It was unique because I was able to see every facet of how a guest relates to a theme park. I interviewed potential new employees, I dealt with upset guests trying to park their cars, and I got to see the same upset guests in guest relations. Once I settled into my everyday job at training, I realized how challenging the job would be. We hired people from every walk of life and thus we had to think about making sure that every employee was able to connect with guests in a way that would sell AstroWorld and the Six Flags theme park experience. Employees took on what the sociologist Arlie Hochschild calls "emotional labor," which meant that they had to act professional with guests and meet their needs all the while keeping their own personal needs fulfilled.[2] In the training seminars that I helped lead, I became accustomed with all of the lingo that we now take for granted—the guest's experience, service first, the gold standard, and many other variations. In our seminars we asked all employees to do role-playing activities that were geared at helping them relate better with guests. Some employees could never quite step into the role of a guest-focused service employee because it was so demanding in many, many ways. Looking back on the opportunities to work in the theme park, I think about the unique experiences that I had with guests and with workers. I didn't love every guest that I met while at AstroWorld, but I came to respect most of them and because so many of the Houston locals had worked hard to save up the money to take their families to AstroWorld, I gained a sense of appreciation of why they should matter so much as guests in our world.

Why the Guest Matters

In addition to the fact that people often pay a lot to visit a themed or consumer space, we can think of all of the other reasons why the guest does truly matter. The spaces that you help to design are not just places that people visit for the heck of it. Guests invest their money, time, and energy to visit these spaces and in so many ways, and often more so than compared to other spaces, consumer spaces have become the primary sites in which people relate to one another (family, friends, and strangers), in which they develop their sense of who they are and how they connect with the world, and in which new and creative ideas can emerge in their minds. These are spaces of possibility, transformation, and excitement. Creating a space that guests truly love is a human act—one that can change the lives of guests (and workers) in dramatic ways.

Insider's View

Anthropologists talk about the "**emic**" view, which is a fancy way of saying the insider's view or how someone from a particular culture sees the world. They see it in an insider's way, which means that they know all the nuances, gestures, attitudes, and values that someone who isn't from the same culture (an outsider) doesn't. Earlier, we considered some internal monologues that might be the thoughts of guests within a given consumer space. We can use an insider's view to think about how to create a space that will anticipate the needs, desires, and dreams of guests who visit a space. Here are some ideas that you might consider:

1. Think about *every element* within the space from the perspective of *how it will be used by the guest*. Put yourself in the shoes of the person who will use the space and consider every aspect of its use.

[2] Arlie Hochschild, *The Managed Heart: Commercialization of Human Feeling* (Berkeley, University of California Press, 1985).

2. Consider ways of *personalizing* the experience of the space. Uses of technology, for example, may allow the space to take on a quality that seems entirely intimate to the guest. A ride can be enhanced by simple technology that allows the guest to input his or her name and then see it displayed with the names of others.

3. Focus on *all possible variations of a guest's mood* as the person encounters a space. For example, if a queue line is being developed, how can you work in an understanding of the possibility that a guest waiting in that queue line might, at times, become annoyed with the wait? How can this possible mood (and a way of transforming it into a more positive one) be worked into the space?

4. Related to the last area, consider ways in which a space may *adapt* to all of the possible uses of the guest. If there is an outdoor garden area, for example, are you willing to consider the fact that a family might spontaneously adapt the space for a picnic lunch?

5. Think about the fact that even though there are many ways that a space can appeal to all guests, there are situations in which *guests bring unique needs* to the space. The quirks that we all share are often confounds to those in the service industry who attempt to meet all of our needs while we are on site.

The Guest over Time

People who have worked in the tourist or service industry are, no doubt, familiar with the unique, if not peculiar, characteristics of the guest. I work in the community of South Lake Tahoe, California. This is a town that is primarily known for the appeal of its natural beauty and the many tourist industries that play off of the landscape. Locals who work in the service industry often bemoan the fickleness, and occasional rudeness, of the tourists who visit the community. These locals are quite aware that they have to suspend their wishes to talk back to a tourist and, instead, they develop innate ways of analyzing and understanding tourist behaviors. We can do the same thing and think generally about how the typical guest has changed over time and how that can be leveraged for more success within the space (Table 5-1).

Demographics

We can see that the guest who comes to the theme park or themed restaurant today is much different than the guest who visited Coney Island amusement parks of the past. We may also look to some demographic trends to get a better sense of how the specifics of the guest can be tied to the design of the space.

In terms of *ethnicity and cultural* background, there have been examples of design trends along the Las Vegas Strip that reflect an interest in meeting the cultural needs of guests. The MGM Grand in Las Vegas changed its casino entrance—which featured guests walking through an MGM lion's mouth—because of some associations that some guests had with the feature and bad luck. *Gender and sexuality* are significant demographic factors in the design of space. Consider what might happen to some guests if they visit a bar or themed casino that is oriented along the lines of male heterosexuality. Images of buxom women and scenarios in which males are at the top of the social hierarchy might not resonate with women and gays and lesbians. In such a situation the client has to consider whether or not it is worth potentially alienating some guests in order to meet the desires of another demographic segment.

In terms of *age* we should think about the tricky ways in which it can impact the reception of a guest to a space. Very quickly, a space can become identified with an age group because of its content. Cruise ship designers have paid careful attention to this issue and have used multiuse spaces—sometimes with contrasting design,

Table 5-1 The Guest and Change

Factor	Change	Leveraging
Family Focus	The family is the social unit of many cultures, and as such the family is the primary focus of many immersive spaces.	Consider ways that space may appeal to all members of the family.
Intelligence	In the past, it was possible to design spaces that didn't account for the intelligence of the guest. Today, the guest is ever more savvy and aware.	Think about ways of honestly and intelligently connecting with guests. Avoid the pitfalls of places like Lapland New Forest and any form of design that takes the guest for granted.
Cultural Awareness	Now, more than ever, guests have experiences and familiarity with other cultures and other cultural experiences.	Focus on any general trends with guest awareness of cultural experience that may help develop a space (for example, consider the idea of charity and generosity within the space). These might be universal values that can transcend cultural differences.
Expectation	Over the years, guests have developed greater expectations of what they would like to see, do, and experience in a space.	Offer a variety of experiences within a space and consider focusing on the adaptability of the space to new social trends. Also consider implementing, at least generally, themes or forms with the space that reflect some of the current interests of guests in a culture.
Connection	Gone are the days in which a guest experienced the space as a solitary person. Today, guests are interested in a variety of experiences and they are fascinated with the possibility of interacting with others, other ideas, and other experiences in the space.	Think of forms of design that may promote the overall idea of connection. Consider forms and approaches that will offer guests the ability to connect with others in the space.
Social Networking	(see below)	(see below)
Imprints, Give Backs, and Takeaways	(see below)	(see below)

sometimes with more abstract or less age-specific design—in ways that are attractive to all age ranges. *Disability* is also a concern for spatial design. Disabled guests deserve the same treatment as other guests. Particularly when there are issues associated with moving up or down levels or into potentially cramped spaces, design should focus on achieving the maximum level of accessibility for all guests.

Religion and belief (including political values) also play a role in designed space. Care must be given to assuring that guests are not offended by any content or interpretations of design that may draw negative associations with certain groups or belief systems. For this reason, it is advisable that very specific or controversial issues be avoided in design spaces. *Life interests* refer to specific things that guests enjoy doing

in their leisure time. People from different cultures have different life interests, but general life interests may be introduced into a space. For example, excitement and interaction are characteristics that can be used in a space because they are ones that cut across most cultural differences. We'll speak a bit more about many of these demographic issues as they relate to the branded space in the next chapter.

Trending—Social Networking

Figure 5-16

Social networking has transformed the ways in which people relate to others and the world around them. Services like Facebook and Twitter allow people to connect with others in ways that had not been possible in the past. Guests use social networking not only to connect with their friends and family members but also to detail the course of their everyday lives. Where else but on Facebook can one read the intimate details of a social contact that includes items like grooming the dog, taking the kids to the mall, and sitting down to watch a reality TV show. One response to such

minutiae is to write them off as babble, but designers can take a different response and instead use insights about mobile media and social networking to think about the design of consumer spaces relative to the guest's needs. In terms of *research*, we might consider how social networking (Twitter, Facebook) can be put to good use in terms of the identification of new consumer trends. In terms of *design*, new emphases can be developed in space, especially those that reflect the ability of guests to map their experiences onto the space and to connect with others. **Geocaching** and location-based social networking (such as foursquare) are examples of trends that combine social networking, mobile technology (GPS), and the use of public space. We will focus more extensively on this topic in Chapter 7.

Imprints, Give Backs, and Takeaways

Figure 5-17 Market Theater Gum Wall (Seattle, WA) — a space that allows an interesting version of the guest imprint.

A very significant trend in the design of immersive spaces has been the imprint, the give back, and the takeaway. These all refer to ways in which there is a more than surface impact on the guest or ways in which the guest can impact the space. In the case of an imprint, the person visiting the space is allowed to

make her presence felt in the space, even long after she has left it. As a child, I recall making a special trip with my parents to Gino's East, a pizzeria in Chicago. I was especially excited about this place because I had heard that anyone could leave a message or personal form of graffiti on the tables, booths, or walls of the restaurant. This kind of imprint makes one feel like he or she has had an impact on the future of the space. Give backs refer to ways in which the guest can give something back to the space. This is like the imprint but it's a much deeper connection between the guest and the place. Near the site of the World Trade Center terrorist attacks, there are interesting multimedia storytelling booths (created by StoryCorps) that allow people to listen to the stories of others who experienced the horrors of September 11th.[3] People can even record their own video diaries and offer the world a sense of their impressions of September 11th. A takeaway refers to whatever things—material or nonmaterial— that a guest takes away from the space. For a child, a takeaway might be knowledge and appreciation of the issue of climate change after visiting an exhibition with his or her family. For another guest, it might be the image of a key water feature in a theme park that will allow the person to recall and fondly revisit the space later in the mind. Whatever the version or form, these types of connections that can be developed between the space and the guest can be invaluable ways of creating more meaning and more immersion in the space.

Application—Design Give Backs and Takeaways

Focus on the last segment that detailed imprints, give backs, and takeaways. Consider one way in which you could design one of these forms in your space. What design approaches would you use to create this form? What would your overall goals be in the design? Why

[3] See http://storycorps.org.

would it be important to use this type of imprint, give back, or takeaway in the space? Work on answering these questions in a short response and feel free to share it with a colleague.

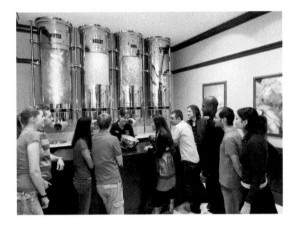

Figure 5-18 One of the many experiences at Heineken Experience (Amsterdam).

Story and Experience

The immersive space is one that is ripe with direct engagement of the guest. When designed with the guest's needs or wishes in mind, the space is transformed from a static one to one that is living, dynamic, and interesting in multiple ways. A key to creating such a living space is to incorporate various forms of design storytelling. What are some ways that stories—as things of life, experience, and energy—can be used to make the space more meaningful to the guest?

Story as the Immersion Factor

Story may be considered the most relevant factor in the creation of immersion within a space. Story is what holds a space together by linking elements, creating situations, establishing moods, and involving guests. Chart 5-3

expresses the total power of story: characters, plot, backstory, setting, and many other factors contribute to a vision of the world that appears, at all times, to be a vivid and realistic telling of that world. Story is the immersion factor, but what is it about certain stories that resonate with guests and others that do not? Why, for example, did people around the world go crazy for stories about child wizards and teenage vampires in the 2000s?

We have addressed some of the elements of this chart in previous chapters. You will notice that at the top we have all of the conditions that influence how someone experiences a story—the person has a background, has an ability to suspend disbelief and accept the story, has a desire to share the story with others, and so forth. Affecting any audience are the traditions of society, such as tendencies to retell certain stories or to tell stories in

Chart 5-3 The Story and the Audience

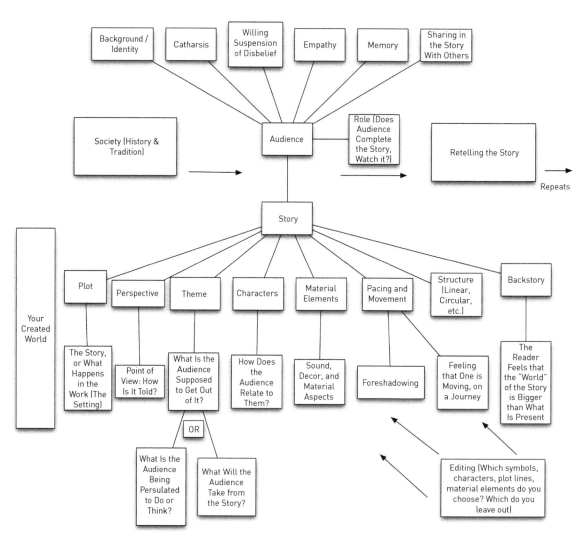

a particular way. The bottom half of the chart includes the many elements of story like plot, theme, characters, structure, and so forth. As the audience interacts with the story an experience is created.

Story and Experience

We can look even more closely at the significance of stories in terms of their direct impact on the guest. In Chart 5-4 we analyze how story and experience relate. In a designed space, experience may be viewed as that which happens when the guest interacts with the space.

For the child who first visits a theme park with his family, the story offered by the spaces in the theme park are absolutely key in creating an association between the space and that child's experiences. The child feels a sense of comfort being with his parents in a safe and clean environment. He feels that he is on a journey as he rides the many rides, interacts with magical characters,

and visits the attractions in the place. All of these vivid associations (represented in the top half of Chart 5-4) are made possible because of the nature of the experiences. At all levels—sensory, cognitive, emotional, and others—the child is taken into the vivid landscapes of this other world.

Spatial Stories

Recall that Chart 5-1 described the different levels of immersion that guests often experience in a consumer space. We can also consider the ways in which designed spaces provide an opportunity for immersion. Story is one of the most powerful ways that people connect with the world, and the case is no different in terms of spatial stories. Just as a novel must involve interesting characters, dynamic plot, and engaging action to get the reader involved in it, the effective immersive space must use a story that guests will appreciate, believe,

Chart 5-4 Story and Experience

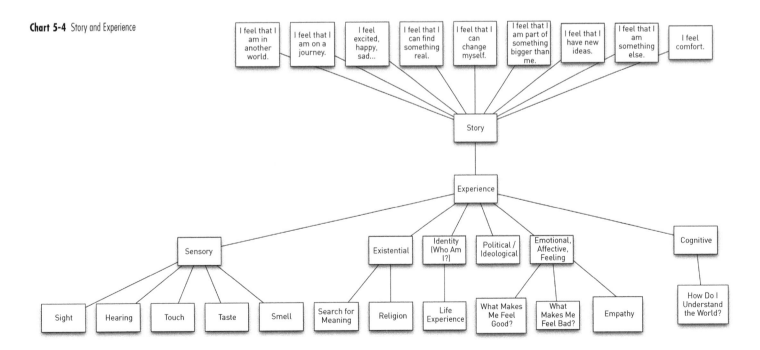

and want to be a part of. Even if the guest feels that he or she doesn't want to be part of the space—perhaps in a situation in which the person visits a harrowing museum exhibit—the guest should still feel connected to that space.

Architect David Rogers offered the following advice in a recent interview: "Storytelling within the built environment is significantly more challenging since it must be a fluid and dynamic story in order to attract and appeal to various generations with ever-changing demands and tastes. The story must involve varying layers of experience and stimulus in a 'choose your own adventure' form without being cheesy or tacky. This is very tricky and requires a unique balance of integrating, entertaining and educational content that appeals to numerous audiences, an emotional connection to the place, a look and feeling of excitement, varietal offerings, historical context, and all under the premise of attracting a large number of people to create a catalyst of sustained value."[4]

The Subjective Factor

As much as we try to design the most immersive spaces, we must realize that there will always be an element of the subjective in terms of whether guests will be able to be immersed in a space or not. The term subjective refers to "reality as perceived" and thus, we can say that any designed space, as it is perceived by a guest, will not necessarily reflect the views of the next guest or the next one after that.

As Rogers reminds us, spatial storytelling poses significant challenges to the designer. There are two factors that are involved: one is the designed space and the ability of it to wrap the guest up in it and the other is the desire of the guest to be involved in that world. We have to consider that no matter the design, there will always be a possibility that the guest will be unable or unwilling to be an intimate part of that space. This "subjective factor" will always loom over a space. Even with the subjective factor at play, the design of immersive spaces may benefit from a number of key considerations of storytelling:

1. Consider the ways that *setting* in a novel can be applied to the design of a space. Some of the greatest theme park rides (EPCOT's Test Track, for example) use all parts of the ride area—the ride itself, but more importantly the queue-house, the exit areas, etc.—to create a sense of the story's setting.

2. Focus on ways of developing *plot*, whether on a small-scale (like one segment of a themed space, a ride, or attraction) or on a large scale (the entirety of the space being developed). Many casinos, including Caesars Palace in Las Vegas, use the chaining of design spaces, thematic vistas, and atmospheric mood elements to suggest the progression of the guest in a loose "plot" of the space.

3. Develop the idea of *characters* in ways that parallel the use of characterization in fiction. In some cases, the characters in a space may be actors or animatronic entities that provide guests with an immediate sense of characterization, while in others, the quality of the space itself acts as a character for the guests.

4. Think of John Gardner's idea of fiction as the creation of a vivid and continuous *dream*.[5] Any space being developed should have the qualities of a dream—a vivid reality that seems real to those within it.

[4] Personal interview

[5] John Gardner, *The Art of Fiction: Notes on Craft for Young Writers* (New York, Vintage, 1991), p. 32.

5. Offer the idea of *perspective* in the space. In a novel, the narrative may be told from the first-person, third-person, or other perspective and how it is told impacts the reception that the reader has to the story. In 2011, the Field Museum in Chicago offered an exhibition called Underground Adventure. What was unique about the story of soil that was being told was the backstory that each guest entering the space was shrunk to a microscopic scale. As people walk through the exhibit, they have the unique perspective of being at the same small scale as the organisms being described in the soil.

6. Consider the power of *theme*. Some of the greatest works of fiction offer powerful themes that help resonate the story in the minds of the reader. In the same way, a space can provide themes to the guests who visit it. Many aquaria, including Monterey Bay Aquarium, create a larger sense of the story being told about aquatic life by extending the narrative to issues beyond the space of the aquarium. Establishing the theme of conservation tells the guest about important issues that are brought to light in the space of the venue.

7. Think about the use of *backstory* within the space. A backstory, like that described at Atlantis Bahamas and Atlantis Dubai, can create a sense that a space is bigger than it seems. The pieces that cannot be exhaustively created in the space—due to practical reasons not present in a novel—are instead described to guests and the overall effect is a greater appreciation for the entirety of the space at hand.

8. Establish a sense of *mood* that can lead to feelings of awe, the epic, and the transcendence of the self. In this way, a space will take on the qualities that make all art (fiction, dance, painting, music) something that seems to transcend its very nature.

Designing with the Guest in Mind
Interview, Nancy Rogo Trainer (AIA, AICP, LEED® AP)
Principal, Venturi, Scott Brown and Associates, Inc.

Figure 5-19

Nancy Rogo Trainer is a principal of Venturi, Scott Brown and Associates (VSBA). Since joining VSBA in 1987, she has provided planning and design services to academic and cultural institutions. Her projects include campus plans, museums, student centers, and libraries—design that helps build community by integrating social, strategic, and physical goals. She has led or directed planning efforts for institutions including Villanova University, Haverford College, the University of Michigan, and the Radcliffe Institute for Advanced Study at Harvard University. Her architectural projects include Harvard Divinity School's Rockefeller Hall, the Schlesinger Library on the History of Women in America at Radcliffe, and VSBA's winning competition entry for the extension of the Stedelijk Museum in Amsterdam. She has taught undergraduates at Temple University and the University of Pennsylvania and has been on the Drexel University Department of Architecture's adjunct faculty since 1990. She is currently a member of the Philadelphia City Planning Commission.

Can you speak a little about your background and/or the work done by VSBA?

VSBA's work is mostly for institutions—colleges and universities, museums, and hospitals—and includes planning, programming, architecture, and adaptive reuse.

Our firm's strengths are rooted in the ethics of its founders Robert Venturi and Denise Scott Brown—combining social planning, an emphasis on responding to context (broadly defined), and a particular interest in the public realm. Dan McCoubrey and I, who currently lead VSBA and direct all design, have deep roots in this ethos. We both have backgrounds in preservation as well, and a lot of our work is in particularly sensitive historic contexts, like our plan for Harvard's Radcliffe Institute and our subsequent renovation projects.

In designing your architectural projects, to what extent do you think about the people who will use the spaces you design? How much do guests matter when it comes to designing your projects?

We think a lot about how people use our buildings (of course)—and there are a lot of different kinds of users to think about. There are the people who live or work there, people who visit, and passersby of many different kinds...and the people who maintain the space. So design has to work on multiple layers.

Could you also get into some of the specific dynamics of how you think about people using the space you are designing, such as functions of spaces, flow, movement of people through it, visual and perception issues of people in the space, etc?

Being able to think about a place from many points of view—and synthesizing these points of view into a coherent whole—is at the center of our design process.

Every project has its own set of variables. I remember, early in my career here, working on a campus center for the University of Delaware. Before we started thinking about the design, Bob asked me to watch over the course of the day how people moved through the existing site, which was a parking lot. A strong "desire line" through the lot was readily apparent, and became the basis of our design—which has a galleria-like "street through the building" adjacent to an exterior path along the building. That experience—of watching how people interact with a place, then translating it into built form—has stayed with me. Our planning work informs our architectural projects, and so we tend to think a lot about how people will approach and move through a space, and how circulation patterns outside a building might continue inside as well. A lot of our projects—and almost all of our planning work—include as part of the process making drawings modeled after those Nolli did of 18th century Rome, showing the continuity of the interior and exterior public realm. We make a lot of diagrams illustrating patterns of use and movement and find that this kind of thinking is useful at many different scales of design. These diagrams and patterns aren't just abstractions or generalizations, though—we use what we learn from them to design places that people will use and enjoy using. They can help us understand where gathering places should be, for example, or where we should put eddies off corridors to allow chance meetings to continue for a while. They help us figure out how to accommodate a great range of social interaction that includes people who like to be in the center of things but also those who like to participate by looking in from the edges; and, of course, places to be alone. Most projects have some combination of these.

Can you speak to some of the differences of designing for different types of spaces— educational, museum, religious, commercial, residential, health care—and perhaps also

speak to differences as related to the different people who will occupy the space?

There are a lot of similarities—everyone wants to be comfortable, to have a beautiful place to be (even if they're not consciously thinking about it most of the time), and most places benefit from having some combination of community space and individual space. But the differences are important, too—in how people relate to each other and the place. Patients and visitors coming to a hospital, for example, might be fearful and distracted—so paths to their destinations need to be beautiful and calming and, above all, absolutely clear. The people who work there every day, though, need other things—the right kinds of space to do their jobs, places to see colleagues, and quiet space to think. So the scale of spaces; their relationships to each other and to the outdoors; their finishes, lighting, and acoustics— these will vary considerably, even within a given project. And, some buildings—like museums and rare book libraries—house objects with conservation needs that need to be integral to the design.

Figure 5-20 Dartmouth College, Rauner Special Collections Library

How do you design work around the unique ethos and traditions of the client?

We try to understand our clients' lives—even if those clients are institutions. So we aim to get well beyond a physical or functional understanding of the project: we learn about their history, their mission, their goals for their institution as well as for the project at hand. We do this by listening, looking, and reading—and by asking a lot of questions. This helps lead to design that not only meets our clients' functional needs (that's a given), but also relates to their identities and values. We seldom begin a project with a very clear idea of where we'll end up— which can be a little unsettling at first, but also exciting. The process of learning about and viewing a project from many different angles gives design its richness and vitality. It's not only an investigation, it's an adventure.

Do you ever think about the feedback that people give when they use a space that you have designed? People as they use a space occupy it—they imprint on it (as in Jonathan Raban's Soft City), they express emotions, they employ their senses.[6] How much of this feedback impacts the projects that you design and, perhaps, redesign or alter in some way?

Often we try to imply uses rather than dictate them— providing low walls for seating instead of benches, for example—and it's great fun to see how people use "our" spaces. And we try to leave some flexibility in the design, too—so people can move things around and inhabit a space in different ways without losing the underlying order of the plan.

Your firm is associated with the landmark study Learning from Las Vegas.[7] Can you speak about why this project was significant and to what extent does it define any of the work that VSBA does today?

[6] Jonathan Raban, *Soft City: A Documentary Exploration of Metropolitan Life* (New York, Harvill, 1998).
[7] Robert Venturi, Steven Izenour, Denise Scott Brown, *Learning from Las Vegas: The Forgotten Symbolism of Architectural Form* (Cambridge, MIT, 1977).

Bob, Denise, and Steve's studio—and the book that came out of it—demonstrated that there were lessons to be learned from every environment, even (or maybe especially) from the ones architects aren't "supposed" to like, like 1960s Las Vegas. The book illustrates ways of seeing, analyzing, and understanding a particular place—one that considers signs and symbols along with patterns of movement and use. It has an ethical dimension as well, advocating for seeing and appreciating things independently and objectively. This ethos continues to inform our work on a daily basis. Almost all our projects begin with a "Learning from..." study, where we look at and analyze the environment we're designing for from multiple perspectives—trying to understand both the what and the why of a place, what it is, and how it came to be that way. We think this helps lead us to design that resonates, that engages in conversation with its context, in a very meaningful way.

Trending—Lifespace

Nancy Rogo Trainer reminds us of the important considerations that must be made in terms of designing a space with the guest in mind. As new trends emerge in the design and execution of themed and immersive spaces, more designers have begun to focus on meeting the intimate needs of the guest. We may call this tendency in design a lifespace, and we'll talk a bit more about it in Chapter 8. It represents the idea of a space that most fully meets the needs of the guest.[8] No longer does the guest feel separate from the space. Instead,

he or she has the sense that the place that has been created is *all about* him or her. It is a place that follows the guest even after the person has left the space, suggesting that design can be impactful not just within the space at hand—theme park, cruise ship, cultural museum—but in the spaces that are used and inhabited by the guest when he or she is at home. Where once themed and immersive spaces sought to take people to other, exotic worlds, a tendency of the lifespace is to make the space feel more intimate to the guest. The greatest impact of both immersion and spatial storytelling is the lifelong effect that it can have on the guest. No doubt, we will see many other trends that will alter the directions that themed and immersive spaces will take, but as we have stressed throughout this book, *the guest is always right* and spatial design must respect this fundamental truth.

IDEAS FOR CONSIDERATION

1. What are the greatest challenges to creating a space that is immersive to the guest?

2. How can designers deal with the fact that different guests will seek different levels of immersion?

3. In your mind, what are some of the most important ways that your design approaches can help make a space one that will better connect with the guest?

4. What are some of the key ways that effective storytelling can be developed in your design space?

[8] Scott A. Lukas, "From Themed Space to Lifespace," in Judith Schlehe et. al. (eds.), *Staging the Past: Themed Environments in Transcultural Perspectives* (New Brunswick, Transaction, 2011), pp. 135-153.

1. What is the value of research in terms of designing immersive spaces?

2. What are some techniques that may be used to inspire creative design?

3. What are some approaches that designers and design teams may use to develop new and exciting spaces?

RESEARCH BREAK

Research

To take a research break means thinking very closely and carefully about the ideas behind immersive space design. The most successful films, video games, novels, and, yes, themed and consumer spaces, are those that draw on knowledge of various sorts. For an author who wishes to write a historical novel about 18th century France, the writer must have the knowledge of the setting, types of characters, events, moods, and everything else that would been experienced by people in that era of France. Not having this knowledge will result in a less-than-believable, if not laughable, novel.

In most cases, when a space fails to live up to its potential, it may be because of bad design, errors in operation, or the pure fickleness of guests combined with market forces. We can't forget that bad design could be a result of bad research or a lack of knowledge about what is needed to make the space work for the guest. The meaning of "research" comes from late-1500s French words *recerche* and *recercher*, meaning an "act of seeking out or searching closely." In the 1600s it developed a meaning associated with "scientific inquiry." As we use it here, let's think of ways to seek out, search, and better understand how to make a space more immersive, authentic, and exciting for the guest. We will look at a series of research tools, methods, or forms of creative inquiry that are presented as ways of thinking about how to generate immersive spaces. The ideas are not presented in any particular order. They are meant to inspire overall creative thinking about the design of immersive spaces.

Mode Reassociation

Approach: Sometimes you need to get out of your own shoes to better understand what you are trying to find. In this case, mode reassociation uses the idea of switching modes to better think about a project. If you are working on a design project and are using visual media to think about it—such as photos, schematic models, or mockups—switch to a different mode like music. Later, you can come back to the original mode of reference and see if your ideas have changed as a result of the switch.

Application: Mode reassociation can be used to switch the frame of reference of your brainstorming or design collaboration and can give you insights from a different frame of reference.

Example: Instead of discussing your plan for a new theme park attraction with images or drawings, you collect clips—sounds, spoken performances, and songs—that represent some of the ideas, moods, values, and events that you would like to associate with the space.

Value: This research tool takes you out of a mode that you are comfortable with and forces you to think in a different one, perhaps resulting in a more creative project.

Game

Figure RB-2

Figure RB-3

Approach: Jane McGonigal, in *Reality is Broken*, argues persuasively for the value that games play in our lives. Games, she offers, can make people more productive and can make them enjoy life more. In the world of design, a game can give a team a better sense of how to move forward with a project.

Application: Using a game—whether a premade or created board game, a video game, or a form of reality simulation—can allow a team to better look at issues in their project as well as develop their collaborative skills.

Example: A team is working on a new design project in which there is a lack of consensus. They use a series of board games, including collaborative ones like *Pandemic*, to develop a more team-oriented approach to the project.

Value: Using games can help motivate a team to work better as well as assess the nature of the project space in relationship to guest experience and interactivity.

Manifesto

Approach: A manifesto is a statement of principles. It offers a sense of the values, ideas, and limitations that can be applied to a project. In the design world, manifestos are sometimes used to stake out new ground in design.[1]

Application: The manifesto can be used to get a design team thinking about the goals behind their space, the values of it, and how the experience will be for the guest.

Example: A team is working on a new branded space that will highlight the values of a new soft drink. They want to avoid repeating other branded spaces and brands so they produce a collective manifesto of how the space (and the design project) should be.

Value: This tool allows designers and teams to state, up front, their desires about a project. This can lead to better understanding among the team and a better sense of how the project should evolve over time.

Defining and Operationalizing

Approach: Sometimes we forget to start at the beginning—the definition of what we are trying to do. In science, operationalizing refers to defining the thing that you are looking at. Sometimes teams get off track because they are not all speaking about the same thing. Better defining or operationalizing the task or project goal can be helpful.

Application: Defining and operationalizing allows the designer and the team to better understand the parameters of what they are looking at.

Example: A design team is developing an interactive attraction for a museum that is supposed to get people to appreciate the role that cultural diversity plays in everyday life. The team realizes that it needs to define what is meant by "appreciate" and "cultural diversity" before they can work on the specific stories and narratives that will be told in the space.

Value: Working on good definitions for the project and its components may result in a clearer sense of how to get the project done.

Figure RB-4

[1] One of the most interesting manifestoes is Bruce Mau's "Incomplete Manifesto for Growth," available at http://www.brucemaudesign.com/4817/112450/work/incomplete-manifesto-for-growth.

Data Collection

Approach: Data collection is one of the main approaches of research. To produce an authentic space that replicates a real space in the world, designers need to focus on gathering information or data that can aid in this design.

Application: Data collection may take many forms: interviews of key people who are familiar in an area of study, the reading of journals and texts focused on specific issues related to the design, the culling of Internet and media sources for valuable information, and the use of field trips and research visits to see places firsthand.

Example: A team is working on a casino project that aims to reproduce the moods and sights of the Rhine River. The team begins by consulting preexisting books focused on this region,

Figure RB-5

the people, and the places. They later take a research visit (see ethnography below) to Germany to get a better sense of how the real place is in person.

Value: The use of rigorous data can be a great benefit to design. It can result in more profound design because the final product will be more authentic and more meaningful to guests.

Ethnography

Approach: Ethnography is a tool from cultural anthropology. It is a way of better understanding a culture or group of people by participating in and observing their everyday lives. Ethnographers attempt to make sense of the culture or the people by looking at how they do things on their own terms. Often, ethnographers write ethnographies or written descriptions of the observations that seek to give readers a sense of what that culture or group is really like.

Application: Ethnography can be used to gather more information about a culture or society in which you are designing a new space or a culture or society that is the source of inspiration for your space.

Example: A design team takes a trip to France in order to gather more information about a Parisian restaurant that they are creating.

Value: This approach gives you firsthand knowledge of a people, place, or culture, which can add valuable authenticity to your space.

The Exquisite Corpse

Approach: Back in the day, the Surrealists came up with a neat technique that allowed a group of people to explore a collaborative approach to creative projects. The exquisite corpse

involves drawing, writing, or other use of media to create a project that reflects the desires of all of the artists.

Application: The idea behind an exquisite corpse drawing is to fold a piece of paper in three or more places. One person draws the head of the body, folds the paper, and passes it to a second person who draws the trunk of the body, and then folds the paper and passes it to the third person who draws the legs of the body. At the end, the paper is unfolded and everyone looks at the results—an exquisite (and collaborative) corpse.

Example: A group is looking at a new dark ride and wants to think about it collaboratively. Without telling the other members about his or her design, one team member draws and conceptualizes the queue house, the other the first section of the ride, and so forth. At the end, the different drawings and concepts are compared and assessed.

Value: The method allows all members of a team to work on a project in a creative way. It yields positive team results as well as necessary creative energies for a project.

Automatic Writing

Approach: Another great Surrealist technique is called automatic writing. It involves the writer jotting down the most immediate ideas that are in the person's head. You don't think about it—you just try to write what comes to your mind in the most unfiltered way possible.

Application: Automatic writing is an approach that looks at getting ideas out of a person's head, sometimes in a subconscious way.

Example: A design team is trying to think about how to create a new Old West themed restaurant so it asks all members of the team to take one minute to write everything that comes to their mind when they hear "Old West themed restaurant." After the writing is complete, each team member reads his or her paper.

Value: This method can yield some great initial creative results. It allows designers to consider what's in their minds in terms of a particular issue in a design project. It can assess if members are thinking about a project in a similar way and it can suggest some new and creative directions for projects.

Budget Workshops

Approach: Budget can be a bane for any designer. You have the greatest idea, but you are limited by the money that can be spent on its execution. This approach focuses on the need to bring together diverse voices in a company or firm in order to discuss how to make budget work for the project at hand.

Application: The budget workshop might include the key players from the design team and members of other departments. The participants might address issues like: How can the project be developed given the limitations of budget? If we don't spend the money on the project, can we still pull it off? If we have to skimp on some aspects of the execution of the project, which aspects will be the least damaging in terms of executing the story and experience of the space?

Example: A team gets together to find a way around the problem associated with a new nightclub design. There is a very innovative approach to lighting and video walls, but the client is concerned about the costs of producing the space. The design team focuses on how to achieve some of the same effects of the lights and video walls using less money.

Value: Having a clear sense of the budget that is available and how that budget can be tweaked to make it work for the project is invaluable.

Out of the Box

Approach: Yes, thinking outside of the box is a bit of a cliché, but it often yields great results. When I interviewed architect David Rogers for Chapter 1, he offered this bit of advice: "This is the only way we work and it yields the highest results. We see this [design] process as a nonstandard solution—one that involves thinking out-of-the-box and one that is outlandish. You would be surprised how often a version of the latter ends up being the right solution."

Application: An out-of-the-box approach is one that allows the designer and members of the design team to suggest any idea that comes to the mind— no matter how outlandish it seems.

Example: A team is meeting to discuss a new ride that will simulate the experiences of astronauts and one designer offers the idea of creating a zero-gravity technology for the attraction.

Value: This type of thinking is valuable because it can result in successful ideas for a design space that would have been otherwise rejected as being impossible, crazy, or too expensive to execute.

Mood Boards

Approach: The mood board is a graphical (or sometimes object-based) approach to a design project. It is used to give designers a visual sense of the mood of a particular project.

Application: The mood board includes images, and even objects, on a board or other physical space. The combination of the images and other items gives a sense of the mood of the thing being designed.

Example: A team decides to create a new restaurant that will convey the feel of Imperial China. It asks team members to bring in images, objects, and other items that can help convey the mood that they are going for in the space.

Value: This tool is valuable because it allows designers to get a visual sense of the feel of a project. It's a good initial place to start as it allows people to think about the overall approach to a design space.

Creating the Mood Board
Interview, Dave Gottwald
Graphic Designer, Oakland Museum of California

Figure RB-6

Dave Gottwald owned an interactive studio for five years before he received his MFA in graphic design from Academy of Art University. His MFA thesis was titled "Themerica—From Disneyland to Dubai: A Visual History of Thematic Design." He has taught graphic design courses and is currently a graphic designer for Oakland Museum of California.

What is a mood board and how might it be valuable for designers of theme parks and other themed spaces?[2]

I was first introduced to the mood board technique as a graduate student. It is a common tool for not only design students but also creative professionals in

[2] There are a number of online and mobile media sources for creating mood boards. These include MoodShare (www.moodshare.co), Sampleboard (www.sampleboard.com/), Olioboard (www.olioboard.com), and Adobe Collage (www.adobe.com/products/collage.html).

graphic design, architecture, advertising, fashion, and interior design. A mood board is a collage of images and other found material done in a large format, such as 24 × 36 inches. It often is flat, but I prefer to employ a more three-dimensional approach. Mood boards are used primarily to gather research and inspiration early on in the creative process and present that material to clients or colleagues. They represent an "impression" of the direction a project should take, in terms of color, typography, and overall style (or in the case of fashion and interior design, material and fabric samples).

In the case of themed spaces, a vision for a project can thus be expressed very succinctly. It's often difficult to put into words how a particular theme might inhabit an environment. How would one describe the intricate details of a Las Vegas casino resort like New York - New York?

Surely it's not enough to say, "Well, we're going to replicate New York City." The hotel complex might suggest the city, but like most thematic spaces, it's distillation—a condensed and abridged version—of an actual place. Some feelings and motifs are highlighted and "sweetened," others are downplayed. Certainly physical scale is altered.

Can you briefly described how you used the mood board in the scope of a larger research project on theme parks and themed spaces, called Themerica?[3]

For Themerica, I created boards as a way to explore the essence of what I call thematic archetypes—that is, themes that recur over and over again in new forms. Two of these were Tropical Paradise (Disney's Adventureland, Tiki bars and restaurants, etc.) and the Old West (Knott's Berry Farm, Dollywood, and others). Using the mood board was an effective way to get at the heart of these archetypes— their common ingredients and repeated tropes. One of the reasons that I stress a three-dimensional approach is

[3] http://themerica.org

that we're dealing, after all, with physical spaces. I found the roof concept from the Tropical Paradise board (Figure RB-7) to be quite interesting, and repeated the technique for the other boards. Each theme had the appropriate "roof over its head." It turned out to be an apt distillation metaphor—if you can describe the roof, you can probably fill in all the other structural details quite easily. In addition, when composing the text for my thesis, I found these boards to be a constant inspiration during bouts of writer's block. Mood boards, in this way, can function almost like a "visual thesaurus" when searching for the proper words to describe a particular themed space.

Figure RB-7

Story Brainstorming

Approach: The approach of story brainstorming involves teams focusing intently on the nature of a story that they plan to tell. The technique involves team members developing the story for a given design space.

Application: A team may use this application to sit down and focus on the specific dynamics of a story that they plan to tell. In the process, the team can discuss issues like plot, characters, setting, backstory, action, and other elements.

Example: A team decides to discuss the plans for a new museum exhibit that is focused on the issue of American debt and economic decline. It brainstorms ways of telling the story, especially given the sensitive and perhaps boring nature of the topic.

Value: This is a valuable tool because it allows designers to think about the story that they plan to tell and to assess the overall quality of that story.

Worldbuilding

Approach: In this approach a team gets together to focus on the design of a new world. The new world, and all of its characters and spaces, may be used for multiple forms of design, such as consumer products, video games, and spaces within theme parks.

Application: This approach includes designers sitting down and developing ideas for new immersive worlds. The approach may involve the use of storyboards, multimedia design, models, and mock-ups, or any other devices that can assist in detailing what the worlds will look like. Chart 1-1 (Chapter 1) may give a sense of the aspects of the world that designers may wish to address.

Example: A team sits down to do a worldbuilding workshop. Its goal is to look at worlds that have not been explored in previous consumer and media projects. By the end of the workshop, the team has two worlds that they can use for future designs.

Value: The worldbuilding approach can pay dividends because it allows for the creation of a rich world that is populated by characters, history, events, and spaces. This world can be tapped into for future projects.

Storyboards

Approach: The storyboard is a graphic tool that involves the layout of images (or "scenes") that detail the aspects of a particular story, including the specific shot to be used with each scene.

Application: The storyboard allows the design team to get a visual sense of how a space might look and to help address the issue of continuity within that space. It can be used in any context—whether a small space or a large one.

Example: For a new project involving a science fiction themed restaurant, a designer draws a series of storyboard scenes. The previsualization allows the rest of the design team to address aspects of the design, including practical issues.

Value: This technique allows for visualization to occur. This is a powerful way to think about the nature of the space, including the pacing of it, the nature of the design (angles, perspective, etc.), and how the guest will be wrapped up in it.

The Meme Machine

Approach: Memes come up more in Chapter 6. A meme refers to a concept, idea, or part of culture that is passed from one person to another in nongenetic means. The "da da da dah" of Beethoven's *Fifth Symphony* is an example of a familiar musical theme that most people recognize immediately. This approach involves the collection of data on a particular topic relevant to the design space. Computers, media, and other sources of information are culled to get a sense of how an issue, space, or approach is realized (or understood by many people) in a larger sense.

Application: The meme machine involves individuals or groups searching for sources of information that can be quite valuable in the genesis of a design project.

Example: A team decides to develop a new ride based on disaster films and disaster scenarios. It uses Google to search for initial terms like "disaster," "disaster ride," "apocalypse," etc. It analyzes the search terms, initially, through the image search feature on Google, as well as the video feature. The team makes notes as to the main ideas—or memes—that seem to be prevalent in this area of disasters and disaster rides.

Value: This tool provides designers with a quick initial survey of a concept. That survey of the most popular memes for a given topic can be used as a starting point for a new project.

Trend Making

Approach: This approach involves a focus on the key trends that appear in the world of popular culture and society. The goal is to think about how trends impact the nature of spatial design.

Application: The focus of this technique is on how trends impact the development of immersive worlds and spaces.

Example: A team sits down to discuss the three most lasting trends in popular culture and consumer spaces. It uses these trends to focus on new design projects and the modification of preexisting spaces. For example, a team determines that reality TV, first-person-shooter video games, and mobile media have taken hold in culture and the team discusses ways that these influences could be expressed within their designed spaces.

Value: This is a valuable tool because it acknowledges that a designed space does not exist in a vacuum. This allows a design team to think about the longevity of design spaces as well as future spaces that may be developed as new trends emerge.

Creative Zones

Approach: In Chapter 4, Kelly Gonzalez spoke of the creative environments that Royal Caribbean creates among designers and architects. A culture in which creativity is the norm is of great value to design. This is not so much a method but a feeling that should be promoted throughout the firm or company.

Application: The firm or company should promote creative thinking by allowing people to suggest the impossible, to dream of new ideas that seem difficult or out of this world. People should be allowed to ask questions and challenge the design ideas of others.

Example: A design team decides to promote new levels of creativity throughout the company. It focuses on a new culture in which designers' ideas will be paramount and in which the questioning of authority and naysayer attitudes will be more the norm.

Value: The culture that results from this attitude is invaluable. It will result in much more creative design projects.

Figure RB-9

Charette

Approach: The charette refers to an interactive workshop in which members of a design team work in a collaborative way to think about a design issue in their space. Collaboration, as architect David

Rogers discussed with me, is a key: "Every one of our projects begins with an interactive workshop or charette with the design team, the client's development team, and any other consultants or professionals involved in the process. We spend several days in a room with everyone looking at ideas. We lead the process of discovery but all parties involved are part of it. We research and look at the project prior to the launching of the design process, but we diagram and discuss ideas to get a client's spontaneous reactions. We don't let them say no to any of the ideas discussed so that we have a chance to develop them during our subsequent stages of design. Most projects do not have a single solution, so we must dream with our clients to seek the combination of ideas to be considered."

Application: This is a collaborative workshop that involves all participants having a role in the dialogue about a project.

Example: There is an effort to develop a new themed mixed-use district in a historic part of a city and the design team decides to conduct a charette that includes members of the design team, the developer, local politicians, and community members.

Value: This form of workshopping allows for collaboration and dialogue and both of these qualities can result in a more meaningful, creative, and executable project.

Research as Inspiration

Whatever the approaches that you use—and there are so many more than can be covered in this short "break"—consider how you can use them to achieve the greatest potential creative result. Research and methods are only as good as the spaces that they produce. In the end, the guest will determine whether the ethnographies, charettes, and mood boards were worth it.

IDEAS FOR CONSIDERATION

1. What are some general values of using forms of research to design compelling immersive and themed spaces?

2. Have you used any of the research approaches described in this text? Have you used them in different ways?

3. Beyond the ones discussed in this text, what are some research methods that you like to use to spark your creativity in your design work?

1. What roles do symbols, memes, and other main ideas play in the design of an effective immersive space?

2. What significant role does the brand play in immersive spaces?

3. How can the senses be used in an effective manner in the themed and immersive space?

THE BRAND AND THE SENSES

Big Ideas

For the guest who walks into an amazing theme park or immaculately themed restaurant for the first time, there may be a sense that the space is timeless. It feels effortless to move within it and every move made by the guest is rewarded with a new feeling, a new activity, a new sense to be explored, a further extension of a meaningful idea, symbol, or brand. This chapter focuses on the powerful ways in which symbols, brands, and the senses may be developed in a themed or consumer space.

In Chapter 1 we considered the "big idea" or the main purpose that is behind any consumer or themed space. When any space is conceived, it is important to think about what the main purpose of the space will be. Will it be a museum that tries to get guests to understand the importance of conservation and recycling? Will it be a theme park that focuses on re-creating the excitement of Victorian England? Will it be a tropical themed restaurant that aims to give guests a sense of luxury, excitement, and escape? Whatever the case, the big idea is important in establishing the lead identity of the space. The big idea must go beyond the level of a concept in the mind of the designer to the real, material world that the guest will inhabit. To that end, we can think about two main areas of realizing the themed and consumer space—one is the large-scale issue of the symbol and brand and the other is the smaller-scale issue of the senses.

Symbols and Memes

One of the most important ways of establishing the big idea of a space is through symbols. Symbols represent the key aspects of a culture—the essence of the culture distilled in a form. Symbols are immediately recognizable and thus they have the power to shape experiences from the minute that a guest enters a space. When anyone comes in contact with a symbol, the person will generally have an immediate impression. Often, it is a good association, sometimes it is a more negative one. Symbols are efficient devices because they can say a lot and do a lot with very little. They are often connected to strong senses of emotion and tap into the collective memories that are shared by many guests. As we think about symbols generally, we can consider the following strengths of using them in a space.

Considerations of Symbols:

1. Consider ways of using symbols that will assist the telling of the story. Symbols can act as "points" (from Roland Barthes' idea of the *punctum* or a prick or poke) that will make a very visceral and immediate connection with the guest.

2. Think about ways of using symbols to help move guests through the space. Children, especially, have learned to react to dramatic colors, noticeable icons, or remarkable physical features that draw them from one area of a space to the next. Symbols, thus, can act as the transition points that move the guest from point A to B.

3. Ask if a given symbol appears to be too specific or too general. A very general symbol, like the American flag, has the value of giving most guests a sense of what the symbol is, but its general nature may inhibit you from focusing on more specific matters. Very specific symbols—especially those that might be connected to the story of a particular space or even a brand—could also detract from the guest understanding and further enjoying the space.

4. Remember that symbols have more than one reference point. Your meaning for a symbol could be "great accomplishment of the nation," while my meaning might be "imperialist country." It's important to create a list of associations that guests

might have for any symbol, regardless of what the symbol is or how it will be used in the space.

5. Focus on how symbols may be used to create memorable experiences. Symbols, by their nature, resonate, often for a very long time. As a result, symbols can be used to create deep and lasting connections with guests. Consider symbols that will have a long and deep impact such that they will become traditions with guests (see Chapter 8 for more on tradition).

6. Consider creative ways to use symbols to effectively connect experiences with brands and products, such as merchandise. Always be sure to use symbols and brands in as natural ways as possible within the space.

Figure 6-2 Symbol Room, a specialized hotel room at Propeller Island City Lodge (Berlin).

Somewhat related to the symbol is the idea of the meme. The meme is a term that comes from the work of Richard Dawkins in his book *The Selfish Gene*.[1] Dawkins was interested in how ideas, just like the biology of organisms, reproduced themselves in the world. Since his initial work, others have talked about the idea of the meme as a unit of information—whether a few bars from a song, a video on YouTube, a popular phrase like "____ is the new black," or a brand or logo—that is effective at reproducing itself. If you can hum the first four notes of Beethoven's *Fifth Symphony*, then you have a real idea of what a meme is. Like symbols, memes are powerful things to use in a space. Memes, according to some, spread even faster than symbols and, as a result, they can be used to:

1. Create a space that everyone will remember.

2. Develop features in a space that people will tell others about.

3. Create a sense of excitement such that everyone will want to come to the space.

Symbols and Memes in Space

Symbols are found in every culture across the world and in just about every type of space—whether a place of worship, a shopping mall, or a city park. Designers can use symbols in their spaces to give guests a fuller experience of that space. Table 6-1 illustrates some of the ways that symbols and memes can be used in a space.

[1] Richard Dawkins, *The Selfish Gene* (Oxford, Oxford University Press, 2006).

Table 6-1 Use of Symbols and Memes in Space

Example	Common Use	Effect
Color	To create dramatic shifts of mood and emotion	Color, due to its symbolic properties, can have an immediate effect on the perception of space as well as the mood of the guest.
Cultural Symbols	To provide guests with a sense of the ideas, values, and characteristics of a place or its people	Cultural symbols can be used to establish a sense of connection with guests and a sense of continuity within a space.
Physical Feature	To create an immediate sense of time, place, history, or culture	A physical feature, whether architectural or interior décor, can establish a connection with the guest that speaks more powerfully than all of the other elements in the space. It helps communicate the essence of the space and the big idea behind it.
Big Feature	To develop a sense of purpose for the guest in the space	A big feature—such as a fountain, a ride, attraction, or other element—gives a sense of purpose to the space. A series of rides within a boardwalk area, for example, tells the guests that part of the purpose of the space is to enjoy the pleasures of rides and other attractions.
Stories and Themes	To offer a sense of meaning to the space	A story that is timeless—such as the hero's journey—gives guests a sense of understanding why the space (as "fictional" as it might be) exists. A story contains many symbols and memes that help convey important big ideas about a space.

Popular Memes in Space

Some of the most popular spatial memes are ones that are permanently etched in our minds. Quite obviously, these exact spatial memes can't be replicated in an exact sense, but the reasons behind their popular appeal can, and should, be considered. These are not listed in any particular order and do not represent an exhaustive listing.

The Eiffel Tower (iron tower located in Paris, France)

The Louvre (museum located in Paris, France)

Sydney Opera House (performance hall located in Sydney, Australia)

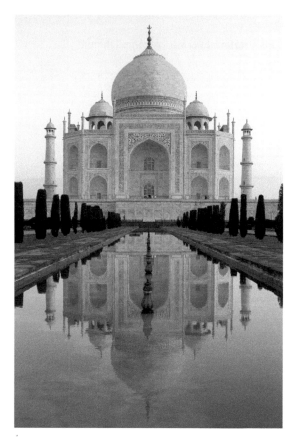
Figure 6-3

Taj Mahal (mausoleum located in Agra, India)

The Pyramids of Giza (tombs located in El Giza, Egypt)

The Temple Mount (religious site located in the Old City of Jerusalem)

The Colosseum (amphitheater located in Rome, Italy)

Big Ben (clock tower located in London, England)

Willis Tower (formerly Sears Tower, office building located in Chicago, Illinois)

Empire State Building (office building located in New York City, New York)

World Trade Center (office building once located in New York City, New York)

Burj Al Arab (hotel located in Dubai, United Arab Emirates)

The Lincoln Memorial (presidential memorial located in Washington D.C.)

Golden Gate Bridge (suspension bridge located in San Francisco, California)

Cinderella Castle (castle located at various Disney theme parks throughout the world)

As symbols and memes are used within a space, the guest will benefit by having a clearer and more immediate sense of what the big idea is as well as a better understanding of the stories, concepts, and themes that are being developed within the space. When appropriately used, symbols can be effective and efficient approaches to creating a more immersive and meaningful space.

Application—"Memeing" It

Now that we have thought about the power of symbols and memes, let's focus on a short application. Take a minute to think of a possible project that you would like to develop (or one that you have already worked on) and focus on the use of symbols and memes within that space. Begin with the big idea or what the space is attempting to do and then work on a list of five key symbols or memes that can be used in the space. Create the following chart on a sheet of paper:

Big Idea: _____

Symbols or Memes	Associations	Material Forms	Accomplishment
1. _____	_____	_____	_____
2. _____	_____	_____	_____
3. _____	_____	_____	_____
4. _____	_____	_____	_____
5. _____	_____	_____	_____

Under Symbols or Memes list a specific symbol or meme like "cowboy hat." Under Associations try to detail all of the possible associations that a guest might have with the symbol or meme, ranging from specific ones ("John Wayne") to general ones ("outlaw"). Under Material Forms write down any possible ways that you could realize that symbol in space (such as "cowboy hat drink glasses") and in the Accomplishment column write down what each form will accomplish for you in the space (such as "will get people to enjoy their drinks more"). Feel free to break from the literal examples that I have given here. Be as abstract, literal, general, or specific as you like in the application.

Attractors, Anchors, Archetypes, and Spectacles

When we start thinking very specifically about the uses of symbols and memes in space (such as in the last application that you may have worked on), we begin to think about the most memorable environments that we have visited (or perhaps designed) and how the greatest qualities of those spaces can be used in new or revived spaces. There are features bigger than symbols and memes themselves (and in some cases these bigger features are also symbols or memes too) and these are ones that can give guests some of the most powerful feelings or senses of what Jane McGonigal calls the epic and the feeling of awe.

The first of these types is a class of symbols that we call by different names—attractors, anchors, or weenies (Disney). The **attractor** or "weenie," just like the stage dog being led to do something because of a hot dog offered as a treat, beckons or calls the guest to a certain area within the space. Disney theme parks have created some of the most memorable attractors and anchors. At Disney's Animal Kingdom, anchors and attractors are used to circulate guests through the park, to enhance their excitement, and to give them the opportunity to see the many rides and attractions in the park. At the Asia section of the park, the guest's eyes are drawn to the massive Himalayan mountains that sit beside the Expedition Everest ride. If guests take one of two possible pathways to get to the ride, they will be at the far edge of the eastern point of the park. In the middle of the park is a second major attractor—the Tree of Life. Like the mountains in the Asian themeland, this feature is massive and cannot be missed from most sections of the park. What both attractors serve to do, as Chart 6-1 represents, is to create a sense of excitement and anticipation as guests get closer to the attractors. These symbolic features also create a sense of flow and continuity within the theme park as each guest moves through the smaller spaces—which are often intimate and secluded—and makes his or her way to the next attractor.

Chart 6-1 The Attractor

The Attractor allows the smaller areas of the space, like the themelands, to be connected. The Attractor helps control flow and helps establish a sense of continuity within the space.

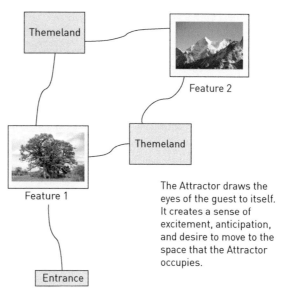

Feature 2

The Attractor draws the eyes of the guest to itself. It creates a sense of excitement, anticipation, and desire to move to the space that the Attractor occupies.

Attractors and anchors come in many forms. In using them, designers should keep in mind the other values of symbols that we have considered.

Archetypes are symbols that can be used, like the attractor and anchor, to create a memorable connection with the guest within the space. The idea of the **archetype** is that it is a universal symbol that all people can understand and connect with. Carl Jung and Joseph Campbell are two thinkers who showed us the ways that archetypes have transformed culture and the people within it. Jung looked at the key archetypes of culture—like the child, the mother, the hero, the wise person—and spoke of the ways in which we see these appearing in cultures across time and space and in forms ranging from rock art to paintings. Today, as Joseph Campbell reminded us, we find these archetypes in major films and video games. *The Matrix* films, for example, develop the powerful hero archetypes and the form that Campbell called the "**monomyth**" or the hero's

journey. We connect with characters in these films because they reflect the ideas of the hero and his or her journey through a series of challenges, transformations, impacts, and realizations. Within a themed or immersive space, we can think about the ways that archetypes can be used to more effectively connect with the guest.

Examples of Archetypes in Space:

1. Within a theme park, a dramatic ride recreates the experiences of pirates and their adventures. The hero's journey is felt by all guests as they take the roles of pirates moving through a dramatic story.

2. At a dinosaur-themed restaurant, guests witness a diorama of robotic dinosaurs in which a mother dinosaur protects baby dinosaurs from advancing predators. The "mother as protector" resonates as a powerful archetype with guests in the restaurant.

3. Inside a Christian theme park/interpretive center the major symbols of Christianity are created

in dramatic form using interactive technology, moving walls, and other features. At the end of the attraction, guests feel a sense of connection to the larger issues of "sin," "redemption," and "salvation."

4. While inside a cultural museum dedicated to the understanding of the role of technology in the world, guests are led along on a journey that covers the key points in which technology helped free people from environmental constraints. The themes of the exhibits include notions of struggle, resilience, transformation, and overcoming.

A third context of symbols is the spectacle. Spectacles make use of symbols and other elements to make a quick and possibly lasting connection with guests. The word spectacle derives from Latin *specere* or "look at." Anything that compels the guest to look at it conveys the sense of the power of the spectacle to transform the designed space. Spectacles may include large physical or architectural features—much like attractors—but they typically have a moving or intransient character to them. As David Rockwell and Bruce Mau comment in their book *Spectacle*, spectacles include features of immersion, involvement of people, transformation, boldness, social connection, and brevity.[2] When spectacles are executed correctly, they can achieve many of these features and thus impact guests in significant ways.

The Las Vegas Strip is home to some of the most significant spectacles that we have seen in designed spaces. The Mirage's volcano eruption, the water show of the fountains at the Bellagio, and the intensely bright light atop the Luxor offer guests an opportunity to regularly see moving, dramatic, and sensory spectacles as a defining part of the bigger experiences of the casinos along the Strip. The fact that spectacles *happen*

and that the guest *witnesses* this happening is one of the most significant reasons why spectacles can positively impact a space.

Figure 6-4

Spectacles are also powerful because they get the guest to do more than simply look at the symbols within the space—they ask the guest to be a part of it. When a dramatic performance takes place in a venue or when a form of monumental architecture moves and transforms the guest, the guest gets a sense that she or he should get involved in the space itself.

Ideas of the Mind

Attractors, anchors, archetypes, and spectacles are a great place to begin the consideration of another important aspect of the big idea and symbols, namely, what are some ideas that all people, regardless of their specifics, will have in common? If we figure out some

[2] David Rockwell and Bruce Mau, *Spectacle* (London, Phaidon, 2006).

of these main ideas that all people have, we might be better able to create immersive spaces that will resonate with each and every guest.

Freedom: Most guests have the desire to experience a space that has no bounds. In everyday life, guests often encounter the pressures and constraints of work, home, and relationships. Themed and immersive spaces can emphasize the value that freedom can play in giving all guests the sense that their time spent in the space will be free and carefree.

Discovery: The value that discovery plays in a space is significant. A space that has a sense of discovery within it will allow the guest to explore, understand, and better relate to the story being told.

Adventure: Adventure, whether created through a storyline with the hero's journey or through the guest's involvement in a journey, can have a powerful impact on how the guest perceives the space. A sense of adventure will result in a space that is more meaningful because there is a *purpose* behind it.

Love: The trending section coming up shortly will discuss the significant role that love can play in a space. Consider the power of the idea: a child who enjoys a space like that of a theme park will not only come to love that space and all that it contains but will feel strong emotions of love towards his or her family.

Connection: Every guest wants to feel part of the bigger drama that is contained in the themed or consumer space. By creating forms of connection—notably through means of interaction with the story, technology, and all aspects of the space—the guest will feel that his or her presence in it truly does matter. The issue of interaction and the guest is covered more fully in Chapter 7.

Figure 6-5

Loyalty: This idea has a very strong effect on a space. In fact, in terms of how brands and spaces complement one another, this may be the most significant of the ideas listed here. We will discuss this component more in Chapter 8. Without loyalty there is little likelihood that a guest will return to the space.

Family: Every guest has a connection to a family. The family, as a direction for popular amusements and entertainment, was popularized in Disney and Six Flags theme parks. Whatever the space that is being designed, an emphasis on the family will result in feelings of inclusion, loyalty, love, and commitment in the guest.

Keep in mind that these ideas are fairly abstract and that for them to be successfully tapped into within your space, you will need the many sorts of nuances, details, and imaginative features that are the subject of the chapters in this book. These types of global feelings, if combined with other aspects of effective immersive design, can lead to tradition or a set of feelings, ideas, and yearnings that guests maintain even when they have left the designed space (more on this in Chapter 8).

Wouldn't You Know It!—Controversial Themes

Figure 6-6

Wouldn't you know it, some themes might, indeed, be too controversial for guests to stomach. The controversial theme—whether represented by a toilet restaurant in Taipei, a jail-themed restaurant in Taiwan, a "buns and guns" restaurant in Beirut, a condom restaurant in Bangkok, a Hitler-themed restaurant in Mumbai, a graveyard restaurant in Ahmadabad, a theme park that deals with topics of vomit and defecation near Copenhagen, or many other variations—has long had a connection to themed and consumer spaces. Some plans for theme parks, including Disney's America, were subject to intense scrutiny by the public in part due to perceptions that their themes (such as the Civil War) would be too controversial. It's too bad, actually, that museums and interpretive centers are typically the only types of themed spaces that get to explore dark and controversial topics. One of the things that I often hear at industry theming conferences is designers commenting about how overused certain themes are. How many times have we seen the same generic New York cityscapes or the same worn-out western motifs? One solution might be to develop these more controversial themes in theme parks, restaurants, lifestyles stories, and others spaces. No doubt, the envelope will continue to be pushed.

Trending—Love

One of the most significant trends that has impacted the consumer and themed space is that of love. Love has its origins in the most intimate and important aspects of culture—the bonds between lovers, the feelings shared by parents and their children, the good deeds of religions and humanitarian groups. Love is powerful because it cuts across all of the divisions that people often encounter. In his book *Lovemarks: The Future Beyond Brands*, Kevin Roberts points to the many ways in which successful companies have used the trend of love to create more powerful and intimate brands.[3] According to Roberts, a lot of brands have become tired, worn out, overused, formulaic, and lacking mystery. By focusing on the most powerful emotion of love, brands can become reenergized and more real for consumers and guests. Roberts suggests that forms of mystery (great stories, myths, etc.), sensuality (the five senses), and intimacy are the most powerful ways that love can transform the idea of the brand. Love thus connects us to some of the most powerful symbols and memes that are known to the world—those of brands.

[3] Kevin Roberts, *Lovemarks: The Future Beyond Brands* (New York, powerHouse Books, revised edition, 2005).

The Brand

Figure 6-7

Figure 6-8 BMW is one of the most recognizable brands in the world—in part due to the iconic logo, in other part due to the high quality of their product line, and in other part due to their use of innovative branded spaces like BMW Welt.

When we think about the most powerful symbols that have the most meaning for the most people around the world, we are likely thinking of symbols that originated in the worlds of religion or consumer culture. Brands are a significant—some people would say *the* most significant—part of today's designed spaces. Most of the spaces that you will see—whether a restaurant, a shopping mall, a theme park, cruise ship, or even a museum or interpretive center—have some signs of the brand. The brand represents one of the most powerful ways to transform an ordinary space into an extraordinary space. But the brand is not without controversy. Some fear that the brand creates a "culture of sameness" in which the experiences that make themed and consumer spaces exciting will be stripped

away because of the overarching power that the brand represents. We'll look at some ways to make the brand meaningful for your space as well as some tips on how to avoid the pitfalls of branding.

What Is a Brand?

The idea of the brand derives from the practice of using hot branding irons to identify the owners of cattle. The brand was a distinctive mark that allowed one cattle owner to differentiate his or her livestock from other owners. The brand was a way to establish a mark or sign that would easily distinguish property. Today, the brand has grown into a quite different entity. The brand is now much more than a property marker—it is a set of ideals, values, products, and services that identify a type of lifestyle.

Over the last twenty years, there has been a remarkable transformation in how brands are used by companies and how consumers interact with these brands. For the corporation, the brand is the primary means by which it communicates with the world. The brand says everything about what the company is—not just in terms of the products that it produces or the services that it offers, but especially in terms of what these all mean to the consumer. Marty Neumeier once remarked that "Brand is not what you say it is. It's what they say it is." Neumeier was 100% on track in terms of understanding that brands have fully merged with the lives, desires, lifestyles, and wants of the consumer. In the context of themed and consumer spaces, the brand has an even more nuanced and significant role. In any space in which a brand is present—and it certainly is present in most, if not all, spaces—there is a special requirement to make sure that the brand complements what is being offered in the space. The brand must seem natural and not apart from the space itself.

Brand Demographics

Brands are powerful because they are symbols that seem to speak to all guests, regardless of their backgrounds. Many of the ideas that we have considered suggest that we should create spaces that *all* guests will enjoy, regardless of their backgrounds. While this is true, we also have to be aware of ways in which different people react to our spaces. Table 6-2 lists some of the concerns when designing for different demographic segments.

Table 6-2 Market Trends

Segment	Market Trends	Considerations
Children	Many theme parks have developed specific themelands, if not entire theme parks, with children in mind. Also, specialty restaurants, museums, and cruise ships have dedicated major spaces to the interests of children.	Should the space be designed with children in mind or will it be adult focused? If children are included in the space, should their spaces be separate from those of adults or should the two types of spaces be integrated?
Adults with Children	Theme parks have been particularly successful in designing spaces that appeal to adults who have children with them. Disney helped popularize the idea of family-focused entertainment.	If spaces are designed with children and adults in mind, it is important to create a mix of attractions and activities within the space that can fulfill the needs of both children and adults. A space for children to play or engage with activities, for example, could be combined with a space in which adults can rest and socialize.
Adults with No Children	Las Vegas casinos and many exclusive resorts have used the popularity of adults-only entertainment. Many parents have the desire to vacation without their children and many spaces have picked up on this idea.	These spaces might be designed with more risqué ideas in mind. Because children are not present in the spaces, more risks may be taken with themes of a sexual, political, or otherwise forbidden nature.

(Continued)

Table 6-2 (Continued)

Segment	Market Trends	Considerations
Gays and Lesbians	Some theme parks have created gay and lesbian days at their parks. More and more spaces are marketing to the growing LGBTQ audience.	Spaces should be designed with the interests of all guests in mind. If a particular attraction within a space is to focus on the dynamics of the family, perhaps it could develop a very inclusive notion of the family.
Cultural or Ethnic Groups	Many Las Vegas casinos market to specific cultures or nations.	It is a good idea to highlight the contributions of all nations and all cultures whenever and wherever possible. At the same time, spaces should contain enough symbols and stories that can relate to *all* cultures.
Aged Guests	Aged guests are an important market. Many consumer spaces have developed specific areas that can be used by aged guests.	Especially since health trends have led to greater longevity of guests, spaces should be designed with the assumption that aged guests will frequent the spaces. With this is mind, design should focus on both stories and spatial design that make aged guests feel included.
Guests with Disabilities	Many spaces have been redesigned to comply with ADA and other guests with disability requirements. Theme parks and other spaces have special ambassador programs that cater to the important needs of guests with disabilities.	All spaces should be designed with disabled guests in mind. It is not only the law, but it is good practice.
Guests with Special Interests	Some spaces, like the closed Star Trek Experience at the Las Vegas Hilton, have developed a storyline or spatial design theme that focuses on a very specific, some would say niche, demographic.	This is one of the most challenging aspects of demographic design. The reason is that while a specific theme may attract a certain niche, it may not appeal to the number of guests that are needed to keep the space afloat. Market analysis is a must in terms of this area of demographic design.

The Brand in Space

As we think about the particular needs of guests who use our spaces, we can think about how their needs reflect back on the power of the brand. We will see shortly in the interviews of Anna Klingmann and Thomas Muderlak just how significant the interaction of the brand and the space can be. Many discussions of the brand focus on the brand as an entity that seems to exist without specific space in mind. We have to think more specifically about the brand *within the context of space*. Two especially important aspects of branding in space are:

1. The meaning of the brand (or how the guest understands the brand).

2. The use of the brand in the themed or consumer space (or how the consumer touches, uses, feels, experiences, interacts with, and relates to the

brand). Chart 6-2 uses the example of Disney—one of the most significant brands and producers of branded spaces.

Chart 6-2 The Brand in Space

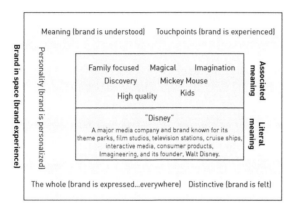

Brand in space (brand experience)

Personality (brand is personalized)

Meaning (brand is understood) Touchpoints (brand is experienced)

Family focused Magical Imagination
Discovery Mickey Mouse
High quality Kids

Associated meaning

"Disney"
A major media company and brand known for its theme parks, film studios, television stations, cruise ships, interactive media, consumer products, Imagineering, and its founder, Walt Disney.

Literal meaning

The whole (brand is expressed...everywhere) Distinctive (brand is felt)

In terms of the first area or the meaning of the brand, we will note two types of meaning. The first is literal and refers to the idea of Disney as a media company that holds multiple interests, including theme parks and cruise ships. The more important of the meanings on the chart is the associated meaning because this is the area in which the guest gets all of his or her understandings of the brand. Over the years, Disney has become associated with ideas like family-focused entertainment, and magical and imaginative products and spaces, among other qualities. The Disney brand has been produced in multiple media and formats—some of which include themed and immersive spaces like Disney theme parks. The combination of all of these formats (something we'll return to in Chapter 8) creates an overall feeling for the brand. Most importantly, as we move to the second area or how the brand is experienced in space by the guest, we can see that Disney has been especially successful in making their brand meaningful within the spaces of theme parks, resorts, and cruise ships. The ideas that surround the literal and associated meaning boxes on the chart indicate how the brand of

Disney is made meaningful within the space. The brand is given personality (a child interacts with Mickey Mouse in Disneyland); the brand is personalized (many rides in Disney theme parks allow the guest to become a part of the direct experience; on some rides, the guest is even named by name); the brand is understood and experienced in multiple touchpoints (whether a ride, attraction, restaurant, or gift shop, the guest at a Disney park is treated to the same consistent, high-quality, friendly form of service and guest interaction). As a whole, the brand is expressed and felt everywhere within the space of a Disney theme park.

Branded Spaces
Interview, Anna Klingmann
Principal, Klingmann Architects and Brand Consultants (KABC)

Figure 6-9

Anna Klingmann (M.Arch./Ph.D.) is principal of Klingmann Architects and Brand Consultants (KABC), a multidisciplinary architecture and branding firm in New York. KABC has been recognized as a leader in the design of complex, international, large-scale, mixed-use destinations—always with a strong focus on sustainability and the local heritage. KABC's strategists and planners work globally on a broad range of projects, from new urban districts and retail to corporate campuses, resorts, public parks, and residential communities. Anna Klingmann's book

Brandscapes: Architecture in the Experience Economy, (MIT Press, 1st edition 2007, 2nd edition 2010), illustrates cutting-edge ideas on how architecture can effectively brand mixed-use destinations, residential communities, and retail environments.

Can you talk a little bit about your work and how you developed an interest in branding and space?

I moved to New York in 1984 and studied fine arts and interior design at Parson's School of Design. I later received my architectural degrees at Pratt Institute, the Architectural Association in London, and at the University of the Arts in Berlin. While in London, I was influenced by the work of Zaha Hadid and Rem Koolhaas. With Hadid, I was fascinated with how she experimented with fluid shapes and how she used architecture to create iconic experiences. With Koolhaas, I was taken with how he combined commercial and avant-garde architecture, much like Andy Warhol brought advertising into fine arts. When I studied architecture, there had been a profound schism between profitable architecture that catered to the consumer but by and large had no vision and visionary avant-garde architecture—on the other side of the spectrum—that lacked a meaningful relationship to the user, and hence was neither practical nor profitable. This opened up the idea of closing this gap and rethinking architecture as a product (that would base its vision on the needs of the user). In terms of branding, we can think about why people want the iPhone so badly and how one might bring this desirability or seduction into architecture.

You have written the important Brandscapes: Architecture in the Experience Economy. *One of the important contributions of your book is the focus on how architecture and design have moved away from functionality to experience. Can you discuss how this shift occurred and why designers today should be aware of it?*

The "experience economy" was coined by B. Joseph Pine and James H. Gilmore in their 1999 book with the same title, which was a big inspiration to me. It was (and still is) a breakthrough idea that argues that goods and services are no longer enough—people now want the experience of a thing or of a place. Take Starbucks as a branded space. There is only so much that they can charge for a coffee bean, but through the café as a themed environment, you can charge for the service and, especially, the experience. In the 1990s, we saw the emergence of many flagship and lifestyle stores where the main concept was no longer based on sales or goods but around ways for people to experience the brand. Similarly, we see this idea in resorts and themed tourism. It's all about offering experiences within themed environments. Even mundane transactions in these places are choreographed as experiences.

In terms of designers, they might think about three main components of an experiential space. There is the hardware (the stage or the designed environment), the software (the programming or what activities you offer in the space), and the humanware (the specific human service that you provide). The Apple Store is an example of a fantastic brand environment in which all of these three elements work together perfectly.

When you design a space, do you have to think about the humanware as you design it?

Yes, absolutely. You must focus not just on the object of design but on the experience. If you are designing a computer store and just focus on the look of it, you might have a nice setting but people will not remember it. Every detail matters and will determine whether a brand space is successful or not. If the human interaction (the humanware) is not in sync with the brand concept, the architecture (or the stage setting) also becomes irrelevant.

You have written of branding as giving everything— products, services, places, events— "an added symbolic value, which, as it were, elevates them above themselves, and makes them more than they are in a material or functional sense."[4] Could you briefly address what BRANDISM® is and perhaps how some of the core principles would allow new designers of theme parks and themed spaces to create more "elevated" spaces?

BRANDISM® connects architecture and branding in a way that creates a unique identity for a space. Architecture has sometimes been used to brand things from the "outside in," as a premeditated image— something imported or tagged on that adds nothing unique or specific to the context of the place. In real estate you have residential communities being exported around the globe. The common style is a Boca Raton/ Spanish one that you can now find anywhere on the planet—in Asia, the Middle East, and elsewhere. This is a status quo of branding that leads to homogenization. We contrast this "outside in" approach to an "inside out" one. Here you look at the specific condition of a place and try to enhance that and bring it outwards. You can look at a place and its potential—its culture, the way people communicate, the climate, the site itself—and then develop the project from the inside outwards. Eventually, the branding can become symbolic for the place.

So the "inside out" approach also allows for more authenticity in the space that you are designing?

Yes, with a place- and brand-based approach the whole point is that you cannot generalize it. A brand guarantees certain levels of quality and certain values, but if you export that brand [space] to every part of the world, you will have homogeneity. We are working on

a coffee shop chain at the moment and we are looking at how to maintain continuity of the brand while not making the interiors of each place the same. When the guest will enter the space, the point is that they will have a certain experience and it is the choreography of that particular experience that makes that space unique and also helps define that brand. In a sense, we should say, let the brand breathe. We are talking about living brands.

The nature of brands and their spaces seems to be changing today.

Yes, the new generation is so brand conscious that they totally get it—the idea of branding. If you are selling a brand of jeans, you don't have to spell out the brand in a literal way like Levi's did years ago. Smaller and even subtler brands are becoming common. So we prefer to create a "branded experience" versus a brand that is about perpetuating the same look from place to place.

What types of experiences do you think about in designing a branded space—the small ones or bigger scale ones?

It's both. People in different cultures have different kinds of associations and you have to respect those cultural subtleties. What makes someone relaxed in the US may not be the same thing as that in Germany.

And in terms of the experience that is planned for a branded space, is it true that the project must begin at the level of the guest?

Absolutely, that is the key to the most successful brands in history. Walt Disney was acutely aware of the guest experience—that's all he was all about, down to the level of every detail—and that's why the Disney Company is still so successful today. You need to pique the guest's

[4] Anna Klingmann, "BRANDISM®" (The Slatin Report, www.theslatinreport.com, 2006).

experience and have an awareness of the customer in that location that you are creating. As the world is becoming more and more homogenized with a repetition of the same formulas, chain stores, signature architects, and corporate business centers, it is my belief that we face an increasing shortage of diversity and truly unique experiences. As a consequence, people are increasingly bored with a repetition of the same and are hunting for the truly authentic. So it falls to branders and designers to turn the concept of branding on its head and provide, again, more diversity and focus on the creation of truly original experiences.

Field Journal—25hours Hotel Frankfurt Tailored by Levi's

Figure 6-10

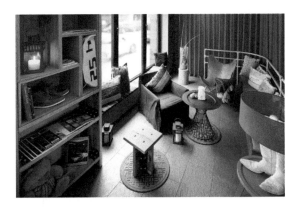

While at a conference on theming in Freiburg, Germany, I decided to spend some time at an interesting themed hotel in nearby Frankfurt. The 25hours Hotel Frankfurt Tailored by Levi's was designed by Delphine Buhro und Michael Dreher and it's one of the first hotels that I have visited that uses a brand—Levi's—to considerable success. I enter the lobby with a sense of curiosity. I wasn't sure how Levi's could be themed across the entirety of the property. The lobby is quite remarkable with floor tiles that mimic the color of denim, a design feature that spreads throughout the property. There is an overall western motif that has been applied to the many accouterments in the lobby—ranging from a lamp made of a boot pedestal, eclectic and contrasting tables, and numerous floor and wall treatments that strike me as incredibly evocative of what Levi's means as a brand. Making my way to my room, I first notice my room number on the outside of the door. It appears to be one of the back pockets from a pair of Levi's jeans. I soon discover that each floor of the hotel is based on a different decade of popular culture—the Fifties, Sixties, and so on. My room has some of the most interesting and playful elements that I have seen in any hotel room. On the wall opposite of the bed is a pair of immaculate Levi's jeans that has been fastened to the wall. Drawer handles, the smallest details in the room, even the toilet paper holder have been transformed to effectively convey the attitudes, moods, and values that are connected with Levi's. I make my way back the lobby and seek out the common rooms. Most interesting to me is the Gibson Session Room—a room that combines the distinctive brand style of Levi's with the grungy authenticity of rock and roll music. The effect is to convey to me what the brand means here in this space. A good night of sleep is the result of the sense of comfort that I had in the space. My surprise came when I discovered that the 25hours Hotel Frankfurt Tailored by Levi's was not a "knock-you-over-the-head" brand space in which the brand is blatantly and haphazardly placed in the space. At this hotel, the characteristics of the brand—the Western legacy, individuality, the frontier, relaxation, and quality—are played out in a spatial manner. This space is, truly, an effective integration of brand and hotel.

Figure 6-11

Brandspaces
Interview, Thomas Muderlak
General Manager, BMW Welt Munich

Figure 6-12

Thomas Muderlak is the General Manager at BMW Welt in Munich, Germany. During his work for various BMW departments he has been recognized with numerous awards, including prizes for the BMW stand at the IAA 2009 and the prize for the best automobile campaign of AutoMotorSport in 2008.

Can you talk a little bit about BMW Welt? What is it? What does it show the public?

The BMW Welt "ensemble"—formed by the BMW Welt, Museum, and Plant—has quickly become one of Bavaria's top attractions. The success of all three realms of discovery lies in their diverse range of regularly changing exhibitions and focus topics, as well as their exciting programme of events. The BMW Welt combines technology, design, and innovation with lifestyle, dynamism, and culture to create a public space for meeting and discussion. Visitors from all over the world come to admire the latest trends and exhibitions, technology, and design, or even experience the excitement of collecting their new car at the BMW Welt. Both as a building and an institution, the BMW Welt serves as an important interface between the company, the brand, its products, and the visitor. This is the only place where it is possible to experience the company's past, present, and future as a whole. Besides personal delivery of up to 100 cars a day to their new owners from all over the world, exclusive presentations of the latest vehicle model series and motorcycles, combined with interactive exhibits, offer insights into BMW research, development, design, and production and allow the visitor to experience the BMW brand and the company from virtually every perspective.

How did the idea of BMW Welt come up? Who thought of it and why was it created?

In 2001, Professor Joachim Milberg, former Chairman of the Board of the BMW Group, stated in the call to tender

that a structure was to be created with an outstanding, characteristic architecture which, at the same time, represents BMW values. Another essential requirement was to integrate the new building harmoniously into the context of the BMW Group headquarters and the Olympic Park. In his speech at the opening of BMW Welt, Dr. Herbert Grebenc, Head of Property and Facility Management for the BMW Group, explained: "It is our aim to create a structure with an outstanding, characteristic architecture which, in its form, processes, and organization, not only reflects every facet of the values and identity of the BMW brand but also shapes these lastingly for the future." Dr. Reithofer, Chairman of the Board of Management, in turn, added further aspects in his opening speech: "The BMW brand is unique. All its products are highly emotional. They offer a unique substance. And they have style. BMW Welt also had to become extraordinary and unique. Only then would it fit the BMW brand and be in line with our claim of always offering something special."

Figure 6-13

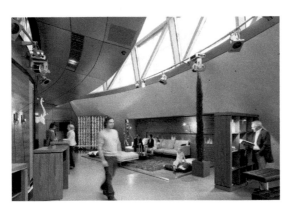

I have heard that BMW Welt is a "multifunctional customer experience." Could you talk about all of the experiences there? How do they all relate to the brand?

The BMW Welt is where up to 100 vehicles per day can be presented to their new owners from around the world. By making the vehicle collection process such an integral part of the BMW Welt, the excitement of becoming the new owner of a BMW fresh off the production line is extremely pervasive. Here, the BMW Welt combines technology, design, and innovation with lifestyle elements, dynamism, and culture to create a public space for meeting and discussion. The BMW Welt's Junior Campus Portal invites younger visitors to enter a fascinating universe for them to discover. Also, the BMW Welt hosts more than 50 exciting events a year. Its many concerts, exhibitions, readings, and receptions are proof that the BMW Welt has become a permanent feature of public life in the city of Munich.

Why is it important that people experience the BMW brand?

The brand and its products represent joy, aesthetics, dynamics, and innovation, but also an experience that is embodied in emotional products that make exclusivity and driving pleasure a reality. This can also be experienced in BMW buildings like the BMW Welt ensemble as well as through the people who represent the brand. A BMW is also unmistakable when it comes to design, where aesthetics and innovative technology are combined with dynamics. BMW design is authentic, groundbreaking, and sustainable. It gives every BMW its own specific character and therefore delivers identification.

Has BMW Welt been successful? Have more people been introduced to the brand because of BMW Welt? What have they thought of it?

BMW Welt is one of the top visitor attractions in Bavaria. In July 2011, it set a new record with over 300,000 guests. No fewer than two million people a year have visited the BMW Welt since it opened in October 2007. BMW Welt was also able to set a new record as a collection centre: In July 2011, 2,181 vehicles in total were handed over to their enthusiastic

new owners. There were also plenty of Americans amongst the vehicle collectors. In the words of Christian Ude, Munich's Lord Mayor: "The overall experience, combined with a multifunctional platform for events of all kinds, is what makes the BMW Welt such a great attraction. There is something for brand aficionados and culture lovers alike to enjoy in Munich."

Why is it important for companies like BMW to have a branded space where people can experience the brand?

We want to show visitors what the BMW brand stands for. We want to explain to them what the ideas are behind the BMW brand. But most of all, we want to offer our visitors the opportunity to really experience the BMW brand at the place where it is created. This kind of brand experience cannot be achieved with books, brochures, or films that are sent out to potential customers. The aim is that enjoying the "ultimate driving machine" should start right here in BMW Welt.

Values

Thomas Muderlak's discussion of BMW Welt reminds us that values are a key aspect of any brand and any brand space. As he related, BMW wants to communicate its lifestyle missions to guests, and one of the best ways to do this is *in situ*, or "in space." Experiencing a brand in the flesh will have a stronger impact on the guest than simply hearing about it or experiencing it at home. What brand spaces prove is that brands and spaces can be effectively merged. One of the greatest values

of a brand space is that it immediately communicates the core ideals, values, and beliefs of the brand to the guest. Values are specific ideals that people hold dear and they are suggestions about how to do something, how to lead one's life, how to react to a certain situation. Very often, values are present in a space but they do not exclusively draw attention to themselves. Cruise ships, for example, promote values like luxury, elegance, and discovery in the design of their spaces but often do not directly talk about them. Museums and interpretive centers encourage guests to develop creativity and intelligence by creating innovative displays and cultural recreations. Theme parks—through the combination of the attractions, services, workers, and all other aspects—promote values like cultural awareness, science and technology, and many others. When used effectively, values can offer the designed space a lasting impact with the guest.

Application—Pick the Values

Take a minute to apply what we have learned from values in this short application. Create a chart like the one below. First, write down the big idea of the space— whether it is a space that you have designed or one that is in the works. Value should be a specific value, while Positive and Negative Meanings should list the things that people associate with that value. The Conflicts with Other Values column refers to ways in which one value might conflict with another and the Use in Space is a specific way that you can use the value in the designed space.

Big Idea: _____

Value	Positive Meanings	Negative Meanings	Conflicts with Other Values	Use in Space
Freedom	Guests feel limitless, as if able to do anything.	None.	Cooperation	An attraction is designed that allows guests to move along any number of possible paths.

After you have completed this application, focus on any aspects that you have learned about. What do the specific values tell you about how spaces often depend on the specific meanings that are given to them? Are there situations in which certain values should be avoided?

The Power of the Senses

We have considered some of the ways in which symbols and brands can bring greater meaning and enjoyment to a space. An additional way in which symbols and brands can be made more meaningful to the guest is through the senses. Many of the themed and consumer spaces of the 1990s and 2000s became quite popular in large part due to the powerful ways in which the senses were used in the spaces. In the next sections, we will consider how the senses can be used to great effect in space and we will hear from Gordon Grice, who will offer his own unique perspective on designing with the senses in mind.

Senses

The most common senses that are used in a space include vision, hearing, touch, taste, and smell. These have been called the five senses. In addition, some spaces utilize other senses like equilibrium (balance), kinesthetic sense (or the movement of the body, such as on a theme park ride), and thermoreception (temperature). Table 6-3 expresses some of the reasons why the senses have been so widely used in themed and consumer spaces.

Table 6-3 The Senses in Space

Sense	Common Uses	Benefits
Sight	Sight provides for the creation of vistas, dramatic views, incredible senses of perception (depth, etc.).	A sense of the epic is created. Sight can be used to create incredible effects in guests, including senses of fantasy, seeing the impossible, and being transported to another world.
Hearing	Hearing includes the development of ambient sounds that help convey the feeling of the space, as well as music and forms of performative sound.	Hearing is a powerful sense because it can create a sense of a total space. It gives the guest all of the auditory cues that indicate where the person is and what can be expected in the space. It can also be used to get guests involved in the space. A dueling piano bar, for example, creates a sense of being a part of the performance and allows for important social dynamics to develop in the space.
Taste	Food and edibles are commonly involved in the sense of taste. Taste is perhaps one of the underused senses within spaces.	Taste is an incredibly deep and personal sense. Eating a new dish and experiencing the multiple taste sensations can give a guest the sense of discovery, imagination, and thrill.
Smell	Smell is used to incredible effect in the case of food. It also is typically used to convey a sense of place, such as the smell of smoke to help express the idea of a battle or warfare.	Smell provides for the creation of senses of nuance in a space, suggesting that the space is complete. Smell can act as a powerful attractor and can complement other senses, such as taste and hearing.

(*Continued*)

Table 6-3 (Continued)

Sense	Common Uses	Benefits
Touch	In museums and interpretive centers, the sense of touch is common because it allows guests to get directly involved in the space. Touch is also used to create authentic and realistic features on walls, doors, and furniture.	The sense of touch suggests an ability to feel for oneself. Touch can be an inviting sense often because of other sensory impulses, like the sight of seeing a patinated wall and desiring to touch it.
Thermoreception	The use of heat and cold sensation has applications in spaces that attempt to create a sense of immediacy of place. Nightclubs use cold as a way of creating unique ice bars.	The sense of temperature has an immediate effect on the body. Guests will feel the impact of the space because of the ways in which it literally bears down on them.
Equilibrium	Equilibrium can be used to create differences in perception and temporary states of disorientation as a guest's balance is thrown off. It is often combined with the kinesthetic sense.	Along with the kinesthetic sense, equilibrium is a powerful sense in terms of affecting the balance and orientation of the guest. It can be used to great effect to change the basic state of the guest within the space.
Kinesthetic Sense	The kinesthetic sense can be used to develop powerful changes in how the guest's body moves, such as on theme park rides, simulators, or in spaces that take advantage of movement. It is often combined with equilibrium.	The kinesthetic sense can be used to transform the guest. This is especially possible since movement can literally force the body of the guest to do new things, to move in new ways, and in new trajectories.

Framing

Figure 6-14

In thinking about how the senses can be used to great effect in a space, we can consider the idea of framing. Framing is the process by which a filmmaker, painter, author, or other artist thinks about the makeup of the thing in mind. It refers to the boundaries that we draw when we consider how the thing—film, painting, or story—will be experienced by the person interpreting it. As Figure 6-14 shows, we can think of an imaginary frame that is placed around the thing we are trying to re-create. In the case of a spatial design, we can think of the frame as all of the (front-stage) spaces that a guest will interact with. Each one can be framed to think about all angles that a guest will view it from (vision),

Chart 6-3 The Senses of a Space

The guest will smell the distinctive and delicious forms of Italian cuisine. Flower shops and cafes will be designed to give the guest a sense of the placeness of the space.

The guest will dine in some of the most spectacular Italian restaurants and will be given a sense of authentic home cooking.

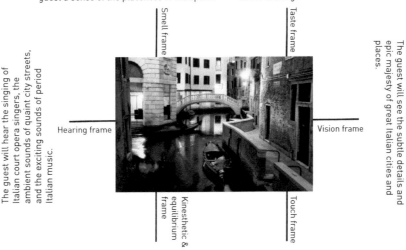

Smell frame

Taste frame

The guest will see the subtle details and epic majesty of great Italian cities and places.

The guest will hear the singing of Italian court opera singers, the ambient sounds of quaint city streets, and the exciting sounds of period Italian music.

Hearing frame

Vision frame

Kinesthetic & equilibrium frame

Touch frame

The guest will ride on simulator attractions that will throw the body around and show the sights and sounds of Italian cities.

The guest will be able to feel authentic heirloom crafts and objects that reflect the rich history of Italy.

all spaces that the person will experience (smell), all possible tastes within the space (taste), the many sounds that the guest will hear (hearing), the things that the person will touch (touch), and the ways in which the guest's body will be affected in the space (equilibrium and kinesthetic sense). Chart 6-3 expresses how framing the senses can be thought of in a fictional space—an Italian-themed theme park and resort complex.

As you think about your own spaces, keep in mind that framing is one possible way of thinking about the senses. It can offer your space a template through which to better understand how the guest will experience your space in all of the possible senses.

The Value of the Senses

We have looked at some of the specific senses and have considered how framing can define a space in sensory terms, but what are some overall reasons that we might choose to use the senses in ways that will further compel guests within our spaces?

Figure 6-15

The senses allow for a powerful sense of *elaboration and nuance* within a space. What was once an ordinary space can be transformed by the use of the senses, perhaps in ways never imagined before. The senses can also orient and guide guests in terms of *movement and direction*. A smell of fresh baguettes can lead a guest from the shopping area of a casino to a restaurant. All the while the guest appreciates the combinations of the senses being used, thus giving an idea of the *total nature* of the space at hand. The senses are also handy in terms of providing a guest with a sense of *the epic*, such as in using vision to create amazing vistas within a theme park or using a combination of vision, hearing, and kinesthesia to produce an incredibly immersive ride. *Personalization* is another key feature of the use of the senses. Touch, smell, and taste can take a guest from one state, such as boredom and disconnection, to a completely opposite one, such as excitement and connection. In this way, the person feels like an important part of the space, not an ancillary part. Senses are also effective tools to establish forms of *emotion* within a space. As each sense is used, the guest is further immersed in a world of emotion. We can also see that the senses provide designers with a great opportunity to create incredible *contrast* in a space. A guest can be taken from a serene, quiet space to a dramatic, loud, and unsettling space (consider the different vignettes of the Pirates of the Caribbean ride, for example). The senses may also be used to create feelings of *familiarity*. As Gordon Grice offers in his interview, space and memory are often intertwined by the ways in which the senses act out in the space. Finally, we can see that the senses allow for the creation of incredibly unique experiences and thus establish a sense of *distinction and tradition*. Many lifestyle stores utilize the senses to offer the guest a sense of an experience that is completely unlike any other. The combination of all of the senses in such a space provides for the establishment of tradition. The smell

of Singapore Airlines, for example, is unlike the smells of other airlines and this establishes it as the most acclaimed airline in the world.

The senses should also be thought of in terms of their complementary features. There could be cases in which one or more senses compete with one another. If there are separate themelands within a theme park, for example, what happens if the smells of one themeland begin to interfere with the sights of another? Will the guest get confused? There can be cases where technological and architectural means have to be employed in order to mark off one area from another, especially if these areas will involve extensive use of multiple senses. The key is to remember the advice that has been given throughout this text. It's important to use the senses in ways that complement a space, that give it a greater sense of depth, that provide an elaboration of the stories being told, and that offer an overall feeling of discovery and authenticity to the guest.

Space and the Senses
Interview, Gordon Grice
Architect and Creative Consultant

Figure 6-16

Gordon Grice is an architect and creative consultant based in Toronto, Canada, with 45 years of international experience in architecture, illustration,

writing, and editing. As an illustrator and designer, his focus has been on resort and entertainment projects around the globe. As an editor, Gordon has produced more than a dozen-and-a-half books on the subject of illustration and design. He is Senior Advisor to the American Society of Architectural Illustrators, Editor of the Ontario Association of Architects' quarterly journal, as well as two other annual professional publications, a reviewer of Architecture and Design Culture for the *New York Journal of Books*, a member of the Ontario Association of Architects, and a Fellow of the Royal Architectural Institute of Canada. For the past 20 years, Gordon Grice has consulted to Forrec Ltd, a multidisciplinary planning and design firm that specializes in the creation of entertainment and leisure environments worldwide. He currently serves Forrec as Senior Creative Advisor.

Many of our readers will be interested in the topic of how the senses can be used to create more engaging and interesting architectural and design projects. With spaces like theme parks, themed restaurants, lifestyle stores, and other related consumer venues in mind, could you comment a bit on how all the senses can be used in a design project?

As designers and conceptualizers, we tend to focus on the visual sense to the exclusion of all others. Projects are conceived, presented, designed, and built, relying almost entirely on their appearance. But if you think about it, entertainment/retail experiences are always subtly colored by hearing, touch, and smell and, in the case of restaurants, taste, even if indirectly. Of these, hearing and touch are probably the easiest to demonstrate. First, let's consider hearing. How many times have you been tempted to linger in a shop or restaurant or, conversely, been driven out of one, because of the background music? A few days ago, a friend and I were eating breakfast in a hotel dining room. The music was designed to soothe the weary business traveler, I suppose, but it was insipid to the point of creepiness. The playlist may have been carefully designed to keep diners relaxed, but not for so long that they occupy their seats unprofitably.

The use of music and sound within a space, or emanating from it, can have subtle behavioral effects. The sound of water in a gathering space can soothe us and make us feel welcome. The sound of screams from a thrill ride excites us and draws us toward the source, even if we have to brave a long queue line, because sometimes we crave excitement too. Sound can fill a space, or it can beckon from a distance. Touch, on the other hand, is always immediate. It requires physical contact. In Japan, sensitivity to feel and texture of surfaces adds an entirely new dimension to the environmental experience. You remove your shoes on entering smaller, private, and sacred spaces because it shows respect and acknowledges a change in attitude. But even more important, it exposes the soles of your feet to a remarkable new range of experiences. Forget about foot massages. Visit a Japanese shrine or temple instead. Your feelings, thoughts, and even movements—speed and direction—can be subtly guided by the floor texture: smooth, cool stone; rough, weathered cedar; soft matting. My own sensitivity to the multisensory aspects of environmental design has been encouraged by the writings of Professor Juhani Pallasmaa, whose books on sensory architecture should be required reading for all designers of the built environment.

What about some ideas on how the senses can work together—play off of one another—in these examples of sensory design?

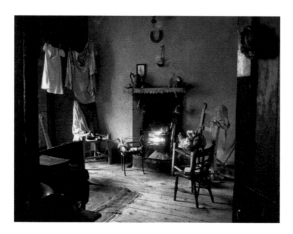

Figure 6-17 One of the evocative rooms found at Dennis Severs' House (London, England).

As in most things, the key to success is consistency. Combining sensations—especially when the ever-present visual sense takes the lead—increases the impact of the experience and reinforces its memorability by settling it in many areas of the brain at the same time.

The most memorable example, for me, has been the residence/museum known as Dennis Severs' House at 18 Folgate Street in the Spitalfields area of London. In the last half of the past century, Californian expatriate Dennis Severs bought the dilapidated house and painstakingly restored it to its 18th century lived-in condition, complete in every detail, including inhabitants (after Severs' passing, the current operator took up residence there). Visits to the house must be booked in advance and are limited to a few people at a time. The experience is not merely one of seeing the house. It is one of sensing—employing all of your senses, including that underappreciated "sixth sense." As a visitor in the house, you move silently and freely through the house, among the furniture, past the unmade bed and recently filled chamber pot. There is the sound of muffled conversation in adjacent rooms, the aroma of a cooking fire, the musty, murky, clutter of an old house. There are no way-finding signs and no chenille ropes to restrict you. You are in a chapter of living history and a subtle work of art. Surrounded by an experience that is both alive and extinct, you are a guest in a spirit world. 18 Folgate Street invites a reconsideration of words such as "authentic" and "themed." The environment employs authentic artifacts and carefully researched effects, creating an overwhelming multisensory experience, but it is a reconstruction. At the same time, it doesn't attempt to generate predetermined sensations. Each visitor takes from the experience what he or she can. So, for us architects and environmental designers, it serves not as a model, but as demonstration of what can be achieved when all the senses are engaged.

What about how memory gets utilized in design? To what extent do architects and designers create spaces that rely on some sense of triggering guests' memories in spaces (inspired somewhat by Proust here and the fact that many memories have a sensory basis to them....I remember the smell of the pizza when I was in....)?

Memory is one of the most powerful tools that a designer has. People will enjoy a new experience that allows them to recall pleasant memories of past experiences—and this newer experience will then form new memories. A successful entertainment environment is a "memorable" environment—one that both triggers and generates memories. Recalled memories may be actual memories, vicarious memories (through secondhand experience), and collective memories (about which Proust, Bachelard, de Botton, Pallasmaa, and others have written at some length). Old memories have the ability to generate powerful feelings and the stimulation of memories can strongly

affect people's engagement with a place. While history is public, memory is personal and, unlike (most) history, it is subject to constant reevaluation and revision. New experiences can generate new memories as well as stimulating and reinforcing or modifying old memories. This is extremely fertile territory for the experiential designer.

In general, what is your advice on using the senses to create great design projects? What distinguishes an effective use of the senses in design versus a less effective use?

In our work at Forrec, although it is mostly bound by the constraints of visual design tools and visual presentation, we consider all aspects of an experience. In the following few examples of built projects, we have taken special care in use of nonvisual cues to heighten the experience. At the bat cave at the Royal Ontario Museum (Toronto), the Forrec design team was commissioned to reinvigorate a popular, but aging, museum exhibit. The result is that all senses are heightened—it is darker, more tactile, and unusual sounds permeate the cool, quiet darkness. The theatrical aspect of the environment provides a seminal experience, creating lasting impressions and supporting the long-term retention of the educational material. At Mystery Mine at Dollywood, the goal was to create a nail-biting experience. To accomplish this, we relied heavily on sound, heat, motion, and darkness. A mechanical rumble announces the arrival of the rusty, eight-passenger mining cart, which shortly lurches to a start and then propels passengers through a mist and into the ride experience. Within the mine, sound, especially when combined with darkness, is used to great effect to increase discomfort. The ride experience includes "the sound of a lever slamming into a slot, a great hiss of steam and the sound of the grinding of gears, followed by the mechanical grumble of a wheel or engine revving up to an intense, ear-blasting roar." Sound, combined with unexpected movement, also helps to establish suspense: "Immediately you hear a chain being dragged and the sound of a large, metal hook being attached to your vehicle. With a mechanical screech, your cart tilts backward until you are lying flat on your back, facing the top of the gallows frame." Now add a little heat and odor: "Suddenly...KA-BOOM!!! The walls around you erupt into flames. The force of the explosion collapses the ground beneath you and your vehicle is sent ripping straight down through a long-forgotten tunnel." In this case, "straight down" refers to a track angle greater than 90 degrees, lifting passengers off their seats and providing an experience as close as possible to a free fall. As in the other examples, sights, sounds, smells, kinesthesia, and temperature all collaborate (or conspire) to create a sensory environment that forms strong impressions and lasting memories. Whether it's a bat cave, an abandoned mine, or any other sensory environment that Forrec has created over the years, the immediacy of the experience is heightened when all the senses are engaged. It is worth remembering that our sense of vision, upon which we all greatly depend, is informed and enhanced by our senses of touch and smell. In immersive experiences, all these senses work in concert to create a total experience.

Trending—Total Immersion

Gordon Grice indicates the ways in which themed and immersive spaces can be made more compelling through the use of multisensory approaches to design. Going back to early amusement parks, museums, and other spaces, we can see that immersion has long been a part of the consumer environment. Only today, we note, are spaces becoming even more immersive.

Today **total immersion**—in which the guest is taken into another world, story, or place through the use of as many senses as possible—is a growing trend. Total immersion has received attention mainly because it represents the realization of all of the ideas addressed in this book up to this point. When a guest experiences total immersion that person feels something that was thought to be impossible—a world in which every detail, each and every symbol, all the senses and the experiences, the nature of the space itself, all have a sense of completeness, consistency, and authenticity. Total immersion, however achieved in a given designed space, allows us to see the total value that is achieved by an effective combination of symbols, brands, and senses in space.

1. Why does material culture play a fundamental role in the creation of effective immersive and themed spaces?

2. How does technology help create immersion within a space?

3. What is movement and flow and how does it relate to the development of a great designed space?

4. In what ways can interactivity be used to extend the stories that are told in a space?

MATERIAL CULTURE, TECHNOLOGY, AND INTERACTIVITY

Material Culture

For all guests, when they walk into an immersive or themed space they often have immediate reactions. Whether they will likely become immersed or interested in the space often depends on their first impressions of the space: Does it look expensive? Does it impress in terms of its features? Does it excite all of the senses such that guests want to explore it further? The impressions that are made on guests are the results of a combination of factors. As we talked about earlier, things like authenticity, the efforts of workers in the space, and other things like the use of the senses all play an important role in delivering a meaningful, fun, and believable space. In this chapter we will get into some additional "nuts and bolts" issues. In addition to addressing how material culture makes a big difference in a space, we will look at the significant ways in which technology, movement, and forms of interactivity can be used to further immerse guests in space.

Figure 7-2

The entrance to the 25hours Hotel Hamburg. The space uses material culture—including furniture, crates, and interesting wall treatments—to create an eclectic and unique visual space.

Extending the Story

To give an object poetic space is to give it more space than it has objectivity.

–Gaston Bachelard[1]

[1] Gaston Bachelard, *The Poetics of Space* (New York, Beacon, 1994).

Like all of the elements discussed in this book, material culture plays a major role in the construction of a successful themed or immersive space. **Material culture** refers to all of the material things—the streets, the bricks, the tables and chairs, the lights, the fountains, etc.—that make up the themed or immersive space. Essentially, material culture is the stagecraft—the props—that is used to tell immersive stories and/or create specific feelings or moods in guests. Without material culture a space would be empty and thus would be unable to tell stories or immerse guests within exciting worlds. Let's look at some specific examples of material culture and consider how they can be used to make the space more meaningful.

Paint

Figure 7-3

Paint is subject to all of the important principles of color that we discussed in Chapter 3. One of the most important benefits is that it can be used in a very efficient way to immediately transform the character of a space. Where once a space was drab, dry, and without life, with a bit of color theory and a high-quality sheen, the space becomes something otherworldly—a place

that guests feel special in. One of the most useful ways in which paint has made a difference in the world of designed spaces is through the use of faux painting. In this case, a wall is given new texture to simulate everything from fabric, grain, marble, or wood. In other cases, such as in *trompe l'oeil*, paint is used to create a sense of architectural illusion. Whatever the use, it is important to keep in mind that paint can have a lasting impact on the space and how it is received by the guest.

Lighting: Lighting, or illumination, is a key part of any designed space. By using lighting in effective ways, incredible senses of story can be told in a space. The use of lighting in a designed space, much like the use of lighting in film (cinematography) and in other contexts, can make or break the space. Lighting can be used to:

1. Create senses of drama within a space. Dark and light contrast can be applied to mark one area of the space off from another.

2. Establish a sense of mood. The angle of lighting, its direction of illumination, and its color can be utilized to transform a space into the mood necessary for the story being told.

3. Transform or modify the architecture. Lighting—whether natural forms like skylight (see Kelly Gonzalez's interview in Chapter 4) or artificial forms—has an ability to add to the dramatic artificial effects in a space.

4. Create movement within the space. Lighting can assist the design of the space by supplying forms of movement and performance.

5. Establish a sense of emphasis within the space. Illumination may be used to highlight some spaces and deemphasize others,

thus providing for powerful forms of variety in the designed space.

Figure 7-4

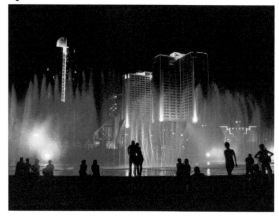

Water: Of the other main elements—air, fire, and earth—water seems to demand that we participate with it or, in some cases, in it. A lazy river that flows along in a posh casino resort beckons us to be a part of it; a boat ride through raging rapids asks us to come along for the journey and the adventure; and a marvelous dancing water fountain tells us that we have arrived somewhere unique. Water is thoroughly transformative.

Water can act as a *conveyance*—as a vehicle that moves people figuratively (and literally in the case of water rides and vehicles) within the space. It can also be used in ways to create *contrast* (as a form of negative space) and *illusion* (such as in reflecting pools and infinity edge pools). Water can also *perform* in the many ways in which fountains and water shows can exhibit the qualities of a space—excitement, mystery, and drama. Water may also be used in *practical* ways, such as in cooling off a guest in a hot outdoor space, and it may be used as a *sensory device* to remind guests of some action that is taking place in a story, such as on a ride.

Art

Figure 7-5

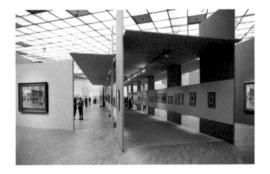

One of the richest sources of material culture is found in art. Art includes painting, sculpture, installation, and other forms of physical aesthetics. Art should never be thought of as a form that is without context. It should be seen as a device that can help convey a story or the mood of a space, not simply as a form that is slapped onto a space. There are many values that art can lend to a space:

1. Art can create a sense of grandeur, a sense of the sublime, and the idea of the epic.

2. Art is a great transmitter of mood. Consider how the artistic renditions inside the lobby of the Venetian convey a sense of Venice and Italian cultural mood.

3. Art provides a human touch to a space and suggests the idea that "someone created this."

4. Art is an excellent conveyer of the senses and of emotions. It can help establish feelings in the guest within the space.

5. Art can assist, quite profoundly, in the development of story within a space. In some cases, such as in the use of murals and dioramas, art can be used in an economical way to fill in gaps in a story. A dramatic diorama, for example, could be used to lend backstory to a space or to detail historical aspects of the story behind the space.

Image: Architect Juhani Pallasmaa speaks of the poetic nature of the image (*The Embodied Image*) and reminds us of the transformative role that an image plays in space.[2] Typically, an image is not used by people in rational or logical ways. The image, instead, impacts us at emotional and multisensory levels. With this in mind, we can think of ways of deploying images that assist in conveying of mood, story, and information within a space. Like forms of art, images can be used in ways that immediately connect the guest to the space, the story being told, or the specific moods within the space. Visual anthropologists remind us that images have deep connections to culture and how people relate to their culture:

1. Images reflect some of the classic and deep-seated ideals of culture. Many images have taken on the quality of archetypes.

2. Images tell us about the history and social life of a culture. Consider the powerful aspects of the Great Depression that are embedded in the image "Migrant Mother" (Dorothea Lange, 1936).

3. Images have the ability to stir powerful emotions in people. Using the right image for the space can pay dividends in terms of immediate and even lasting effects on guests.

4. Images provide designers with a very effective means through which stories can be told. Instead of describing a character in a particular attraction or ride, the designer can use images (including video images) to tell the story.

Images, unlike some of the other forms of material culture that we are considering, have the potential to be used in multiple media formats. Images can be used in murals, as paintings, in photographs, in video, and in other forms of art and installation.

[2] Juhani Pallasmaa, *The Embodied Image: Imagination and Imagery in Architecture* (West Sussex, Wiley, 2011).

Object: Objects are as varied as the spaces in which they appear—chairs, fixtures, tables, screens, windows, etc. The designer, when using any object in a space, has fundamental choices to make in terms of both form and function. Some of the greatest innovations in home product design have occurred because designers asked serious questions about both the form and the function of the product at hand. Even everyday objects that seem established in our lives—like scissors—have been analyzed by designers in order to look at whether their form or function could be altered. In some cases, thousands of versions of a product are looked at from an aesthetic standpoint (what does it look like?) and a functional viewpoint (how does this thing work?). While radically altering the design of an established household product can be a challenge, critically looking at design in an informed manner allows for a revolution in terms of thinking about how that object might be used in a home. You might consult Gary Hustwit's interesting film *Objectified* (2009) for more on this area of design.

Much like the work of product designers, the designers of themed and immersive spaces can think about the ways in which their objects will be used in a space. Consider these aspects of object use:

1. Will the object have one primary function? Is that function a result of certain conventions of culture that exist regardless of your space?

2. Will the function of your object easily mesh with the other aspects of your space? If not, what adjustments have to be made to the use of the object, its design, or the parameters of your space?

3. Will the function of your object connect with the aesthetics of your space? Will the object tie in with the story that you have created for the space?

4. Will the object distract from the space or will it help complement the other meanings that you are trying to get across in the space?

Let's have a look at Chart 7-1 and consider four main ways in which an object may fit in a space.

Functional	Aesthetic	Thematic	Narrative
The object only exists for its function; in this case, to be a place where a guest can sit.	The object exists for its function but it adds just a bit of design in order to combine form with function.	The object takes form and function to the level of the theme and attempts to fit in with the story or theme of the space.	The object is not only themed, it has a history or is an active part of the story of the space. In this case, the chair was once owned by a dignitary.

Chart 7-1 Four Approaches to an Object

Application—Object Meaning

We have looked at one example of how an object (a chair) can be used in different contexts within a space. Choose another object—besides a chair—that plays a role in one of your spaces. Discuss the object in the case of each of the four approaches to its use—functional, aesthetic, thematic, and narrative. Does the object in your space naturally fit into one or more of these categories? Are there challenges to using it in one or more of the four ways? Overall, reflect on why objects play a significant role in your space and consider some ways that you can use these objects in ways to create greater connections with your guests.

What Is Mana?

In a number of Pacific Island cultures, the word **mana** is used to describe a place, an object, even a person that is charged with powerful—perhaps supernatural—energy. The word mana is hard to translate, but roughly means a sense of "prestige" or "power" that is contained in certain things. Elvis Presley had mana and, especially since his death, many people from various cultures try to imitate the persona of Elvis. Graceland continues to be a spiritual site of pilgrimage for Elvis lovers and it also has a sense of mana to it. The film *Mana: Beyond Belief* (2004) describes many other people, places, and objects that have a sense of energy to them. What is key to the understanding of places and objects that have mana (as compared to those objects and places that do not) is that these places and objects have qualities that draw people to them. It could be the history that is tied up in a family heirloom watch or a tragedy that occurred at a historical site that is frequented by people. Whatever the case, it is worth researching some of the examples of mana throughout the world and thinking about the ways in which these unique qualities of prestige and power can be replicated in a designed space of your own. Mana can be a great source of inspiration for all design.

The Top Ten Story Breakers

In some cases, the story being told in a space (or the specific mood or moods being created within it) begins to break down, often because of problems in the way that the material was used (or wasn't used) in the space. Here are some reasons why story breaks happen in a space. These are not listed in any particular order.

1. *The Unclear Story*: There is a lack of clear thought about what the story is in a total sense. In this case, the space offers the guest a story but the parameters of it—the plot, characters, and the action—have not been carefully thought out. This problem may result in the guest saying after leaving the space, "What was that supposed to be about?"

2. *The Man behind the Curtain*: A functional element of a space—such as a restroom or even a chair—has not been integrated into the story or mood of the space. While in some cases this may be acceptable because the guest realizes that he or she doesn't need to be told a story while in the restroom, in other cases the magic breaks down in the sense of a "**man behind the curtain**" phenomenon.

3. *The Gratuitous Function*: Somewhat related to the last story breaker is the situation in which a story is lessened in a space to make way for something else— like a ride. Or in other cases, the element like the ride is integrated into the space through story but it's done in a gratuitous manner. This could be illustrated by the situation in which a roller coaster is given just the minimal amount of theming or story treatment to excuse it being a part of a particular themeland.

4. *The Sore Thumb*: This is a situation in which one design element is not in sync with other design elements. For example, a space might have a posh hotel that, in every sense, is a well-designed space. It's full of detail and no expense has been spared on the design or the operation of it. The problem is

that the design aesthetic contrasts too much with the other spaces around it.

5. *The Bad Story*: In some cases, there is great intent behind a space and much effort is put into developing a great story for the space. The only problem is that the story is bad. This could be because of the fickle dynamics of guest reception to the story—they just didn't like it. In other cases, it is the result of a lack of research about how to make the story work for the space. In other cases, there could be an issue with a lack of sufficient budget to effectively convey the story within the space.

6. *The Bad Transition*: In other cases, a space has great individual elements that help tell the story, but there is a bad transition—or a lack of transition—between the elements of the space. It is the equivalent of a bad edit in a film. Many theme parks avoid the bad transition by paying attention to effectively theming the spaces in between the entrances and exits of themelands.

7. *The Hard Sell*: When a space tries too hard to sell something to the guest, we have an idea of the hard sell. The hard sell is too overt in that it asks the guest to buy something without thinking about his or her more immediate needs. Entertainment, desire, and happiness of the guest are sacrificed for the financial ends of the space.

8. *The Bad Actor*: In previous chapters we have talked about the scenario in which a bad actor brings down all of the magic of the space. In such a case, the guest will be unwilling or unable to accept the design of the space only because the actors can't play their parts.

9. *The Shallow Story*: For whatever reasons, a space sometimes displays the scenario in which a story is just plain shallow. It lacks the necessary nuances, details, and theme and variations to pull off a connection with the guest. The space displays a lack of attention to a story that is compelling enough to draw the guest in.

10. *The Burdened Guest*: In some cases, a space might fail to tell its story or to deliver its mood or ambiance because it asks the guest to do too much—it asks the guest to do all of the work that should be done by the designers and operators of the space. Consider the situation in which a few cheap props are used to convey a sense of a "Western village." Are these enough to make the guest feel like he or she is in the Wild West?

Provocation—Story Breakers

We have just addressed ten reasons why a story might break down within a particular space. Take a moment to work on this application. Choose one of the ten reasons listed above. Think about a hypothetical situation in which one of these story breakers has become a problem in your space. You have been asked to correct the problem. Discuss how you would do this. What would you do to make the space more effective and to bring great storytelling back into the fold? How can material culture assist in avoiding various story breakers?

No Story, No Problem

In some cases, instead of an explicit theme, a space might reflect more of a mood or atmosphere in terms of

Figure 7-6

the design aesthetic. Much of Las Vegas' CityCenter, for example, does not reflect the themes that are found in the resorts on the rest of the Strip. Instead, CityCenter uses an aesthetic of modern cityscapes—elegance, culture, high art, comfort—to connect with guests. Some critics have expressed concern that this particular design move—especially in the context of the themed Las Vegas Strip—presents a challenge. Guests, it is argued, will not appreciate a space that offers a less explicit story or developed theme. While this could be a concern, it doesn't have to be.

All designed spaces, whether conveying an explicit theme or a more implicit sense of mood or aesthetic, should be created with the sense of making a connection with the guest. Earlier, we discussed all of the ways in which this is possible. In the case in which a space opts for the more subdued use of story, there still needs to be a clear focus on the use of material culture in a thoughtful and compelling sense. Specifically, these sorts of spaces might be thought of in terms of these design principles:

1. Do the objects within the space offer the guest a sense of mood, excitement, energy, or other qualities that can effectively take the place of a developed story within the space?

2. Do the objects provide a combination of function and aesthetics that will accomplish two things— meeting the basic needs of what the guest needs to do in the space (such as sit down) and addressing the desires of the guest to experience beauty, the sublime, and other qualities of aesthetics and form?

3. Do the objects *do more* than simply fulfill a function in the space? If not, can they (perhaps in combination with the space) be redesigned or thought of in a new way?

4. Do the objects offer the guest a sense of discovery that might be otherwise found in a space with an explicit story or theme? If not, can the objects be thought of in a way to address mystery or discovery? Consider, for example, an exquisite table that has been designed with multiple nooks and crannies—or perhaps takes an unexpected form— and how that object draws in the guest. It creates a sense of desire.

Technology

Like forms of material culture, technology plays a vital role in every designed space. Technology comes in many different forms and relates to multiple media and millions of possible applications. As part of the design scheme of the designer, technology offers some of the most important ways to create spaces that combine excitement ("pop"), immersion, authenticity, believability, and effective storytelling. In this segment we will consider some significant ways to use technology in themed and immersive spaces and hear from two designers from the firm BRC Imagination Arts who offer additional ideas of how to use technology in successful ways.

How Technology Has Impacted Space

Technology, like architecture and material culture, can lend a space incredible potential. Effective technology has the ability to transform a space from a drab and uninspired one to a place that will give guests every reason to come back. At the same time, technology, when used in a careless way that takes for granted the intelligence and creativity of the guest, will result in a space that is memorable, except for all of the wrong reasons. Human development researcher Denis Goulet once spoke of the fact that technology is a two-edged sword. It has the potential to assist people but it can also create unintended and sometimes negative consequences. In the case of how technology can be used to great effect in a designed space, we may consider some of the general uses of it:

- Technology, as an *extension of the architecture and material culture* of the space, provides an opportunity to create rich, new spaces that look nothing like those of the past. Electronic atmospherics, or the use of various form of technology to create physical and atmospheric effects in a space, are one opportunity to create striking, imaginative, and original spaces. Video walls and other forms of installation further extend the traditional understandings of leisure and entertainment architecture.

- Technology may allow the designer to *create more meaningful stories* in a space. Technology can be used as a realization of the rich tapestry of imagination of the designer. Just as the painter chooses the right combination of colors, the designer can use technology to imagine realizations of stories that guests would have never thought of.

- Related to the last point, we see that technology may *provide for greater immersion* in a space. Through any number of virtual, audio-visual, simulation, and other techniques, the designer may use technology to transport the guest into another world that is made more believable due to the technology.

- Technology also allows for *greater choice by the guest*. We will see in the interviews that follow that technology (including handheld and mobile media) gives the designer an ability to "hear" from the guest. Guests can provide instant feedback, interact with spaces, and leave a sense of their mark on the space being visited.

- Technology provides for various forms of *improved efficiency* within a space. Especially for operators of the space, technology can be used to gather important data related to how guests use the space, demographic characteristics, and queuing and flow within the space.

Whatever the use, as Bob Rogers and Carmel Lewis will offer us, technology must also be thought of within the context of the space and the story being told in it.

Technology as Storytelling
Interview, Bob Rogers and Carmel Lewis
Chief Creative Officer and Vice President of Cultural Experiences, BRC Imagination Arts

Figure 7-7

Figure 7-8

Bob Rogers is the Founder and Chief Creative Officer of BRC Imagination Arts. Master storyteller, inventor, and writer, Bob has been a leader in the field of experience design and production for over three decades, sought after by international brands, world expos, museums, cultural institutions, and entertainment attractions. In 2007, Bob received the Thea Award for Lifetime Achievement, this industry's highest honor. In 2010 Bob was inducted into the IAAPA Hall of Fame. Carmel Lewis is Vice President of Cultural Experiences at BRC Imagination Arts. A true renaissance woman, Carmel's background at BRC runs the gamut. Since 2001, she has contributed to projects from virtually every aspect—from creative and design management, client relations, project

development, and business and legal affairs. Carmel earned a Bachelor of Science degree in Theater Production from Towson University in Maryland.

Can you talk a little bit about the work done by BRC?

Our work has been rooted in creating immersive, story-based experiences. With respect to museum attractions, we think experience-driven adventure instead of traditional exhibit display. Immersive, emotional storytelling in place of deliver straight facts. An extremely effective way to reach the mind is through the heart. Make someone care, and you've created a path toward learning. A misnomer we often face is that a story-based approach sidelines any educational goals. We disagree. The educational goal is often the same. The means toward that goal is what is changed. (Carmel Lewis)

How does your work relate to telling a story and creating an experience?

Anyone can send a message, that's easy. Changing behavior is hard. That's why we focus on creating experiences that change behavior. Artifacts have great power, but only if you know their story before you see them. If you know the story of an artifact, its presence can move you deeply. If you don't know its story, it's just stuff. At BRC, we are telling stories and creating experiences that release the power of the artifact in a way that will change behavior. (Bob Rogers)

Could you discuss some specific design projects that illustrate your approach to museums and interpretive environments?

We recently worked with Louisiana's Old State Capitol in Baton Rouge. They have a very large artifact to interpret—the capitol building itself, a gothic style mid-19th century castle. How do you make people feel deeply moved about a building—to not only care about it, but to see it as their own? Our story solution came in the form of Sarah Morgan, an authentic Civil War era girl. Sarah Morgan had a deep emotional connection to the State Capitol. In her published diary she wrote passionately about the capitol and the indignities it suffered alongside her native Baton Rouge. So, we created an experience in which the ghost of Sarah Morgan brings the building's story to life—a history that closely parallels that of Louisiana. In the end, the building—the artifact—is the embodiment of the exceptional spirit of Louisiana's people. The story provided a wonderful connection between people, history, and pride of place. (Carmel Lewis)

At the Abraham Lincoln Presidential Museum, we created a Whispering Gallery and filled it full of the nastiest, most offensive political cartoons and writings about Lincoln and his wife Mary. It became a nightmarish gallery of twisted perspectives and twisted picture frames. This had the effect of making the visitor feel the way Abraham and Mary must have felt reading these things and looking at these vicious political cartoons. The net effect sticks with the visitor long after some of the individual political cartoons have been forgotten. It paints a picture of a president who is very much like a president of today, subjected to vicious criticisms.

In another example, we created a living Civil War map that reduced the Civil War to four minutes—one second for each week. You can watch the battle lines shift back and forth while an odometer counts the rising casualties on both sides. This map is intellectually interesting to the historian or aficionado who is fascinated to see all of the battles and battle lines shifting relative to one another. They are also fascinated to watch the casualty

counts accelerate and decelerate based on seasons and battles. But to average visitors, the emotional effect of that casualty odometer stays with them well after their visit. The indelible impression is that our nation was tearing itself to pieces and that the American casualty counts of the Civil War made all of our American losses in other wars look small by comparison. The scholarship of the casualty counts was a breakthrough, but at the same time, the emotional impact made the whole thing extremely memorable. (Bob Rogers)

Can you discuss what Holavision™ is and how it was used at the Abraham Lincoln Presidential Library and Museum in Springfield, Illinois?

Holavision™ is a high-technology illusion that allows us to suspend an image in a place where there is no image-forming surface. The effect is stunning as a live actor on stage appears to manipulate, control, and relate to suspended vapor, which twists and forms itself into the characters and ghosts of history. As amazing as this is, we think of Holavision™ less as a technology and more as a storytelling device. The effect is mesmerizing, but after the first minute or two, you had better have a strong story that resonates with the hearts of your audience. There is no excuse for becoming so fascinated with the technology that you lose track of your educational and inspirational objectives. (Bob Rogers)

A number of the readers of this book will be interested in using multiple forms of technology in their theme park, museum, and other design projects. Can you give our readers any tips on how to use technology to make their projects more appealing to guests?

You cannot think of technology for technology's sake. It must always be backed by strong storytelling. (Carmel Lewis)

Figure 7-9

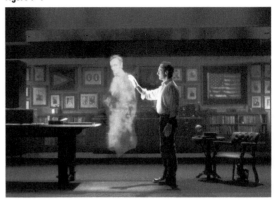

There is a very good answer in your question. By all means do use multiple technologies in presenting material. If for no other reason, it wakes up and resets the attention span. When you change technologies and environments going from, say, Holavision™ into a traditional gallery, it resets the audience's attention span clock and you begin anew with a fresh focus. A museum that uses fewer techniques handicaps itself and sentences its visitors to attention exhaustion. By the way, it also helps if you vary the interiors as well. Traditional 19th and early 20th century museums tend to make all the interiors alike. The National Gallery of Art in Washington, DC is a good example. All of the galleries and rooms have nearly identical interior architectural finishes. Thus the art may change, but all the rooms are the same. A better approach for a 21st century audience is to frequently vary the size and shape of rooms, alternate theme rooms with unthemed rooms, change the flooring, etc. In the Abraham Lincoln Presidential Museum, we even changed the temperature going from a colder room in which Mary Lincoln was mourning the death of her son, Willie, to the White House Kitchen, which was deliberately kept warmer. Anything you do to sharply change environments tends to wake up your visitor and get them to pay attention again. (Bob Rogers)

What Bob is describing [in Lincoln] is technology that is designed seamlessly into the experience and is intentionally invisible. It's not seen, only experienced. On the other end of the spectrum, our most recent project at Kennedy Space Center is Exploration Space. Here, the technology means are obvious, used to transform a single space into multiple environments. Using media and projection on every surface, the space can be changed based on the content that is being featured at a given story point. When talking about NASA's future moon missions, the entire environment takes on a moonscape. When talking about future exploration of Mars, the entire environment takes on a Mars landscape. This is advantageous from an experience perspective because you can physically immerse your audience in the content. It's also attractive from a client's perspective in its flexibility. There is a single technology infrastructure with infinite content possibilities. (Carmel Lewis)

It's really interesting to see how much technology has transformed the museum and the theme park experience. Have you noticed any differences in how guests respond to the ways in which you have used technology in your projects? Do they seem more involved, more interested, etc.?

If it makes them want to repeat the experience or recommend it to others, this is a very helpful means, but it's not an end. The final measure of success is not whether they liked the technology or not. It's not whether they felt entertained or not. Did the experience have a long-range positive impact on their behavior? Always remember, the medium is NOT the message, the message is the message. That's a clever play on Marshall McLuhan, but it's still not quite right. To be more precise, the change in behavior is the only important thing. If you don't change the audience's behavior, then the entire project has no function and

should not be built. If you are trying to change behavior, focus on that change and rigorously discard anything and everything that might interfere or which simply fails to support the change in behavior you seek. (Bob Rogers)

Do you ever run into a situation in which the technology that you want to use to tell a story in a space doesn't exist? What did you do?

Well you invent it, of course! We have many examples. For the Louisiana Old State Capitol there was no system that would fit into a small room in a 160-year-old listed building, so we invented one. For another show we needed a way to form images out of mist that would support a story experience, so we invented Holavision™. At the 2010 World's Fair in Shanghai when we needed a handheld device capable of being issued to 1900 people per hour, recording their experiences, and then creating 1900 personal Web pages per hour—we invented it. If you are focused on the outcome rather than the method, always follow the advice of Hannibal: "We will find a way or make one." (Bob Rogers)

It seems that many of BRC's projects focus on immersing a guest in an experience. Can you talk about your approaches to projects that wrap a guest up in an experience?

We have a term for this. It's sensory illusion. The idea is to use multiple effects including visual, oral, and tactile, in order to convince the body that more is happening to it than is really taking place. For example, most simulator experts passionately debate the number of degrees of freedom in a simulator. Six degrees of freedom is the gold standard, three degrees of freedom is considered subpar. Our Shuttle Launch Experience has only one degree of freedom: pitch. But it has lots of pitch. We combine four different types of vibration at four different frequencies to convince you that you are feeling the effects of G forces on your chest when in fact, you are

never subjected to more than 1 G. The visuals also contribute to this by providing motion queues changing the color of light, the angle, the view, etc. By combining dozens of tricks like this, we convince your body that it is experiencing a real acceleration, straight up, accelerating from zero to the speed of sound in less than a minute. The astronauts have called this simulator the most realistic simulator they have ever experienced in NASA or the military—a high compliment indeed. All of the above delivers on the promise. The guests at the Kennedy Space Center for years have wanted to experience what a space shuttle flight would have been like. At last, they can. Who would want to achieve less? (Bob Rogers)

Figure 7-10

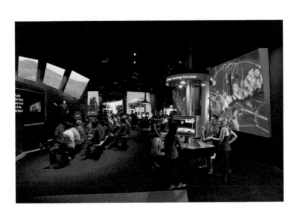

More and more guests are using hand-held technology (social networking, cell phone apps, etc). Have any of these made their way into any of the projects that you have designed?

Millions have been spent trying to develop technology that will allow a guest to relate to a museum or theme park using handheld technology/communication devices. One of the many interesting steps forward was the device BRC created for the 2010 Expo Information and Communications Pavilion. In the long term this kind of thing is something that our guests increasingly expect us to provide. It's not a choice. It's something guests expect to do and they will do it whether we provide

for it or not. One of the great opportunities before our industry now is the challenge of meeting this unfulfilled expectation. The mistake that is easily made by those trying to answer this call is that they think of it as a technology rather than thinking about it from the guest's point of view, i.e., what would be fun? What would be interesting? The successful handheld technologies will attack the problem from the guests' point of view and from a story experience point of view, not from the programmers' point of view. (Bob Rogers)

Mobile Media and Augmented Reality

Bob Rogers spoke of the ways in which mobile media have impacted the design of today's themed and immersive spaces. As he said, the use of mobile media in a space is not a choice—it's a given because guests expect it. Like many aspects of design that we have considered, mobile media is an important design element because it's so popular in the world outside of designed spaces. People use handheld devices of various sorts to navigate their world. Mobile media covers it all—directions to the grocery store, an online shopping experience, an ability to unwind and watch a film, the opportunity to connect with friends, being able to "check in" and meet up with friends in your community, and many other things.

A recent development in the world of mobile media is augmented reality. Augmented reality involves the use of media to interact with and alter the physical reality of the everyday world. One of the earliest forms of this technology that we are familiar with is the superimposition of first down markers in televised football games. Today, augmented reality is continuing to develop with numerous applications on mobile phones. Users may use their phones' GPS navigation system and camera to interact with the world around them in totally new and unique ways. These systems have uses ranging from the practical (such as overlaying

a map on top of the guest's real-time camera image on the phone to help guide the person in the space), to the entertaining (such as transforming a wait in a queue line into a compelling real-time game), and the immersive (such as inserting of videos, still photos, or text in the guest's screen on the phone as he or she moves the camera around a space). Whatever the use, augmented reality has the potential of transforming an immersive venue into an even more enthralling space.

Figure 7-11

As mobile media and augmented reality continue to be used in spaces, more and more designers have begun to speak of ways of using these media to expand the space at hand. In a sense, we can consider that mobile media offer an expansion of the space beyond the architectural effects that spaces had on guests in the past. As Chart 7-2 suggests, a space that utilizes mobile media

can create different sorts of effects within the guest (the guest can be made to feel even closer to the space) and the guest can respond in an individual way to that space.

Mobile media and augmented reality will continue to impact the design of themed and immersive spaces and designers should consider some of the basic ways that the space can be made more immersive and meaningful to the guest. Here are a few ideas of such ways:

1. Consider mobile media as an extension of the space and the story being told in it. If a story is presented with the architecture and material culture around the guest, more elements of it—plot, characters, action, backstory—can be developed through the mobile media applications of it.

2. Think about using mobile media in ways that maintain the significance of the material space around the guest. Involving a guest with mobile devices can be a plus but can also be a minus if the guest gets too wrapped up in the personal screen and ignores the architecture and material culture around him or her.

3. Offer uses of mobile media that will extend the effects of the designed space beyond the spaces that are visited by the guest. Allowing the guest to continue to use, reflect on, and relate to the space once that person has returned home may result in continued visits to your space. This is the idea of the lifespace that we have considered.

4. Use mobile media in ways that will allow the guest to have a greater voice in the space. This includes allowing the guest to interact with the space, to communicate with it directly, and to leave behind some evidence of his or her presence in it. Later in her interview, Mindi Lipschultz suggests one project that offered such a use.

5. Think about mobile media applications that provide a sense of discovery and imagination to the guest.

Chart 7-2 Mobile Media and Augmented Reality

Designed spaces of the past

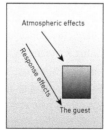

Designed spaces in era of mobile media

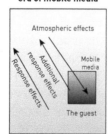

A space can become even more dynamic if a guest is given an opportunity to interact with it in more, rather than less, ways. Guests might be given the chance to collect information from the space and/ or leave their own impressions of it so that future guests (and designers) can read their stories.

6. Use forms of augmented reality to create new visions of space for the guest. If given a simple software application for the guest's iPhone or Android phone, the guest can interact with the space in new and innovative ways.

The Machine and the Ride

Machines and rides play significant roles in many designed spaces. Often, these are determined by the space in question. Theme parks, for example, rely on rides to deliver many of the basic aspects of their theming, storytelling, and general purpose. Many theme parks also use vehicles—trains, for example—to move guests from one section of the park to another. Restaurants often use machines in back-of-house contexts to deliver cuisine to guests. Cruise ships are machines that involve design within their spaces to meet the needs of guests. Museums and interpretive centers use machines as ways of creating simulations and recreations, such as in the case of historical lessons.

Some retail stores use machines in unique ways, but typically the emphasis is placed on the product being sold or the service being offered and thus a machine could essentially distract the guest from the economic purposes of the venue. Casinos (see below) have relied on the slot machine as a (sometimes) themed component of the entertainment offered to guests within their spaces.

In the case of rides that are found in theme parks or other entertainment spaces, they offer some of the most vital connections that can be made with a guest. Many authors have looked at the epic history of roller coasters and how people have become so deeply connected with them (consider the many enthusiast groups like ACE, The American Coaster Enthusiasts). Table 7-1 presents some ideas on the elements that can be used to create more excitement and effective immersion in the case of rides. While rides are the focus here, any sort of front-stage device or machine can be considered in these contexts.

Slot Machine: The slot machine is one of the most important devices for offering casino guests an opportunity to directly experience the excitement of the casino space. Slot machines have transformed the nature of casino entertainment, especially as they have illustrated the potential that a machine has in providing many functions of entertainment space in one compact form.

Figure 7-12

Figure 7-13

Table 7-1 The Ride

Element	Description
Cultural Modeling	To what extent does the ride reference cultures, values, or ideals and how do these play a part, if at all, in the ride experience?
Thematic Development	To what degree does the ride utilize theming or design as an integrated part of the ride and how does it enhance the ride experience?
Interactive Components	How does the ride manage interactions with the individual or groups of riders and how does interaction relate to other key aspects of the ride?
Psychological Qualities	How does the ride immerse the guest in the ride experience and to what degree does the guest suspend his or her disbelief and accept the ride as an alternate reality?
Kinetics	Does the ride utilize kinetics—movement in all forms—as part of the experience and does the ride utilize "group kinetics" in involving guests with others?
Extra-Ride "Text"	How does the ride extend itself beyond the space in which it operates and to what degree is the ride connected to other people's experiences or forms of culture (films, books, etc.)?
Function	Does the ride meet operational goals in terms of throughput, efficiency, operational contexts, worker training, and abilities?
Identity	Does the ride effectively use history (classic rides) or the wow factor (new technology, the future) to establish effective connections with guests and does it maintain those connections over time?
Pre-/Post-synergy	How does the ride use the connecting areas (queue lines, gift shops, exteriors and interiors) as a means of telling the overall story and does the ride seems to be integrated into the space in a holistic way?

Slot machines are especially effective machines because they combine the *excitement of the game* (including the possibility of winning), the important sense of *individuality and comfort* that comes with the guest being caught up in his or her personal "womb" (as casino theorist Bill Friedman suggests), the *power of the story and the theme* (as many slot machines are themed along product lines, famous shows like *Star Trek*, or certain more general but equally provocative themes), the use of *powerful ideals and symbols* (such as many slots that use concepts of adventure, the journey, or other forms of the monomyth in their theming), and the power of *group dynamics* as people around neighboring slot machines get wrapped up in the next person's excitement.[3] The slot machine proves that the next great technological evolution—a **game changer**—is possibly just around the corner.

Movement and Flow

Movement and flow refer to the ways in which guests move throughout a designed space. Movement and flow relate to a number of important design decisions that must be made in a space. Care must be given to the ideas of *efficiency and practicality* (the throughput

[3] Bill Friedman, *Designing Casinos to Dominate the Competition* (Reno, Institute for the Study of Gambling & Commercial Gaming, 2000).

of guests in a space, the ability of guests to get to the areas that they want to get to, etc.), the *achievement of maximum impact* in a space (by assuring that guests will see everything that "they should" see in terms of understanding the stories or concepts behind the space), the *focus on the products or services* offered in the space (in the sense of assuring that guests have the opportunity to spend their money in as many varied ways as possible), and on *interest and curiosity* in terms of the issue of making sure that guests are moved in such a way that their interests are continually piqued.

Master Site

The basis of any space is the master site or the overall layout of the space. The master site includes the front- and backstage spaces—ranging from everything the guest sees while in the space to all the ancillary and support spaces that function behind the scenes in creating the experience for the guest. Some spaces— like theme parks, casinos, shopping malls, resorts, and cruise ships—have large and extensive master sites. These sites can involve hundreds of square miles and multiple smaller spaces within them. Other sites—like retail stores and some museums—have smaller spaces. Some of the keys to a master site are considering all of the *components* of the site (down to the detail of every

attraction, space, and offering in it), understanding the *flow and wayfinding issues* of the site (including a consideration of both efficiency of guest movement and guest involvement in the story or atmosphere as it evolves in the space), and thinking about how the master site plan will *support the storytelling or atmosphere* of the site.

Application—Creating the Site

We have spoken about the master site and how it relates to the designed space. Take a moment to work on this application and refer to Chart 7-3. First, consider an idea for a new space that you might design. Choose the type of space—theme park, restaurant, retail store, etc.—and then write out the four main identifiers of the site (these are the Big Idea, Story, Experience, and Design that we covered in Chapter 1). Having this basis of the space, next work on a list of at least ten attractions that you would like to include in that space. Next, use the following sample diagram (Chart 7-3) and create a sketch of your master site. As you develop it, include the ten attractions that you have created and then fill in details about the Story Flow (or how the guests will experience the story over time and throughout the space) and Guest Flow (or how guests

Figure 7-14 Canal City Hakata Armature Diagram (The Jerde Partnership).

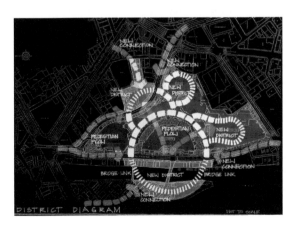

Chart 7-3 Master Site

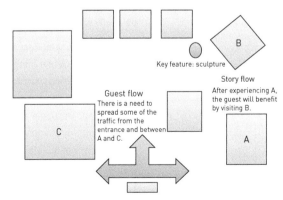

will be moved practically and efficiently in the space). In addition, detail any Key Features that may assist in the development of Story and Guest Flow.

Maps and Layouts

Maps are a visual representation of a space. They are used both for the purposes of planning a space and thinking carefully about how different points within the space will connect and for navigating and finding one's way in a space. For the designer, a map holds incredible possibility of creating a space that will connect with the guest. As we saw with the master site, there are many choices available to the designer in terms of the layout of a space. Whether a theme park, restaurant, shopping mall, or cruise ship, the layout of the space has a big impact on how the space will be perceived by the guest.

Chart 7-4 Hub and Spoke

The *Hub and Spoke* (Chart 7-4) is a layout that was popularized by Disneyland. In this form, there is a central hub—which is typically an anchor feature or "weenie." A series of spokes jut out from the center. This form has been applied in many city designs, including the Place de l'Étoile that radiates out from the Arc de Triomphe in Paris. This layout has advantages in terms of the ease and intuitiveness of the form and how it allows guests to easily move from one point to another. It also provides for effective control of flow and makes it possible to efficiently divide the space into meaningful partitions (such as themelands in a theme park) that can be easily visited by guests.

Chart 7-5 Loop (Out and Back)

The *Loop* or *Out and Back* (Chart 7-5) is another common layout. In this case a main loop is used. Around the loop are the various attractions. In some cases, such as at Universal Islands of Adventure, a main feature like a lagoon occupies the center of the loop. Traffic flows in both directions and while this can be an issue in assuring that guests see everything, information and signage can be used to make sure that all of the sites in the space are visited by guests.

The *Anchor* (Chart 7-6) is a form that is common to retail spaces, particularly shopping malls. In this model the main space is divided by anchor stores or major attractions that buttress the overall space. The anchors that represent the outskirts of the map create a flow of guest traffic because of their visibility and attractiveness. The smaller spaces that make up the inner areas—what some architects refer as the armature—are guaranteed traffic due to the guest's movement to and from the anchor spaces. There are many variations of this form with some layouts representing four anchors in a square pattern and others, like the one pictured in Chart 7-6, that offer a more triangular layout.

Chart 7-6 Anchor

Similar to the Anchor form is the *Cruciform* (Chart 7-7). In this approach, which is also popular in shopping and entertainment venues, a long linear layout is avoided in favor of a series of cross-like projections that help unify the space and spread out guest traffic. This form can also take advantage of anchor spaces that may be placed at the top of any cross.

Chart 7-7 Cruciform

In a *Maze* layout (Chart 7-8), space is much less organized according to logical patterns of geometry. Instead, the guest is encouraged to wander and, sometimes literally, get lost in the maze of the space. Many casinos have used this approach with the idea that guests will linger longer in certain spaces and take advantage of gaming, entertainment, retail, and dining options that are often spread out—sometimes equidistantly—throughout the master site.

Chart 7-8 Maze

Chart 7-9 Linear

In a final form, *Linear* (Chart 7-9), the layout of the space follows a practical A-B line. Some older malls have used this form. Many cruise ships, due to their obvious linear shape, also use this layout. Each of the decks of the ship are connected by elevators and each deck provides a different set of offerings for guests—food, retail, guest cabins, etc. One disadvantage of this layout is the congestion that may occur within the space.

These layouts are illustrations of only a few of the possible ways of thinking about the overall design of a space. There are not any hard-and-fast rules that will guarantee that one or another of these forms will result in a successful space. What is more important is the extent to which the layout of the space may support the nature of the themes, stories, and goals of your space.

The Worn-Out Path

Figure 7-15

If you have ever taken a walk in a nature area you may have noticed a curious fact of movement and flow. The designers of the space may have created specific pathways that are the "recommended" ways to get from one point to the next. These are the designed and constructed paths that are carved out of the ground, made from wooden planks, or marked off by fences of various sorts. Quite curious and in contrast to these pathways are the paths that have been made by wild animals or those of human visitors who decided, for whatever reasons, that the paths chosen by the designers are not the ones they want to take. There is a stronger element—one of desire—that guides the design of these paths. Over time, other people take note of the paths that begin to show their wear on dirt, soil, and earthly matter and, eventually, they become as noticeable as the ones created by the designers of the space. During my time inside the park at AstroWorld, it was common for me and my fellow workers to try in vain to get guests to walk on the paths that were designed for them. Many times, they figured out a way to take a shortcut—sometimes even through back-of-the-house

areas. We shrugged at their desire to move in a way of their choosing, but maybe we should have thought about what was really behind their motive to take *their* paths, not *ours*! We should never forget the role that guests play in responding to the spaces that are designed for them. In the case of pathways, sometimes the guest wants to move in directions and in ways that designers never intended.

Queues and Flows

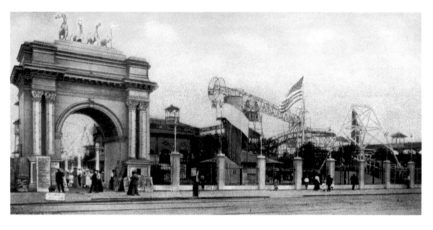

Figure 7-16 The entrance of George Tilyou's Steeplechase Park.

George Tilyou's Steeplechase Park was the first enclosed amusement park. Tilyou realized the potential of using a berm or exterior wall to enclose all of the amusements within a space. Quite practically, the enclosed amusement space gave guests everything they needed in one space and in terms of quality control, the operators of the park could focus on developing consistency within the space. Today, it goes without saying that themed and amusement spaces are closed off from the world around them. One thing that remains a challenge is figuring out ways of establishing queues and flows within the space.

Queues are used as a means of temporarily restricting access to a space and of controlling the number of people in the space. Queues are often found:

- At the entrance of a space. Especially in theme parks, on cruise ships, and in restaurants, the operators of the space need queues in order to conduct economic transactions and to assess security issues with guests.

- Where a product is sold or a service is offered. An example is if guests are asked to wait in line in order to purchase a hamburger.

- Where there is an attraction. Whether a film, ride, simulator, museum exhibit, or other attraction, the queue line is used to control the number of people who may visit and use any space.

Queuing theory is an important facet of both the design and operations of spaces. Much of this theory is rooted in mathematical models and considers variables of queuing like capacity, incoming rate, service rate, time, priority, and others. Part of the issue with queuing is deciding how guests will be treated when they are waiting. Queue lines are spaces that allow operators of a space to control the flow of traffic to a second space. Many successful theme parks, such as those of Disney, have created queue lines that are a part of the story of the space. In Pirates of the Caribbean, for example, guests are often not thinking about the fact that they are waiting in a queue line but are instead being told parts of the story, being immersed in the architectural story

Figure 7-17

of the space, and gaining anticipation about the ride that awaits them.

Flows are the ways in which guests are moved around the overall space. Flows not only involve queue lines but all of the other aspects of design and operations that take people from one point to the next. Flows can be used:

• When there is a need to spread guests out over a larger space in order to avoid congestion. An example is a classic "hub and spoke" theme park layout in which the operators of the space want to make sure that a crowd of people doesn't overload the capacity of any one area or attraction in the park.

• Where the operators of a space want to make sure that guests will see a variety of things in a space.

• In situations in which operators of a space wish to gather people in one area, perhaps for the purposes of a public show or spectacle.

It is important to remember that queues and forms of flow should never be used in a purely functional way. Guests do not like to be treated as persons in a crowd (what sociologists call an "aggregate"). Instead, they want to feel that they are part of something special. In this way it is important to make sure that queues and flows are as organic or natural as possible. As well, it is a great idea to make them a part of the overall story of the space. This is done to great effect in many museums in which a guest follows the course of time or history and has a sense of wanting to get to the end after the guest has seen the beginning of the exhibit. Queues and flows can, in some cases, be thought of as forms of transitions or edits that, like in film, allow for the story to have a bigger impact.

Wouldn't You Know It!—Experience & Movement

Years ago, I took a group tour at the Museum of Tolerance in Los Angeles. Along with a group of students, I went through the many harrowing spaces that make up the museum. About halfway through, I noticed countdown timers above some of the walls within the museum. Their function was to time any of the rooms in which a discussion between the docent and the group occurred. Some of the rooms offered

multimedia events that were timed and once they ended, the group moved to the next room. A second group then queued into the room that the first group occupied. In the discussion rooms, the timers were used to make sure that throughput could be achieved and that the thousands of guests who visit the museum each day can see each exhibit. During one experience within a discussion group, I watched as some students discussed their views on genocide. The discussion got going but then, wouldn't you know it, the countdown timer went to zero and the docent had to end the conversation. It was a somewhat awkward moment only because the students were in the middle of an intense discussion. What these experiences offer us is a sense of the trade-off that occurs between the desire for the guest to experience a space on his or her own terms (and timeframe) and the needs of the space to achieve effective flow and movement of guests through the space.

Information and Signage

Figure 7-18

All designed spaces, regardless of their function, use various forms of information to communicate with guests. Information plays a vital role in the ways in which spaces can achieve effective flow and movement as well as in developing principles of interactivity. Information takes various forms, each depending on the role that the information plays in the space. Basic information is often *practical,* meaning that it gives a guest tips on how to explore the space or states the hours of the venue. Some information is *prohibitive* meaning that it warns the guest of things that should be avoided. Many malls have used prohibitive information placards to inform guests of conduct codes that help maintain a family-spirited mood. Other forms of information provide *direction* and help guide guests to a certain location in the space—the restroom, food court, buffet, or arcade—and other forms provide identification in terms of letting guests know

that they are in a new space. Information is also used to *extend the storytelling* of the space. Placards, signs, and video screens can be used to explain aspects of a story to guests and heighten their experiences of it. Information may also be *educational* in the sense that it details something about the space or something in the space that can be taught to the guest. Museums and cultural centers often rely on this use of information.

Signage is a key form of information within a space. Entire design companies that are dedicated just to the production of effective signage have formed. As David Gibson offers in *The Wayfinding Handbook*, signage plays a key role in the development of effective wayfinding within a space.[4] The color, design, typeface, placement, and material construction of signage all impact how effective the signage and information will be for the guest. Signage and wayfinding can even help establish the branding of a space. One thing to keep in mind in terms of the information and signage that is offered to guests is the use of both should always be determined by the combination of factors that dictate the unique context of your space. Information and signage should complement the overall space and not get in the way of it. They should also be used in ways that are relatively transparent in the space. This means that they should stand out enough to communicate what they need to communicate but they should be invisible enough that they do not detract from the mood, atmosphere, or story that is the focus of the space.

Interactivity

Figure 7-19

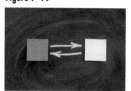

[4] David Gibson, *The Wayfinding Handbook: Information Design for Public Places* (Princeton, Princeton Architectural Press, 2009).

Interactivity is the important issue that ties three things together: the designed space, the story or atmosphere of that space, and the guest who enters it. Interactivity, as the name implies, involves an active sense of feedback that develops between a guest and a space. As Figure 7-19 shows, a basic feedback loop involves one thing interacting with a second thing. The key to feedback is that:

1. The two things interact with one another.

2. The two things change themselves as a result of this interaction.

Let's look more closely at how interactivity can assist the designer in creating a more profound immersive or themed space.

The Guest's Role

Throughout this text, we have talked about the fundamental role that the guest plays in a designed space. Quite frankly, the guest is the only reason that any themed or immersive space exists. When we speak about the primacy of the guest in space, we are really talking about the role of the guest in the space or, namely, how the guest interacts with it. In Chapter 1 we discussed the concept of the Big Idea and we spoke of how it related to what you want to accomplish in the space and what the guest is supposed to do and feel in it. Let's look at a different take on this idea in terms of how the Big Idea relates to the ways in which guests interact with designed spaces. Chart 7-10 illustrates that there are four worlds that relate to the interactions of a guest in a space. The first is the real world or the one that the guest tries to leave behind, the second is the created world that is designed by the designer (essentially the stories behind the world to be imagined in material forms), the third is the experienced world or the material version of the space that you have designed for the guest, and the fourth is the guest's world or the ways in which the guest actually responds to the spaces

that you have created for him or her. The chart includes 13 specific connections that guests have with these four worlds—a red line indicates a hard connection or one that is influential or strong, a black line is one that is less influential or weak.

What this chart attempts to look at is how guests interact with a space in the most global sense possible. A space cannot be designed with the specifics of every guest in mind. One cannot, for example, design a ride that will keep track of a guest who is having a bad day and another guest who is having the time of the person's life. Rides, like all designed spaces, should be designed with the "mean" or most common guest in mind. It is always important to think about the ways that guests interact with the various worlds around them.

Reason versus Desire, Choice versus Nonchoice

As the section on the worn-out path offered in the last segment, we can see that the designer is also wrapped up in the tough choices about how best to design a space given the guest's interests and desires. The worn-out path is an example of the guest deciding that there is a better or more desirable way to get from point A to B. In any space, the designer may encounter a situation in which she or he might think, "Will the guest like this?" "Will the guest be OK with this decision that I have made for him or her?" Test marketing and ethnographic research are some ways to work on the issue of decision making prior to the final construction of a space, but more generally, we might think about the overall philosophies that we have in designing a space with the guest's desires in mind. Here are some ideas that might help us frame some of these design considerations:

1. If a decision is made to control the guest—such as preventing him or her from entering a space within the site—how will the guest react to it? If the reaction might be negative, is there a way to redirect the negativity by either providing more

Chart 7-10 Four Worlds of Storytelling and Interactivity

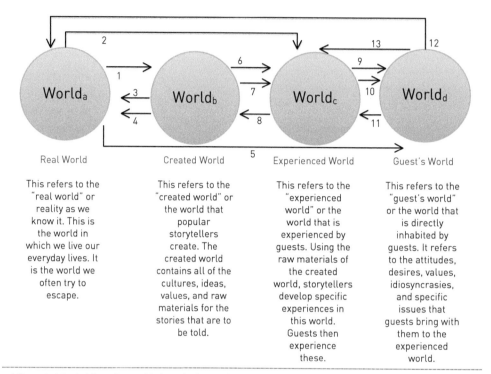

Real World Created World Experienced World Guest's World

Real World	Created World	Experienced World	Guest's World
This refers to the "real world" or reality as we know it. This is the world in which we live our everyday lives. It is the world we often try to escape.	This refers to the "created world" or the world that popular storytellers create. The created world contains all of the cultures, ideas, values, and raw materials for the stories that are to be told.	This refers to the "experienced world" or the world that is experienced by guests. Using the raw materials of the created world, storytellers develop specific experiences in this world. Guests then experience these.	This refers to the "guest's world" or the world that is directly inhabited by guests. It refers to the attitudes, desires, values, idiosyncrasies, and specific issues that guests bring with them to the experienced world.

1 The materials, decisions, time, and budgets that impact the created world.
2 The materials, decisions, time, and budgets that impact the experienced world.
3 The created world has a major impact on the real world (e.g. J.R.R. Tolkien).
4 The created world has a minor impact on the real world (perhaps some economic one, not world changing).
5 The real world's demands impact the guest's ability to enjoy fantasy (their limits, quirks, and interests).
6 The created world's foundations provide for an immersive experienced world (the ideal situation).
7 The created world's foundations provide for a mildly amusing experienced world (the less ideal situation).
8 Developments in the experienced world necessitate updating of the created world (e.g. expansion of Pirates of Caribbean).
9 The experienced world causes a guest to be moved—a deep impact (ideal).
10 The experienced world causes a guest to be mildly entertained—a superficial impact (less ideal).
11 Guests bring their own issues to the experienced world and impact the operations of it.
12 Ideally, depending on branding, guests will appreciate the experiences of the created and experienced world that they will bring their own stories back into the real world (e.g. Henry Jenkin's *Convergence Culture*, see Chapter 8).
13 The guests may have an ability to interact with the attractions within the experienced world.

refers to a 'hard' connection or one that is especially influential on the world.

refers to a 'soft' connection or one that is less influential on the world.

information about why the space is off limits or giving the guest an opportunity to experience joy or excitement in that area (such that the guest will forget about the prohibition)?

2. If a space is designed in a way such that the guest is asked to participate in it, what is the nature of this participation? Is it full immersion (such as in the case of a diving experience with live sharks), is it middle of the road, or low? Will the nature of the participation come off as shallow to the guest? Will the guest feel taken for granted?

3. If, in a space, the guest is asked to do something— whether buy a product, watch a film, or move from one point to the next—what is the motivation behind the suggestion? How does the motivation behind this request of the guest differ in the case of what the designer or operator wants to accomplish and what the guest might want out of the space? If there is a contradiction between the two, how might this be resolved in the space? Is there a way to balance the wishes of the designer/ operator to use reason (efficiency, practicality, and control) in the space and the hopes of the guest to experience his or her desire and will in that space?

4. Are the choices that are being given to guests the result of entertainment or education (pedagogy), or both? If a guest is asked to learn something in a space, versus being asked to enjoy that space, how will that impact the design of choices in that space?

There are many other issues to think about, but these are offered as an introductory look at some of the choice/nonchoice issues that are present in the designed space.

Trending—Games

Games are having an increasingly active role in our everyday lives. Games are, at their heart, a form of interaction between a player and a world. Whether a board game, a video game, or a real-life simulation exercise, a game offers the player an incredible opportunity to experience a world on the gamer's own terms. Jane McGonigal has written of the ways that games can transform both the world and the experience of the gamer. She contrasts the often drab and mundane world with the world of the virtual and of the game. In the game world, the gamer has a "sense of being fully alive, focused and engaged in every moment."[5] Games focus a person's experience, give him or her a heightened sense of the world, and offer a sense of purpose—a sense of something bigger than oneself— and reward. The structures of some theme park rides have taken on many principles of successful games. Consider the multiple endings of the Men in Black Alien Attack ride at Universal Studios Florida theme park. The guest has a sense of greater choice and the idea that he or she is making a decision, not being led along a predetermined narrative path. Another example is Disney's Toy Story Midway Mania ride. In this case, guests board a traditional ride vehicle but take part in a video game adventure that includes 3-D glasses and a series of carnival mini-games that rely on video game technology. In this example, each guest's experience is different and a guest may compete with another guest by taking part in the mini-games and assessing his or her scores. Even beyond explicit rides, any space may take advantage of the power that games may have in creating a more interactive experience for the guest. Consider using games as a way of increasing the immersion of the space and making the guest feel that he or she is part of a bigger story and experience.

[5] Jane McGonigal, "Be a Gamer, Save the World" (*The Wall Street Journal*, January 22, 2011).

Figure 7-20

Compelling Interactivity
Interview, Mindi Lipschultz
Cross-Platform Digital Media Producer/Creative
Director

Mindi Lipschultz has been involved in the production of extraordinary and innovative media for the television, museum, and themed entertainment industries as a producer, director, editor, and innovative thinker for over 30 years. She was nominated for an Emmy and has produced and edited television series for HBO, PBS, and the BBC and co-directed Janet Jackson's Because of Love music video. She worked as Creative Director and Senior Producer for the California Academy of Sciences (interactive media segments), as Media Producer/ Director for the ArtScience Museum at the Marina Bay Sands (four screen large format film), as Interactive Media Senior Producer/Designer/Director for Discovery Science Center ("Eco Challenge" Exhibit—Interactive Group-Play Games), among many other projects. She received the 2010 Thea Award, presented by the Themed Entertainment Association, for "Excellence in the Integration of Technology and Storytelling" (Shanghai World Expo, Information & Communications Pavilion).

Can you talk a little bit about your work? Specifically, can you focus on what excites you about using media, technology, and interactive approaches in your projects?

In terms of technology and the guest, everybody is looking for a big wow moment. People are often bored with conventional media presentations, and they would love to do something that is the coolest thing ever when they are in a space. Designers have this pressure, in a good way, to come up with the next coolest thing and thankfully we have technology now that can help us do it. The didactic types of learning—like putting copy up on a wall or even conventional video—is no longer

viable. You have to use technology to keep up with the times, to be five steps ahead. In addition to the guest who is looking for the most cutting-edge experience to interact with, you have the client. The client is behind the whole project and it's the designer's responsibility to meet and exceed the client's needs and also provide an unforgettable experience for the guest.

How do you work with a particular topic and turn that into something interactive and memorable for the guest?

In one of my projects I was producer/director for the "centerpiece" exhibit for Paul Allen's Experience Science Fiction Museum in Seattle. I used NOAA's Science on the Sphere projection system and had to come up with a way to project a collage of preexisting feature films onto a completely spherical screen. The client wanted a retrospective of science fiction films and I had to reverse-engineer the system and figure out how to design and produce a visually impactful new movie to play on the system, which had never displayed an originally created piece of media before.

So, in some cases if the technology doesn't exist for a project, you still have to create it.

Yes, that's right. In my work I've found an interesting niche. There's somewhat of a gap between technology innovators and the creators, and coming from the world of entertainment, I've learned to apply the technology in a way that includes human participation. The technology is a tool to break down mass media into a personalized experience. There's a lot of cool technology out there, but you have to create practical applications for it in terms of entertainment.

The personalized aspect of using technology seems to be a key. How have you approached this in a specific project?

I worked on a project as Digital Media Producer/ Director for the Information and Communications

Pavilion at the 2010 World Expo held in Shanghai, China. The overall project was supervised by BRC Imagination Arts. I produced the media for an interactive handheld device that each visitor to the pavilion received. We didn't use a preexisting device, so that hardware—and the software for it—were created from scratch. I was responsible for the media that was to play on the device. When guests walked into the pavilion, they put in a username and a password and all got their own website that they could look at when they got home. As you walked through the space, you could use the handheld device to collect information from various theaters and information in the space. When guests got home, they could view that information on their Web pages and get additional information from provided links. The overall theme of the pavilion was communications technology of the future and people were able to use the devices to not only collect information but also view videos and play games. In one of the theaters, people watched a huge theatrical presentation on the big screen and then were able to look down and see a whole subtext of complimentary imagery on the handheld devices. A lot of this is about mass customization—it's for the masses but is able to be customized for each person.

The last area of the pavilion was the most exciting part—the post show. Visitors got to customize their own experience and see the technologies that are in store for everyone in the future by playing a game in the palm of their hand. The handheld device included a futuristic game board that could be filled in as people interacted with the various fun and informational pieces by downloading floating lanterns to fill in the game board on their devices. They could collect more information about communications, medicine, the family, and other topics. It was structured like a game and people ran around the room to try to collect as much information as they could. They loved it!

What do guests take away from these experiences with technology and interactivity?

Well, in addition to having fun in the space, people can learn new things, but they don't know they are learning. I often use the saying that "a spoon full of sugar helps the medicine go down." In a lot of cases, like at the California Academy of Sciences, I have to work with specific educational material that some people might find to be boring. In the case of a bug and insect exhibit, we had all of the scientific information that was requested to be included from the entomology department and my job was to make it into something that kids would really get involved in and understand. I pitched a game idea and, long before the Wii came out, it was a scientist's tool that the kids would swing in the air. I heard from some parents that after they left the museum and went home, their kids were more interested in exploring insects in their own backyard. There's another project that I recently developed for Discovery Science Center called Eco Challenge. In this case the less-than-exciting topic was garbage. We created the media experiences in the form of carnival midway games to get children directly involved in understanding garbage and recycling. When the kids got involved in the exhibits, the energy level was 110%. It was amazing. In both of these cases, we see that we are superimposing technology over a potentially mundane subject and all of a sudden kids are clamoring to play—especially in a museum, where you also want people to walk away and change their behavior.

In these projects, it seems like guests completely accepted the technology.

Well, the idea is to create the experience and the technology is invisible. You don't want it to be about the technology, you want it to be about the story. When I worked on a Galapagos project for the California

Academy of Sciences, I used 18 scanned historic photos of the Galapagos—they were from 1906. I used them to create a three-dimensional world—like a View-Master on steroids—and used them to pull visitors into the world of 1906 Galapagos. They are plunged into a three-dimensional world and yet they don't see a lick of technology. When guests saw the old photos as part of the space, they didn't think about the technology. They thought: "I feel like I'm immersed in a world over a century old."

What are some overall tips that you have for using technology and forms of interactivity in designed spaces?

Well, as I mentioned, there should be a personal experience going on (like in mass customization) and people should take part in some form of learning while in the space. The use of technology, as I said, should be invisible, and you should have some form of storytelling connected to the technology. Most important, I think that you need to design the experience in such a way that the visitor is a participant in it. In a way, the experience alone is incomplete without the visitor—like a yin yang thing.

What trends in technology and guest interactivity do you see for the future?

One is the continued use of virtual and augmented reality. Both will become more prevalent. A lot of augmented reality hasn't been fully tapped into. As we develop new technologies we should also think about putting the player inside the game board and look to more intrinsic envelopment of the guest and the technology together. The other trend to look at is the use of wearables—shirts or other fabrics that have built-in technology—and other ways that guests can interact with a space and be plunged into an experience.

Mystery, Discovery, and Transformation

Mystery, discovery, and transformation: these are three elements that many of us often seek when we are taking part in something for the first time (like an extreme sport or outdoor adventure) or when we are visiting a new place for the first time. Anthropologists sometimes call this desire a **liminal state**. This is a state that is in-between worlds, of living on the margins, or of being on the threshold. Initiates in cultures who seek to be part of a new group experience liminality when they are going through the process of initiation or a rite of passage. This initiation is often a ritual that is marked by incredible senses of connection between the world and the initiate and is often characterized by heightened senses of emotion.

Designers, too, can think about the power that mystery, discovery, and transformation may play in a space. Most great dark rides take advantage of some or all of these elements. The sense of mystery that occurs when a guest moves through darkness to discover a hidden place and, all through the process, feels a sense of transformation is an approach to space that creates greater immersion. The phenomenon of Easter eggs—in which a person discovers a hidden message or special feature in a video game, DVD, or other media—is an example of how mystery and discovery has been used in the nonspatial world. This same approach has been applied to space. One example is the excitement that many people get from the activity of geocaching. Geocaching involves the use of GPS devices to discover hidden virtual or physical caches. Even more applicable to the designed world is the Hidden Mickey that is common in many Disney theme parks and animated films. In this case, a guest discovers an iconic image of Mickey Mouse's face and ears in a hard-to-spot image, architectural feature, or other material form in the park.

Hidden Mickeys have created the sense of excitement and discovery in guests who, upon finding one, have the sense of seeing something that no one else has. Whatever the techniques that you choose to use in a space, consider developing multiple forms of mystery, discovery, and transformation in it.

Organic Stories

In this chapter we have addressed a series of issues—material culture, technology, movement and flow, and interactivity—that have the ability to completely transform the design of a themed or immersive space. As we close this chapter's consideration of these important issues, we might reflect on the idea of the **organic story**. When we speak of something as being organic we mean that it is alive—it is something that is not made up of artificial things. Instead, it is created to best mimic the "real" conditions of the world. An organic story is just this—a story that is, by its very nature, natural, whole, and complete, in the sense that everything that is related to it appears to fit together seamlessly. The reasons behind an organic story are not related to the content of the story alone. While that is a big part of it, there is even more to be said

about how the elements of the story are developed within a space. Using the right forms of material culture can bring it alive, and appropriate forms of technology can sustain the guest's positive experiences with it. By using forms of effective movement and flow, the story will be both manageable in a practical sense and also significant in a narrative sense of how the guest experiences it. Interactivity also can bring about senses of real involvement with the story such that the guest will feel a part of the drama, not ancillary to it.

IDEAS FOR CONSIDERATION

1. What are some of the most effective ways to use material culture in a themed or immersive space?

2. What do you think are the top three ways in which technology can be used to make an immersive world more believable and exciting for the guest?

3. What are some ways to use techniques of movement and flow that will make the story, mood, or atmosphere in the space more desirable for the guest?

4. How has interactivity transformed the ways that we think about themed and immersive spaces? How can you use interactivity in new and innovative ways that will make profound connections with the guest?

1. What are some effective ways to create loyalty within a themed or immersive space?

2. What is tradition and why is it an important part of the successful longevity of a designed space?

3. What is change and how can your space be designed to effectively deal with change?

4. What sorts of stories will be told in designed spaces of the future?

LOYALTY, TRADITION, CHANGE, AND THE FUTURE

Loyalty

Throughout this book, we have addressed how exciting themed and immersive spaces can be created. We have talked about all of the little things that can make a space more exciting for the guest. This chapter will focus on the last significant aspect of the successful space—its longevity. A space's longevity refers to its ability to maintain meaningful, significant, and lasting impressions with the guest. A space that impresses only for a year or two is a doomed space. The most lasting spaces have qualities that allow them to impress year after year. We will talk about aspects of loyalty, tradition, change, and the future and talk to two important persons in the field who will share their ideas about these important topics.

What Is Loyalty?

Loyalty involves the creation of a sense of personal devotion between the guest and a space. While working at Six Flags AstroWorld, I became very familiar with how important loyalty was to the successful operation of our park. We welcomed all guests—whether they were first-time visitors or regulars—but we had a special sense of admiration for the guest who was a season pass holder and who came to the park five, ten, or even one hundred times in a season. The exceptionally loyal guest was someone who couldn't live without the park. To build loyalty at the park, just about everything had to be at the level of perfection. First, the design of the spaces had to be convincing enough such that the guest would want to revisit the park. Also, the activities—the rides, shows, entertainment, and food—had to be at a top level.

Third, the service of the employees had to be attentive and focused on meeting the guest's unique needs. We also had to focus on all of the ways to make the guest feel welcome in the park. Finally, we needed to be attuned to ways in which the park could change (a subject that we will cover a bit later in this chapter). If there were new trends happening outside the park, we had to think about how we could address those in the park. Any space—whether a theme park, casino, or cruise ship—has to be conceived in the best ways to establish loyalty within that space. The first major consideration is the design of the space and whether it will initially attract the guest and meet his or her needs and how the space, if necessary, can change. The second consideration is all that happens once the space is opened: how effective the operations are, how nice the employees act, and how willing the entire team responsible for the space is to critically thinking about the successes and failures of the space.

Inclusive Design

Throughout the book, we have considered a number of ways in which design can positively connect with the guest. The whole point of designing a themed or immersive space should be to connect with the guest. We may call this **inclusive design**. This is design that takes into account every need of the guest and which makes the guest feel that the space is about him or her, not about the designers or operators of the space. One key to such design was considered in Chapter 1. We talked about the importance of connecting the Big Idea, Story, Experience, and Design in a holistic or complete way. By attending to these four areas, there is a greater chance that the guest will feel that the space means something. It's not careless—it's thought out carefully and the stories being told in the space make a connection with the guest in the sense that the guest is a part of the stories. In Chapter 3 we addressed another important area of how to use atmosphere and mood to connect with the guest. Theming was one of many ways that we said could be used to make the guest feel included in the space. The idea of authenticity (Chapter 4) was, in part, to create a space that seemed real or believable to the guest. An authentic space, as opposed to a shoddy one, has the potential of making the guest feel included in the space because it seems like so much time, money, energy, and thought went

into the creation of that space. Immersion (Chapter 5) is a further significant aspect of connecting with the guest. If a space is designed with the immersion of the guest in mind, then inclusion will be a reality, not a dream. In Chapter 7, we addressed the many ways in which technology and forms of interaction can literally throw the guest into the thick of things. By having well-scripted and story-driven forms of technology and interactivity, the space has a greater chance of connecting with guests. The ultimate goal of any of these techniques is to think about how to make the guest feel as significant as possible in the designed space.

Criticism

One of the many tests of loyalty is how the designers and operators of a space respond to forms of criticism. Simply disregarding the criticism may result in a serious lack of loyalty with guests. **Criticism** takes many forms, but in short it is any comment on the design of a space that reflects concerns about the thought behind it, any aspect of the design elements, the operational issues, or other aspects of the space. Often, we think of criticism as primarily negative. Indeed, in some cases it can be mean-spirited and the results of jealousy, politics, or personality differences among individuals. Ideally, we should think of it as an important lens through which we can assess the quality of a designed space. Academics have offered criticisms of many of the types of spaces considered in this book. Typically, these focus on the quality of the spaces (the lack of authenticity) and the behaviors of guests within them. Unfortunately, many of these critics have barely stepped foot in a theme park or on a cruise ship and thus their concerns lack merit in terms of the real ways in which these spaces make a difference in the lives of everyday people.

A more important form of criticism is that which comes from guests. Guests are the ultimate barometer of the quality of a space—both in terms of its design and its use.

In the past, much of the concerns leveled by guests took place at a guest relations area within the space. Today, the world of social networking and mobile media has resulted in much of this criticism reaching a public level. Fans (and critics) react to a space and post their views on websites like Facebook and Yelp. Some people can be quite harsh in their views of the space—whether their criticism has any merits or not. Designers, sometimes, also get involved in offering criticism of a space. In some cases, this can have a very practical purpose. Think, for example, of a situation in which a designer in a firm reflects on some concerns with a current project. Instead of seeing this in a defensive manner, another designer could consider that person's different perspectives on the project. This form of criticism can lead to important forms of collaboration and may help deal with the tendencies of **groupthink** in which the team starts to head in the same direction but perhaps not for the betterment of the project. The key to responding to any of these forms of criticism is to think about the issues in a positive way. Do not get defensive and assume the worst of people just because they have an issue with some aspect of your space.

Tradition

Figure 8-2

Like loyalty, tradition is an important foundation for any successful space. Loyalty develops over short periods of time and when it blossoms over longer

periods of time, tradition is established. In terms of its meaning, tradition is the "handing down" or "delivery" of something. For the designer, tradition means the creation of a space that will result in such positive feelings among guests that it will become a natural, and necessary, part of their lifeworld. Tradition is the feeling that guests have of your space including:

- *Affinity*, or the feeling that the space is special, meaningful, and that it directly relates to the guest.

- *Inclusion*, or the idea that the guest is a real part of the story, that the guest matters, and that the guest is not simply an ancillary to the space.

- *Commitment*, or the intent to tell others about the space, to bring others they know with them to enjoy it, and to make an effort to come back and spend their money and time at the space.

- *Connection*, or the idea that the space connects with the guest and all that is a part of the person's lifeworld, connects with the local community and culture, and perhaps connects to values or issues that the guest finds to be especially significant.

- *Embeddedness*, or the feeling that the space deeply connects with the guest, such as examples of the guest connecting with other fans of the space (in person or on Internet social networking sites) or the guest getting involved in collecting memorabilia associated with the space or in decorating the home or office with themes reminiscent of the space.

We review a few more specific areas in Table 8-1. These will allow us to consider some ways in which certain practices may result in greater senses of tradition within a space.

Table 8-1 Tradition

Concept	Value to Tradition
Brand Extension	Because brands are such effective tradition-inspiring devices, it stands that brands should play a significant role in the designed space. Creating forms of brand extension and linking brands and spaces in a natural way may result in more meaningful senses of tradition.
The Careful "Break"	A little later in the chapter, we will look at how a break with tradition can, interestingly enough, help establish a new tradition. As you think about how far to push the established boundaries, consider that a break with tradition can help sell the uniqueness of your space.
Home/Away	As the later section called "From Space to Lifespace" considers, the extension of a space beyond its physical boundaries can pay incredible dividends in terms of tradition. If a space becomes a part of the life of the guest while that person is home, it has a chance to become an even more intimate part of the guest's life.
Meaningful Story	The Harry Potter frenzy in the 2000s helped prove how a creative story can do much more than move readers. It can actually create real traditions. One of the most important ways to create tradition is to be sure that the stories being told in the space will be powerful enough to establish similar sorts of frenzy within the designed space.
Careful Definitions	Previously, we've looked at the value of addressing the Big Idea, Story, Experience, and Design (see Chapter 1) in a careful and connected manner.
Not Too Pushy	Starbucks has been an especially effective model of tradition. The design spaces of Starbucks are incredibly thought out, yet their final outcome is an aesthetic that doesn't appear to be overly designed. Also, the space of a Starbucks café seems natural, comfortable, and not too pushy.

These are just a few of the ways that a space can develop meaningful forms of tradition. Chart 8-1 offers a general look at how a space might evolve into a meaningful tradition for guests. The ultimate keys to creating tradition through a designed space is to first focus carefully on the nature of the design, to think about how it will be used by the guest, and to constantly strive to connect the space to the interests of the guest.

Chart 8-1 — Developing Tradition

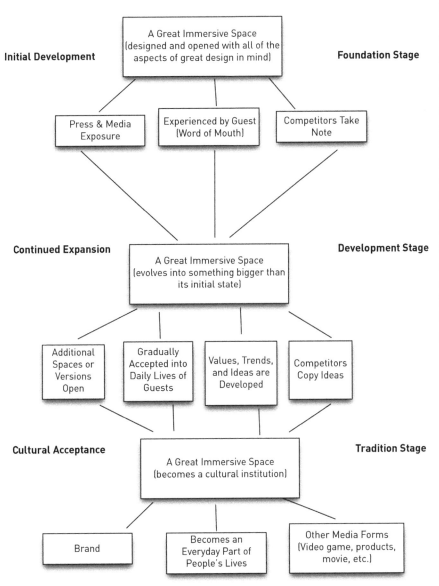

Initial Development

A Great Immersive Space (designed and opened with all of the aspects of great design in mind)

Foundation Stage

Press & Media Exposure

Experienced by Guest (Word of Mouth)

Competitors Take Note

Continued Expansion

A Great Immersive Space (evolves into something bigger than its initial state)

Development Stage

Additional Spaces or Versions Open

Gradually Accepted into Daily Lives of Guests

Values, Trends, and Ideas are Developed

Competitors Copy Ideas

Cultural Acceptance

A Great Immersive Space (becomes a cultural institution)

Tradition Stage

Brand

Becomes an Everyday Part of People's Lives

Other Media Forms (Video game, products, movie, etc.)

Special Events

Special events are an extremely important part of the calendar assigned to a themed or consumer space. They are significant because they help establish regular and seasonal connections with guests. Certain holiday celebrations—like those of Christmas, Halloween, and Valentine's Day—can be connected to the activities within the themed or consumer space. Within the local community, guests may come to associate part of their family holiday traditions with your space. Typically, the space is not designed exclusively for these special events but is instead transformed during such a time. Like the many other ideas discussed in this chapter, the special event is an opportunity to make an initial connection with the guest, which can then be built upon into the creation of a tradition. Additional special events may be planned that honor specific groups—such as veterans—or that are connected to a new brand being introduced or a new space being opened at the venue. Whatever the event, think of it as a way to establish a greater sense of loyalty with the guest.

Figure 8-3

Pictured here is a holiday celebration at Europa-Park.

Predetermined by Your Genre or Form?

As much as tradition can be a powerful force in establishing meaningful and lasting connections with guests, in some cases tradition can get stale and lead to the eventual decline of the space. Over time and due to a number of circumstances, a space that was incredibly successful can begin to feel tired. At some point, the space may become too familiar or feel out of touch with the culture. At a very basic level, some of the predetermination of a space happens because of the *form of the space*. This is similar to the situation of genre in fiction writing. An author may have a great idea for a novel about vampire romance, but since the genre of paranormal romance (specifically, the work of Stephenie Meyer and the *Twilight* series) has been done already, the author is posed with a potential problem of predetermination. The same can be said of any themed or consumer space. A theme park, by definition, will have themelands and rides, so trying to open one up that lacks one or both of these features will likely not fly. That being said, there is so much room for variation within the form that creativity can still prevail. Related to this are the *trends that are a part of the market in which your space operates*. In the 1990s, for example, a trend that developed within theme parks was the offering of stunt shows, often based on a popular brand, film, or other property. If guests were clamoring for stunt shows, the issue of whether to open one at your park had to be considered. Another issue is that *the culture has changed faster than the space itself*. In such a case, the culture has changed—perhaps new forms of technology or new social orders have developed—and the space has remained the same.

From Space to Lifespace

A significant trend in the creation of themed and consumer spaces is the idea that the guest never leaves the space at hand. In the past, the tradition was that the guest came to the space, did all of the things that he or she enjoyed doing, and then went home. When the guest got home, he or she did not necessarily spend time reflecting on the time spent in the space. Today, a different idea has emerged. Instead of thinking of the "home" and the "away," the guest can be encouraged to think about ways in which "he or she takes the space home." As such a "**lifespace**" is created. This is thinking about a design space in such a way that it connects with the guest (and his or her lifeworld) even when he or she is at home. Many successful retailers, like Home Depot, have used a "taking it home" approach to help sell their spaces. In addition to the typical retail experience that Home Depot offers homeowners, the chain provides many classes that help teach novice homeowners how to accomplish a particular task, like staining the deck. Also, Home Depot stresses a "You Can Do It, We Can Help" slogan that reflects the idea that homeowners can purchase products at the store and then, with a little help, use them successfully at home. In any designed space, a philosophy of "taking it home" can help establish forms of tradition. Many theme parks and museums, for example, use e-mail as a way to connect with guests after they have left the space. Information or ideas gained at the space can be further explored when the guest gets home.

Another issue is when a *competitor has blazed a new trail*, such as a new ride technology in a theme park, and you have to consider whether to stay the course with your tradition or to follow the path of the competitor. Related to this is the situation in which a *competitor flat out copies something from your space*. In some Asian cultures, such a situation has occurred with the copying of Disney theme parks. One such park, Nara Dreamland in Japan (closed in 2006), went so far as to cheaply copy Cinderella Castle and offered rides that included

"Adventure Jungle Cruise" and a version of Matterhorn Bobsleds. Obviously, when such copies are executed in a shoddy manner, the threat to your space is minimal. A bigger concern might be if the copy becomes more real to the guest than the original version from your space.

A further issue is the trend of how *guests have changed over time* and how certain demographic factors might impact your space. Some theme park companies, for example, have had internal discussions of how to expand their brand demographics to areas beyond what they were before. If the theme park was marketed primarily at upper-middle-class and higher guests, should the market change to be more inclusive of people in other social classes? A final issue to consider is the situation in which the *wishes, desires, and behaviors of guests have changed*. Going back to Walt Disney's understanding of the importance of the guest, we can see that this is one form of change that most designers and operators of a space will have to think about. The guest, no matter what, is always right.

If your space suffers from being too familiar or being out of touch with new trends of the times, do you change the space in terms of keeping up with the times or do you hold onto the tradition that you have established and that has, up to this point, made your space very successful?

The Break

Figure 8-4

In 2010 I had the opportunity to tour an interesting design exhibit (12 + 7: Artists and Architects of CityCenter) that discussed the philosophies behind the creation of CityCenter—a new area that adorns the middle of the Las Vegas Strip. The exhibit included many of the design drawings for the new CityCenter. What was really surprising about the exhibit was one particular quote of one of the designers: "With CityCenter, Las Vegas moves out of the realm of the misunderstood and under-appreciated in terms of its cultural offerings. Instead, CityCenter's fine art collection, along with its collection of significant buildings, will become a benchmark for enlightened development here and around the globe." What the person was talking about was a need (or a perceived need) to break from the tradition of the past. Later in this chapter, architect Joel Bergman will consider the interesting evolution of themed and consumer spaces along the Las Vegas Strip. In his interview, Bergman offers a number of interesting insights about how the Strip has changed and how it continues to change. For now, let's consider some examples of breaks with tradition (Table 8-2).

New Traditions

While tradition means a sense of "staying power" with the guest, it also means that things will change. New traditions emerge all the time, and many of them (probably most of them) take place outside your sphere of control. The last part of the chapter will reflect on how change impacts the designed space. Right now we can focus on a few ways in which new traditions have begun to emerge. One of the most popular ones is *social networking*. Social networking is not new, but it is new in terms of how it now takes place on the Internet and through mobile media. This topic was considered in Chapter 7 and one thing to think about now is how to create spaces that will positively connect to the world of guests who are, more and more, immersed in online social networks. A second tradition worth our attention is the culture of *remaking, adaptation, and remixing*. Walt Disney was one of the first and most successful

Table 8-2 Breaks with Tradition

Space	Type of Space	Why Was It a Break?	How Successful Has It Been?
CityCenter (Las Vegas, NV)	Casino/Resort	CityCenter doesn't use theming and instead goes for a modern, city design.	As of 2012, Las Vegas has experienced significant economic downturn, so it is impossible to connect the design choices to guest satisfaction. Some have argued that the design of CityCenter is too much like that of a major city and thus lacks some of the fun more common to themed resorts and casinos.
Hard Rock Park (Myrtle Beach, SC)	Theme Park	This theme park used unique theming based on rock and roll and included a number of risqué approaches to the theming.	Hard Rock Park closed shortly after opening in 2008 and was later reopened as Freestyle Music Park in 2009 but again closed in that year.
Hitler's Cross (Mumbai, India)	Themed Restaurant	The restaurant, quite controversially, used theming that referenced Adolf Hitler and Nazism. It broke from the standards of common decency.	After much controversy surrounding the restaurant's insensitive use of swastikas and other Nazi symbols and memorabilia, it dropped all references to them and changed its name. This example shows that extremely offensive themes are never justified in a space.
The Cosmopolitan (Las Vegas, NV)	Casino/Resort	The space uses elements of subtle controversy—such as the slogan "Just the Right Amount of Wrong"—and provocative design elements to establish itself as very different from other Strip properties.	The casino and hotel has been one of the most popular in the CityCenter area of the Las Vegas Strip.
elBulli	Restaurant (Molecular Gastronomy/ Avant Garde)	Ferran Adrià created one of the most iconic and revolutionary spaces—restaurant or otherwise. It was a break from the standards of previous cuisine and set a new mark that no others could match.	elBulli, though closed in 2011, became one of the most revered dining establishments of all time. Adrià has been called one of the most important artists of his time.
Royal Caribbean Oasis Class	Cruise Ship	The Oasis class ships were the largest cruise ships in the world in 2011. They have introduced design elements and attractions that were never thought to be possible on a cruise ship.	Royal Caribbean is one of the most popular cruise lines in the world. Many of its design innovations are now being copied by its competitors.
Disneyland	Theme Park	The Disney theme park model introduced a number of new trends including family-focused entertainment, new approaches to theme park design, and innovative approaches to attractions and entertainment.	Disneyland, and the many Disney theme parks that followed, have inspired other theme parks to develop Disney-like design and attractions.
Starbucks (various locations)	Café	Starbucks introduced a new approach to design aesthetics and to the purpose of coffee as it is enjoyed in a space.	Starbucks is considered one of the most successful models in introducing a new type of space to the consumer landscape. The "**third place**" is now sought out in other industries.

artists to remix culture. His early animated films were remixes of classic fairy tales and many of the features of Disneyland were remakes of other places that Walt had visited. Many themed and immersive spaces, by their very nature, involve forms of remixing and adaptation. One of the most interesting ways in which this trend could lead to new traditions is through the idea of **syncretism** or the combining of different and sometimes contrasting forms to make a new tradition. A last area is that of *convergence culture*, or the ways in which old and new media are connected in new ways. This topic is addressed in the next interview with Henry Jenkins.

Figure 8-5

Convergence
Interview, Henry Jenkins
Author and Media Theorist

Henry Jenkins is Provost's Professor of Communication, Journalism, and Cinematic Arts at the University of Southern California and former Director of the MIT Comparative Media Studies Program, and is the author and/or editor of thirteen books on various aspects of media, including Convergence Culture: Where Old and New Media Collide. **He has a Ph.D. from University of Wisconsin-Madison.**

Your book Convergence Culture: Where Old and New Media Collide *(New York University Press, 2006) provides a number of groundbreaking insights about the status of media and popular culture. Could you provide a brief synopsis of what convergence culture is?*

Convergence Culture captured a moment of transition within the ways we relate to media culture—one where we were moving from a model where new media displaced old media (the digital revolution) to a model where old and new media interfaced with each other in ever more complex ways (convergence culture). I explore in the book three big ideas—that convergence

is a process, not an end product, and as such, that the relations between different media systems would constantly shift in response to other technological, social, cultural, economic, and legal changes; that our culture is going to become more participatory and that as we do so we will see more and more struggles over the terms of participation; and that a networked society will push towards new mechanisms of collective intelligence (now often described as crowdsourcing) which will allow us to work through more complex challenges together than we can confront individually. I am about to publish a new book, *Spreadable Media* (written with Sam Ford and Joshua Green), which explores how social media is changing the processes of circulation and appraisal through which media content travels. We understand circulation as distinct from distribution. Distribution is top down and corporate controlled, while circulation is a hybrid system which also involves a range of consumer practices, some authorized, some not, that shape how media content travels through the culture.

You have written about the idea of "transmedia storytelling" and how, in examples like The Matrix, *fans are encouraged to take part in a storytelling tradition that spans multiple authors and media forms. Why is transmedia storytelling playing such a vital role in today's popular culture?*

Transmedia storytelling is a concept which has exploded over the past few years. The Producers Guild, for example, has created a job classification for Transmedia Producer, and many recent media franchises have been shaped both by the model *The Matrix* offered (along with, say, *The Blair Witch Project* and *Lost*) and by the larger discussion around transmedia entertainment. Transmedia describes a specific strategy which expands the story across multiple media platforms and in the process seeks to intensify and prolong audience

engagement. It is at once a theory of storytelling, branding, and fan relations. It recognizes the fact that more and more people are discussing entertainment media through social networks and as they do so, they demand more complex challenges to work through together. This approach can result in deeper, more meaningful relations, with the core stories and myths of our culture.

How might you predict that forms of transmedia storytelling will enter into the worlds of three-dimensional design and storytelling, such as in theme parks, retail stores, shopping malls, and casinos?

In many ways, theme parks were one of the spaces where transmedia entertainment first emerged. Walt Disney would be a key figure in any account of the history of transmedia. With the creation of Disneyland, Disney took characters and situations from his fiction films and embodied them into physical attractions. At the same time, Disney used his television program to tell the story of his park and used the park's structure to organize the variety of content on the series (so that each week might be designated as Fantasyland, Adventureland, Tomorrowland, and Frontierland, depending on the content). The practices of theme park designers, thus, paved the way for the special stories we now associate with games or virtual worlds, translating events in the stories into spaces which we can visit.

In Convergence Culture *you speak about the differences between passive and active consumers. It seems that all corporations involved in forms of popular culture will have to identify ways of connecting with active consumers. Can you speak of some ways in which this is occurring, perhaps referencing the worlds of theme parks and associated consumer spaces?*

I am pretty sure there are no such things as passive consumers, but my own interest is in expanding

opportunities for consumers to more directly and actively participate in and shape the emerging media environment. We are certainly seeing this desire to participate shape contemporary theme parks—everywhere from the Kim Possible game or the Jedi training programs which Disney now offers to the American Idol competition conducted among visitors to their Orlando attraction, where tourists do auditions and others vote on their performance, in hopes of getting considered for the actual program. Beyond specifically provided interactive experiences, we might also point to the ways theme parks are now designed as much as evocative spaces onto which fans may project their own fantasies as rides which take them through a directed path (see the new Wizarding World of Harry Potter for example). And beyond that, we can think of efforts such as D23 Expo which are at last acknowledging directly the culture of adult buffs and collectors which have emerged around the Disney films and theme parks. All of this points to a world where we seek to play and participate rather than simply being amused and entertained.

In terms of the theme park and consumer space designers who are reading this book, what are some tips that you might have for them in terms of incorporating ideas from Convergence Culture *into the designs of their spaces?*

I would start from a basic premise about transmedia storytelling: it seeks to expand our engagement by continuing to add new information about the characters, their worlds, and their stories rather than replicating the same core experiences across each media platform. So, when we visit a theme park ride based on a popular media franchise, we expect to see those elements which make the world distinctive—the core icons—but we also expect to see something new, to learn something we did not already know about the story, and we are looking for those insights at every step along the ride—from the outer shelter, through the waiting experience, to the ride

itself, and to the gift shop outside. Each element should expand our experience of the franchise and the longer we spend, the richer the details need to be to satisfy our transmedia appetite. I am particularly intrigued by the redesigned Star Tours which launched in 2010 and promises us a chance to visit more different worlds from Lucas's franchise and to have a different experience each time we ride it, but we could also point to the rich *mise-en-scène* of something like the original Pirates of the Caribbean or the Haunted Mansion, both of which have more going on than we can absorb on a first visit. Increasingly, fans and designers alike have been mapping backstory onto the individual pirates or ghosts through online commentary, which gives us more things to look for with each new encounter.

In Convergence Culture *you define world-making as "the process of designing a fictional universe that will sustain franchise development, one that is sufficiently detailed to enable many different stories to emerge but coherent enough so that each story feels like it fits with the others." This definition of world-making applies to the worlds that designers of theme parks and other consumer spaces inhabit. I am wondering if you have any ideas that would indicate why fans have been more receptive to some fictional worlds than others?*

Yes, theme parks have long been in the worldbuilding business. They offer us a chance to immerse ourselves within the fiction, to have a total sensory experience of the places of our imaginations. We can trace this back to early-twentieth-century attractions which borrowed their ideas from historical epics about the fall of Pompeii or the science fiction novels of Jules Verne (offering trips to the moon or journeys to the center of the Earth). To work in this way, the world has to be richly imagined and be emotionally compelling. The individual details have to add up to a meaningful whole. They have to evoke powerful human experiences and at the same time, provide resources for social interactions (give us something to talk about with our friends and family). There has to be a sense of negative capability—that is, the hint that there is something more to learn, new elements to master, and thus new spaces to explore.

Change

Change is potentially one of the most challenging things to deal with in terms of a designed space. Change refers to any circumstance in which the conditions that once defined the themed or immersive space are no longer the same. Whether it is a ride technology that is no longer up to date, a story that seems too dated

Figure 8-6

The War of the Worlds, an attraction from Luna Park (Coney Island, 1903).

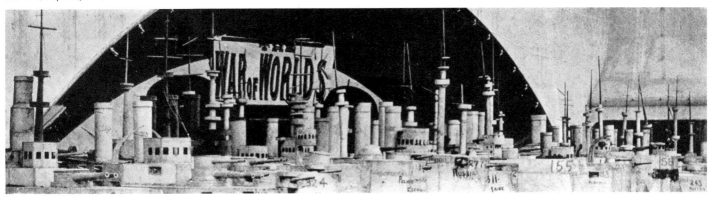

for the times, a topic or theme within the space that could be deemed insensitive or inappropriate and that necessitates a change, or a new trend in which guests react differently to the space, the issue of change is one that should be considered carefully.

Types of Change

Change may be categorized in two main ways. First, there is change that occurs in the short term. Social and market trends sometimes happen in the short term, such as in the example of an economic downturn that leads to less visits to themed and consumer spaces. A natural disaster, such as an earthquake or hurricane, could temporarily impact the operation of a space. Short-term change can typically be weathered by the operators of a space and it usually does not impact a space so significantly that designers have to consider alterations in the space itself. More significant is long-term change or change that has the potential to impact a space in both positive and negative ways. Table 8-3 considers a few examples of change.

Figure 8-7

In the case of long-term change that may impact the space—such as in the example of new forms of social networking and mobile media—designers do have a responsibility to at least consider some ways in which

the space could be designed (or redesigned) to keep up with the times.

Provocation—Change

For your specific area of design, consider a form of social change that took place over the last ten years. Based on that specific form of change, focus on some ways in which you had to think differently about the design of your space. What were some things that you had to do differently because of this change? What were some things that stayed the same even though the change occurred?

Trending—Temporary Space

A very curious and new form of space is the temporary space. The temporary space is illustrated by many restaurants (sometimes called pop-up restaurants) that have opened up. What is curious about these places is not the theme or the menu being offered but the fact that the spaces only stay open for a few months or perhaps keep the current theme and menu for only a few months. Grant Achatz's Next in Chicago, as one example, offers a menu that reflects the food of a particular place and time period and then changes that menu up in three months into an entirely different place and time inspiration. This trend is not limited only to restaurants. Pop-up stores reflect an approach to retail that emphasizes a similar "flash" mentality. Perhaps there is a desire to hype a new brand, to revitalize an old one, or to simply get the customer interested in a new and unique product or service—whatever the case is, the temporary space reflects a trend of creating a designed space that lasts for but a moment. 139 Norfolk Street (New York City) has offered a space that changes its theme and approach every so often. It has included a Ping-Pong venue, a mini drive-in theater, an office party, a wedding chapel, a talk show, a barn for sale, and many other eclectic themes. While this trend may not be directly applicable to your space, the idea of a space that

Table 8-3 Forms of Change

Form of Change	Example	Social Impact	Design Impact
Social Networking	More people are involved in the (sometimes excessive) use of Facebook, Twitter, and other social networking sites.	Social networking has altered the ways in which we interact with the world.	Some spaces may be designed with the use of social networking in mind. This is a way to extend the space to the lifeworld of the guest after the person goes home.
Multitasking	People have become more accustomed to doing multiple tasks at the same time.	Multitasking has affected the ways in which we gather information, perform tasks, and interact with others.	Many guests are not only familiar with multitasking but expect it. Some designs may have to consider the shorter attention spans of guests.
Mobility	People are involved in using forms of technology that allow them to take their lives with them, on the road.	Mobility has given people the ability to connect with forms of information, people, and places while on the go.	Some spaces may be designed with the idea of guests "checking in" with their friends (for example, foursquare).
Technology	More and more people use handheld cell phones, cameras, GPS units, and other devices as they move about their daily lives.	New developments in technology have changed the ways in which people relate to the world.	Spaces might be designed in terms of new forms of technology. Guests expect the latest technologies in their homes and thus they might also appear in designed spaces.
Market	There is a downturn in the market.	In the case of market changes, many guests alter their spending habits and often cut back on entertainment and use of discretionary income.	Designers may have to think more efficiently in order to make projects more manageable in terms of budgets. Some of the savings could be passed on to guests.
Social Forms	There is an increase in single-parent and LGBTQ families.	Differences in social forms have impacted the traditional stories and themes of the consumer world.	There should be a consideration to make any design decisions—including storylines—more in line with new social trends.
Social Trends	There is a new trend in which young people express and seek out coolness.	Cool hunting has become one of the staples of many media companies. This involves companies searching out and later marketing forms of coolness.	Designs may be altered in order to conform with some of the newer trends of society, especially those which will, in your estimation, have the longest staying power.
Social Events	A major natural disaster or a tragedy of epic proportions like September 11 causes extreme shifts in the world.	Social events, such as global tragedies like September 11, cause a complete shift in how people think about the world.	Some design themes may have to be altered—either on a temporary or permanent basis—in order to address a major social event (for example, the memorial outside of the New York-New York in Las Vegas).

is new, changing, unique, and memorable to the guest may be an inspiration to future designs.

Figure 8-8

Themed Space Design Retrospective Interview, Joel Bergman
Principal, Bergman, Walls & Associates

Joel Bergman is recognized worldwide as a leader in entertainment and casino resort design. For 43 years he has been intimately involved in the design, planning, and programming of projects throughout the US and around the world. He has brought innovative, cutting-edge, sustainable, and energy-efficient design to all forms of entertainment architecture, ranging from boutique retail venues to large-scale mixed-use resorts, including hospitality, dining, retail, performance, and gaming projects. Joel graduated *cum laude* as a member of the National Honor Fraternity from the University of Southern California in 1965. He and his projects have won numerous awards and he received the prestigious Sarno Lifetime Achievement Award for Casino Design in 2006.

Can you talk a little bit about the influence that your work has had? I read in a Las Vegas Sun interview that your work has been called "entertainment architecture." If that's an accurate term for your work, can you address what this means?

Forty-three years ago when I started designing casino resorts in Las Vegas—then the only legal gambling city in the United States—the hotels merely paid lip service to a theme. Caesars Palace had some Roman statues, stylized uniforms, and "Romanized" names for their facilities; the Frontier, Hacienda, Flamingo, and the Aladdin had a few quasi-themed elements and costumes; and the Dunes, the Sands, and the Sahara used names to honor their desert heritage.

When the time came to create the Mirage in Las Vegas, we noticed that people were visiting Las Vegas and walking on the Strip. It seemed to us—Steve Wynn, Henry Conversano, and I—that there ought to be something for them to look at while they were walking. And so Steve Wynn's idea of the waterfall which turned into a volcano at night with water flowing red as lava and water and steam spewing from the top of the volcanic waterfall was born. Not only did thousands of pedestrians stop every fifteen minutes to watch the phenomenon, automobile traffic stopped. So people went to see what was inside and they were not disappointed, because there were more waterfalls inside and 17,500 square feet of lushly planted interior gardens. They learned of a 1.5 million gallon Dolphin Habitat which was later joined by Siegfried and Roy's Secret Garden. Beyond gaming, there was more to do and see and participate in—hence to be entertained by.

How do you use architecture and design to make casinos, resorts, and other spaces appealing to the guests who visit them?

People have become so conditioned to all that is available through the various media that it is difficult to stay ahead. My job is to create environments in which they can have new experiences—whether those experiences are physical or emotional. This includes the sights, the sounds, the aromas, and the tastes. On the exterior and the interior I create moments and surprises so that not everything is explained in one look. Travelling to and through one of my buildings is meant to be part of the experience—every bit as much as shooting craps, playing 21, or sitting at a slot machine.

Can you talk a little bit about how your approaches to casino architecture have changed over time?

After the Mirage was so successful, Treasure Island was the next project on the boards. How to go from a

definite sense of place—having created a subtropical wonderment in the desert—to a storybook fantasy seemed a bit of a challenge. Moreover, how could we top a volcano erupting every fifteen minutes on the Strip of Las Vegas? Steve Wynn said, "How about a pirate battle?" And, thus, Treasure Island was born. A pirate village on the edge of a man-made cove, booty and swag, the crow's nest, Captain Kidd, the Black Hand, and so on. After 16 years of working with Steve Wynn, 26 years into my career as a casino/entertainment architect, I started the firm of Bergman, Walls & Associates. Caesars Palace was my first client and has remained a client to this day. We have added three very Roman themed high-rises and have Romanized the original three towers. In addition we have added onto and rethemed much of the rest of Caesars Palace. Caesars Palace is an extraordinary client in that they have, through several owners and presidents, single-mindedly maintained and enhanced the integrity of the theme. It is the most recognized name in the gaming world today.

Paris Las Vegas Hotel and Casino was not the first casino resort created as an assemblage of building icons. However, like its most noticeable icon, the Eiffel Tower, it was a heroic effort led by Arthur Goldberg, then-Chairman of Bally's. Paris was as authentic as any project I have ever worked on, right down to the cobbled Champs-Elysees. Having visited Paris many times previous to its conception, I was very familiar with many of the major and lesser buildings that would be available to paraphrase. However, visiting Paris again with the entire design team once I received the commission gave me another perspective which I believe made Paris more successful. Even those elements such as the highly stylized art nouveau porte-cochère and its street setting, which was created out of our imagination, seemed to be perfectly placed. Living in the Strip environment was unheard of just a few years ago.

Within the last seven years, I have added The Signature, a 1,800-unit condominium-hotel complex to the MGM Resort and the Trump, a 1,282-unit condominium-hotel, sans casino.

One of the things that I discuss in another chapter is the change that is taking place in terms of Las Vegas casino design. CityCenter, the Fontainebleau Resort Las Vegas (unopened), and the Wynn take an approach that seems to move away from theming. This personally concerns me because I think the Strip theming that kick started in the 1990s is what makes the Strip so unique. What is going on in terms of these newer projects and some of the new directions for architecture and design?

As first discussed above, in the beginning theming was more verbal than physical. And then I and then a few others created projects such as at Caesars, Mirage, Excalibur, New York–New York, Luxor, Paris, Snoqualmie, Treasure Island, Golden Nugget of Atlantic City, and so forth, which made theming real. Subsequently a trend towards anti-theming developed. Newcomers to the field of gaming resort design did not recognize that it was entertainment design and that the visitors to megacenters such as Las Vegas did not come to be educated or awed by sophisticated, "intellectual," edgy design. They come to Las Vegas to have fun, to be entertained, and to feel comfortable. While the buildings of CityCenter and Cosmopolitan may be at home in dense big city areas such as New York, San Francisco, Chicago, or Miami, they are not visually welcoming nor are they vehicular or pedestrian friendly in Las Vegas. With the exception of Cosmopolitan, people stay away in droves. They prefer the visual and physical accessibility of places like Paris, Excalibur, Venetian, Mirage, and Caesars. Even some of the more experienced gaming resort architects who publicly announced the death of theming have ceased such pronouncements and have resumed designing themed projects. Why, because

the public likes themed projects—they like to be entertained. They like having a good time—their way—not some arrogant starchitecht's way.

What about some of the casinos that have begun to retheme (Planet Hollywood) or detheme (Luxor, Paris)? What is happening there?

Certain of the Vegas casinos, such as Luxor—which had a very weak interior design to begin with—have over the years dethemed which has neither hurt nor helped business. Positioned between two other marginal properties, it has simply not achieved significant financial success. Paris has recently allowed a totally out-of-theme restaurant/confection venue with the Chateau nightclub above to hide the themed façade of the Paris Opera House and cause the removal of the fountain from the Place de la Concorde. Planet Hollywood has made an attempt at theming using tinsel and LED. Fontainebleau was to be as unthemed as CityCenter with a pedestrian maw aimed to the South. It was most likely destined for failure should it have finished in its conceived form. Tropicana has made an attempt to retheme with the use of white paint. Everything is white—inside and out. What appears to be absolutely obvious is that if a project is to be themed, it must be a strong theme and must be intensely done in good taste for the target audience. Today's guest is far more sophisticated than the guest of forty plus years ago when I was first introduced to gaming resort design. Secondly, when faced with intense competition within an environment such as Las Vegas, location, location, location is still key.

How much should designers of themed and immersive spaces be concerned with criticism (before, during, or after a project)?

Unfortunately, criticism and feedback generally come after a project is completed. In my experience, very often evaluation of critique on built projects is misinterpreted and jaundiced by the project team—from owners through design administration and the architect/interiors group. While well intentioned, personal preferences and idiosyncrasies coupled with predetermined intentions impose challenges to the design program. It is part of the architect's role to bring all of the diverse elements together to create a good-looking, well-planned, focused project. For me, that is part of the fun and excitement of what I do—bringing all of the personalities and ideas together to create a harmonious whole that is ultimately financially successful. In the end, no matter how beautiful, how well put together, or how well the construction budget is used, the project must make a profit.

Overall, our readers are interested in how they can update a space or make it fresh given the toll of time. What advice do you have for our designers who wish to keep their projects up to date?

Maintaining a project or portion of a built project is an ongoing effort that commences immediately after the completion of any construction project and must be led by top management. For example, Steve Wynn believes that all spaces—whether they are front-of-the-house or back-of-the-house—are to be rejuvenated on an as-needed basis and not more than five years goes by for that rejuvenation. Others extend the time frame to as long as ten years, and, in some cases, not at all—applying a "band-aid" when something disastrous happens. In most cases, the architect and interior designer can only suggest that a program be established. It is up to top management to decide how and when they wish to freshen and redo a facility.

Are there ways for designers to predict how things will change and how people will react to their spaces and somewhat anticipate this in their architectural designs?

The way I plan and design spaces pretty well predicts how people will use and react to those spaces. By that I mean I sit at every table, I stand at every viewing position (or craps table), and I work at every counter. I guide the various consultants on projects such that my visualization is not impaired by their efforts. Certain of the consultants, such as interior designers and landscape architects, when properly selected, bring a synergy to the project such that my vision is transformed and the end result is very often better than my original conceptions. One such individual is Don Brinkerhoff of Lifescapes International who creates gardens that magically enhance any project.

The most key ingredient is ultimately the right design team and the right leaders—owner, project manager, architect, interior designer—and a common goal: to make sure that the people who work in the completed project and who visit the completed project have a fantastic experience. Telling an employee to paste a smile on his face before he greets the public because he comes out of a horrible, ill-designed, poorly lit, poorly maintained back-of-the-house—no matter how well designed the front-of-the-house is—does not cause a customer to have a great experience. An employee who comes out of a well-designed, nicely appointed back-of-the-house automatically smiles and is happy to be there and a guest experiences that and gets that. Now the guest knows that he is in a great place where great people are serving him and are happy to be there and that guest has a great experience. That is what all of what I do is about.

Cross-Culture

There is an interesting situation that develops when a space that was designed for one culture is later developed for another culture. In this situation the designer is asked to think about a form of change that is a reflection of the fact that a space that was conceived

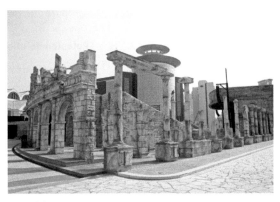

Figure 8-9

for one culture may not fit into another culture. One of the keys for designing themed and immersive spaces in a cross-cultural situation is to focus on *what makes the most sense* for that culture, not necessarily what makes the most sense for the space itself. Of course, the pushes of the parent company that operates the space, budgetary and market forces, the issues of the brand, and tradition may impact the ability of the designer to completely create a space *only* in regards to the local culture. Table 8-4 expresses some concerns that may arise in the case of a cross-cultural design approach.

There are many cross-cultural issues of design in addition to the ones listed on this table. One key is that context is always an important factor in making decisions about design. Another key to cross-cultural design is no different than the main idea that has been stressed throughout this text—*the guest is always right, no matter the culture*.

Trending—Social Justice

One of the most interesting trends focuses on the idea of social justice or ways in which the needs of people less fortunate can be addressed. In online forums (www.freerice.com) and in games that take place in the real world, people are encouraged to think more fully

Table 8-4 *Cross-Cultural Design Considerations*

Problem	Potential Solution
The design conflicts with cultural traditions of the guest.	The design should focus on ways in which the experience can still be immersive but also reflect a respect for local customs and values. In some cases, architecture or technology might have to be altered to be in closer accord with guest traditions.
There is a lack of understanding or a problem of translation.	Some designs, such as the Twilight Zone Tower of Terror, have to be altered if they are to be translated to a new culture. This happened as a new storyline was used for the same ride at Tokyo DisneySea.
The design is "plopped in" without regard to the culture.	As many designers have expressed to me, a design must be authentic to the local culture and not be a design idea that is imported without regard for the local culture.
There is a lack of focus on the local culture or people.	The design should develop storylines and themes that reflect local cultural interests.
The new design might conflict with older versions of design, including "stereotypes."	A design firm once described a situation in which they had to create a resort in Egypt that did not reflect the understandings of previous "Egyptian" resorts like the Luxor in Las Vegas. In some cases the design may have to avoid any associations with previous design stereotypes.

about social justice needs by engaging in interactive games and simulations. Historical reconstruction, like the forms discussed in Chapter 4, allow participants and onlookers to think more critically about historical issues and connect those to contemporary concerns. Within the specific world of themed and consumer spaces, we have seen the most attention on issues of social justice within museums and interpretive centers. Guests are encouraged to think critically about issues and in some cases their experiences are challenging, emotionally complex, and personally transformative. Even cruise ships have gotten into this area of concern. Celebrity Cruises, for example, has a Team Earth lounge that allows guests to consider the impact of consumerism and the possible solutions in terms of conservation. Social justice is an important trend because it reflects a future type of story that is positive. Helping others, as we shall see shortly, is a trend that all themed and immersive spaces may benefit from.

What Won't Ever Change

For all of the aspects of social change that we have considered, we should remember that some things will never change. Well, perhaps one shouldn't say never, but as close to certainty that we can get, here is a list of things that will remain the same and thus will likely be the focus of themed and consumer entertainment spaces of the future.

The guest will always:

1. Have a desire to be entertained, especially in as new and interesting ways as are possible.

2. Want to be part of the space and not feel taken for granted by the designers or the operators of it.

3. Want to be told compelling stories and feel that he or she is an intimate part of them.

4. Desire a variety of entertainment and forms of entertainment that are up to date and reflective of the times.

5. Want to experience social connections—whether with family, friends, loved ones, or even strangers—while visiting the space.

6. Focus on the quality of the space at hand and desire to be in the spaces that have the greatest attention to detail, charm, and magic.

While these things will never change, we have seen that change does impact the themed and immersive space. We close this chapter and this text with the idea that the themed and immersive space itself can change and this may be a benefit to designers, operators, and guests.

Future Stories

One of the most interesting ways in which themed and immersive spaces can be used is to help guests. Here, the focus is not on the brand, the selling of a product, or the development of a specific theme. The focus is on helping guests with personal needs. The case of Florida Hospital Celebration Health is especially important. Florida Hospital Celebration Health has a unique center called Seaside Imaging. The traditional look of MRI and CT technologies and the room that houses them have been replaced with a dynamic virtual beach environment. According to Florida Hospital Celebration Health, "This peaceful virtual beach is designed to immerse our guests in a relaxing experience and furthers our dedication to providing a healing environment."[1] Hallways and flooring look like beachfront boardwalks; walls reimagine beach murals; patients sit in Adirondack chairs and change in beach cabanas; patients wear surfer shorts instead of typical medical patient garb; MRI and CT machines resemble a large sandcastle; and patients experience the sound of ocean waves and the smell of fresh ocean spray during

their procedures. As Florida Hospital Celebration Health puts it, "The Future...Today."

Figure 8-10

Seaside Imaging at Florida Hospital Celebration Health illustrates one powerful direction of both the stories and the design that will be used in themed and immersive spaces of the future. Immersive worlds can be used to help guests in need and to make lives that have been rocked by potentially life-threatening health conditions more tolerable. Designed spaces can be used in innovative new ways that reflect the growing concerns that all people have with the uncertain, changing, and complex world; the values of cooperation, multiculturalism, understanding, and tolerance; the powerful uses of creativity, innovation, and out-of-the box ideas; the potential of greater (guest) participation in the immersive world; and the need to envision forms of conservation and responsibility towards the planet. These and many other ideas can be thought of as the future of the stories and the designs that will be developed in your spaces. We can only imagine the many new themes, trends, and concepts that will impact the design of immersive spaces in the future. In the meantime, good luck!

[1] http://www.celebrationhealth.com/services/imaging

1. What are some of the ways that loyalty can be developed within your space? Are there specific design practices that can be used to create forms of loyalty?

2. In terms of the spaces that you have designed (or others that other designers have created), what are some reasons why tradition did (or did not) develop in those spaces?

3. What are some forms of change that can't be controlled in terms of the design of your space?

4. As we think about the future of designed spaces, what sorts of trends do you think will impact their design, use, and appreciation by guests?

The following books offer additional information on many of the topics addressed in this book.

Adams, J.A., 1991. The American Amusement Park Industry. Twayne, Boston. This book offers a good overview of the American amusement park industry. This book is out of print.

Benjamin, W., 2002. The Arcades Project. Belknap, Cambridge. A major undertaking of one of the greatest philosophers of our time; this book delves into some of the earliest designed and often themed spaces—the covered shops or arcades of 19th century Paris.

Boyle, D., 1996. Authenticity: Brands, Fakes, Spin and the Lust for Real Life. Harper Perennial, New York. This interesting book looks at the many issues connected to the fake and the real, including examples from the worlds of theme parks, the media, and celebrity culture.

Calvino, I., 1978. Invisible Cities. Harcourt Brace Jovanovich, San Diego. A wondrous journey in which Marco Polo relates to Kublai Khan the many fantastical cities that he experienced on his journeys.

Cartmell, R., 1988. The Incredible Scream Machine: A History of the Roller Coaster. Amusement Park Books, Fairview Park, OH. This is a classic from one of the most interesting authors to have considered the significance of the roller coaster.

Coleman, P., 2006. Shopping Environments: Evolution, Planning and Design. Architectural Press, Amsterdam. A very thorough text that focuses on the evolution of the shopping mall and retail store and offers many excellent images and illustrations.

Curtis, G., 2007. The Cave Painters: Probing the Mysteries of the World's First Artists. Anchor, New York. This book tells the interesting tale of how archaeologists and others have interpreted cave art.

De Botton, A., 2008. The Architecture of Happiness. Vintage, New York. A book that considers the many reasons why architecture connects with people and how it often creates happiness in them.

De Botton, A., 2004. The Art of Travel. Vintage, New York. A very enjoyable text that considers the many reasons why people travel and the sorts of things that they seek while on vacation.

Falk, J., 2009. Identity and the Museum Visitor Experience. Left Coast Press, Walnut Creek. A text that offers an in-depth look at why people visit museums and what they expect when they are there. This book challenges the assumption that the only thing that should matter in the museum is the content chosen by the designers.

Franci, G., 2005. Dreaming of Italy: Las Vegas and the Virtual Grand Tour. University of Nevada Press, Reno. This text offers an interesting look at how ideas of Italy have been transformed in the iconic casinos of the Las Vegas Strip.

Gibson, D., 2009. The Wayfinding Handbook: Information Design for Public Places. Princeton Architectural Press, Princeton. A nice introduction to the many issues that designers face in creating wayfinding systems and developing signage.

Gottdiener, M., 2001. The Theming of America: American Dreams, Media Fantasies, and Themed Environments, second ed. Westview, Boulder. This book, the first of its kind, has a number of useful insights on the concept of theming.

Handler, R., Gable, E., 1997. The New History in an Old Museum: Creating the Past at Colonial Williamsburg. Duke University Press, Durham. An interesting study that looks at the interplay between historical interpretation and guest understandings at Colonial Williamsburg.

Herwig, O., Holzherr, F., 2006. Dream Worlds: Architecture and Entertainment. Prestel, Munich. A curious look at the many ways in which fantastical and dreamlike architectural environments have been created.

Hodge, S., Smith, P., Persighetti, S., Turner, C., 2003. An Exeter Mis-guide. Wrights & Sites, Exeter, UK. A book from the Wrights & Sites group based in Exeter (www.mis-guide.com/) that focuses on ways of developing drifting or new psychogeographical approaches to space.

Huxtable, A.L., 1999. The Unreal America: Architecture and Illusion. New Press, New York. This book offers one of the most damning criticisms of contemporary entertainment environments and, as such, it's a good text to ponder.

IDEO, 2003. IDEO Method Cards: 51 Ways to Inspire Design. William Stout, San Francisco. This set of method cards provides designers, architects, and other creative types with a great resource for inspiring design. The cards involve various activities that are organized according to four main areas—Ask, Watch, Learn, and Try.

Jacobs, J., 1992. The Death and Life of Great American Cities. Vintage, New York. This book sparked something of a revolution in terms of its main concept about how great cities benefit from eclectic, mixed-used, socially focused, and decentralized designs.

Jaschke, K., Ötsch, S. (Eds.), 2003. Stripping Las Vegas: A Contextual Review of Casino Resort Architecture. University of Weimar Press, Germany. A curious look at many of the facets of Las Vegas, including some chapters focused on themed casinos.

Kasson, J.F., 1978. Amusing the Million: Coney Island at the Turn of the Century. Hill & Wang, New York. This is a very interesting and quick read that focuses on the unique history of the Coney Island amusement parks. It's one of the best historical takes on Coney Island.

Klingmann, A., 2007. Brandscapes: Architecture in the Experience Economy. MIT Press, Cambridge. This is an important book that focuses on the experience economy and how architecture and branding play important roles in it.

Koolhaas, R., 1994. Delirious New York: A Retroactive Manifesto for Manhattan. The Monacelli Press, New York. A delightful text that is part architectural criticism, part manifesto, and part historical review. One of the best chapters considers the history of early Coney Island amusement parks.

Kyriazi, G., 1978. The Great American Amusement Parks: A Pictorial History. Castle Books, Secaucus, NJ. This was one of the first texts to look at the traditions of the American amusement park.

Lennon, J., Foley, M., 2000. Dark Tourism. Continuum, London. A book that presents the curious topic of dark tourism. This is worth looking at if you have ever considered developing a dark or potential controversial topic in a designed space.

Lidwell, W., Holden, K., Butler, J., 2010. Universal Principles of Design, second ed. Rockport, Beverly, MA. A provocative book that offers quick suggestions on some of the key ideas from the world of design.

Lindstrom, M., 2010. Brand Sense: Sensory Secrets Behind the Stuff We Buy. Free Press, New York. A book by a famous brand guru that focuses on the ways in which the senses impact the development of recognizable brands.

Lowenthal, D., 1999. The Past is a Foreign Country. Cambridge University Press, Cambridge. A great primer on the many ways in which forms of the past, history, and nostalgia have been used in museums and other spaces.

Lukas, S.A., 2008. Theme Park. Reaktion, London. This study focuses on the cultural history of the theme park and includes discussion of history, branding, and how the theme park has been translated as novels, video games, and films.

Lukas, S.A. (Ed.), 2007. The Themed Space: Locating Culture, Nation, and Self. Lexington Books, Lanham, MD. This book is written at a high theoretical level. It includes articles on theming and how theming has been used in theme parks, casinos, and many other spaces.

MacCannell, D., 1999. The Tourist: A New Theory of the Leisure Class. University of California Press, Berkeley. One of the most important texts to look at the nature of the tourist experience, including discussions of authenticity and front- and backstage issues.

Mangels, W.F., 1952. The Outdoor Amusement Industry: From Earliest Times to the Present. Vantage Press, New York. An informative look at amusement parks and outdoor amusements, in part showing us where modern theme parks and themed spaces came from.

Mau, B., 2005. Life Style. Phaidon, New York. A book from an influential designer who shares a number of his creative projects and approaches to design.

McGonigal, J., 2011. Reality Is Broken: Why Games Make Us Better and How They Can Change the World. Penguin, New York. This book shows us the power that games can have in our lives.

Mikunda, C., 2004. Brand Lands, Hot Spots and Cool Spaces: Welcome to the Third Place and the Total Marketing Experience. Kogan, London. An interesting look at some of the most innovative themed and branded spaces.

Miller, C.H., 2008. Digital Storytelling: A Creator's Guide to Interactive Entertainment, second ed. Focal, Waltham, MA. An innovative look at how storytelling may be used in the digital and multimedia world.

Mitrasinovic, M., 2006. Total Landscape: Theme Parks, Public Space. Ashgate, Aldershot, Hampshire, UK. An innovative text that addresses many of the recent developments in theme parks and designed urban spaces. Included is extensive discussion of Huis Ten Bosch theme park.

Moggridge, B., 2007. Designing Interactions. MIT Press, Cambridge. An important book that addresses the numerous issues involved in the design of objects and human interactivity.

Norman, D., 2002. The Design of Everyday Things. Basic Books, New York. This book looks at the design of everyday objects and addresses situations in which designers get it wrong and create objects that people cannot use or understand.

Novelli, M., 2005. Niche Tourism: Contemporary Issues, Trends and Cases. Elsevier, Amsterdam. This book covers the many interesting trends in the world of niche tourism. The case studies are excellent.

Ockman, J., Frausto, S. (Eds.), 2007. Architourism: Authentic, Escapist, Exotic, Spectacular. Prestel, Munich. This text looks at why some buildings and destinations (such as the Mall of America) become tourist destinations.

Oldenburg, R., 1989. The Great Good Place: Cafes, Coffee Shops, Bookstores, Bars, Hair Salons, and Other Hangouts at the Heart of a Community. Marlowe & Company, New York. This text addresses the significant topic of the third place and offers insights on the roles that the third place plays in communities.

Pine, B.J., Gilmore, J.H., 2007. Authenticity: What Consumers Really Want. Harvard Business School Press, Boston. A text that explores the ways in which authenticity can be used to impact consumer decisions to purchase products or services.

Pine, B.J., Gilmore, J.H., 1999. The Experience Economy: Work Is Theater & Every Business a Stage. Harvard Business School Press, Boston. An important book that illustrates why the experience economy has become so prevalent in contemporary consumer worlds.

Rapaille, C., 2007. The Culture Code: An Ingenious Way to Understand Why People Around the World Live and Buy as They Do. Broadway Books, New York. The author looks at some of the main trends or culture codes that impact the how, why, and where of guests buying things.

Raz, A.E., 1999. Riding the Black Ship: Japan and Tokyo Disneyland. Harvard University Asia Center, Cambridge, MA. This text looks at how Disney was adapted to Japanese society and offers insights about workers and guests at Tokyo Disneyland.

Register, W., 2001. The Kid of Coney Island: Fred Thompson and the Rise of American Amusements. Oxford University Press, Oxford. A significant historical text that addresses the work of Luna Park architect and entrepreneur Fred Thompson.

Roberts, K., 2005. Lovemarks: The Future Beyond Brands, revised ed. Powerhouse Books, New York. One of the most cutting-edge statements on the contemporary brand and the role that love plays in connecting the brand with the consumer.

Rockwell, D., Mau, B., 2006. Spectacle. Phaidon, London. A very unique text that evokes the sense of how spectacles of various sorts have transformed people and cultures.

Rose, F., 2011. The Art of Immersion: How the Digital Generation Is Remaking Hollywood, Madison Avenue, and the Way We Tell Stories. W. W. Norton & Company, New York. An insightful look into the ways in which storytelling and forms of immersion have transformed the ways in which people interact with the world.

Schlehe, J., Uike-Bormann, M., Oesterle, C., Hochbruck, W. (Eds.), 2010. Staging the Past: Themed Environments in Transcultural Perspectives. Transaction, New Brunswick. A highly theoretical text that offers insights about contemporary theme parks as well as interpretive museums.

Schmitt, B., 1999. Experiential Marketing: How to Get Customers to Sense, Feel, Think, Act, and Relate to Your Company and Brands. Free Press, New York. An interesting look at strategies that may be used to transform brands and products; included is a look at how experiences and the senses play vital roles in branding.

Sherry, J.F. (Ed.), 1998. Servicescapes: The Concept of Place in Contemporary Markets. NTC Business Books, Chicago. A useful collection that features discussions of branded spaces, lifestyle stores, and other venues.

Simon, N., 2010. The Participatory Museum. Museum 2.0, Santa Cruz. A look at how museums can use techniques to make their spaces more participatory for guests.

Solnit, R. (Ed.), 2010. Infinite City: A San Francisco Atlas. University of California Press, Berkeley. This nontraditional atlas considers the many curious aspects of San Francisco's urban history. A great inspirational text that will get you thinking about how we should view architecture.

Sucher, D., 1995. City Comforts: How to Build an Urban Village. City Comforts Press, Seattle. This text looks at a number of ways in which cities could be remade to make their spaces more comforting for the people who use them.

Tufte, E., 1990. Envisioning Information. Graphics Press, Cheshire, CT. A very intriguing and well-illustrated text that looks at creative approaches to information design.

Underhill, P., 2004. Call of the Mall: The Geography of Shopping. Simon & Schuster, New York. A unique text that looks at how people use shopping malls.

Venturi, R., Brown, D.S., Izenour, S., 1993. Learning From Las Vegas: The Forgotten Symbolism of Architectural Form, revised ed. MIT Press, Cambridge, MA. This was one of the first and most influential texts to address how architects could be inspired by popular spaces like Las Vegas.

Wasserman, L., 1978. Merchandising Architecture: Architectural Implications and Applications of Amusement Themeparks. Privately printed, Sheboygan, WI. One of the first and only texts to address the amusement park from an architectural perspective.

Wheeler, A., 2009. Designing Brand Identity: An Essential Guide for the Whole Branding Team. Wiley, Hoboken, NJ. A clear, concise, and informative text that offers numerous approaches to designing compelling brands.

Whyte, W.H., 2011. The Social Life of Small Urban Spaces. Project for Public Spaces Inc., New York. A revolutionary text that addresses how urban spaces can be designed with the guest or user in mind and describes how the patterns of people using city spaces can be understood and applied in urban design.

Wickstrom, M., 2006. Performing Consumers: Global Capital and Its Theatrical Seductions. Routledge, New York. A text that looks at how various forms of performance have entered consumer spaces.

Young, T., Riley, R. (Eds.), 2006. Theme Park Landscapes: Antecedents and Variations. Dumbarton Oaks Research Library and Collection, Washington D.C. An eclectic collection that delves into the topics of theme parks, historical pleasure gardens, and many other spaces.

archetype A universal symbol that all people can understand and with which they can connect.

assessment Using all the available information to see how well your design space is performing.

attractor A feature in a designed space—such as a large architectural construction—that serves the purpose of drawing guests through the space (sometimes called a "weenie" in Disney nomenclature).

automatic writing A form of writing in which a person attempts to write in a subconscious manner such that he or she has no awareness of what is being written.

avatar The graphical form or character that represents a person in a video game, online world, or MMORPG.

backstory A method of relating more information about characters, aspects of a world, or both that gives the guest a better sense of what the characters or world are like.

creativity An ability to move beyond the conventional limits of art or expression in order to create new ideas, forms, movements, and aspects of expression.

criticism Any comment on the design of a space that reflects concerns about the thought behind it, any aspect of the design elements, the operational issues, or other aspects of the space.

culture The values, customs, social practices, tendencies, and all other features that are shared by a particular group of people.

design story A story that is told in three-dimensional space, using architecture, design, and forms of material culture. It may also include actors, performance, and forms of technology.

detheming The process by which a themed space removes its theme and becomes relatively unthemed.

emic approach The insider's approach or a view that reflects how someone from a particular culture would uniquely view that culture.

ethnography A written document that accurately reflects the nature of a particular culture and its people.

evocation A state in which something produces a vivid, memorable, and profound feeling in a person.

existential Anything that deals with the issues of existence and reality, such as the question of the meaning of life.

fakery A process by which an aesthetic or design means is used as a shortcut to a spatial end.

game changer A form of technology, such as the slot machine, that changed the nature of themed and immersive spaces in a significant way.

geocaching A tradition in which enthusiasts use GPS devices to find items that have been hidden in hard-to-find places or caches.

groupthink A situation in which the team starts to head in the same direction but perhaps not for the betterment of the project; it is a form of conformity that results in a substandard project.

happening A 1960s art movement that involved the creating of events in a public space, essentially eliminating the boundary between the artist and the viewer. Viewers of a happening did not realize that a performance was taking place.

holism An approach to looking at things that takes the big picture into account. It is an approach that looks at how things are connected to make up a whole.

inclusive design This is design that takes into account every need of the guest and which makes the guest feel that the space is about him or her, not about the designers or operators of the space.

immersive world A place in which guests can become fully absorbed or engaged.

lifespace A designed space that "stays with" the guest for the entirety of that guest's life. It is a space that when visited "follows the guest home."

liminal state A state of being in-between worlds, of living on the margins, or of being on the threshold.

lived theming A situation in themed spaces that develops when a guest, worker, or actor begins to take on the theme in a closely personal sense, essentially transforming the person in line with the world implied by the theme.

macro world A big world that encompasses everything that is and everything that can possibly be.

mana A concept from Polynesian cultures in which a place, object, or person is imbued or charged with supernatural energy, power, or prestige.

man behind the curtain phenomenon A circumstance in which the guest realizes that there is something behind a given illusion at hand with the result being the magic of the space being lost.

material culture All of the material things—the streets, the bricks, the tables and chairs, the lights, the fountains, and everything else—that make up the themed or immersive space.

metaphor A form of making a connection between an idea in one world with an idea in another world.

micro world A small world or one that is characterized by the details, the fine brushstrokes.

meme A concept, idea, or part of culture that is passed from one person to another in nongenetic means. The "da da da dah" of Beethoven's *Fifth Symphony* is an example.

microtheming A form of theming in which attention to very small detail is given.

mise-en-scène The total arrangement of the set, the action of the actors, the lighting, the movement of the camera, and all of the other elements of a film. Literally, "put in the scene."

MMORPG An acronym for "massively multiplayer online role-playing game," which refers to an online, virtual gaming world in which many players participate.

monomyth An idea associated with Joseph Campbell and James Joyce and which refers to the hero's journey or a recurring pattern in which a hero leaves the ordinary world, travels to a supernatural place, and then returns to the ordinary world, often triumphant.

mood The associations that people have when they enter a space.

organic story A story that is, by its very nature, natural, whole, and complete, in the sense that everything that is related to it seems to fit together seamlessly.

Pareto principle The idea, adapted from economics, that 20% of the design of a space can be used to make 80% of the impact on guests.

placeness The ways in which a place conveys the sense that it is unique and is markedly different from other places.

postmodern A stylistic approach that incorporates multiple and often radically contrasting elements, styles, design patterns, or forms within one space.

reality principle The idea that designers create spaces — whether based in a real or fictive world — that guests will come to see as real to them.

retheming The process by which a themed space gets a theme different from its last version.

simulation In an immersive world, the combination of various design elements, forces, and situations that creates the sense that the guest is in another world.

style cluster An overall trend within the design of consumer spaces that reflects a major theme or approach.

syncretism The combining of different and sometimes contrasting forms to make a new tradition.

theming The use of an overarching theme, such as Western, to symbolically and conceptually organize a space that is designed in accord with that theme.

third place A place suggested by Ray Oldenburg where people can gather, socialize, and have a nice time (in contrast with the first place of home and the second place of work).

total immersion The circumstance in which a guest is taken into another world, story, or place through the use of as many senses as possible.

Cover Image The Coney Island Globe Tower, pictured in a conceptual image from 1906; it was never built. Collection of the author.

Chapter 1

Figure 1-1 © Alexey Rumyantsev | Dreamstime.com
Figure 1-2 © Gregor Kervina | Dreamstime.com
Figure 1-3 © Ruslan Gilmanshin | Dreamstime.com
Figure 1-4 © Mikhail Markovskiy | Dreamstime.com
Figure 1-5 © Nathanphoto | Dreamstime.com
Figure 1-6 © Stelianion | Dreamstime.com
Figure 1-7 © Arne9001 | Dreamstime.com
Figure 1-8 © Niderlander | Dreamstime.com
Figure 1-9 © Tupungato | Dreamstime.com
Figure 1-10 © Ra2studio | Dreamstime.com
Figure 1-11 © Larry Tuch, used with permission
Figure 1-12 Collection of the author
Figure 1-13 © Harryfn | Dreamstime.com
Figure 1-14 © Chonlapoom | Dreamstime.com
Figure 1-15 © Kelvintt | Dreamstime.com
Figure 1-16 © Nikonaft | Dreamstime.com
Figure 1-17 © Nick Stubbs | Dreamstime.com
Figure 1-18 © Dave1276 | Dreamstime.com
Figure 1-19 © Presiyan Panayotov | Dreamstime.com
Figure 1-20 © Sascha Dunkhorst | Dreamstime.com
Figure 1-21 © Gbautista87 | Dreamstime.com
Figure 1-22 © Heineken Experience
Figure 1-23 © Baloncici | Dreamstime.com
Figure 1-24 © The Jerde Partnership
Figure 1-25 © Sauliusl | Dreamstime.com
Figure 1-26 © David Rogers, used with permission
Figure 1-27 © The Jerde Partnership

Chapter 2

Figure 2-1 © Chinawds | Dreamstime.com
Figure 2-2 © Sergiy Rudenko | Dreamstime.com
Figure 2-3 © Kts | Dreamstime.com
Figure 2-4 © Sweedish | Dreamstime.com
Figure 2-5 Screenshot, in public domain
Figure 2-6 Screenshot, in public domain
Figure 2-7 © Tanyae | Dreamstime.com
Figure 2-8 © Margaret King, used with permission
Figure 2-9 © Leung Cho Pan | Dreamstime.com
Figure 2-10 © James Camp | Dreamstime.com
Figure 2-11 Collection of the author
Figure 2-12 © Mike Leeson, used with permission
Figure 2-13 © Industrial Revolution Eatery & Grille
Figure 2-14 © Industrial Revolution Eatery & Grille

Chapter 3

Figure 3-1 Atlantis, The Sunken City, Coney Island. Collection of the author.
Figure 3-2 © Ssuaphoto | Dreamstime.com
Figure 3-3 © The Library
Figure 3-4 © Europa-Park GmbH & Co Freizeit- & Familienpark Mack KG
Figure 3-5 © Propeller Island City Lodge | Lars Stroschen
Figure 3-6 © Propeller Island City Lodge | Lars Stroschen
Figure 3-7 © 25hours Hotels
Figure 3-8 © Wong Chee Yen | Dreamstime.com

Chart 3-3 images:

Tropical © Juliengrondin | Dreamstime.com
Western © Witthayap | Dreamstime.com
Italian © Mikael Damkier | Dreamstime.com
Parisian © Dan Breckwoldt | Dreamstime.com
English © Anthony Berenyi | Dreamstime.com
Egyptian © Dmitry Pichugin | Dreamstime.com
Middle Eastern © Maxim Petrichuk | Dreamstime.com
New Orleans © trekandshoot | Dreamstime.com
Irish © Agnieszka Guzowska | Dreamstime.com
Americana © Michael Shake | Dreamstime.com
Asian © Victor Zastol`skiy | Dreamstime.com
Mexican © Anthony Aneese Totah Jr- | Dreamstime.com

Figure 3-9 Thomas Cole (American, born England, 1801–1848), The Architect's Dream, 1840, oil on canvas, 53 × 84 1/16 in., Toledo Museum of Art (Toledo, Ohio), Purchased with funds from the Florence Scott Libbey Bequest in Memory of her Father, Maurice A. Scott, 1949.162. © Image Source, Toledo Museum of Art

Integration	© Bjørn Hovdal	Dreamstime.com
Small stuff	© Darko Plohl	Dreamstime.com
Figure 4-41	© Filip Fuxa	Dreamstime.com

Chapter 5

Figure 5-1	© Konradbak	Dreamstime.com
Figure 5-2	© Denis Pepin	Dreamstime.com
Figure 5-3	© Paul Wolf	Dreamstime.com
Figure 5-4	© Robert Adrian Hillman	Dreamstime.com
Figure 5-5	© Brett Critchley	Dreamstime.com
Chart 5-2 images:		
Immersive World	© Kathleen Handy	Dreamstime.com
Non-Immersive World	© Kathleen Handy	Dreamstime.com
Figure 5-6	© Topstep07	Dreamstime.com
Figure 5-7	© Lukasz Tymszan	Dreamstime.com
Figure 5-8	© Rob Van Esch	Dreamstime.com
Figure 5-9	© Dutchinny	Dreamstime.com
Figure 5-10	© Europa-Park GmbH & Co Freizeit- & Familienpark Mack KG	
Figure 5-11	© Gina Smith	Dreamstime.com
Figure 5-12	© Brett Critchley	Dreamstime.com
Figure 5-13	© Heico Neumeyer	Dreamstime.com
Figure 5-14	© George Mayer	Dreamstime.com
Figure 5-15	© Ronfromyork	Dreamstime.com
Figure 5-16	© Sergey Khakimullin	Dreamstime.com
Figure 5-17	© Matthew Ragen	Dreamstime.com
Figure 5-18	© Heineken Experience	
Figure 5-19	© Nancy Rogo Trainer, used with permission	
Figure 5-20	© Venturi, Scott Brown and Associates, Inc.	

Research Break

Figure RB-1	© Miroslav Beneda	Dreamstime.com
Figure RB-2	© Natalia Vainshtein	Dreamstime.com
Figure RB-3	© Convisum	Dreamstime.com
Figure RB-4	© Costasz	Dreamstime.com
Figure RB-5	© Scott A. Lukas	

Figure RB-6	© Dave Gottwald, used with permission	
Figure RB-7	© Dave Gottwald	
Figure RB-8	© Stanislav Kharchevskyi	Dreamstime.com
Figure RB-9	© Dzianis Miraniuk	Dreamstime.com

Chapter 6

Figure 6-1	© Abawab	Dreamstime.com
Figure 6-2	© Propeller Island City Lodge	Lars Stroschen
Figure 6-3	© Steve Allen	Dreamstime.com
Chart 6-1 images:		
Feature 1	© Jan Quist	Dreamstime.com
Feature 2	© Galyna Andrushko	Dreamstime.com
Figure 6-4	© Ciprian Vladut	Dreamstime.com
Figure 6-5	© Olga Makovey	Dreamstime.com
Figure 6-6	Screenshot of video	
Figure 6-7	© Roberto1977	Dreamstime.com
Figure 6-8	© BMW AG	
Figure 6-9	© Anna Klingmann, used with permission	
Figure 6-10	© 25hours Hotels	
Figure 6-11	© 25hours Hotels	
Figure 6-12	© Thomas Muderlak, used with permission	
Figure 6-13	© BMW AG	
Figure 6-14	© Feverpitched	Dreamstime.com
Chart 6-3 image	© Abawab	Dreamstime.com
Figure 6-15	© Marcin Jagiellicz	Dreamstime.com
Figure 6-16	© Danny Drapiza/FORREC	
Figure 6-17	© Dennis Severs' House	

Chapter 7

Figure 7-1	© Ian Walker	Dreamstime.com
Figure 7-2	© 25hours Hotels	
Figure 7-3	© Gina Smith	Dreamstime.com
Figure 7-4	© Lieska	Dreamstime.com
Figure 7-5	© Pavel Losevsky	Dreamstime.com
Chart 7-1 images:		
Functional	© Horiyan	Dreamstime.com
Aesthetic	© Aparagraph	Dreamstime.com

T - #0509 - 071024 - C288 - 229/229/13 - PB - 9780240820934 - Matt Lamination